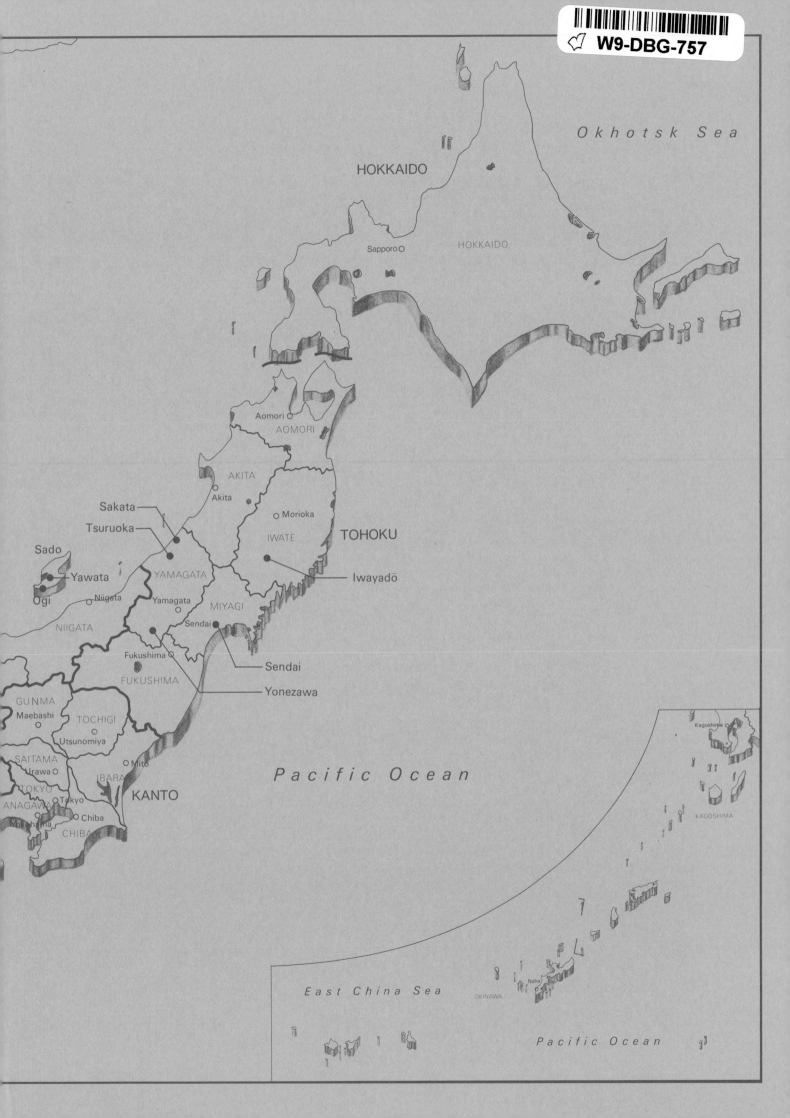

TRADITIONAL JAPANESE FURNITURE

TRADITIONAL JAPANESE FURNITURE

A Definitive Guide

Kazuko Koizumi

Translated by Alfred Birnbaum

KODANSHA INTERNATIONAL
Tokyo · New York · London

Pieces on pages 6 and 7: From the left along the perimeter, a six-panel folding screen, various chests, and an apothecary chest (above). In the foreground, a *zataku* dining table, *zabuton* cushions, an armrest, and a metal hibachi.

ACKNOWLEDGMENTS

Antique Hasebeya; Antique Nishida Bunchōdō; The Furniture Museum, Tokyo; Heibonsha Ltd., Publishers; Ishii family; Iwao Hata (collection); Izumo Folkcraft Museum; jtb Photo Library; Kawai Kanjirō's House; Kei Enoki (collection); Keisuke Kumakiri; Koyama family; Kusakabe Folkcraft Museum; Mashiko Sankō-kan (folkcrafts collected by the potter Shōji Hamada); Matsumoto family; Matsumoto Folk Arts Museum; Matsumoto Folkcraft Living Museum; Minano-machi Minzoku-shiryō Shūzōko (Kobayashi Collection); Minki Isozaki; Miura family; Mori family; Museum Meiji-mura; Okayama Museum of Art; Okayama Prefectural Museum; Osaka Castle; Photos Sonobe; Sankei-en Garden; Sekai Publishing Inc.; Shōgakkan Publishing Co., Ltd.; Shūsuke Kobata (collection) at Yakumo Honjin (hotel); Suntory Museum of Art; Taiji-chō Kujira no Hakubutsu-kan (whale museum); Taizan Nakamura (collection); Tokugawa Reimeikai Foundation; Tokyo National University of Fine Arts and Music; Toyama City Minzoku Folkcraft Village; Tsumura Juntendō, Inc.; Yabumoto (collection).

Additional photography by Eiji Kōri and Masashi Ogura. Line drawings for the Illustrated History of Japanese Furniture by Ritta Nakanishi.

The Japanese surname precedes the given name in the text, following the customary Japanese order. The author's name and those listed in the Acknowledgments follow the Western convention.

Distributed in the United States by Kodansha America, Inc., 575 Lexington Avenue, New York, N.Y. 10022, and in the United Kingdom and continental Europe by Kodansha Europe Ltd., 95 Aldwych, London WC2B 4JF. Published by Kodansha International Ltd., 17-14 Otowa 1-chome, Bunkyo-ku, Tokyo 112-8652, and Kodansha America, Inc. Copyright © 1986 by Kodansha International Ltd. All rights reserved. Printed in Jpaan.

LCC 85-40067
ISBN 0-87011-722-X (U.S.)
ISBN 4-7700-1222-5 (Japan)
First edition, 1986
99 00 01 10 9 8

CONTENTS

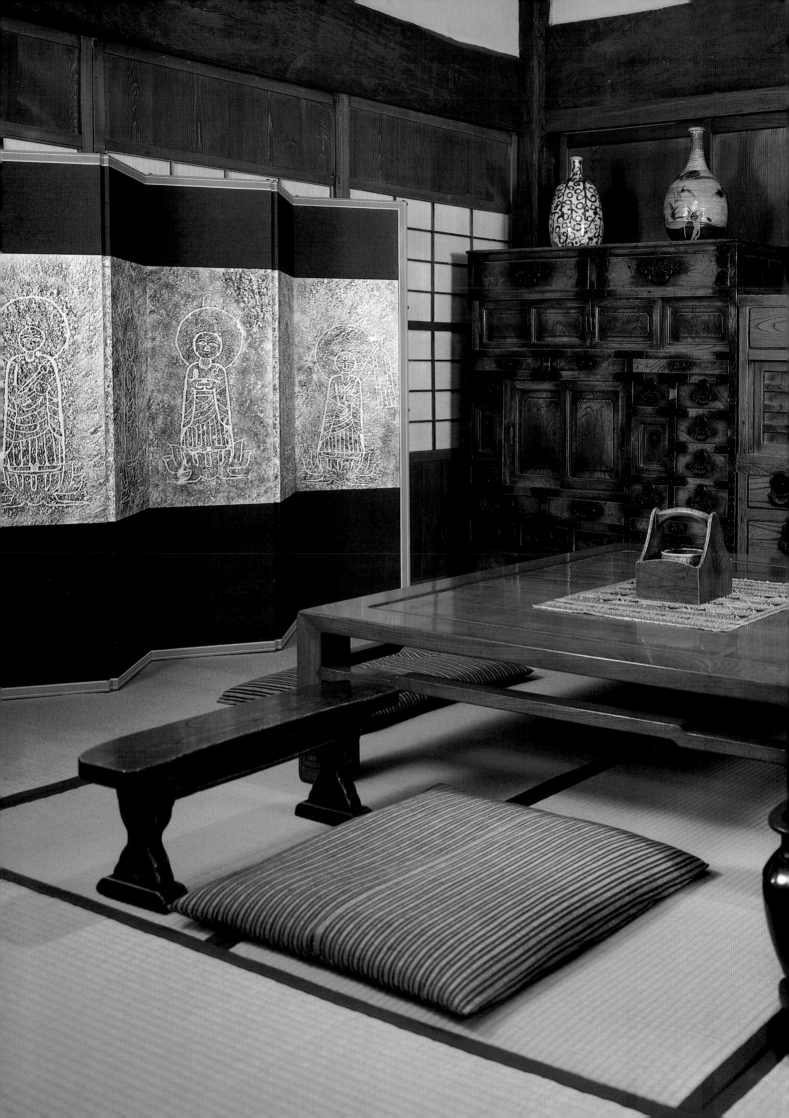

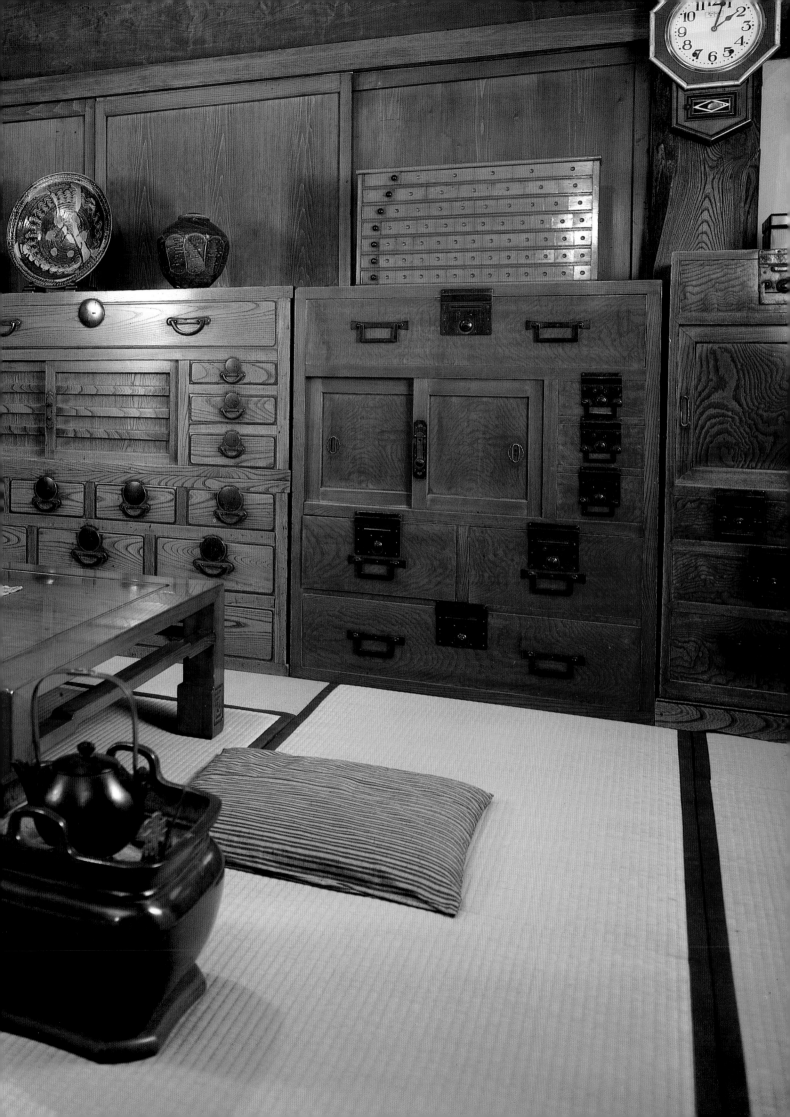

INTRODUCTION

Japanese traditional furniture reached its highest level of perfection and craftsmanship in the seventeenth to nineteenth centuries, and products of this period are among the most cherished in and outside of Japan. Most pieces in Western collections belong to this era. Since up to now a great many Japanese furnishings have found their way abroad unaccompanied by any identifying background information whatsoever, there is a very real priority for providing accurate information in this direction. This book has been conceived in part as a guide for collecting and appreciating these "mysterious" items.

The broad overview of the types of Japanese furniture presented in Part 1 forms the heart of the book. Coverage has been limited to those common household effects developed and used from around the beginning of the Edo period (1600–1868) on into the Meiji era (1868–1912). This selection suggests itself for a number of reasons.

First, the time frame chosen corresponds to that historical period when the Japanese people had brought their traditions in furniture to the highest level of development, traditions that still form the basis for Japanese furniture today. For even amidst markedly increasing Western influence over lifestyles and the living environment, when most traditional Japanese furnishings have fallen into disuse, pieces of this period are valuable for understanding the furniture of contemporary Japan.

Second, there is the difficulty of covering every single type of furniture in Japan's lengthy history. People of different social classes and occupational backgrounds varied in the furnishings they used; the sheer diversity is overwhelming. Covered here, then, are the major types of furniture and furnishings along with their most important and interesting variations.

Third, the fact that furniture of the recent past survives in relatively greater numbers makes it possible to study the actual pieces, old and recent photographs, and precise reference drawings. Needless to say, such materials are invaluable for illuminating the text.

The history section is intended to supplement the information in the first section, offering a perspective on the intricate and changing relationship between architecture and furnishings from ancient times to the present.

The final section on techniques rounds out the study, paralleling the historical and cultural dimensions to Japanese furniture with an examination of such equally important technical aspects as joinery, finishing, and metalwork, along with a step-by-step examination of procedures for lacquer and metal fitting techniques.

Articles introduced to represent Japanese furniture in this book have been selected with an eye to their aesthetic role in the living environment (except where exclusion might lead to an imbalance in the category as a whole). Hence such pieces of kitchen equipment as pots and kettles have been excluded from consideration. On the other hand, lanterns and certain other items not usually regarded as "furniture" in the Western sense are included because many of these pieces have considerable artistic value, and because of the broad meaning that the word *kagu* (see below) at one time carried.

THE CONCEPT OF *KAGU*

As a point of departure, it should be noted that the term *kagu*—literally "house-makings," though rendered variously as "furniture," "furnishings," or "household effects"—has continually fluctuated in meaning over the course of history. Even today, definitions have sizable "gray areas." Such ambiguities are not limited to Japan, however, for even in the West, different countries and peoples have their own view of what is and what is not "furniture." Where some would proceed from the idea of *meubles*—"movables"—others might insist that even such built-ins as fireplaces ought to be included.

In the case of Japan, one especially problematic borderline area is that of kitchen equipment: should cookstoves (*kamado*), well-housings (*ido*), pots (*nabe*), and kettles (*kama*) be regarded as *kagu*? Or perhaps even more difficult, there is the question of how to deal with pieces whose status has changed dramatically according to the times; for example, trays (*bon*), which up until the Meiji era were in common use as individual place-settings for meals, have since ceased to be regarded as *kagu* with the widespread adoption of the Western concept of dining at a table. Then, there are tatami floormats, now built-in flooring, though in ancient and medieval Japan they were hauled about and positioned for sitting and sleeping. Doorway curtains (*noren*) likewise no longer seem to meet the popular notion of *kagu*, yet they too had once been important as a type of partition. Architectural innovations have effectively absorbed their role as furniture.

A related problem is that the very word *kagu* has a limited history of use. In fact, terms for furniture have changed with nearly every period. In written records of the Nara period (710–94), furnishings apparently came under such blanket headings as "holdings" (*shizai*), "odds-and-ends" (*zatsu-butsu*), "installed items" (*hosetsu-butsu*), or "trappings" (*shōzoku*). In the Heian period (794–1185), the most common usages were "equipage" (*chōdo*), and again "trappings," while in the Kamakura period (1185–1333), the terminology shifted to "fittings" (*gusoku*), "honorable items" (*gyomotsu*), and "properties" (*kizai*). The Edo period brought out still different expressions, among them "implements" (*dōgu*), "indoor properties" (*okuzai*), and "household properties" (*kazai*).

What is striking here is that historical investigation fails to come up with any single comprehensive word for articles in the home. At the very least, the things these words describe did not necessarily always conform to the modern idea of furniture. Take *chōdo*, for instance, which carried such diverse meanings as small personal accessories, metal architectural trim, and bows and arrows. Or *dōgu*, originally a Buddhist term for articles used in religious training, whence usage gradually broadened to include any implement for whatever end, far beyond the bounds of mere furnishings.

Even the word *kagu* itself seems to have meant something different than it does today. First coined in the Kamakura period, the "house-makings" in question at the time were things like roof beams and rafters—actual structural elements. Paradoxically, period writings also contain such combined phrasings as *wan kagu*, the "complementary article to the *wan* (bowl)"—in this case a tray-table (*zen*).

It is no coincidence that the word *kagu* attained its current meaning only as recently as the Meiji era, after the importation of Western furniture. For once the Japanese came in contact with these new chairs, tables, and beds, they were hard put to apply such existing vocabularies as *kazai* and *dōgu*, and so coined the neologism *seiyō kagu* ("Western house-makings"). And, of course, as new concepts lend themselves to new distinctions, it seemed natural to contrast these with the more familiar accouterments of the Japanese home. So that sometime between the end of the Meiji era and the beginning of the Taishō (1912–26), Japanese-style chests (*tansu*), shelving (*todana*), and the like came to be called simply *kagu*. Needless to say, this left the definition somewhat hazy, the bounds varying according to the purposes of discussion.

One more important consideration toward establishing general characteristics in Japanese furniture is that the Japanese have traditionally lived at floor level, as op-

posed to using chairs and beds. While every culture certainly began with floor-level lifestyles in primitive times, most evolved to living at chair height with the advance of civilization. Yet for some reason, Japanese civilization has retained the custom of floor-seating. Even more curious is the fact that the custom of chair-seating has found its way to Japan from abroad repeatedly over the course of history, and had at times even been adopted in part, but never made a lasting mark. The present chair-seated lifestyle really only caught on in the post–World War II era. Reasons why chair-seating did not "take" are suggested in the introduction to the historical chapters; meanwhile, suffice it to say that the choice not to have such raised furnishings as beds, tables, desks, and chairs in the living environment has to a great extent shaped the face of traditional Japanese furniture.

THE CONCEPT OF *SHITSURAI*

The essentially floor-level lifestyle of the Japanese meant that there was no need to develop raised furniture for seating and reclining. Hence one does not find legs or stands on Japanese furniture, not even on chests and cabinets. Everything stays low, within reach from a sitting position on the floor.

Next, it should be pointed out that floor-seating has tended to dictate a strong frontality in furnishings. Living at chair height frees people to move about the room, and such mobility brings the sides and even the backs of chests and cabinets into view, encouraging more volumetric designs. People seated on the floor, however, see things from a fixed perspective, which places proportionately greater emphasis on the frontal aspects. Hence singularly frontal designs are the rule; little or no consideration is given to the backs or sides of pieces.

Another significant feature is that Japanese furniture works to wholly systematize interiors within a standard architectural frame. This "from the floor up" approach to furnishing was traditionally called *shitsurai*, and dates from the beginnings of modular residential architecture in the mid–Heian period *shinden* style (see pages 158–59). This style was characterized by an extreme sparseness, interiors virtually bare stagelike settings of wooden floors and columns and little else. In order to render such space livable, doorway curtains (*noren*) and folding screens (*byōbu*) had to first partition off an area, in which tatami matting would be laid down, and then a low table or free-standing shelf set in place; only then could it function as a room. *Shitsurai* thus meant the act of providing and arranging articles so as to create a room for some given purpose or activity, and in fact it was *shitsurai* that made for the extreme versatility of *shinden*-style villas, where otherwise existed no special-purpose rooms such as sleeping chambers or dining halls. While this architectural style gradually changed over the course of Japan's middle ages (1185–1573), and eventually developed into the *shoin* style (see page 165) with fully partitioned rooms, which in turn continued up to modern times, the practice of *shitsurai* was passed on intact directly from the *shinden* to the *shoin* styles. Yet even here, the partitions had nothing of the solidity of Western or Chinese walls. Instead, there now were removable sliding-door panels (*fusuma*) and translucent paper panels (*shōji*). Furthermore, there continued to develop a whole battery of independent partition devices along the lines of the folding screens, doorway curtains, and *sudare* blinds. This trend was an entirely characteristic product of the tradition of *shitsurai* and the idea of "set in place" living arrangements.

Conversely, another characteristic offshoot of the *shitsurai* tradition was the tendency for once-independent furniture items to become functionally absorbed into the architecture. Free-standing shelves soon came to be built in place, while cabinets for bedding were tucked away in the walls as *oshiire* (literally "push-in" bedding closets). As a result, certain furnishings utterly lost their "occasional" status and appearance.

The idea of standard dimensions and interchangeable modular units also seems to have developed from much the same basic thinking. Even today, tatami, *fusuma*, and *shōji* all have the exact same 3- by 6-foot (90- by 180-centimeter) measurements (there are regional variations, but the concept remains the same), making it possible

to outfit (*shitsuraeru*) rooms of various sizes using multiples of these units. *Sudare* blinds come in standard 3- and 6-foot (90- and 180-centimeter) widths; broader window areas need only be hung with the appropriate number of units. *Tansu* may likewise be stacked chest-on-chest, and broken down for carrying by attached handles. Even tray-tables are made to allow stacking to impressive heights, as can still frequently be seen in traditional inns and restaurants. Such systematization of the furnishings had no parallel in the West until the advent of modern industrial society, yet it characterized Japanese furniture from early history.

LINEARITY, ASYMMETRY, AND FINISH

The most immediately apparent formal characteristic of Japanese furniture is its linearity. The *tansu*, for instance, is almost a box compared to Western chests of drawers, with their elliptical designs or intricately curved façades, replete with ornamental carving and fluting. Tables also are blocklike and simple, with legs that, excluding some ceremonial tables with legs that exhibit more fluidity, also tend toward boxlike forms.

There is probably no simple answer as to why the straight-line format should predominate, but one reason that does suggest itself is the wood-frame construction of Japanese buildings. For whereas other traditions in furniture are matched to more "sculptural" stone or earthen buildings, Japanese furniture might well echo the rectilinear, exposed post-and-beam structural joinery of Japanese architecture.

One more salient formal characteristic to be cited is that of simplicity. Unlike European furniture in which wood, leather, metal, even stone and other materials might be laboriously tooled into highly involved combinations, there is little striving after complicated effects in Japanese furniture. There apparently had been leanings in this direction in the Nara period, but from the Heian period on construction rarely went beyond wood with metal fittings or ornamentation, eschewing more diverse materials.

On the level of design, there was a decided preference for asymmetry. Needless to say, this taste was not limited to furniture, but extended to gardens and architecture itself, and to a broad range of plastic and decorative arts. Though a key feature in the aesthetic sensibilities of the Japanese, this preference for the asymmetric was not apparent from the very outset. There had always existed, on the one hand, the symmetric ideal, from which asymmetry was sought through the "relaxation" of form. That is to say, there were formal levels of stringency or propriety in design, as in the breakdown of calligraphy into formal, semiformal and cursive scripts (*shin, gyō, sō*). When applied to furniture, the most formal designs display an exacting symmetry, while semiformal and informal styles are progressively freer in conception. As was the case with so many cultural imports from China, where the Chinese had, and still do, prefer the quintessential formality of *shin* furnishings, the Japanese repeatedly chose to "play" upon the severe original forms, effecting *gyō* or *sō* alterations: throwing that shifted poise slightly off center, the stolid weight lightened, the aloof fixity injected with varying degrees of dynamism, even humor. There is, of course, a definite risk of overextending this breakdown process; the trick is to catch things right at that "just so" point of balance. A sensitivity to just such subtleties lies at the heart of the Japanese genius for design.

Numerous cultural and psychological factors would seem to contribute to this Japanese preference for the asymmetric, and no simple explanation suffices. However, it should be noted that many otherwise rigid or monotonous rectilinear designs in both architecture and furniture are in fact "saved" by the element of asymmetry,

Finally, there is an attention to the beauty of finish and detailing. Since the interest of Japanese furniture generally has little to do with the complexity of shapes themselves, aesthetic qualities are expressed mainly in surface treatment. In the case of wood furniture, this takes two forms: one is the cosmetic application of lacquer or decorative *maki-e* lacquer designs, typically in delicate, lyrical pictorial representations or symbols from nature; another is the rendering of the wood itself into the object of aesthetic appreciation. This latter approach aims either to emphasize the

beauty of unfinished wood (*shiraki*) or to bring out a pleasing wood-grain effect (*moku-me*).

As a rule, light-colored woods such as cypress, cryptomeria, pine, paulownia, and magnolia are left unfinished, and convey a sense of purity. Hence, the newer the materials, the better. With richly grained woods like zelkova, mulberry, boxwood, cherry, maple, black persimmon, walnut, and imported *karaki* woods, common practice is to heighten the sheen with thin layers of *fuki-urushi* lacquer, or with a coat of transparent *kijiro* or *shunkei* lacquers.

Of the two, the eye attuned to plain, unfinished *shiraki* seems a uniquely Japanese sensibility. Elsewhere in the world, the taste for wood grain runs strong: in the West, from Gothic to English country furniture, and particularly in Baroque and Roccoco furniture parquetry; in the Orient, Chinese and Korean Yi dynasty chests are exemplary. Yet probably no other culture exhibits such fondness for fresh, clean, planed wood surfaces. Very recently, some furniture coming out of Scandinavia in particular has begun to feature plain pine for its aesthetic value, but this is largely due to a Japanese influence on the vocabulary of Modernism.

Just how and when the Japanese came to this appreciation of unfinished wood is difficult to pinpoint. The most that can be said is that it relates to certain indigenous religious beliefs existing on the Japanese archipelago from before the transmission of Buddhism in 538, and specifically to the cult of purity and abstinence from defilements. The Grand Shrine of Ise (see page 151) and other shrine architecture is of plain wood, as are almost all ritual implements of Shinto. For fundamental to their design was the understanding that all utensil objects, architecture included, were to be discarded after use. This clearly ties in with the nature of woods such as Japanese cypress and cryptomeria—fragrant and beautifully bright when new, but all too quickly soiled.

While any conscious valuation of unfinished wood that existed prior to the influx of Chinese culture was no doubt limited to a priest-aristocracy, such awareness still remains strongly rooted in the cultural life of the Japanese people even today.

THE
COLOR
PLATES

CABINETRY

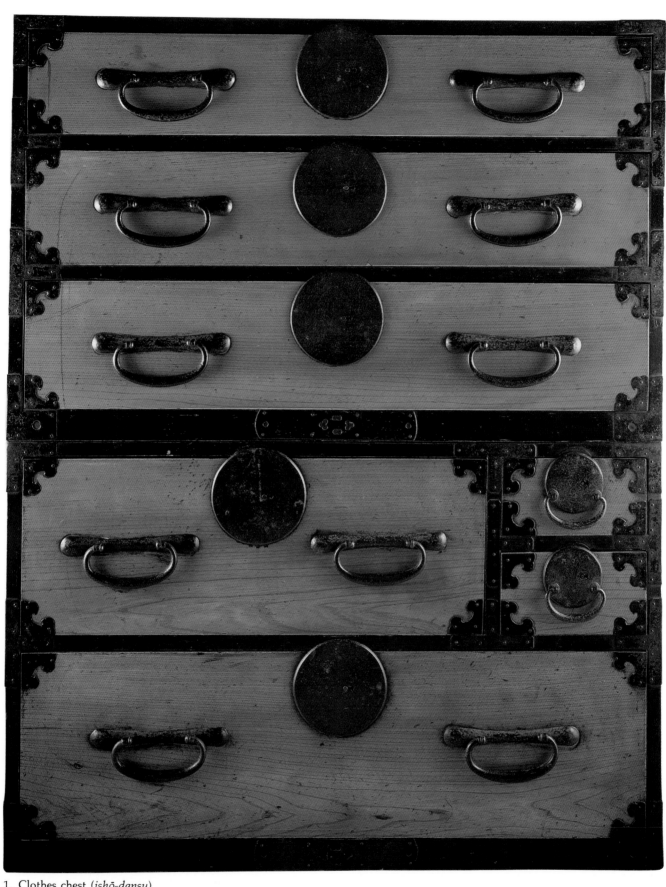

1. Clothes chest (ishō-dansu)

Late nineteenth century, Nagano Prefecture
H. 42, W. 34, D. 16 in. (109, 87, 39 cm.)
Pine, black-lacquered iron fittings, *bengara* stain

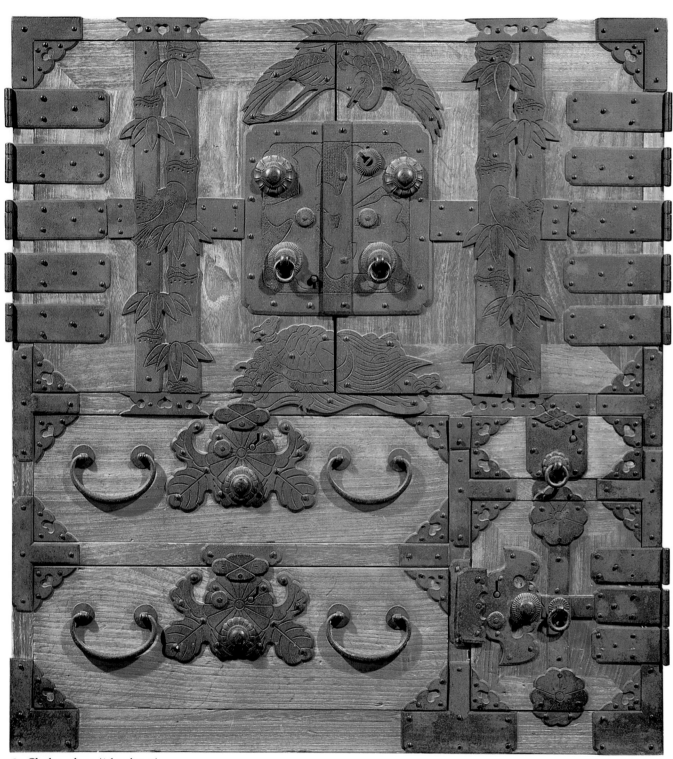

18

2. Clothes chest (*ishō-dansu*)
Late nineteenth century, Sakata, Yamagata Prefecture
H. 28, W. 25, D. 15 in. (70, 64, 37 cm.)
Paulownia, iron fittings, no finish

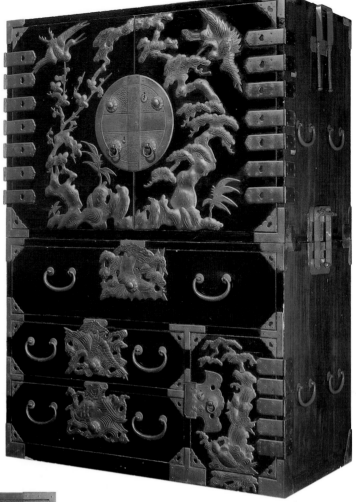

3. Clothes chest (*ishō-dansu*)
Late nineteenth century, Tsuruoka, Yamagata Prefecture
H. 48, W. 34, D. 18 in. (122, 88, 45 cm.)
Paulownia, iron fittings, black lacquer

19

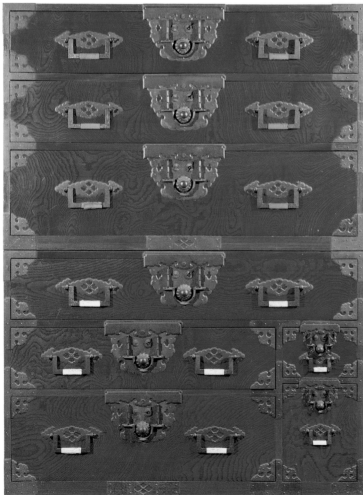

4. Clothes chest (*ishō-dansu*)
Early twentieth century, Sakata, Yamagata Prefecture
H. 48, W. 35, D. 18 in. (122, 91, 45 cm.)
Zelkova, *kijiro* lacquer

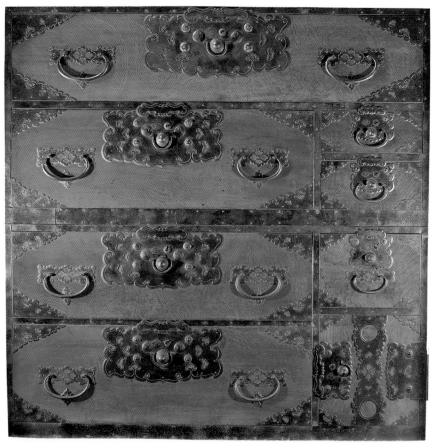

5. Clothes chest (*ishō-dansu*)
Late nineteenth century, Sado, Niigata Prefecture
H. 40, W. 38, D. 16 in. (103, 95, 42 cm.)
Zelkova, iron fittings, *fuki-urushi* lacquer

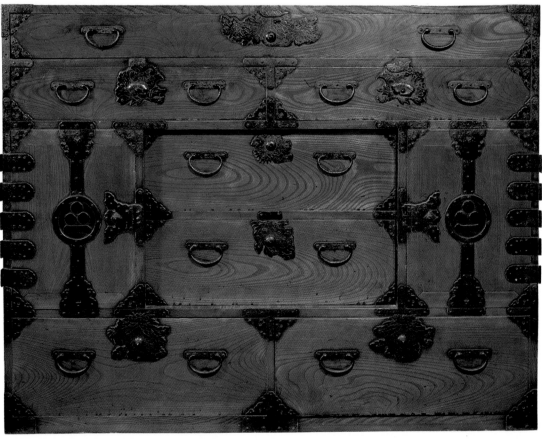

6. Clothes chest (*ishō-dansu*)
Middle nineteenth century, Sendai, Miyagi Prefecture
H. 41, W. 54, D. 19 in. (105, 139, 49 cm.)
Zelkova, iron fittings, *fuki-urushi* lacquer

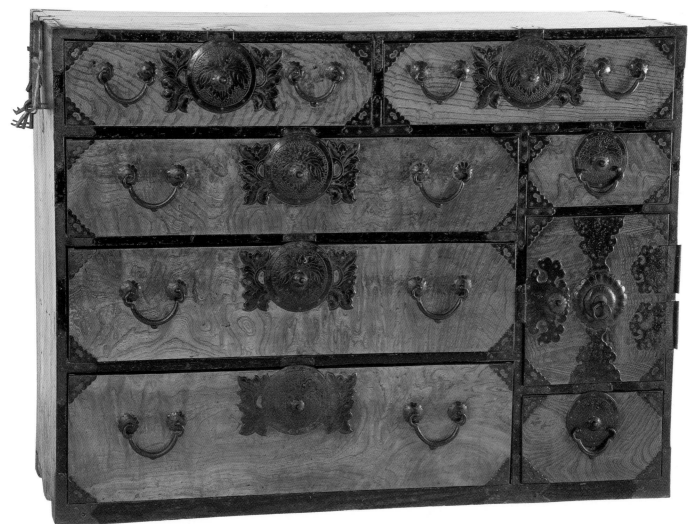

7. Clothes chest (*ishō-dansu*)
Late nineteenth century, Sendai, Miyagi Prefecture
Approx. H. 35, W. 47, D. 18 in. (90, 120, 45 cm.)
Zelkova, iron fittings, *fuki-urushi* lacquer

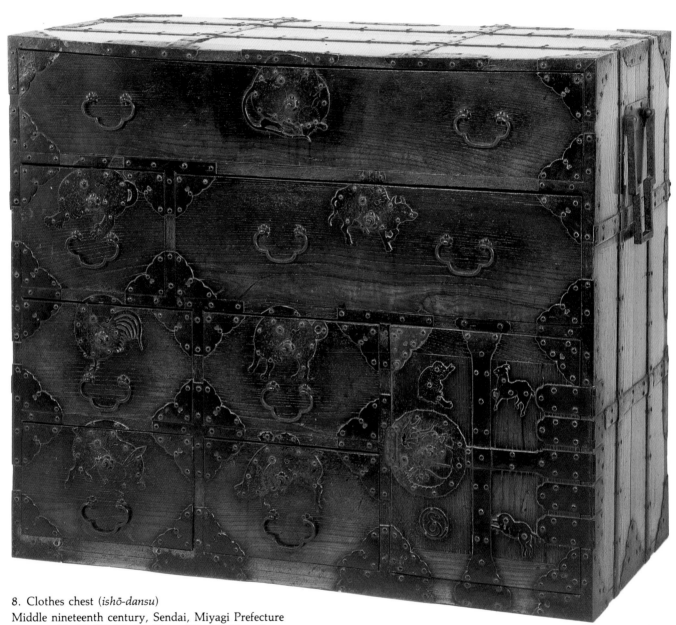

22

8. Clothes chest (*ishō-dansu*)
Middle nineteenth century, Sendai, Miyagi Prefecture
Approx. H. 30, W. 33, D. 16 in. (75, 85, 40 cm.)
Zelkova, iron fittings, *fuki-urushi* lacquer

9. Tea chest (*cha-dansu*)
Late nineteenth century, Toyama Prefecture
H. 35, W. 30, D. 16 in. (91, 78, 41 cm.)
Zelkova, iron fittings, *fuki-urushi* lacquer

10. Small chest (*ko-dansu*)
Late eighteenth century, Tokyo
H. 14, W. 16, D. 10 in. (35, 41, 25 cm.)
Hinoki cypress, mother-of-pearl inlay,
 black lacquer

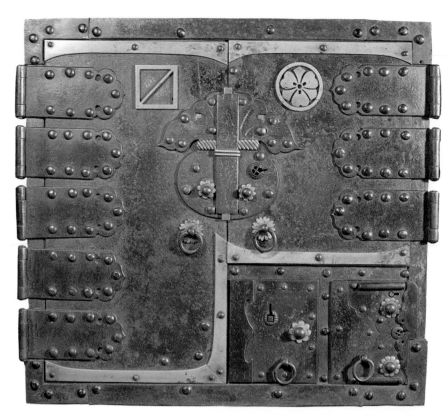

11. Small chest (*ko-dansu*)
Middle eighteenth century, Niigata Prefecture
H. 16, W. 18, D. 20 in. (41, 45, 50 cm.)
Brass family crest with floral motif, brass
trademark, iron metalwork

24

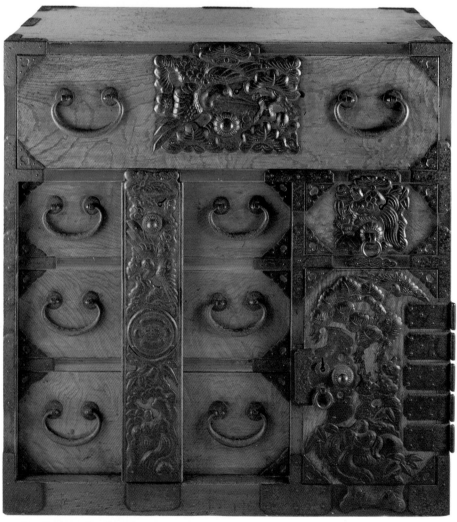

12. Small chest (*ko-dansu*)
Late nineteenth century, Tsuruoka, Yamagata Prefecture
H. 26, W. 25, D. 14 in. (64, 62, 36 cm.)
Zelkova, *fuki-urushi* lacquer

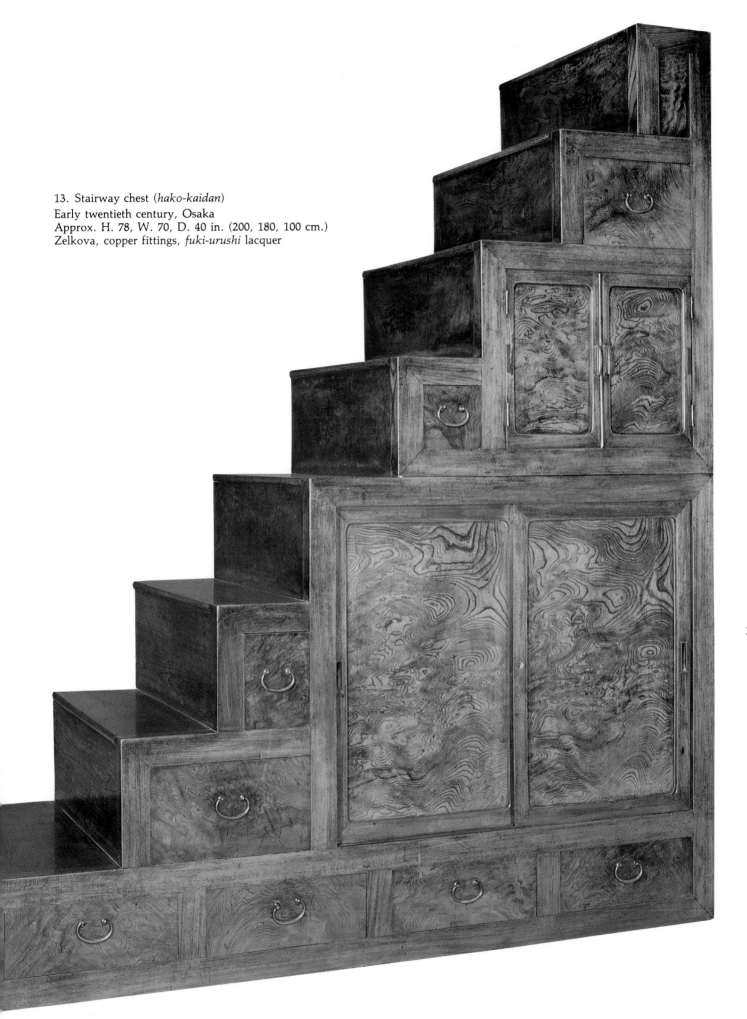

13. Stairway chest (*hako-kaidan*)
Early twentieth century, Osaka
Approx. H. 78, W. 70, D. 40 in. (200, 180, 100 cm.)
Zelkova, copper fittings, *fuki-urushi* lacquer

25

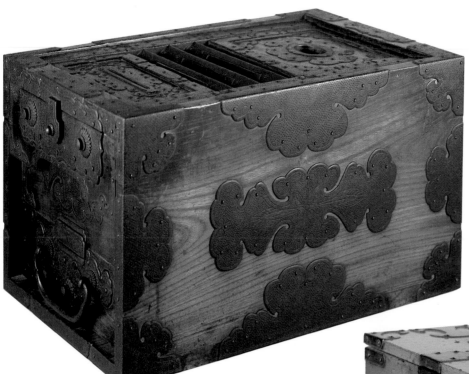

14. Cash box (*zeni-bako*)
Late nineteenth century, Matsumoto, Nagano Prefecture
H. 11, W. 12, D. 20 in. (29, 31, 50 cm.)
Zelkova, iron fittings, *fuki-urushi* lacquer

15. Portable writing box–safe (*kake-suzuribako*)
Late nineteenth century, Matsumoto, Nagano Prefecture
H. 7, W. 6, D. 11 in. (18, 15, 26 cm.)
Zelkova, black-lacquered iron fittings, *fuki-urushi* lacquer

26

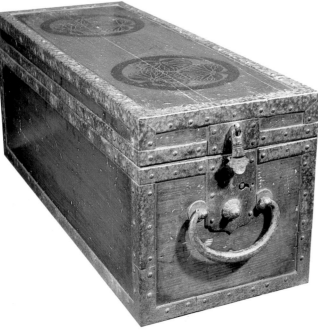

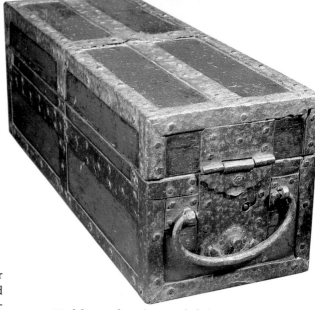

16. Money chest (*senryō-bako*)
Late eighteenth century, Nagoya, Aichi Prefecture
H. 10, W. 8, D. 20 in. (25, 20, 50 cm.)
Cryptomeria, family crests of iron, iron fittings, *fuki-urushi* lacquer
Both this and the piece in plate 17 were built to hold one thousand elongated gold coins. In order to house and secure such a large quantity, construction was necessarily sturdy. The chest in plate 17 is belted for added reinforcement, while this one is decorated with a family crest. Larger ten-thousand-coin and smaller five-hundred-coin chests also exist.

17. Money chest (*senryō-bako*)
Late nineteenth century, Tokyo
H. 8, W. 8, D. 20 in. (20, 20, 50 cm.)
Cryptomeria, iron fittings, *fuki-urushi* lacquer

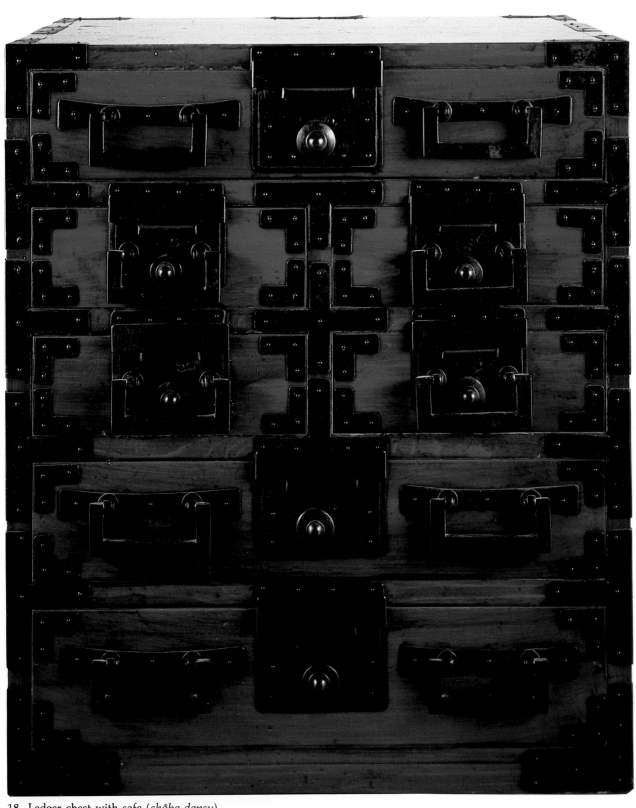

27

18. Ledger chest with safe (*chōba-dansu*)
Late nineteenth century, Matsumoto, Nagano Prefecture
H. 23, W. 20, D. 14 in. (57, 50, 34 cm.)
Pine, black-lacquered iron fittings, *shunkei* lacquer

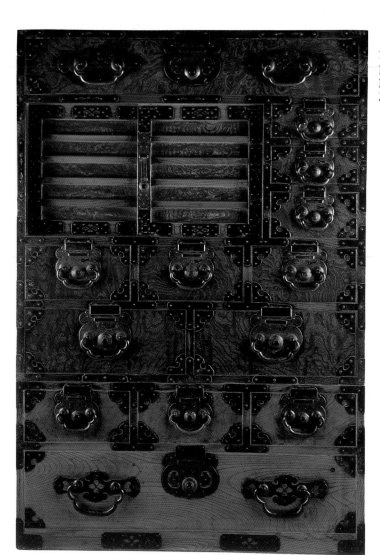

19. Ledger chest with safe (*chōba-dansu*)
Early twentieth century, Matsumoto, Nagano Prefecture
H. 25, W. 33, D. 16 in. (63, 85, 42 cm.)
Zelkova, iron fittings, *fuki-urushi* lacquer

28

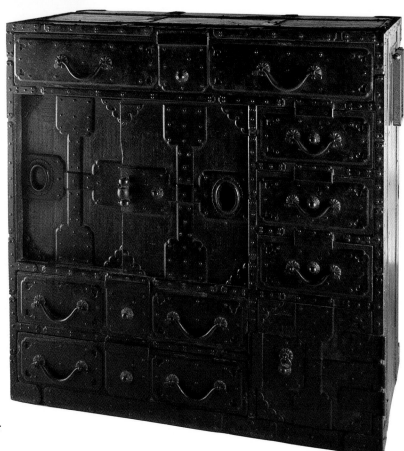

20. Ledger chest with safe (*chōba-dansu*)
Early nineteenth century, Tokyo
H. 28, W. 29, D. 16 in. (71, 73, 39 cm.)
Paulownia, iron fittings, *fuki-urushi* lacquer

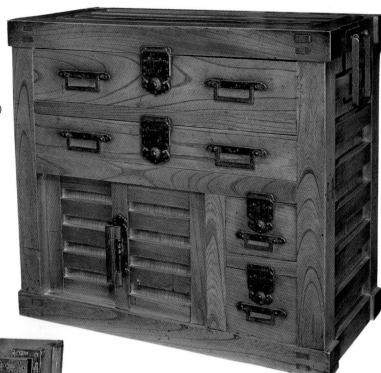

21. Ledger chest with safe (*chōba-dansu*)

Middle nineteenth century, Niigata Prefecture
Approx. H. 41, W. 39, D. 19 in. (102, 96, 48 cm.)
Zelkova, iron fittings, *fuki-urushi* lacquer

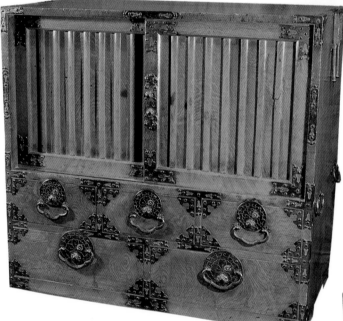

22. Ledger chest with safe (*chōba-dansu*)

Late nineteenth century, Yonezawa, Yamagata Prefecture
Approx. H. 29, W. 33, D. 17 in. (72, 85, 43 cm.)
Zelkova, iron fittings, *fuki-urushi* lacquer

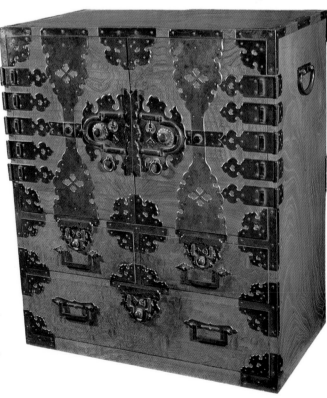

23. Ledger chest with safe (*chōba-dansu*)

Late nineteenth century, Sakata, Yamagata
Prefecture
H. 40, W. 33, D. 18 in. (101, 85, 46 cm.)
Zelkova, black- and vermilion-lacquered iron
fittings, *fuki-urushi* lacquer

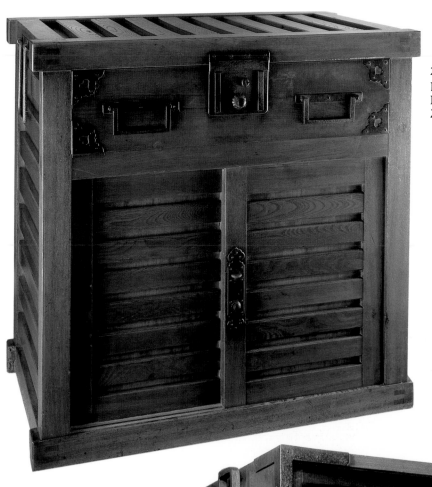

24. Ledger chest with safe (*chōba-dansu*)
Late nineteenth century, Niigata Prefecture
H. 18, W. 35, D. 33 in. (49, 89, 85 cm.)
Zelkova, iron fittings, *fuki-urushi* lacquer

25. Ledger chest with safe (*chōba-dansu*)
Late nineteenth century, Sakata, Yamagata Prefecture
Approx. H. 40, W. 36, D. 18 in. (100, 93, 45 cm.)
Hinoki cypress, iron fittings, *fuki-urushi* lacquer

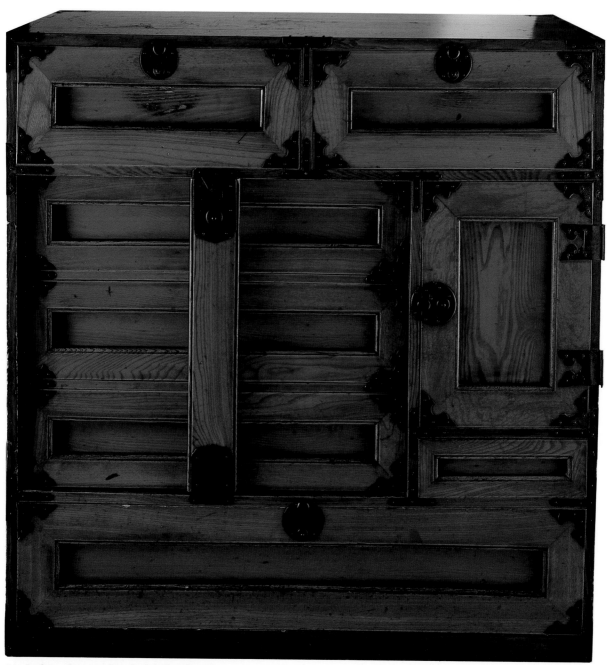

26. Ledger chest with safe (*chōba-dansu*)
Middle nineteenth century, Takayama, Gifu Prefecture
H. 31, W. 30, D. 15 in. (81, 79, 38 cm.)
Hinoki cypress, iron fittings, *shunkei* lacquer

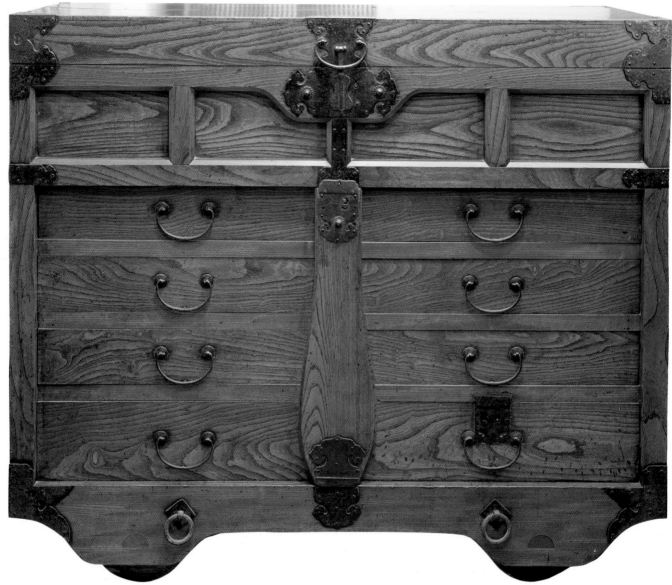

27. Wheeled chest (*kuruma-dansu*)
Type: clothes chest (*ishō-dansu*)
Late nineteenth century, Kanazawa, Ishikawa Prefecture
H. 43, W. 50, D. 23 in. (109, 127, 58 cm.)
Zelkova, iron fittings, *fuki-urushi* lacquer

28. Wheeled chest (*kuruma-dansu*)

Type: ledger chest with safe (*chōba-dansu*)

Middle nineteenth century, Yonezawa, Yamagata Prefecture

H. 41, W. 35, D. 21 in. (105, 90, 52 cm.)

Zelkova, iron fittings, *fuki-urushi* lacquer

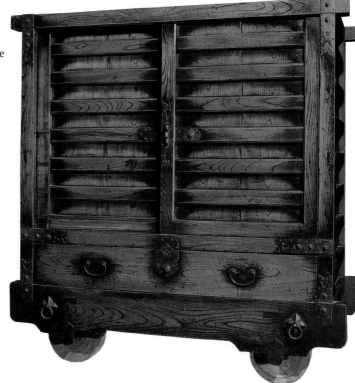

29. Wheeled chest (*kuruma-dansu*)

Type: clothes chest (*ishō-dansu*)

Late nineteenth century, Iwayadō, Iwate Prefecture

Approx. H. 30, W. 67, D. 22 in. (75, 170, 55 cm.)

Zelkova, iron fittings, *fuki-urushi* lacquer

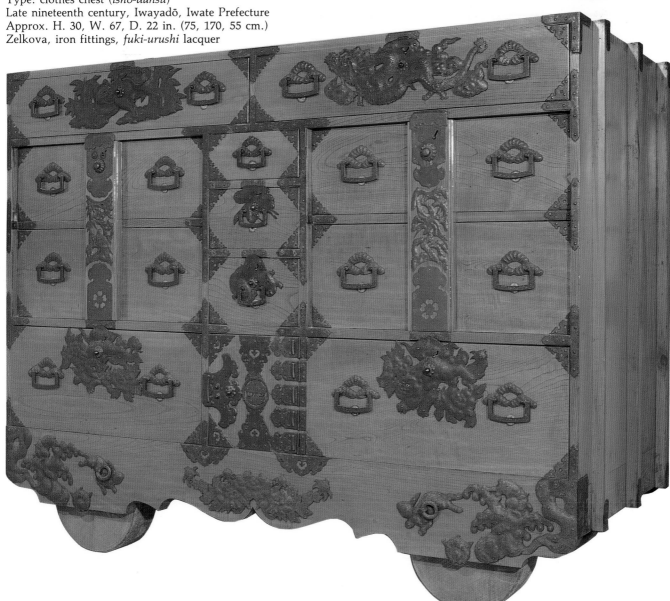

33

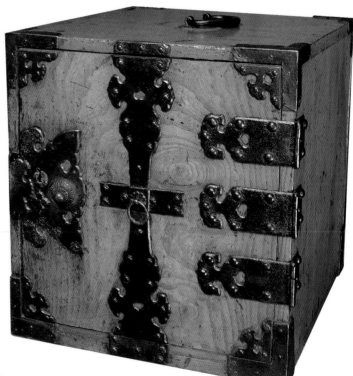

30. Sea chest (*funa-dansu*)
Type: portable writing box–safe (*kake-suzuribako*)
Middle nineteenth century, Sado, Niigata Prefecture
H. 14, W. 15, D. 16 in. (36, 38, 40 cm.)
Zelkova, black-lacquered iron fittings, *fuki-urushi* lacquer

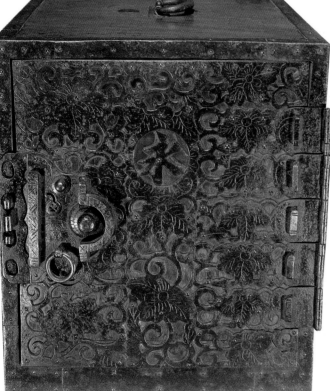

31. Sea chest (*funa-dansu*)
Type: portable writing box–safe (*kake-suzuribako*)
Middle nineteenth century, Sado, Niigata Prefecture
H. 19, W. 18, D. 21 in. (49, 45, 52 cm.)
Zelkova, black-lacquered iron fittings, *fuki-urushi* lacquer

34

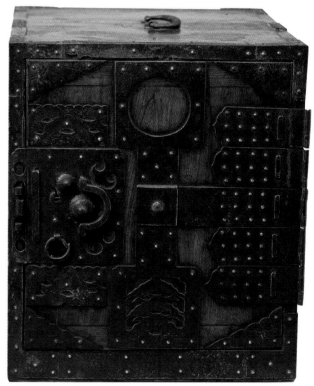

32. Sea chest (*funa-dansu*)
Type: portable writing box–safe (*kake-suzuribako*)
Middle nineteenth century, Sado, Niigata Prefecture
H. 16, W. 15, D. 18 in. (41, 37, 45 cm.)
Zelkova, black-lacquered iron fittings, *fuki-urushi* lacquer

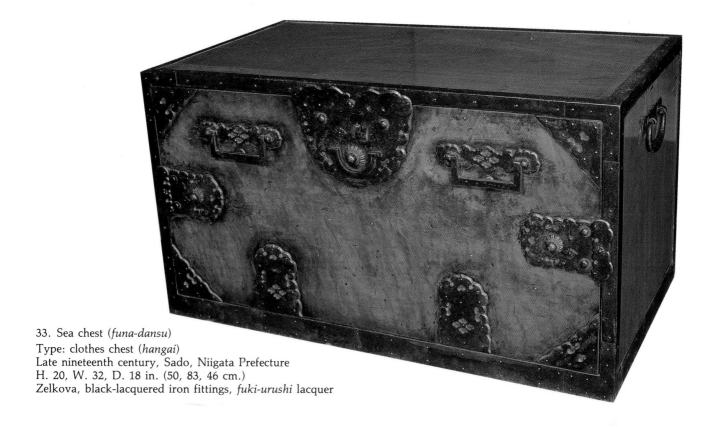

33. Sea chest (*funa-dansu*)
Type: clothes chest (*hangai*)
Late nineteenth century, Sado, Niigata Prefecture
H. 20, W. 32, D. 18 in. (50, 83, 46 cm.)
Zelkova, black-lacquered iron fittings, *fuki-urushi* lacquer

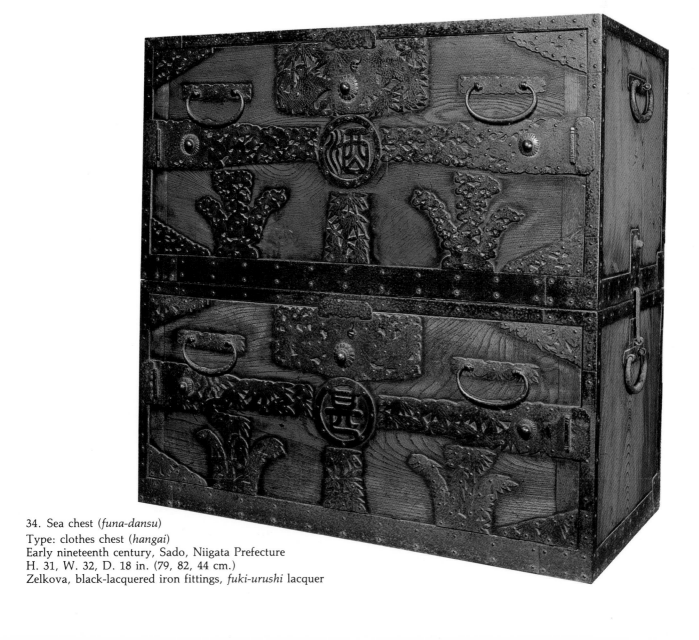

34. Sea chest (*funa-dansu*)
Type: clothes chest (*hangai*)
Early nineteenth century, Sado, Niigata Prefecture
H. 31, W. 32, D. 18 in. (79, 82, 44 cm.)
Zelkova, black-lacquered iron fittings, *fuki-urushi* lacquer

35. Sea chest (*funa-dansu*)
Type: portable ledger box with safe (*chōbako*)
Middle nineteenth century, Sado, Niigata Prefecture
H. 20, W. 19, D. 18 in. (50, 46, 45 cm.)
Zelkova, black-lacquered iron fittings, *fuki-urushi* lacquer

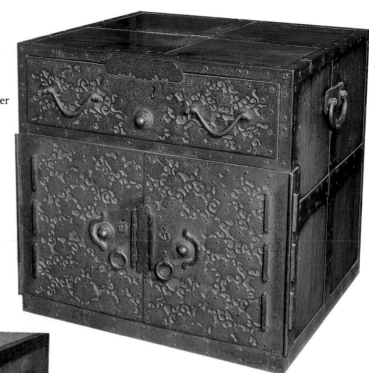

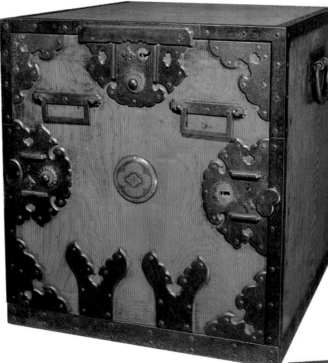

36. Sea chest (*funa-dansu*)
Type: portable ledger box with safe (*chōbako*)
Middle nineteenth century, Sado, Niigata Prefecture
H. 18, W. 19, D. 20 in. (45, 48, 51 cm.)
Zelkova, black-lacquered iron fittings, yellow copper
 family crest, *fuki-urushi* lacquer

36

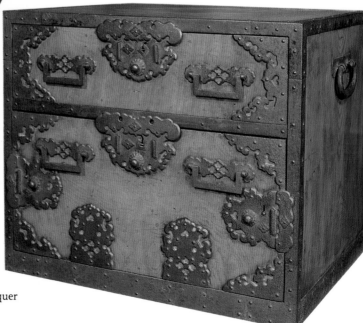

37. Sea chest (*funa-dansu*)
Type: portable ledger box with safe (*chōbako*)
Middle nineteenth century, Sado, Niigata Prefecture
H. 19, W. 22, D. 18 in. (46, 55, 45 cm.)
Zelkova, black-lacquered iron fittings, *fuki-urushi* lacquer

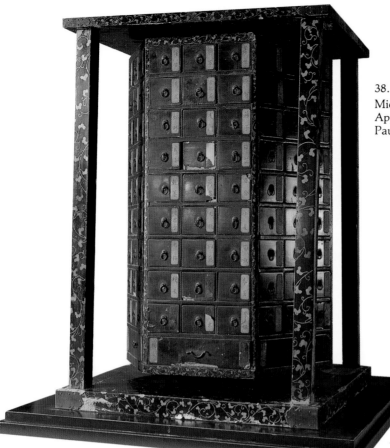

38. Apothecary chest (*kusuri-dansu*)
Middle nineteenth century
Approx. H. 47, W. 28, D. 28 in. (120, 70, 70 cm.)
Paulownia, *maki-e*, iron fittings, black lacquer

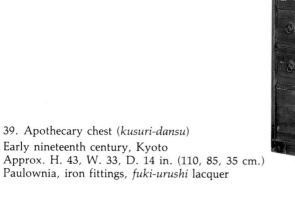

39. Apothecary chest (*kusuri-dansu*)
Early nineteenth century, Kyoto
Approx. H. 43, W. 33, D. 14 in. (110, 85, 35 cm.)
Paulownia, iron fittings, *fuki-urushi* lacquer

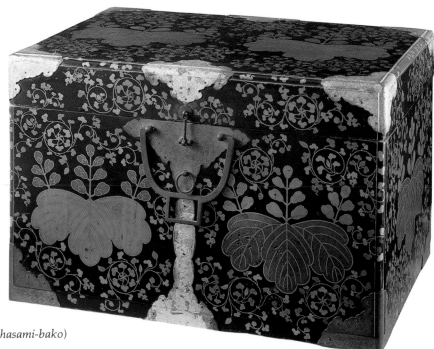

40. Scissored hamper (*hasami-bako*)
Late sixteenth century
H. 15, W. 24, D. 17 in. (37, 59, 41 cm.)
Paulownia, gold *maki-e*, copper fittings with gold leaf, black lacquer

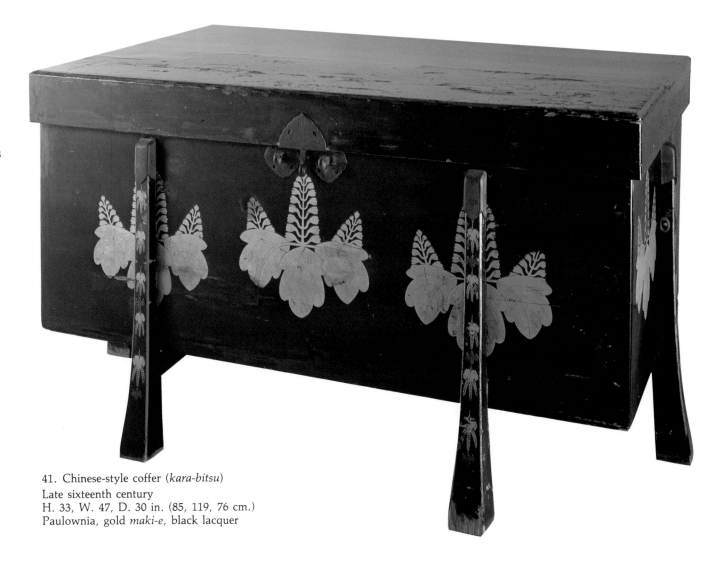

41. Chinese-style coffer (*kara-bitsu*)
Late sixteenth century
H. 33, W. 47, D. 30 in. (85, 119, 76 cm.)
Paulownia, gold *maki-e*, black lacquer

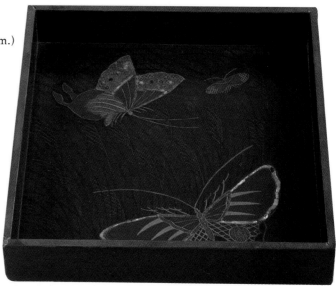

42. Clothes tray (*midare-bako*)
Middle eighteenth century
H. 1 3/4, W. 11, D. 11 in. (4.3, 26, 26 cm.)
Mother-of-pearl inlay, *maki-e*

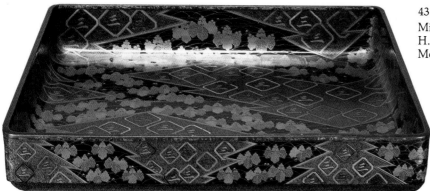

43. Clothes tray (*midare-bako*)
Middle seventeenth century
H. 4, W. 23, D. 21 in. (10, 57, 54 cm.)
Mother-of-pearl inlay, *maki-e*

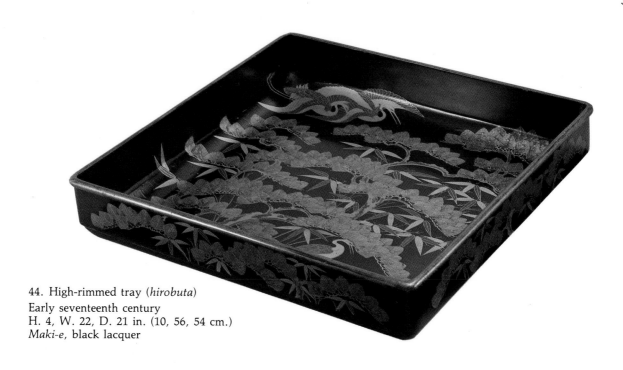

44. High-rimmed tray (*hirobuta*)
Early seventeenth century
H. 4, W. 22, D. 21 in. (10, 56, 54 cm.)
Maki-e, black lacquer

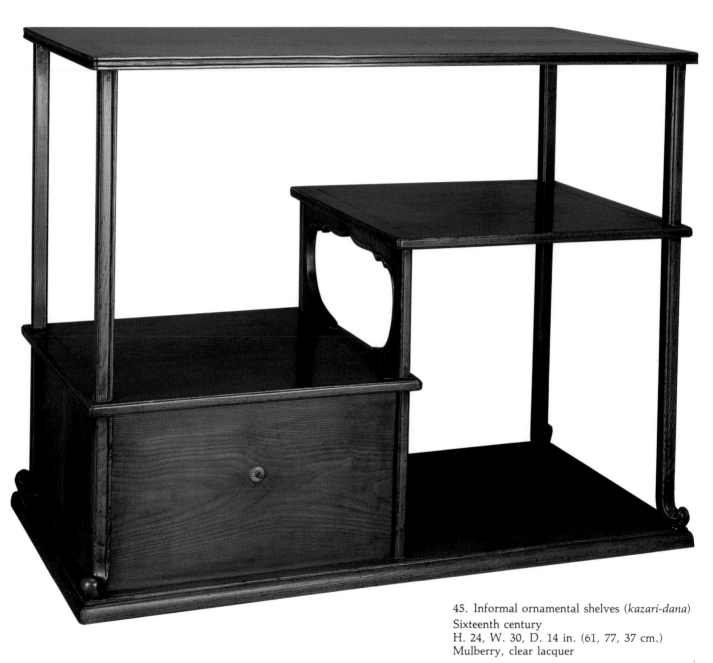

45. Informal ornamental shelves (*kazari-dana*)
Sixteenth century
H. 24, W. 30, D. 14 in. (61, 77, 37 cm.)
Mulberry, clear lacquer

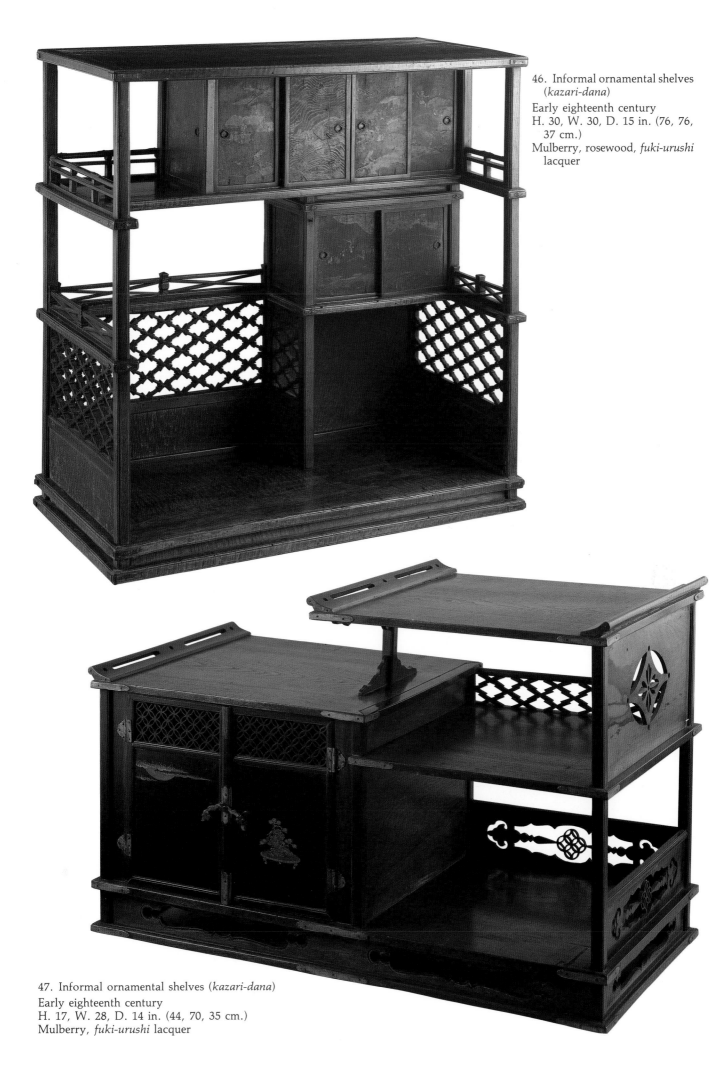

46. Informal ornamental shelves
(*kazari-dana*)
Early eighteenth century
H. 30, W. 30, D. 15 in. (76, 76,
37 cm.)
Mulberry, rosewood, *fuki-urushi*
lacquer

47. Informal ornamental shelves (*kazari-dana*)
Early eighteenth century
H. 17, W. 28, D. 14 in. (44, 70, 35 cm.)
Mulberry, *fuki-urushi* lacquer

48. Pair of six-panel folding screens (*byōbu*)
Early seventeenth century
H. 63, W. 145 in. (162, 372 cm.)
Paper

42

49. Screened clothes rack (*ikō-byōbu*)
Late sixteenth century
H. 60, W. 78 in. (152, 201 cm.)
Paper

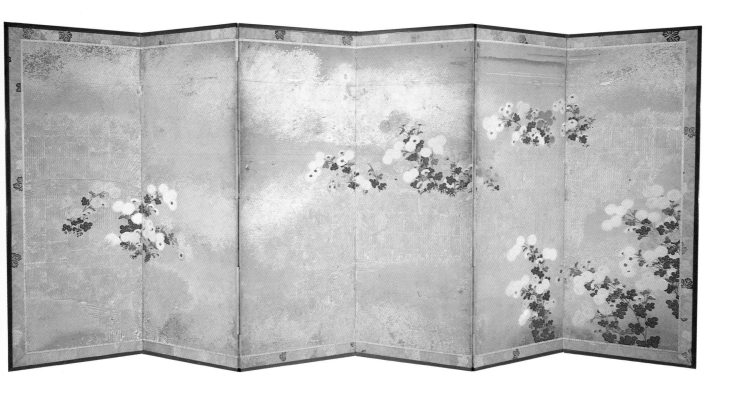

43

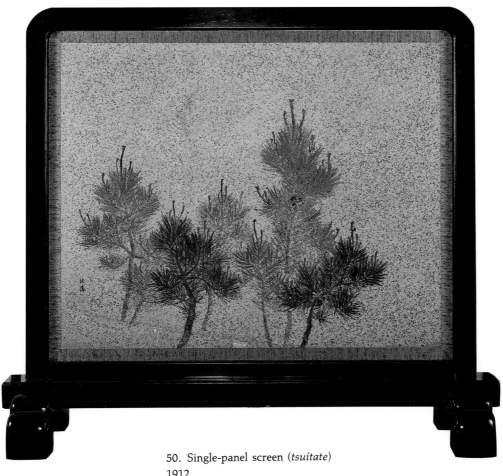

50. Single-panel screen (*tsuitate*)
1912
H. 55, W. 65 in. (141, 166 cm.)
Paper, gold leaf, black lacquer

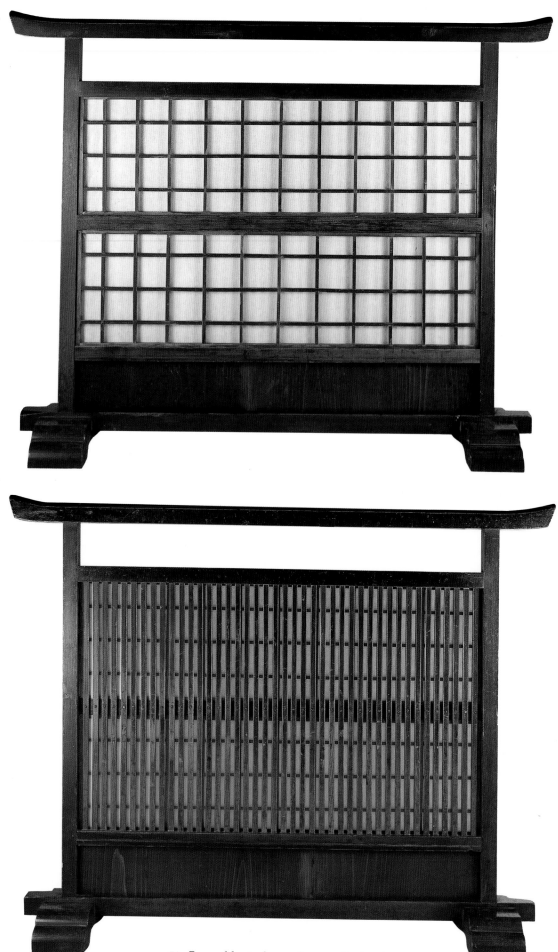

44

51. Reversible single-panel screen (*tsuitate*)
Late nineteenth century
H. 35, W. 47 in. (90, 119 cm.)
Cryptomeria

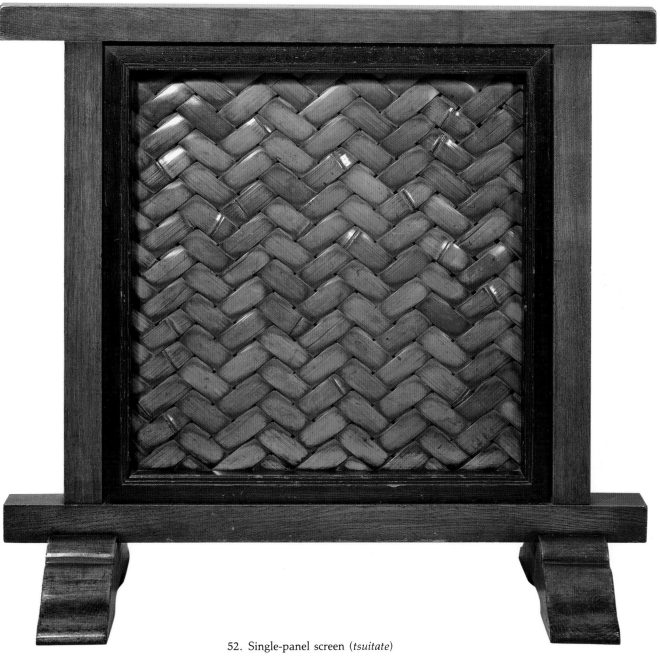

52. Single-panel screen (*tsuitate*)
Early twentieth century
H. 30, W. 32 in. (75, 83 cm.)
Zelkova outer frame, cryptomeria inner frame,
 bamboo panel, *fuki-urushi* lacquer

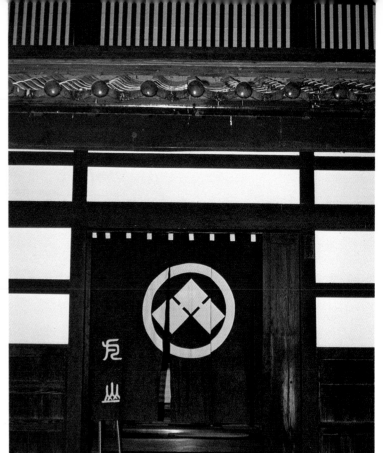

53. Doorway curtains (noren)
Early twentieth century
Approx. H. 58, W. 53 in. (150, 135 cm.)

54. Doorway curtains (noren)
Early twentieth century
Approx. H. 23, W. 53 in. (60, 135 cm.)

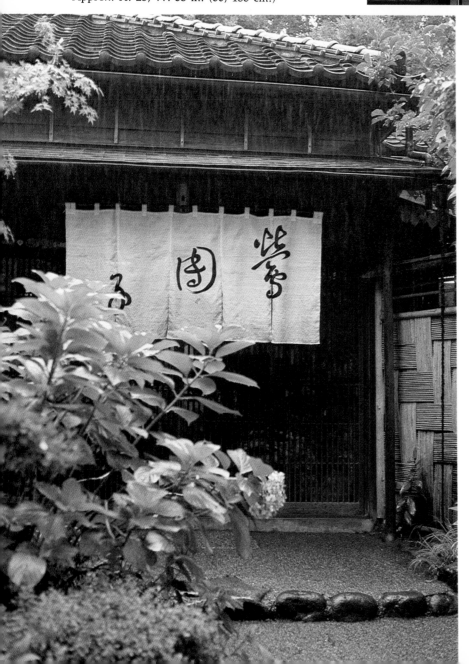

56. Doorway curtains (noren) ▶
Ishikawa Prefecture
H. 70, W. 35 in. (180, 90 cm.)
Cotton

An indoor divider curtain (uchi-noren) done in a streamered ball (kusu-dama) motif. To the side a stairway chest (hako-kaidan), with an improvised handrail, supplies storage and leads to the second floor.

55. Rope doorway curtains (*nawa-noren*) of rice straw (*wara*)
H. 59, W. 70 in. (150, 180 cm.)

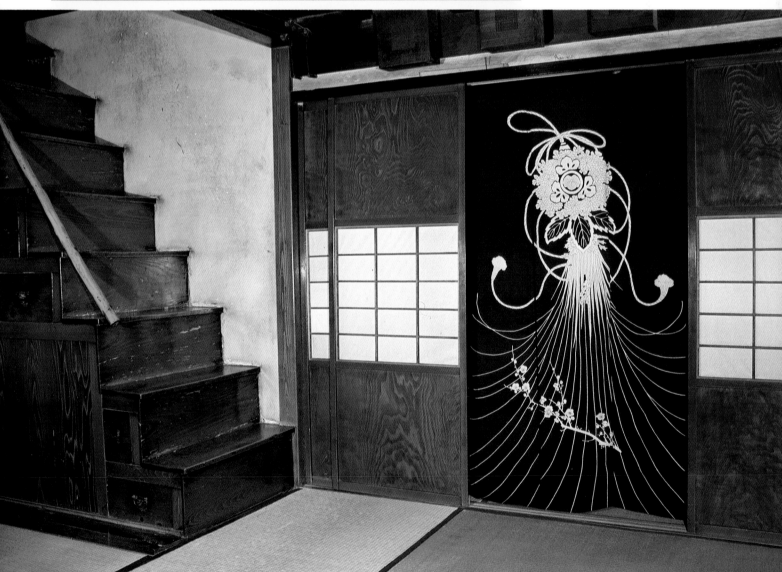

FLOOR COVERINGS

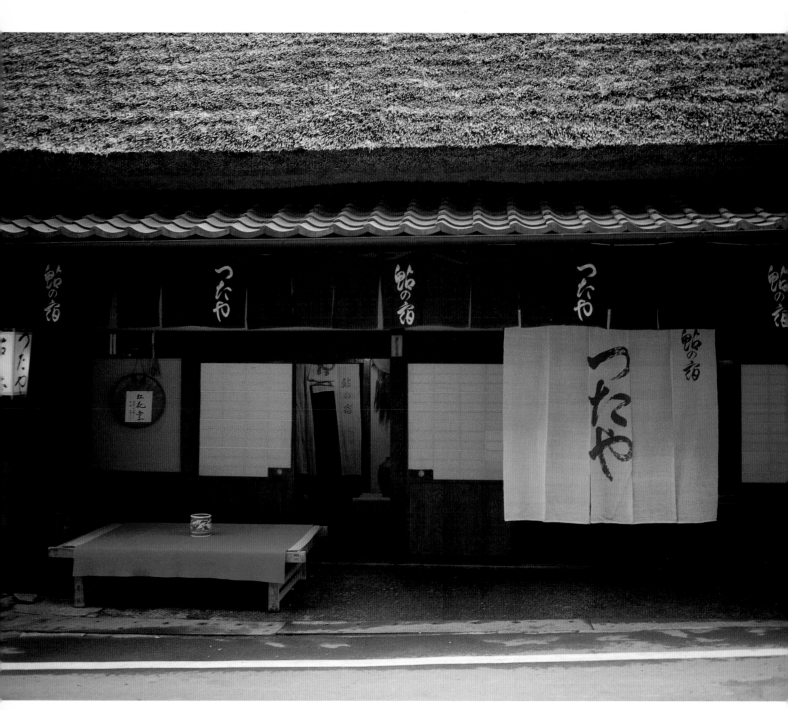

57. Entrance to a Japanese inn

This prototypical scene, rich in Japanese accessory furnishings, illustrates the effectiveness of the red felt spread (*hi-mōsen*). Used to cover various seating surfaces from tatami-matted outdoor platforms for seating to grassy picnic spots, *hi-mōsen* today still find service in rural and more traditional settings. Here, adorning a wooden bench (*endai*), it provides a splash of contrast and color and offers a clean, quiet place for repose.

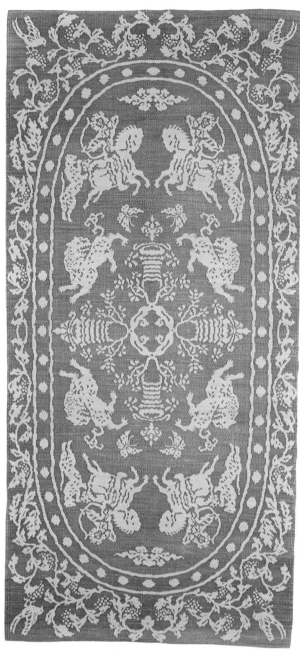

58. Patterned mat (*hana-mushiro*)

1885, Okayama Prefecture

Approx. L. 70, W. 35 in. (180, 90 cm.)

Igusa rush

An atypically ornate woven *mushiro* mat decorated in a Persian lion-hunt motif.

59. Patterned mat (*hana-mushiro*)

Okayama Prefecture

Approx. L. 70, W. 35 in. (180, 90 cm.)

Igusa rush

SEATING

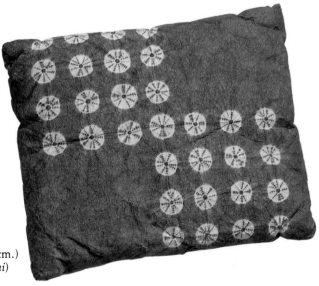

60. *Zabuton* cushion

Approx. L. 22, W. 18 in. (55, 45 cm.)

Traditional handmade paper (*washi*)

SEATING AND BEDDING

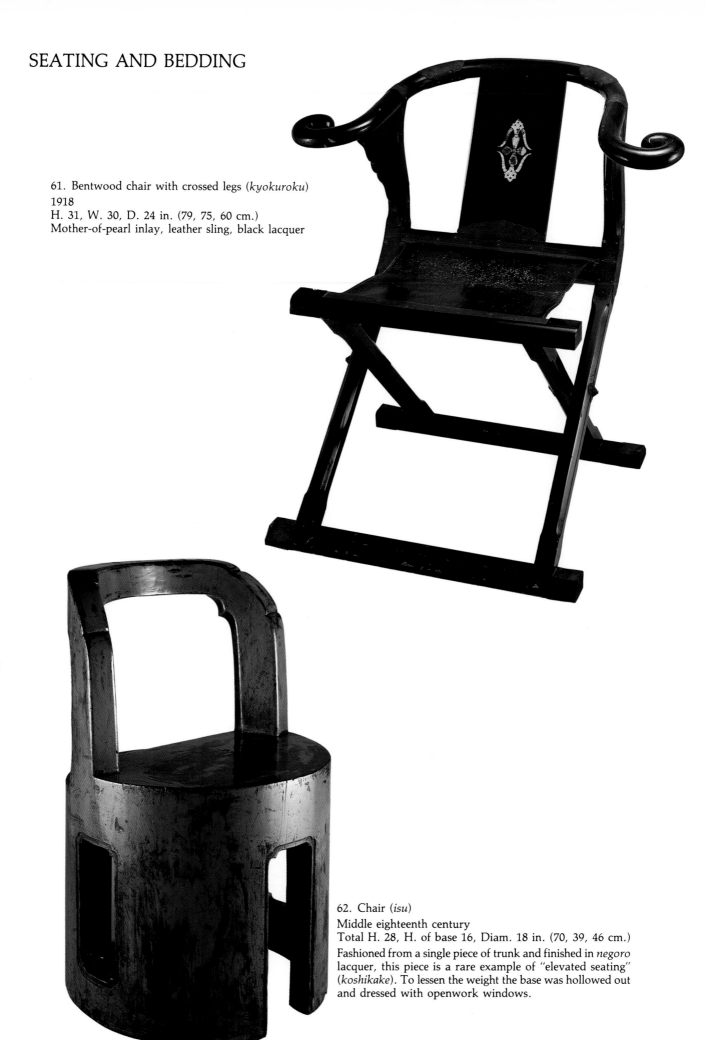

61. Bentwood chair with crossed legs (*kyokuroku*)
1918
H. 31, W. 30, D. 24 in. (79, 75, 60 cm.)
Mother-of-pearl inlay, leather sling, black lacquer

62. Chair (*isu*)
Middle eighteenth century
Total H. 28, H. of base 16, Diam. 18 in. (70, 39, 46 cm.)
Fashioned from a single piece of trunk and finished in *negoro* lacquer, this piece is a rare example of "elevated seating" (*koshikake*). To lessen the weight the base was hollowed out and dressed with openwork windows.

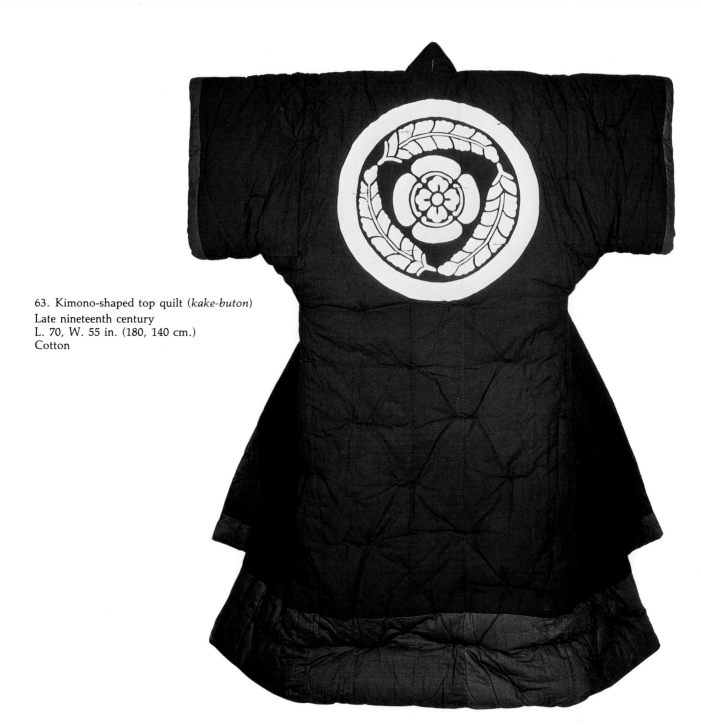

63. Kimono-shaped top quilt (*kake-buton*)
Late nineteenth century
L. 70, W. 55 in. (180, 140 cm.)
Cotton

65. "Perfume pillow" (*kō-makura*)
Late eighteenth century
H. 5, W. 4 ¼, D. 8 in. (13, 12, 21 cm.)
Mother-of-pearl inlay, black lacquer

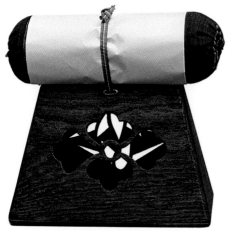

64. Box pillow (*hako-makura*)
Late nineteenth century
H. 8, W. 7, D. 4 in. (20, 18, 11 cm.)
Mulberry, *fuki-urushi* lacquer

LIGHTING DEVICES

67. Candlestands (*shokudai*)
Early nineteenth century
Approx. H. 30 in. (80 cm.)
Copper

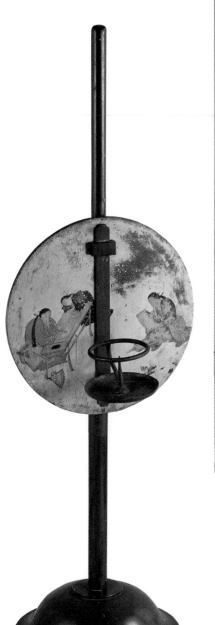

66. Candlestands (*shokudai*)
Early eighteenth century
H. 34, Diam. of reflector 11 in. (87, 28 cm.)
Hinoki cypress, brass

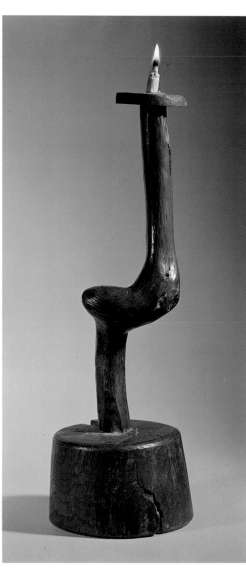

69. Candlestands (*shokudai*)
Late nineteenth century
Approx. H. 20, Diam. 6 in. (50, 15 cm.)

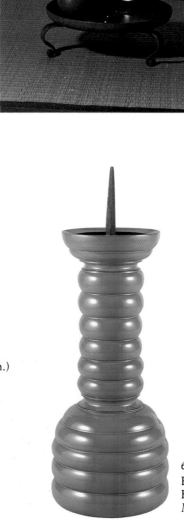

68. Candlestands (*shokudai*)
Early eighteenth century
H. 14, Diam. 6 in. (35, 16 cm.)
Negoro lacquer

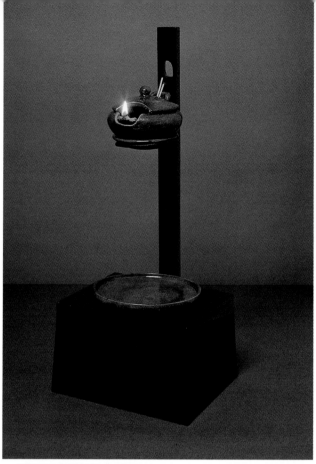

70. Short oil lamp (*tankei*)
Early eighteenth century
Approx. H. 24, W. 10, D. 8 in. (62, 24, 20 cm.)
Porcelain, black lacquer

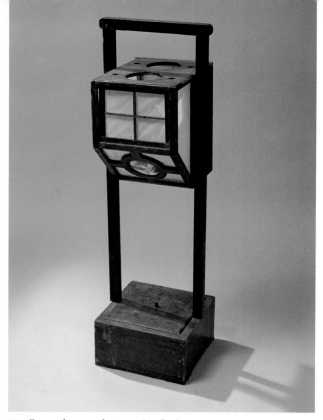

72. Framed-paper lantern (*andon*)
Late nineteenth century
H. 31, W. 11, D. 9 in. (80, 27, 24 cm.)
Cryptomeria base, paulownia frame, no finish

This ingenious variation on a framed-paper lantern features a
convex glass lens in the cropped corner, focusing the light in
a precise area for easy reading or study.

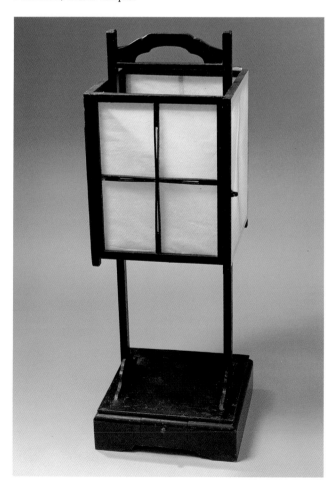

71. Squared framed-paper lantern (*kaku-andon*)
Nineteenth century
H. 31, W. 12, D. 12 in. (79, 29, 29 cm.)
Cryptomeria, black lacquer

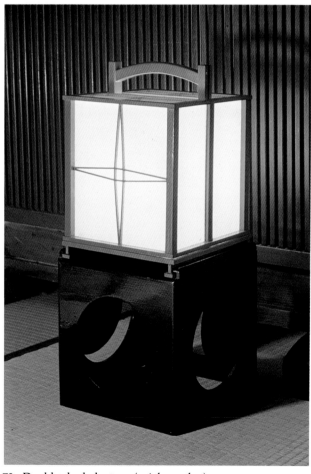

73. Double-shade lantern (*ariake-andon*)
Early nineteenth century
Approx. H. 33, W. 14, D. 14 in. (85, 35, 35 cm.)
Hinoki cypress, *shunkei* lacquer, black lacquer

53

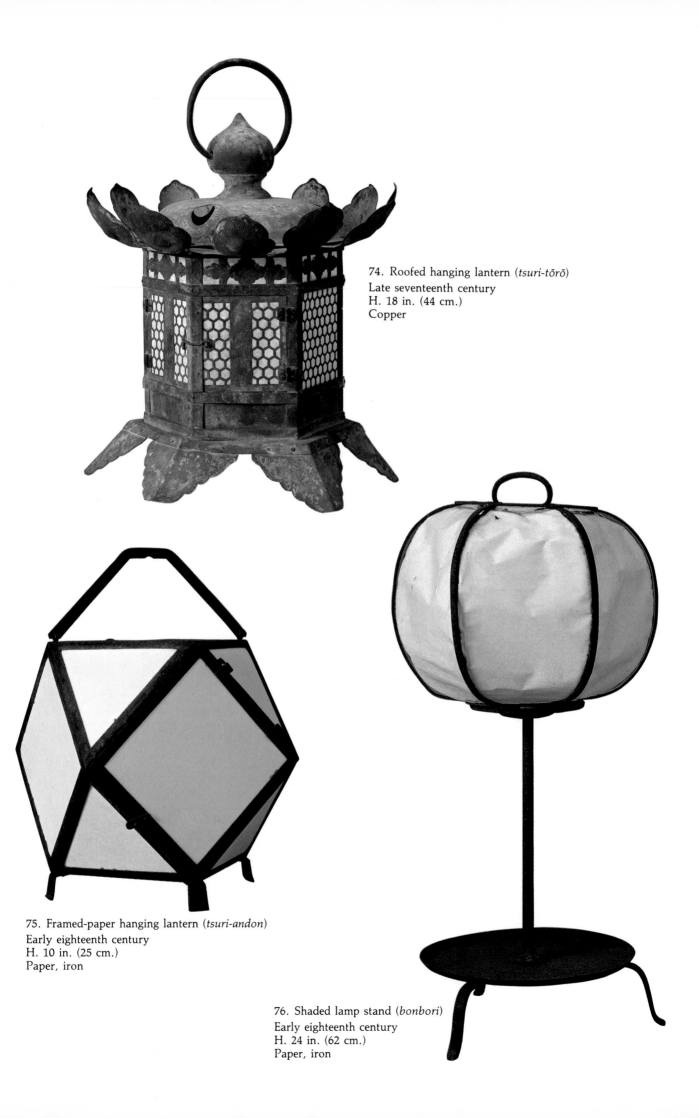

74. Roofed hanging lantern (*tsuri-tōrō*)
Late seventeenth century
H. 18 in. (44 cm.)
Copper

54

75. Framed-paper hanging lantern (*tsuri-andon*)
Early eighteenth century
H. 10 in. (25 cm.)
Paper, iron

76. Shaded lamp stand (*bonbori*)
Early eighteenth century
H. 24 in. (62 cm.)
Paper, iron

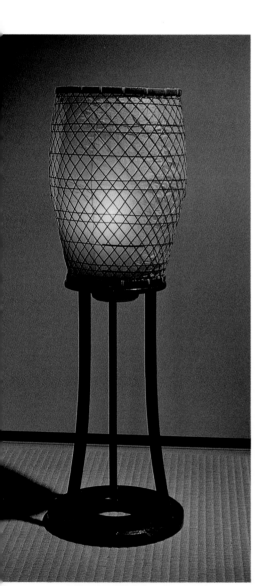

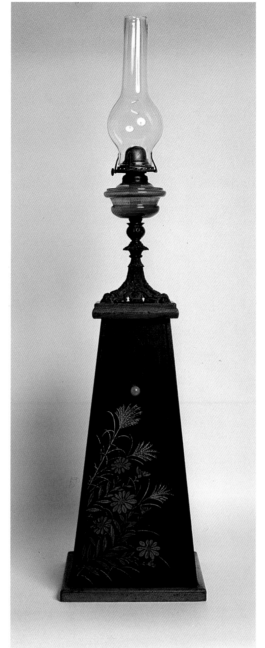

78. Kerosene lamp (*sekiyu-ranpu*)
Type: stationary lamp (*oki-ranpu*)
Late nineteenth century
Approx. H. 40, W. 10, D. 10 in. (100, 25, 25 cm.)
Cryptomeria, cast iron

77. Kerosene lamp (*sekiyu-ranpu*)
Type: stationary lamp (*oki-ranpu*)
Late nineteenth century
Approx. H. 35, W. 12 in. (90, 30 cm.)
Bamboo-and-paper shade, wood base

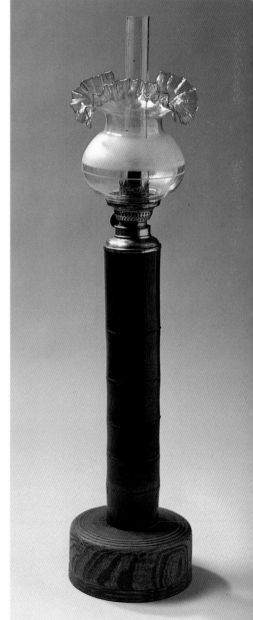

79. Kerosene lamp (*sekiyu-ranpu*)
Type: stationary lamp (*oki-ranpu*)
Late nineteenth century
Approx. H. 30, W. 8 in. (80, 20 cm.)
Bamboo-and-wood base

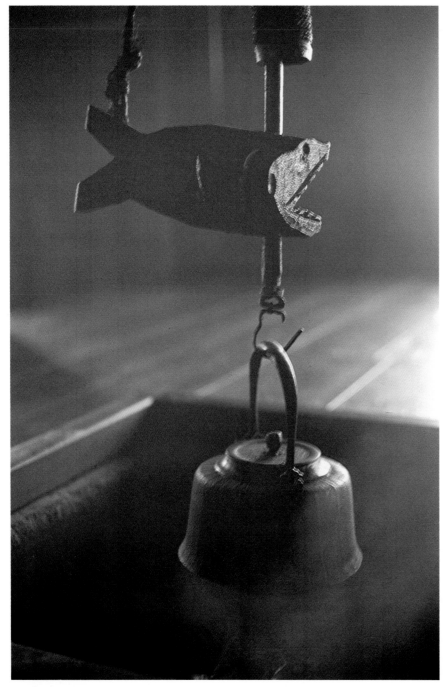

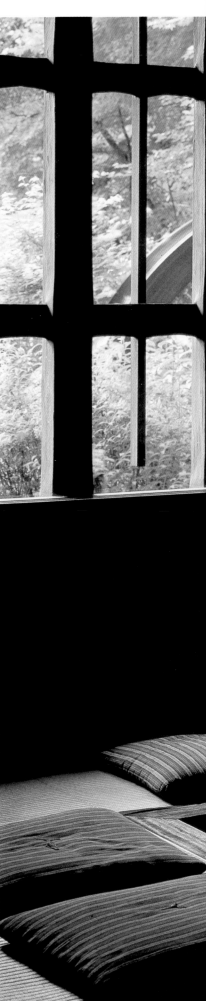

80. Sunken hearth (*irori*) with fish-shaped free hook (*jizai-kagi*)

81. Walk-up hearth (*fumikomi-ro*) with free hook (*jizai-kagi*) assemblage. *Zabuton* cushions provide seating. Kyoto.

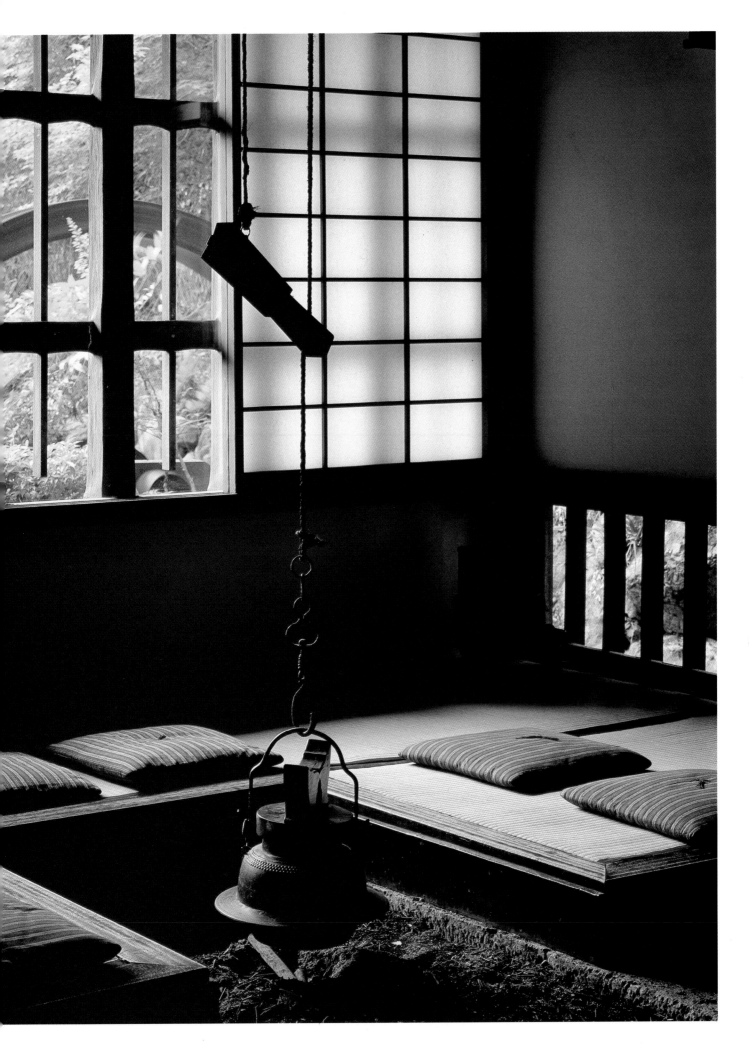

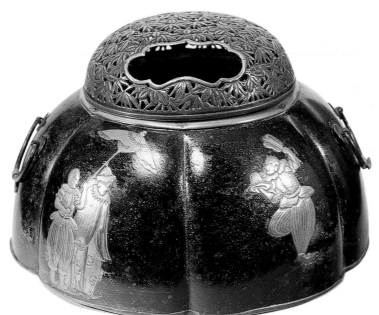

82. Hand-warmer (*te-aburi*)
Early eighteenth century
Approx. H. 6, Diam. 10 in. (15, 25 cm.)
Brass

83. Hand-warmer (*te-aburi*)
Early seventeenth century
H. 6, Diam. 10 in. (16, 26 cm.)
Paulownia, copper

58

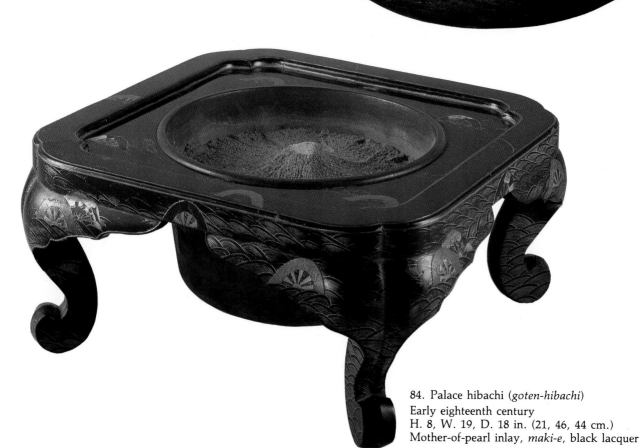

84. Palace hibachi (*goten-hibachi*)
Early eighteenth century
H. 8, W. 19, D. 18 in. (21, 46, 44 cm.)
Mother-of-pearl inlay, *maki-e*, black lacquer

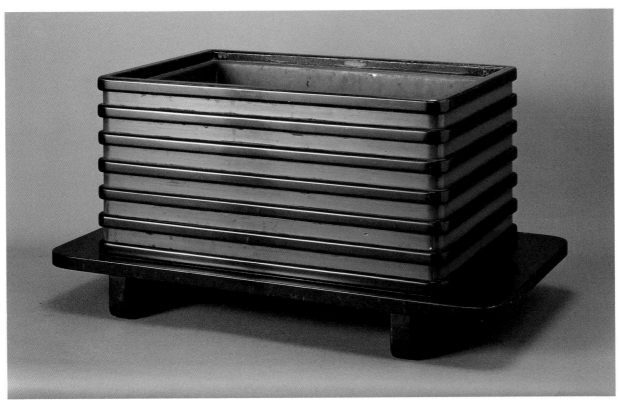

85. Hibachi
Early eighteenth century
H. 9, W. 12, D. 6 in. (23, 33, 15 cm.)
Negoro lacquer

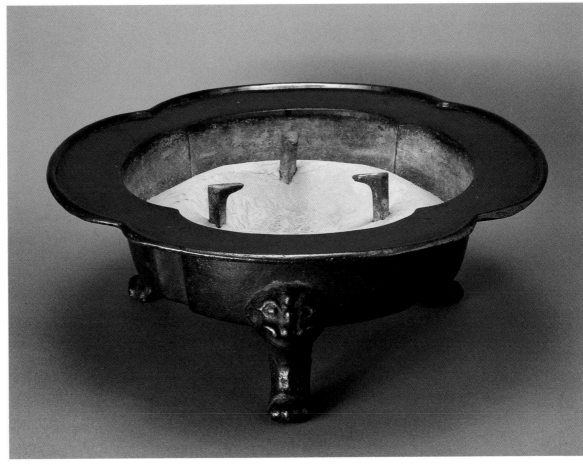

86. Hibachi
1543, Osaka
H. 7, Diam. 19 in. (18, 49 cm.)
Copper

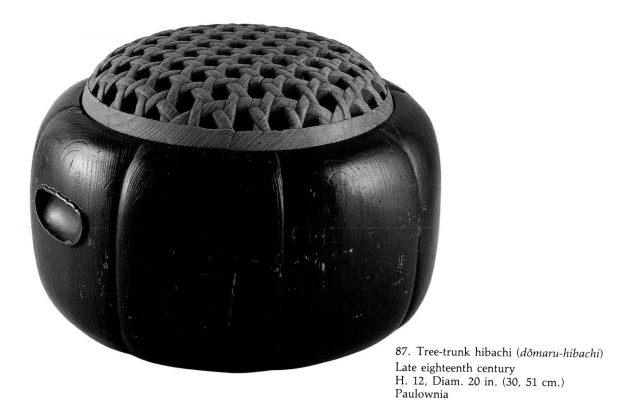

87. Tree-trunk hibachi (*dōmaru-hibachi*)
Late eighteenth century
H. 12, Diam. 20 in. (30, 51 cm.)
Paulownia

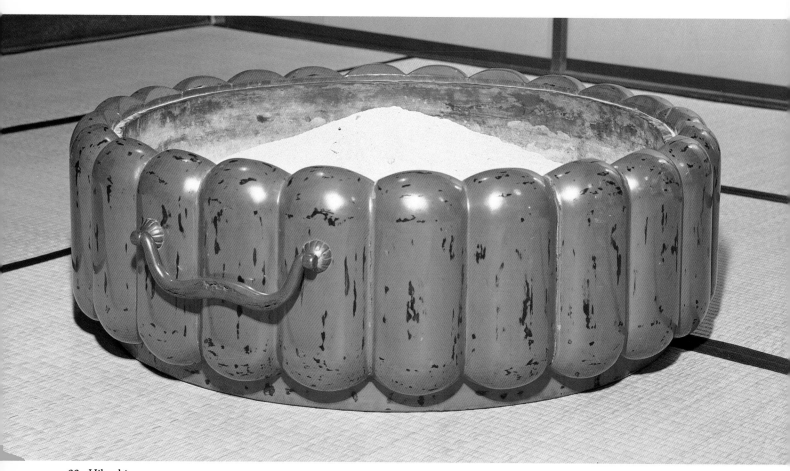

88. Hibachi
Late nineteenth century
H. 12, Diam. 35 in. (29, 91 cm.)
Brass handles, copper lining
This type of hibachi, used mainly in temples, is noteworthy
for its largeness and chrysanthemum pattern.

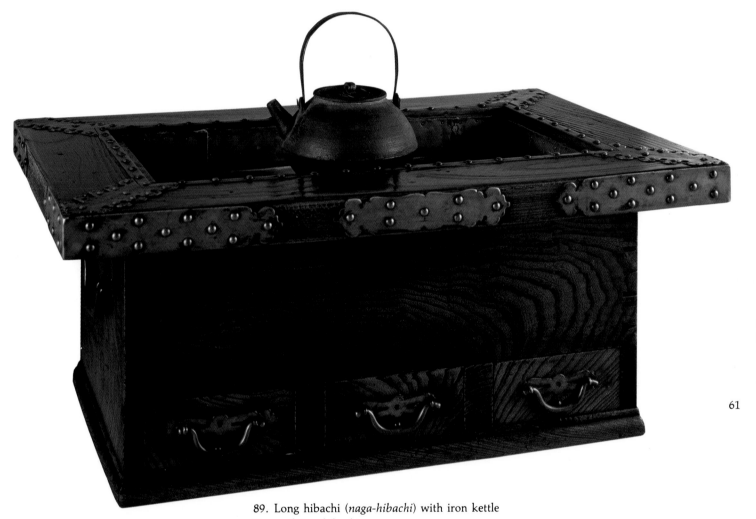

89. Long hibachi (*naga-hibachi*) with iron kettle
Type: *daiwa-hibachi*
Middle nineteenth century
H. 14, W. 32, D. 22 in. (35, 83, 55 cm.)
Zelkova, copper lining, brass fittings, *fuki-urushi* lacquer

90. Writing table (*fuzukue*)
Middle sixteenth century
H. 13, W. 47, D. 16 in. (34, 120, 39 cm.)
Hinoki cypress, *maki-e*, black lacquer

91. Writing table (*fuzukue*)
Late nineteenth century
H. 14, W. 26, D. 13 in. (36, 64, 34 cm.)
Hinoki cypress, copper fittings, black lacquer

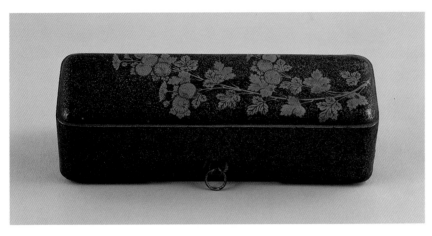

92. Letter box (*fubako*)
Eighteenth century
H. 2 1/2, W. 2 3/4, D. 8 3/4 in. (6.3, 7, 22.3 cm.)
Maki-e, black lacquer

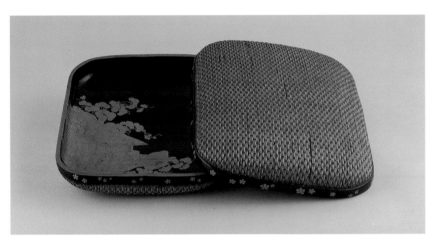

93. Document box (*bunkō*)
Early eighteenth century
H. 2 3/4, W. 10, D. 12 in. (7, 25, 29 cm.)
Willow (osier), *maki-e,* black lacquer

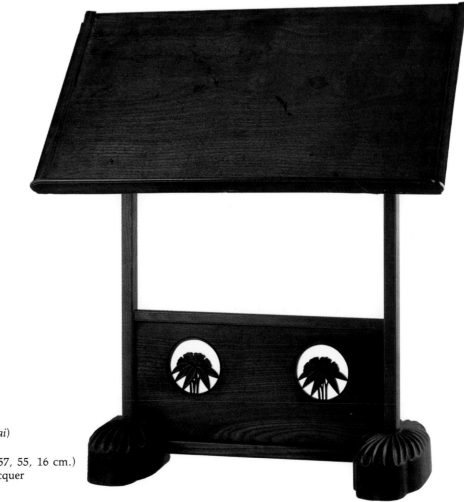

94. Reading stand (*kendai*)
Early eighteenth century
H. 23, W. 22, D. 6 in. (57, 55, 16 cm.)
Mulberry, *fuki-urushi* lacquer

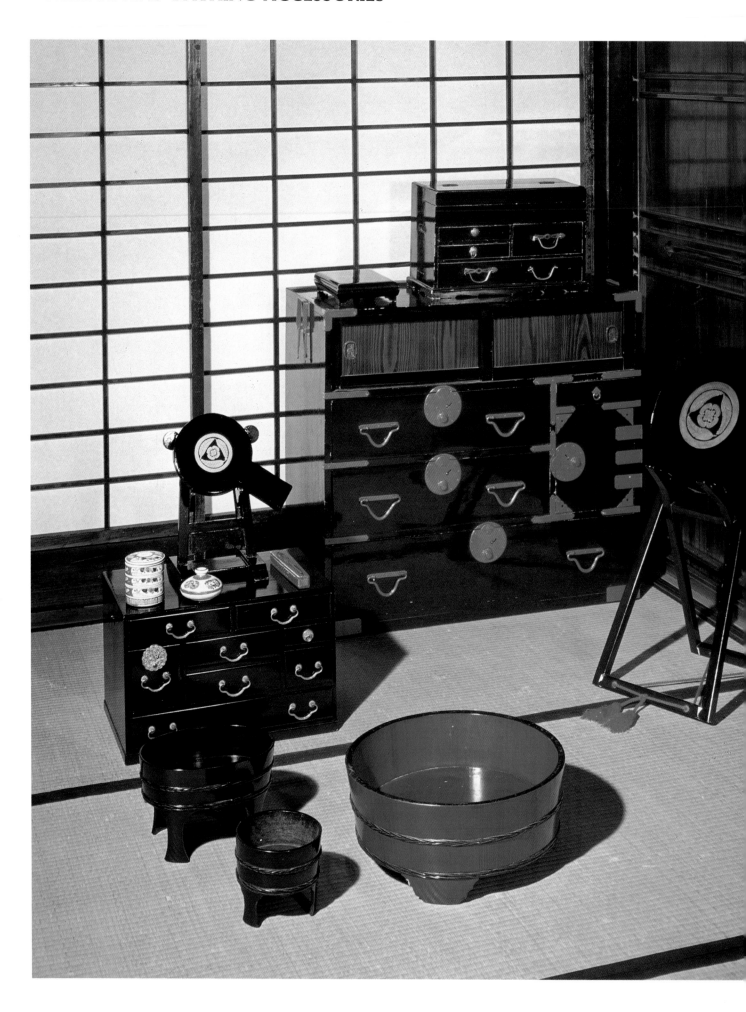

95. Toiletry furnishings (*yōshoku-gu*)
Late nineteenth century
1. Basin (*tarai*), 2. Small basin (*ko-darai*), 3. Basin for face washing (*senmen-darai*), 4. Large and small handled mirrors on mirror stands (*e-kagami* on *kagami-tate*), 5. Dressing stand (*kyōdai*), 6. Writing box (*suzuribako*), 7. Sewing box (*hari-bako*), 8. Small chest (*ko-dansu*), 9. Towel rack (*tenugui-kake*).

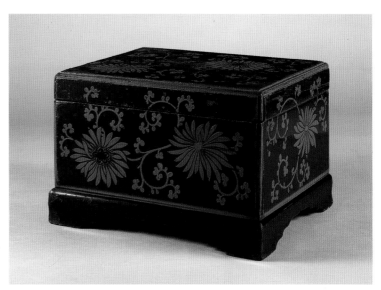

65

96. Handy box (*tebako*)
Late eighteenth century
H. 8, W. 14, D. 10 in. (22, 34, 26 cm.)
Red-on-black lacquer

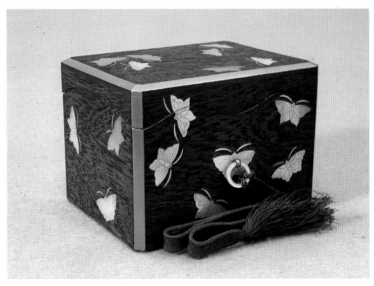

97. Comb box (*kushi-bako*)
Mother-of-pearl inlay, *maki-e*

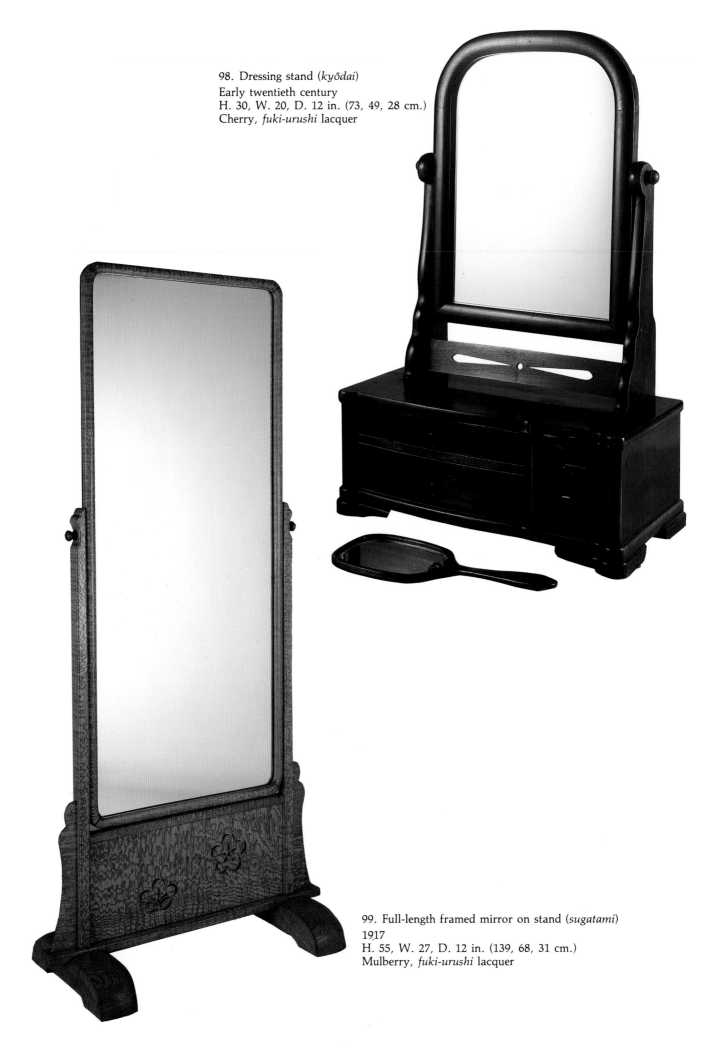

98. Dressing stand (*kyōdai*)
Early twentieth century
H. 30, W. 20, D. 12 in. (73, 49, 28 cm.)
Cherry, *fuki-urushi* lacquer

99. Full-length framed mirror on stand (*sugatami*)
1917
H. 55, W. 27, D. 12 in. (139, 68, 31 cm.)
Mulberry, *fuki-urushi* lacquer

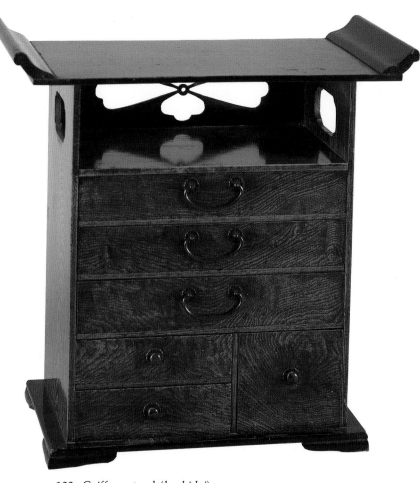

100. Coiffure stand (*kushidai*)
Middle nineteenth century
H. 18, W. 18, D. 9 in. (45, 45, 22 cm.)
Zelkova, *fuki-urushi* lacquer

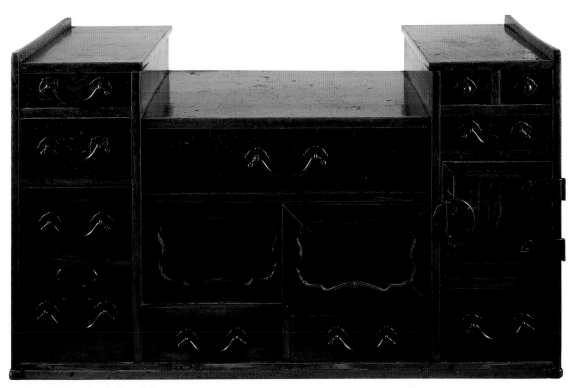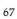

101. Dressing stand (*kyōdai*)
Late nineteenth century
H. 17, W. 29, D. 13 in. (42, 73, 33 cm.)
Japanese chestnut, *fuki-urushi* lacquer

MEALTIME FURNISHINGS

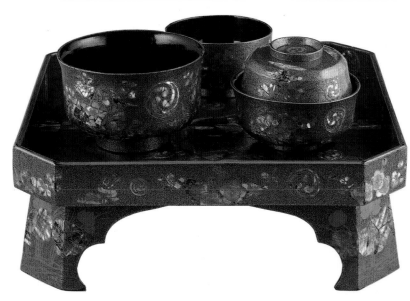

102. Butterfly-legged tray-table with bowls
 (*chōashi-zen* with *wan*)
Early eighteenth century
H. 5, W. 15, D. 15 in. (12, 36, 36 cm.)
Mother-of-pearl inlay, *maki-e*

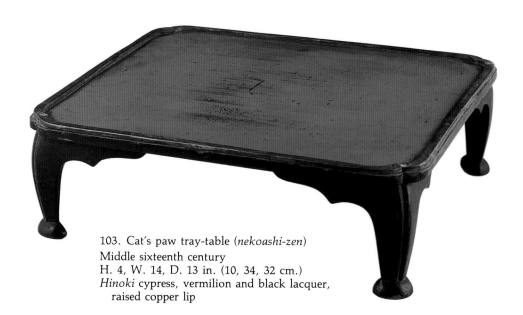

103. Cat's paw tray-table (*nekoashi-zen*)
Middle sixteenth century
H. 4, W. 14, D. 13 in. (10, 34, 32 cm.)
Hinoki cypress, vermilion and black lacquer,
 raised copper lip

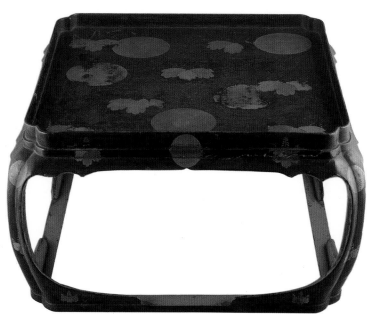

104. Box-legged tray (*kakeban*)
Late sixteenth century
H. 10, W. 17, D. 17 in. (25, 44, 44 cm.)
Maki-e, black lacquer

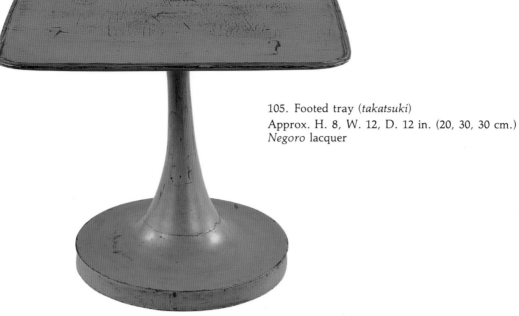

105. Footed tray (*takatsuki*)
Approx. H. 8, W. 12, D. 12 in. (20, 30, 30 cm.)
Negoro lacquer

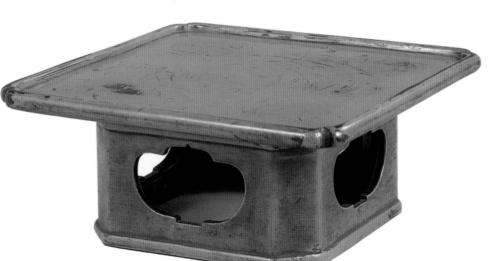

106. Broad-pedestaled tray (*tsuigasane*)
Middle sixteenth century
Approx. H. 7, W. 15, D. 15 in. (18, 40, 40 cm.)
Negoro lacquer

107. Ornamental sweets box (*jikirō*)
Middle sixteenth century
H. 4, W. 3 1/2 in. (10.5, 8.8 cm.)
Mother-of-pearl inlay, *maki-e*

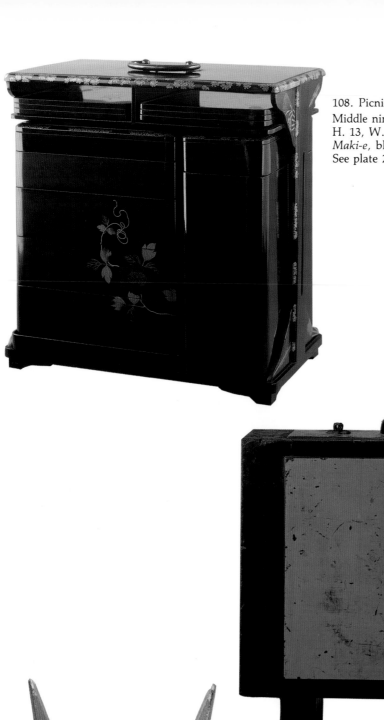

108. Picnic case (*sagejū*)
Middle nineteenth century
H. 13, W. 12, D. 8 in. (33, 32.5, 19 cm.)
Maki-e, black lacquer
See plate 264 for disassembled case.

109. Rectangular saké keg (*sashi-daru*)
Middle sixteenth century
H. 20 in. (49 cm.)
Negoro lacquer

110. Horned saké keg (*tsuno-daru*)
Late eighteenth century
Approx. H. 20, Diam. 8 in. (50, 20 cm.)
Cryptomeria, bamboo, vermilion lacquer

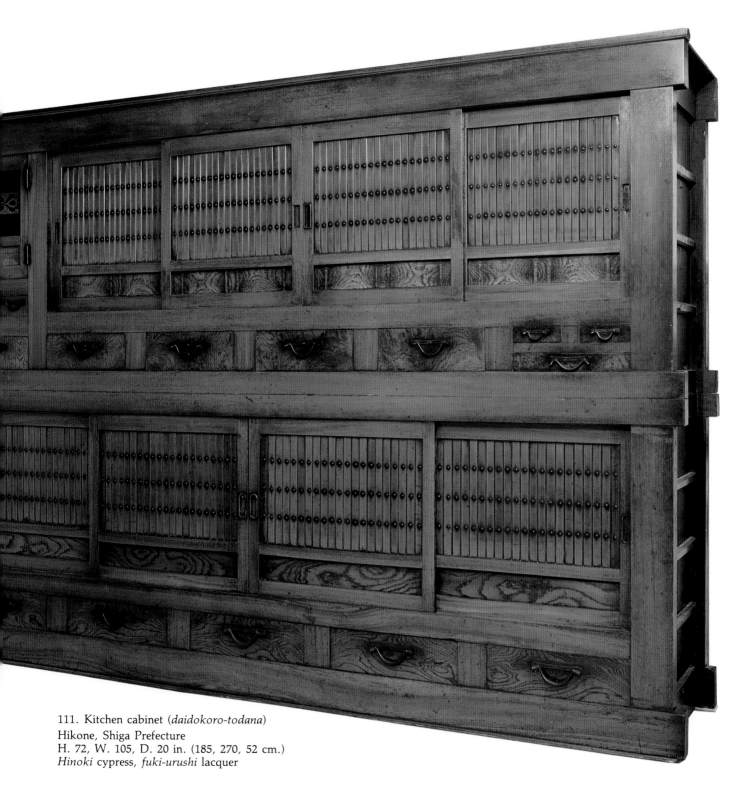

111. Kitchen cabinet (*daidokoro-todana*)
Hikone, Shiga Prefecture
H. 72, W. 105, D. 20 in. (185, 270, 52 cm.)
Hinoki cypress, *fuki-urushi* lacquer

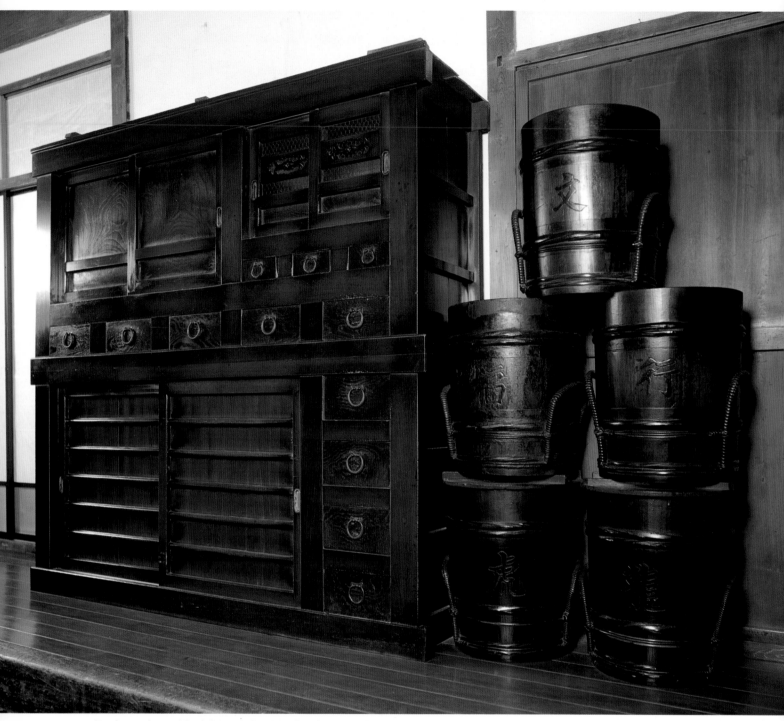

112. Kitchen cabinet (*daidokoro-todana*) and casks (*taru*) for storage of oil
Cabinet: *hinoki* cypress, *fuki-urushi* lacquer

1

FURNITURE AND FURNISHINGS

CABINETRY

For most Japanese, the very mention of "furniture" conjures up images of chests (tansu) and trunks (nagamochi), so predominant are these and other storage units in the scheme of traditional Japanese household effects. They are found in a seemingly endless array of shapes and sizes, but a general classification can be made along the following lines.

First, there are the tansu, *representative of a whole class of "drawer-type" pieces. Then, there are the "box-type" pieces, such as trunks, coffers (hitsu), and portable hampers (tsuzura, kōri, hasami-bako); the high-rimmed trays (hirobuta) that were used for presenting gifts on formal occasions; and the related clothes trays (midare-bako). Last come the various "shelf-type" pieces, notably formal and informal ornamental shelf units (kazari-dana), the elegant* sho-dana *shelves used for exhibiting scrolls and the like, and tea-ceremony shelves (chanoyu-dana), as well as cabinetry with interior shelves (todana, literally "shelves with doors").*

CHESTS *Tansu*

The most typical drawer-type furnishing, the *tansu*, first appeared toward the latter half of the seventeenth century and came into widespread use from the eighteenth century. Reaching peak popularity in the transitional years between the late nineteenth and early twentieth centuries, *tansu* had by then come to incorporate a number of regional styles.

Tansu were also made to meet specific needs. The most common type in general use was the clothes chest (*ishō-dansu*; plates 1–8, 113). Before the advent of Western-style closets in Japanese homes, the notion of hanging up clothes was unheard of; kimono were always folded flat for storage in clothes chests, hence every household possessed at least one. Many designs existed: plain drawer-type chests, bolted-door chests, stacked chest-on-chest types, and combinations of these.

The next most common household *tansu* was the tea chest (*cha-dansu*; plate 9). Standing about 35 to 40 inches (90 to 100 centimeters) tall with a width of 28 to 31 inches (70 to 80 centimeters), tea chests combined drawers with cabinet space, and

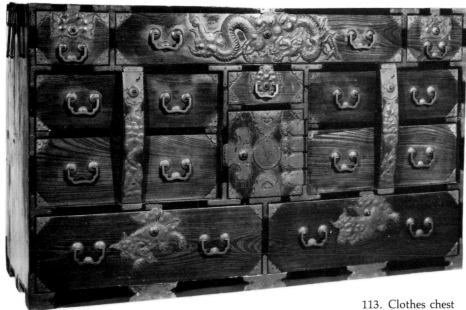

113. Clothes chest
Late nineteenth century, Sendai, Miyagi Prefecture; H. 26, W. 65, D. 21 in. (67, 166, 53 cm.); zelkova, iron fittings, *fuki-urushi* lacquer.

from the Meiji era (1868–1912), they often featured glass cabinet doors. Tea chests were kept in the communal "tearoom" (*chanoma*) where the family would gather for meals, and were used for storing teacups, teapots, serving dishes for sweets, and other teatime items. Typically drawers would hold chopsticks, chopstick rests, and coasters, as well as wallets and all manner of small everyday effects.

When more storage space for general household items was needed, there was a number of different large and small catchall chests. The smaller of these chests might either be movable, like the portable writing box–safe (*kake-suzuribako*; plate 15), or stationary, like the small chest (*ko-dansu*; plates 10–12). The former item was originally conceived as a writing box (*suzuribako*; see page 123) suspended in the upper portion of a deep casing—seated on a raised inner lining or some such—with ample space below for writing paper; this was eventually combined with a safe (plate 114) and used by townsfolk in general and merchants in particular for keeping abacuses (*soroban*), signature seals (*inkan*), money, and certificates. Merchants found the portable writing box–safe a convenient means of carrying their business with them in much the same way as today's salesperson carries a briefcase. By the middle of the Edo period (1600–1868), however, demand for the portable pieces had grown not only among merchants but ordinary households as well, so designs came to reflect more general needs; the writing box now sat on one or two layers of drawers, had a horizontal spring-lock on the lid, and a handle on top for one-hand carrying. Even further on into the Edo period, the merchant class had grown to such proportions and affairs of trade had become so complex that simple storage of writing implements and money was not enough. Separate cash boxes (*zeni-bako*; plate 14)—with a slotted top to accept money and often with a drawer to hold memo stationery and writing brushes—and ledger chests (*chōba-dansu*; plates 18–26) developed as commercial furnishings, and the writing box–safe returned to its original function as a mere "briefcase." While *zeni-bako* served for daily business transactions, the upper classes, and later, the richer merchants stored large sums in sturdy money chests (*senryō-bako*; plates 16, 17).

Larger *tansu* include an unusual hybrid furnishing called the stairway chest (*hako-kaidan*; plates 13, 56), which as the name implies was fitted into the architecture to serve both as a staircase and a storage unit, utilizing the otherwise empty area under the steps for a wall of drawer space. From the beginning of the Edo period, stairway chests were in common use in townhouses and storehouses where space was at a premium.

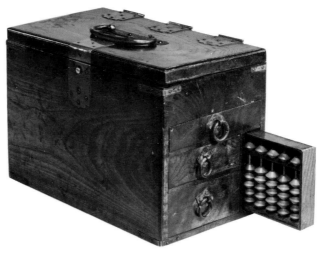

114. Portable writing box–safe with abacus
Late nineteenth century; H. 10, W. 8, D. 13 in. (25, 20, 33 cm.); zelkova, iron fittings, *fuki-urushi* lacquer.

Similarly, *tansu* for commercial applications can be divided between those required for accounting and conducting business, and those for storing or displaying merchandise. The previously mentioned ledger chests fall under the former category, having any of a number of combinations of small drawers, sliding panels, and hinged doors for the safekeeping of business records and money. Although they tended to be small in size, they were kept out in plain view of customers, so most were lavishly decorated to give a favorable impression of the establishment. Designs were many; some ledger chests were even provided with back straps to facilitate transport in the event of fire or other emergencies. Smaller shops or stands generally needed only a simple money box to hold the day's sales, not a ledger chest. Money boxes were generally quite sturdy affairs made of thick slabs of zelkova, chestnut, or other hardwoods and fitted with heavy iron bolts. The lids were provided with raised lips, forming trays for loose change, while occasional pieces also had wheels.

A special kind of ledger chest was the functionary chest (*goyō-dansu*; plate 115), in which important documents of feudal domains and local officials were kept. Functionary chests vary considerably in style, and again, many were fitted with special means to aid removal in an emergency.

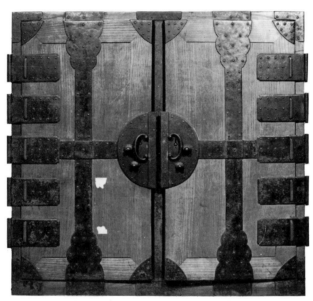

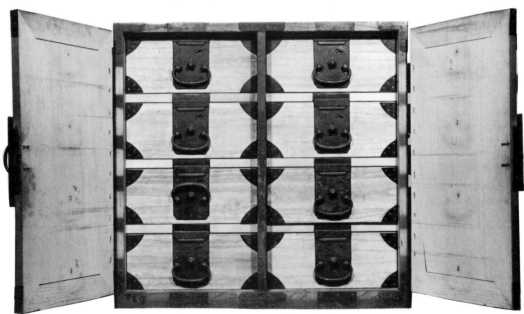

115. Functionary chest
Early nineteenth century, Tokyo; H. 30, W. 33, D. 21 in.
(77, 83, 53 cm.); paulownia, iron fittings, no finish.

Sea chests (*funa-dansu*) were used on board trading ships to keep accounts and money safe during the voyage from port to port. Since almost all trade in Japan from the Edo period up through the Meiji era was conducted by sea, there was a great demand for sea chests. Moreover, because shipping was an extremely lucrative business, many sea chests were sumptuously decorated. There were three main types of sea chests: the portable writing box–safe (plates 30–32)—essentially a watertight version of the land-use *kake-suzuribako* mentioned above—the ledger, or account, box (*chō-bako*; plates 35–37, 116), and the clothes chest (*hangai*; plates 33, 34). The seagoing portable safe had a writing box stacked on top of drawers the same as its land counterpart; however, instead of opening directly from the outside the portable version was concealed in an inner compartment behind a hinged door. Again, there

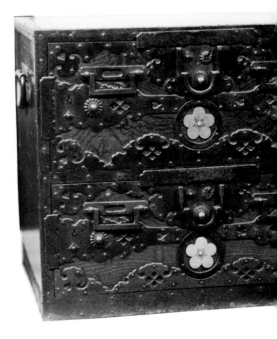

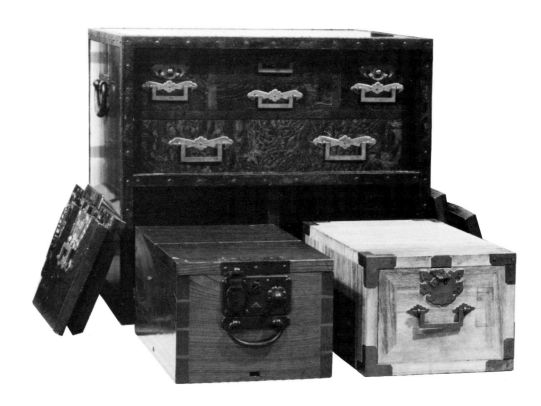

was a carrying handle on top. The account box was larger than the portable writing box–safe and had any of a number of combinations of drop-fit lids, drawers, and sliding panels. Carrying handles were provided on both sides, while the insides were often intricately contrived with hidden compartments and other special features. The precision of woodcrafting and metalworking on account boxes can be quite amazing. By comparison, clothes chests were simple affairs, with drop-fit lids in front, handles on either side, and two large drawers, though typically they were stacked chest-on-chest.

Undoubtedly the most well-known merchandise chest was the apothecary chest (*kusuri-dansu*; plates 38, 39), with its multitude of tiny drawers for particular herbs and Chinese medicines. Seed merchants, folding fan dealers, haberdashers, tobac-

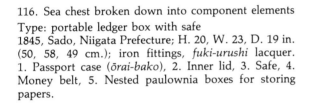

116. Sea chest broken down into component elements
Type: portable ledger box with safe
1845, Sado, Niigata Prefecture; H. 20, W. 23, D. 19 in. (50, 58, 49 cm.); iron fittings, *fuki-urushi* lacquer. 1. Passport case (*ōrai-bako*), 2. Inner lid, 3. Safe, 4. Money belt, 5. Nested paulownia boxes for storing papers.

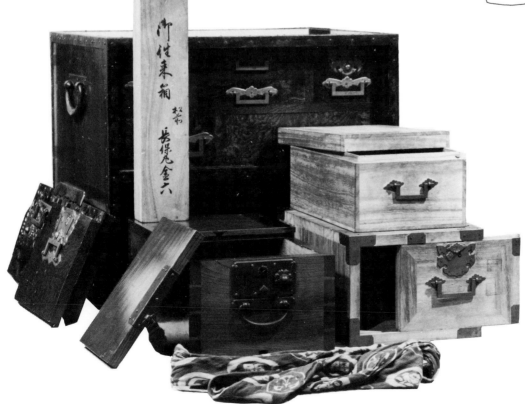

conists, and others likewise had their own specially adapted chests. Craftspersons would keep tools, supplies, and finished products in some form of *tansu* (plate 117), and traveling merchants necessarily sold their wares out of portable chests (plate 118). In addition to these, there exist numerous other variations on the *tansu* designed for specific commercial uses.

Higher up on the social scale, samurai had *tansu* for swords and for firearm provisions. The typical sword chest (*katana-dansu*; plate 119) contains two drawers for storing the blades, along with smaller compartments to store honing and polishing materials. The bullet-and-gunpowder chest (*tamayaku-dansu*; plate 120) measures approximately 1 foot (30 centimeters) square, has a hinged front that opens to reveal small drawers, and bears metal fittings on the sides for carrying with a pole. In addition to such "practical" chests, samurai possessed various other *tansu* for storage of books, Nō masks (plate 121), and other implements for spiritual and educational studies.

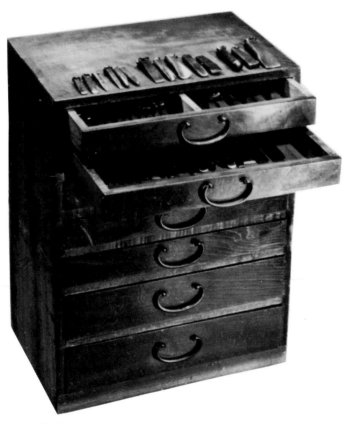

117. Craftsman's tool chest with various punches and gouges
Early twentieth century; H. 24, W. 16, D. 12 in. (60, 40, 30 cm.); cryptomeria, persimmon tannin.

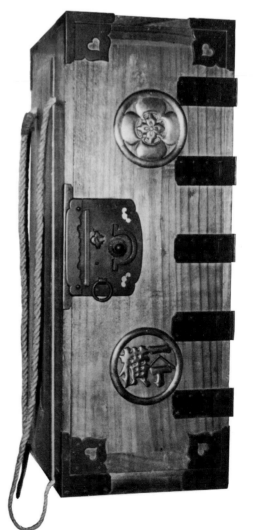

118. Portable chest
Late nineteenth century, Hokkaido; H. 36, W. 18, D. 14 in. (91, 46, 35 cm.); paulownia, iron fittings, brass family crest.

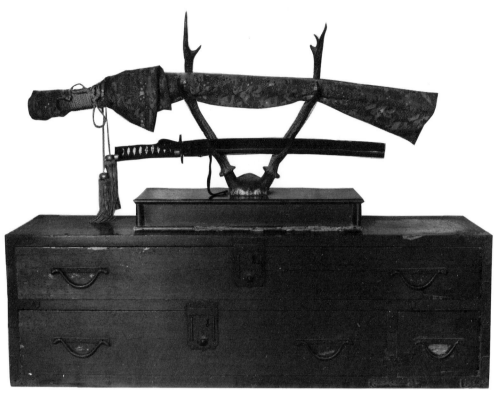

119. Sword chest
Early eighteenth century; H. 20, W. 42, D. 13 in. (51, 106, 33 cm.); paulownia, iron fittings, *fuki-urushi* lacquer.

120. Bullet-and-gunpowder chest
Early seventeenth century, Hirado, Nagasaki Prefecture; H. 18, W. 14, D. 16 in. (45, 35, 40 cm.); cryptomeria, iron fittings, lacquer.

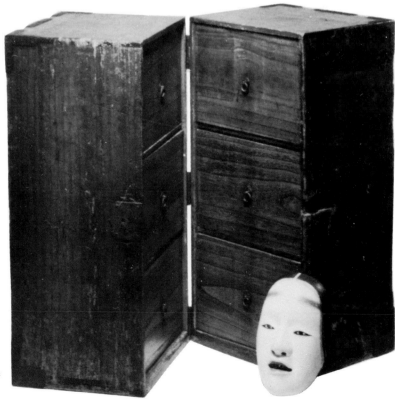

121. Nō-mask chest
Late nineteenth century; H. 31, W. 28, D. 14 in. (80, 70, 35 cm.); paulownia, *shunkei* lacquer.

TRUNKS *Nagamochi*

The storage trunks known as *nagamochi* are on the average 2 by 5 by 2 feet (60 by 150 by 60 centimeters) and provided front and back with *sao-tōshi*, metal handles through which a pole could be passed for shoulder-carrying (plate 122). Trunks would either be finished (*nuri-nagamochi*; plate 123) or left with a plain-wood surface (*kiji-nagamochi*). The highest-quality finishes were of black lacquer, with some pieces even boasting decorative *maki-e* designs. Better-quality *nagamochi* were used almost exclusively for keeping clothing and bedding, while more simply finished or unfinished pieces held basins, bowls, trays, and other household utensils, though peasants sometimes kept clothing and bedding in unfinished *nagamochi*. From the Edo period on into the Meiji era, *nagamochi* were of central importance to the practice of setting aside a bridal trousseau, and pieces so destined often had cotton oilcloth covers resist-dyed with the prospective family crest.

An interesting variant was the wheeled trunk (*kuruma-nagamochi*; plates 124, 125), an oversized *nagamochi* on wooden rollers for quick removal in an emergency. Paradoxically, though, this innovation proved quite hazardous in fires and other calamities, for the streets would be jammed with people pulling their wheeled *nagamochi* to safety (plate 126). Hence wheeled trunks were prohibited by law in the cities of Edo (present-day Tokyo), Osaka, and Kyoto, from which they disappeared early in the Edo period. In rural villages, however, they remained in use until the beginning of the twentieth century. Moreover, wheeled trunks spawned the wheeled chest (*kuruma-dansu*; plates 27–29).

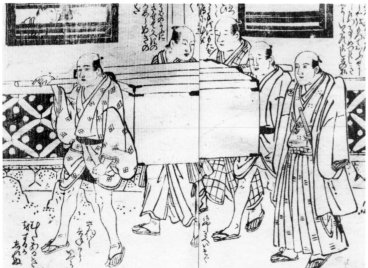

122. Plain-wood trunk
More commonplace than lacquer-finished trunks, both types of trunks were yet provided with fittings to allow pole-carrying as shown. From a 1781 illustration.

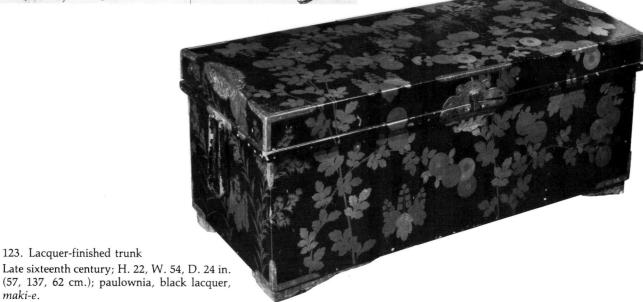

123. Lacquer-finished trunk
Late sixteenth century; H. 22, W. 54, D. 24 in. (57, 137, 62 cm.); paulownia, black lacquer, *maki-e*.

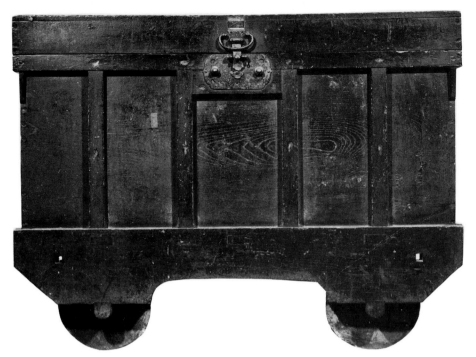

124. Wheeled trunk
Type: clothes trunk
Yonezawa, Yamagata Prefecture.

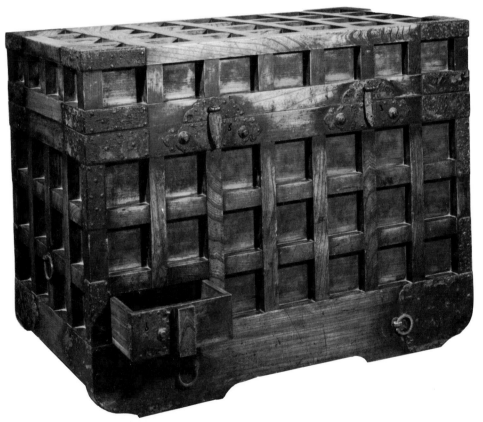

125. Wheeled trunk
Type: ledger trunk
Early twentieth century, Akita Prefecture; H. 29, W. 36, D. 21 in. (73, 92, 55 cm.); zelkova, cryptomeria, iron fittings, *fuki-urushi* lacquer. Gridwork designs were common on furniture items from the Akita area. This particular piece, being on the small side, was used as a shop safe.

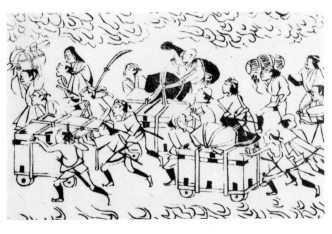

126. Wheeled trunks
One of the largest conflagrations ever recorded in Japan swept through the city of Edo in 1657, killing over one hundred thousand. The rumbling of the wheeled trunks, filled with valuables and household possessions, being hastily hauled through the streets combined with the screams of the populace was "as loud as a thousand thunderbolts." From a 1661 illustration.

COFFERS *Hitsu*

Closely related to the *nagamochi* trunk, the *hitsu* coffer differs basically in its lack of metal fittings for pole-carrying. These coffers were the single most important furnishing for storage through the sixteenth century. Two styles were in widespread use: the Chinese-style coffer (*kara-bitsu*; plate 41) with legs, and the Japanese-style coffer (*wa-bitsu*) without. Of these, the *kara-bitsu* was greatly favored as a container for transport. With the advent of the early modern age, *hitsu* fell into disuse and were largely supplanted by *nagamochi*, though among Okinawans and the indigenous Ainu tribes *hitsu*, referred to respectively as *kei* (plate 127) and *spoppu* (plate 128), continued to find acceptance. The most representative type is the clothes coffer (*ishō-bitsu*). For lidded storage boxes (*fumi-bitsu*), see Book Boxes, page 121.

HAMPERS *Tsuzura, Kōri, Hasami-bako*

These are all box-type hampers of a rectangular shape and of a size one person might carry, the *tsuzura* and *kōri* having deep-nesting covers. The *tsuzura* (plates 129, 130) is the older of the two, originating in the Muromachi period (1392–1482), when they were woven of wisteria vine, and reinforced in the corners and along the edges with leather. By the Edo period, sturdier materials and methods were employed: from *ikkan-bari*—whereby woven bamboo or thin strips of *hinoki* cypress or cryptomeria would be surfaced with paper, then treated with coats of persimmon tannin (*kaki-shibu*)

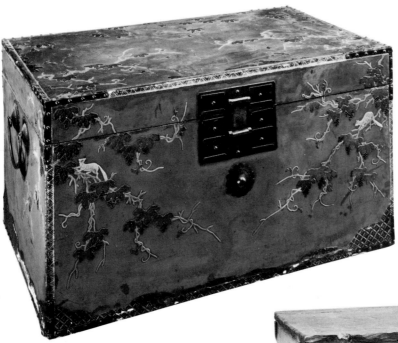

127. Okinawan coffer
Nineteenth century, Okinawa; approx. H. 24, W. 35, D. 22 in. (60, 90, 55 cm.); vermilion lacquer, incised gold decoration.

128. Ainu coffer
Late nineteenth century, Hokkaido; H. 11, W. 21, D. 10 in. (27, 53, 26 cm.); cryptomeria, no finish.

and lacquer—to stretching woven *mushiro* mats (see page 97) over frames of cryptomeria or bamboo.

Similar to the *tsuzura*, only smaller and without leather reinforcing, *kōri* (plate 131) came into widespread use during the Edo period, most of these being made of woven willow vines or bamboo. Both hampers were used mainly for storing clothing, although small pieces also found use as sewing baskets, letter boxes, and small-article catchalls, and oversized ones sometimes held accounting ledgers (*daifuku-chō*), bedclothes, or bolts of kimono fabric. Furthermore, because both are extremely lightweight, they were well suited to the needs of the traveling peddler of medicines or other small items.

The scissored hamper (*hasami-bako*; plate 40) is again fitted with a cover, though only half as deep as the body of the box. The longer sides have looped handles for pole-carrying (plate 132), making this a truly portable storage unit. In fact, two *hasami-bako* were frequently shouldered on a single pole. The scissored hamper traces its origins to the samurai practice of carrying bundles of clothing "scissored" between split lengths of bamboo, hence the name. Eventually, *hasami-bako* were substituted, and still later, from the Edo period, they were used by members of the merchant and peasant classes as well. These might be made of leather, in the *ikkan-bari* style, or of thin strips of cypress or cryptomeria finished with lacquer. Cheaper paper-manufactured pieces were also to be had, but as the *hasami-bako* was essentially intended for outdoor transport, these had to have covers of lacquered paper or leather

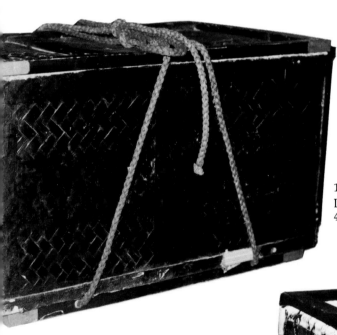

129. *Tsuzura* hamper
Late nineteenth century; H. 17, W. 35, D. 17 in. (43, 90, 43 cm.); bamboo, paper, black lacquer.

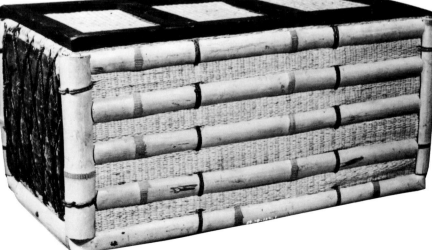

130. *Tsuzura* hamper
Late nineteenth century; H. 16, W. 35, D. 16 in. (40, 90, 40 cm.); bamboo, *igusa* rush.

for protection from the rain. Even as convenient as they were, scissored hampers fell into disuse as *kōri* and *tsuzura* gained in popularity.

HIGH-RIMMED TRAYS *Hirobuta*
CLOTHES TRAYS *Midare-bako*

The high-rimmed *hirobuta* (plate 44) served as a form of tray on which to place gifts and other items for formal presentation. Fairly standardized to rectangular dimensions of approximately 30 by 15 inches (75 by 38 centimeters) and featuring a raised rim, pieces were lacquered, and most emblazoned with family crests (*kamon*) or evocative patterns in *maki-e*. The name *hirobuta*, literally "broad lid," derives from the ancient aristocratic practice of formally presenting gifts to others on the lids of *hitsu* coffers or wooden boxes. The lids were kept from blowing away with wrought gold and silver weights (*uchi-eda*), typically shaped like flowering branches.

The clothes tray (*midare-bako*; plates 42, 43) was used in the sleeping quarters or bath area as a receptacle for soiled clothing. Though similar to the *hirobuta* in shape, pieces generally are less carefully crafted, using unfinished paulownia, bamboo, or other materials.

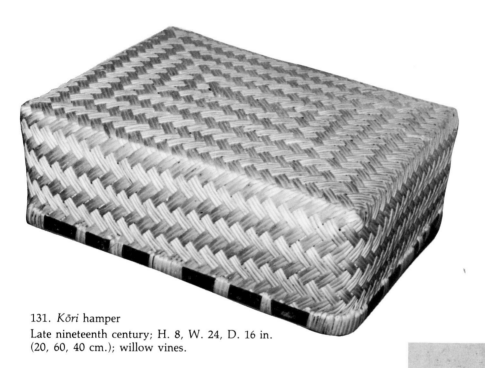

131. *Kōri* hamper
Late nineteenth century; H. 8, W. 24, D. 16 in.
(20, 60, 40 cm.); willow vines.

132. Scissored hamper
Eighteenth century. By Miyagawa Chōshun.

SHELVING *Tana*

Shelf-type units can be divided into three classes: ornamental shelves (*kazari-dana*), both formal and informal, for decorative display in the home; tea-ceremony shelves (*chanoyu-dana*) used in the tearoom; and simple *tana* intended for practical purposes in the kitchen or shop.

At the very pinnacle of *kazari-dana* are three very formal and elegant accouterments of the feudal lord—the *zushi-dana*, *kuro-dana*, and *sho-dana* (collectively known as the *san-dana*, or "three shelves"; plates 133–35)—all embellished in *maki-e*. Originally these three *tana* belonged exclusively to the samurai class, but as the Edo period passed the midway point, and the merchant class rose in economic strength, they too adopted these attributes of social status.

The *zushi-dana* (plate 133) is a three-tiered shelf with rolled-edge top, openwork designs on the side panels, legs undercut in contour motifs, and double-door compartments on two levels. As the most elegant of the three, the *zushi-dana* was always prominently placed. Decorum dictated that the shelves hold a series of writing supply boxes—a handy box (*tebako*; see plate 96), a box for *tanzaku* narrow-format papers (*ō-tanzaku-bako*), a box for *shikishi* square-format papers (*shikishi-bako*), *fubako* letter boxes (see page 122), a box for *mizuhiki* ceremonial tie-strings (*mizuhiki-*

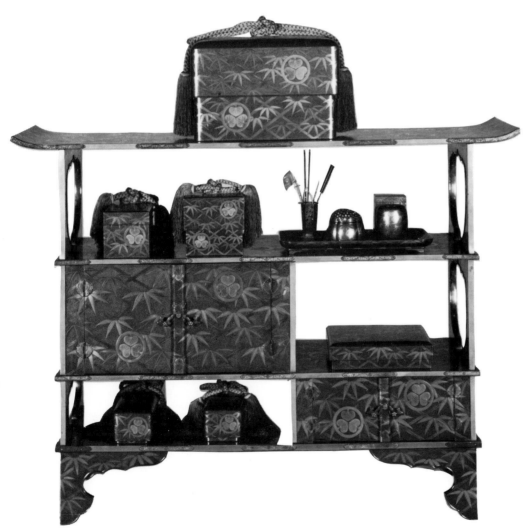

133. *Zushi-dana*
1735; H. 30, W. 40, D. 16 in. (76, 102, 40 cm.); black lacquer, *maki-e*.
The shelves hold, in descending order, a handy box for cosmetic accessories, incense boxes, a set of incense utensils on a tray, a writing-paper box, a box for *mizuhiki* rolled-paper strings for adorning the hair (left), and lastly, a letter box (right).

bako), a writing box (*suzuribako*; see page 123), and a stationery box (*ryōshi-bako*); and a complete set of incense utensils—incense boxes (*jin-bako* and *kō-bako*), an incense utensil tray (*kō-bon*), an incense censer and assemblage (*hitori-kōro*), and incense chopsticks (*kōro-bashi*).

The *kuro-dana* (plate 134) is also three-tiered, but has only one level of double-door compartments, a flat top, and squared posts in the corners that extend straight down to become legs. This unit also had its requisite display: an extensive set of cosmetic supply boxes, including a facial-wipe case (*harai-bako*), a *kosumiaka* ceremonial hair-tie case (*motoyui-bako*), a comb case (*kushi-bako*), an eyebrow-makeup case (*mayu-tsukuri-bako*), and a tooth-dying case (*haguro-bako*); catchall boxes (*konbu-bako* and *uchi-midare-bako*), and a basin-gridiron and nail-clipping-knife case (*watashigane tsumekiri-bako*).

The *sho-dana* (plate 135) also has four squared posts and a flat top, but sits solidly on a sliding-door compartment base, and in the mid-levels features a run of three staggered shelves. The items displayed in this case would include scrolls and other written materials and a writing box.

Since only the most refined *sho-dana* were counted as one of the three shelves essential to the formal decor in the residences of feudal lords, there was a tendency toward elaborate pieces even among the common classes. Valued as much for display as for actual storage, like other *tana* shelf units, they often boasted compartments with sliding-door panels, and ornamental staggered shelving (*chigai-dana*).

With the advent of the Meiji era, *sho-dana* came to be made with hinged cabinet doors. Shelves of this variety were more practical items, hence most were made of plain cypress or cryptomeria. Most of these were likewise quite simple in design, with only one or two shelves inside their doors. Nonetheless, some also had drawers across

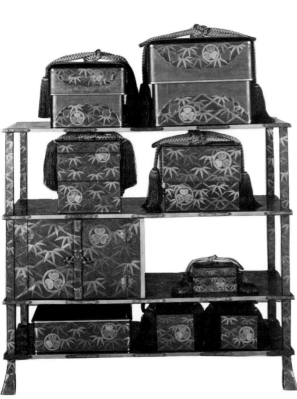

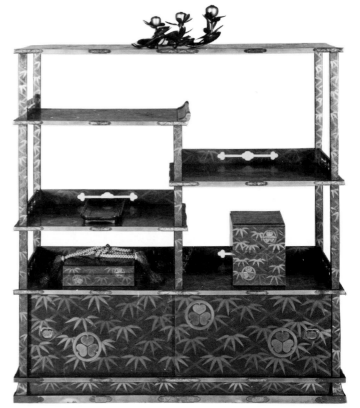

134. Kuro-dana
1735; H. 27, W. 31, D. 15 in. (68, 78, 38 cm.); black lacquer, *maki-e*. Visible on the shelves are, from the top left, small and large red-edged boxes (*sumiaka*) for various personal effects; an eyebrow-makeup case, which also holds a mirror and face powder; a comb case for hair-styling accessories; a tooth-dying case; a catchall box for assorted toiletries; a basin and gridiron case for rinsing the mouth; and a nail-clipping-knife case.

135. Sho-dana
1735; H. 39, W. 38, D. 17 in. (100, 96, 44 cm.); black lacquer, *maki-e*. Empty of the handscrolls and folios they were meant to hold, the shelves here display, from top to bottom, a weight in the shape of a tree branch, a tray for scrolls (*makimono-zara*), a writing-paper box (*ryōshi-bako*), and a stacked writing box.

PARTITION DEVICES

The term byōshōgu *covers all furnishings for breaking the line of vision or blocking the wind, and for partitioning and decorating interior spaces. Most notably this includes folding screens* (byōbu), *single-panel screens* (tsuitate), *doorway curtains* (noren), sudare *blinds, and running curtains* (manmaku).

FOLDING SCREENS *Byōbu*

Folding screens come in two-, four-, six-, eight-, or even ten-panel hinged formats of the same basic vertical, rectangular wood-framed surface. Of these, the six-panel screen was most common, often in paired sets (plate 48). So prevalent were the paired screens (*issō-mono*, literally "paired things") that single pieces were sometimes called half-pairs (*isseki-mono*). When classified by height, *byōbu* fall into three categories: "true measure" *honken-byōbu* of around 5 feet (150 centimeters), "small" *ko-byōbu* of some 3 feet (90 centimeters), and "medium" *chū-byōbu* in the mid-range. Materials include paper, cloth, wood, bamboo, and reed. The classic example of folding screens in use up until the premodern age (1573–1868) was paired six-panel screens of painting or calligraphy on paper. From the Edo period (1600–1868) on, however, as other classes grew to afford such items in the home, single unit two- or four-panel screens of wood, bamboo, and reed also came into fashion. Moreover, innovations brought two-panel screens into everyday use: the wide kitchen screen (*katte-byōbu*), the low waist-high screen (*koshi-byōbu*), the pillow screen (*makura-byōbu*; plate 141), the brazier-area screen (*furosaki-byōbu*; plate 142) for tea ceremony, and an ingenious hybrid with the clothes rack (*ikō*; see page 145), the screened clothes rack (*ikō-byōbu*; plate 49).

Since for the greater part of their history folding screens were produced for prescribed functions and occasions observed in aristocratic and samurai households, certain traditions persisted even after screens achieved wide popular use. For instance, births called for screens with the auspicious crane and turtle painted in monochrome ink, while congratulatory celebrations merited screens in gold leaf; Buddhist observances had their screens with calligraphy, which were turned upside down in the event

141. Pillow screen
Early twentieth century; H. 22, W. 35 in. (55, 90 cm.). Often decorated, as here, with the owner's favorite folding fan paper and texts such as these Nō theatrical scores.

of a death. In this sense, screens proved most convenient for symbolically "coloring" interiors in an instant, evoking whatever mood the situation required.

Screens were generally placed near the seating area or behind the seat of honor, although they might also be flattened and hung up on a wall purely for decoration, fastened to the trabeation timbers for stability, effectively an extension of the mural art tradition in *shoin*-style architecture.

Thus, through the Edo period, folding screens penetrated many aspects of daily life, both indoors and outdoors: from backdrops at official functions and flower-viewing picnics to box-seat partitions (*koshi-byōbu*) for a bit of privacy at the theater. Folding screens were highly prized and at some local festivals friendly competitions arose in which families would display their best screen.

142. Brazier-area screen
Approx. H. 24, W. 55 in. (60, 140 cm.).

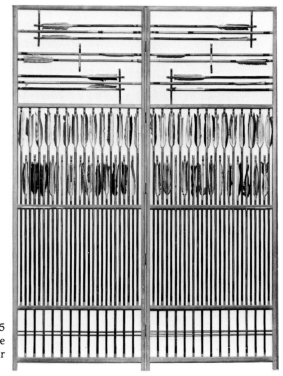

143. Arrow-shaft folding screen
Early eighteenth century; H. 62, W. 183 in. (157, 465 cm.). A novel way to display arrows received from the feudal lord of the domain. Two panels from one of a pair of four-panel screens.

SINGLE-PANEL SCREENS *Tsuitate*

The next class of partitions is, curiously enough, referred to in China with the characters for *byōbu*, but came to be known in Japan as *tsuitate*, or "upright stands" (plates 50–52). Generically a kind of portable barricade consisting of a single vertical panel on a base, *tsuitate* function both to conceal and to visually enhance, and are either for indoor or for outdoor use.

Indoors, *tsuitate* were commonly placed at the boundary between *engawa* verandas and drawing rooms, at the entrance to sleeping quarters, near the front and back house entrances where shoes were customarily removed before stepping up to the floor-level of the house proper, and in the Kansai region, between the earthen-floored kitchen and the higher matted rooms bordering it. Partitions used for this last purpose might be provided with a small decorative shelf on the matted side. Screens also gave privacy in restaurant and theater seating areas. Outdoors, they would have been just inside a gate.

The form and materials for indoor screens are diverse: paper panels (*fusuma*), cloth, *shōji* panels, reeds, imported rare woods, domestic woods, bamboo, and wire mesh among them. More sophisticated pieces boast a wooden frame designed to accept interchangeable units: *fusuma* panels for winter and reed screens for summer, sliding *shōji* panels, or a panel with a central opening to allow a suggestive glimpse through *sudare* blinds into the garden. Outdoor pieces are generally made of sturdy slabs or burls of cryptomeria, cypress, zelkova, chestnut, or other woods.

DOORWAY CURTAINS *Noren*

Noren curtains, hung in doorways or under the eaves at the entrance to a house, were typically made of several 1-foot (30-centimeter) widths of linen or cotton cloth sewn together part way down their lengths to form a curtain with two or more flaps that could be parted when passing through a doorway. Those hung under the eaves were called outdoor divider-curtains (*soto-noren*); those inside the house, predictably enough, indoor divider-curtains (*uchi-noren*).

Soto-noren became popular trappings for shop entrances from the early premodern period on (plates 53, 54, 57), and through the first half of the Edo period it was not uncommon to see a chandler's *noren* bearing a picture of a candle, or fan merchant's that of a folding fan. Only later, with the spread of literacy did *noren* with written characters or store insignias prevail over those with simple product images. Varieties

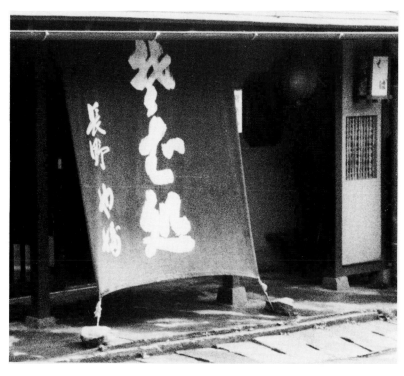

144. Full-length sunshade curtain
Middle twentieth century; H. 69, W. 40 in.
(175, 135 cm.).

include doorway-width pieces—long curtains (*naga-noren*) that reached from the lintel (*kamoi*) all the way to the doorsill (*shikii*), and half-length hangings (*han-noren*)—whole storefront-width horizontal pieces (*yoko-noren*), very short cloth under-eave runners (*mizuhiki-noren*), and even doorway-length sunshades sewn their full-length down to the ground (*hiyoke-noren*; plate 144) and held in place with rocks. Still others not made of cloth were the rope doorway-curtains (*nawa-noren*; plate 55) and straw-mat divider-curtains (*mushiro-noren*), the former preferred by popular drinking establishments, and the latter commonly used on the backdoors of farmhouses or on barn doors.

Uchi-noren (plate 56) were hung in the doorways to sleeping quarters or drawing rooms, at the kitchen door, and between open shop areas and the private rooms behind. Most were of silk, or else lightweight cotton; pictorial images figured on many, as did a number of beautiful motifs abstracted from nature—the "flax-leaf" (*asa no ha*) and "pine-bark diamond" (*matsukawa-bishi*) patterns, to name but two. In the Hokuriku and eastern Tōhoku regions, *noren* of this kind customarily formed part of the bridal trousseau, and were temporarily hung at the door to the newlyweds' room.

BLINDS *Misu, Sudare*

Misu (plate 145) hung in Shinto shrines, Buddhist temples, the Imperial Palace, and villas, and were made of *higo*—thin ¹⁄₁₂-inch (2-millimeter) squared strips of bamboo—which were dyed yellow, woven together with red silk threads, and bound at the edges in borders of embellished brocade. On especially wide *misu*, vertical inner borders of brocade (*tachiberi*) might also be added at intervals for decoration and reinforcement below ornamental silk tassels (*fusa*) and functional hooks (*kagi*) that held the rolled-up blinds in place.

Sudare blinds (plates 146, 147) were for use in the common home, and include three varieties: bamboo blinds (*take-sudare*), reed blinds (*yoshi-sudare*), and Iyo bamboo blinds (*Iyo-sudare*). *Take-sudare* were again made of *higo*, while *Iyo-sudare* were of somewhat thicker strips of Iyo bamboo with the bark left on; the string for weaving was usually hemp for both.

The basic difference between *misu* and *sudare* was originally the presence or absence of borders, but this distinction diminished over time. Before the advent of air conditioning, *sudare* were an indispensable furnishing, hanging in the windows of every house and shading out the summer sun but letting in the breeze. This custom still holds in the old capitals, Kyoto and Nara.

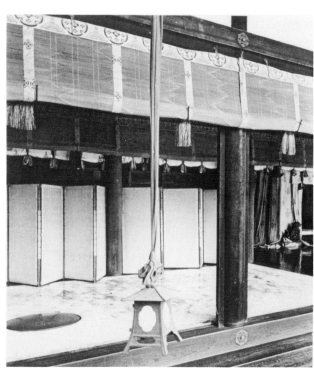

145. *Misu* blinds
H. 70 in. (180 cm.). Blinds rolled up and held in place with hooks. In the foreground are hanging lanterns (*tsuri-tōrō*). Seiryōden hall of the Kyoto Imperial Palace.

RUNNING CURTAINS *Manmaku*

Running curtains (plate 148) were made by seaming together lengths or widths of cloth, which were then either sewn with loops or with a long rope casing to which metal fittings were attached for hanging. Alternatively, some *manmaku* were drawn taut with cords at the four corners. When hung outdoors, these would often be tied to posts erected for the occasion (*makugushi*). Typical fabrics were silk or cotton, with indigo the preferred color in ancient times. Up through the middle ages (1185–1573), they were almost exclusively military articles, but from the premodern age they also found use at country outings, banquets, weddings, and other festive occasions. Today, celebratory banners are generally striped in auspicious red and white, and those for mourning in austere black and white. Their use parallels that of folding screens (*byōbu*) as especially effective backdrops, providing an atmosphere appropriate to the situation.

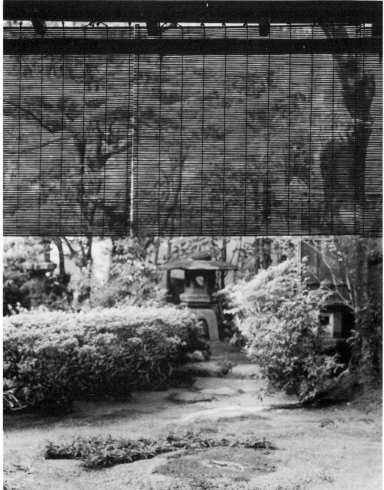

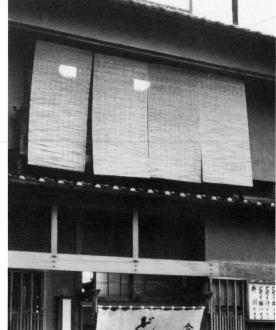

146. *Sudare* blinds
Middle twentieth century; H. 31, W. 35 in. (79, 90 cm.); bamboo.

147. *Sudare* blinds
Middle twentieth century; H. 59, W. 35 in. (150, 90 cm.); bamboo.

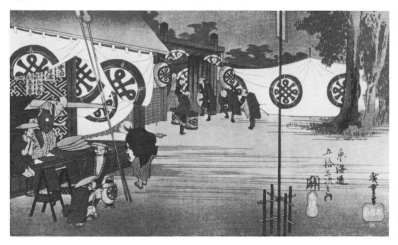

148. Running curtains
Middle nineteenth century. The quarters where a feudal lord or person of nobility lodged, as well as the immediate vicinity, were festooned with curtains dyed with his family crest. By Utakawa Hiroshige.

MOSQUITO NETS *Kaya*

Mosquito nets (plates 149, 150) were hung over sleeping areas in aristocratic households since early times, though the practice was probably extremely limited overall. From the Muromachi period (1392–1482), however, the custom gradually trickled down to the common classes, so that by the Edo period, mosquito nets were in popular use. Edo-period *kaya* were made of such materials as linen, silk, cotton, and even paper, with linen being the most prevalent. The fabric was a rough broadcloth weave of green linen threads, which was then pieced together into a rectangular "tent" of four walls, a ceiling, and no floor, bordered in red at the seams. The ceiling sheet would have loops at the four corners for suspension from nails in the structural posts. *Kaya* were fashioned according to the size of the room.

Silk nets were luxury items, dyed light blue and having white borders along the seams. Cotton *kaya* were the poor person's article, generally afforded by farmers and hired business help.

Paper *kaya* were glued together out of large sheets of Japanese paper (*washi*). They were commonly used by the poor, not only as mosquito netting, but as insulation to trap heat during the winter. Paper nets found another, more specialized, use in lacquer studios providing a dust-free working environment.

For infants or for daytime naps, there were smaller hooded nets (*horo-gaya*; plate 151). First, a collapsible frame would be fashioned of arched bamboo rods bound where their ends touched the floor. This frame would then be fanned out and draped with linen netting.

Widely used up through World War II, mosquito nets fell into disuse from the 1960s when much of the mosquito problem was eliminated with the advent of insecticides, improvements of public sewer systems in the cities, and the addition of window screens for the home.

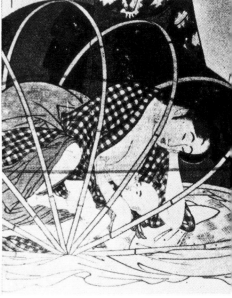

150. Mosquito net
Inside the netting, a courtesan is burning the remaining mosquitoes with the flame from a paper taper (*shisoku*). On the floor behind her is a box pillow; half-hidden by the net, a round fan (*uchiwa*); beyond, a framed-paper lamp. By Gototei Kunisada.

149. Mosquito net
Middle eighteenth century. By Suzuki Harunobu (detail).

151. Small hooded net
Early nineteenth century. By Kitagawa Utamaro (detail).

FLOOR COVERINGS

Shikimono, literally "things for spreading out," is the Japanese term for floor and ground coverings in general. In traditional Japan these included komo *and* mushiro *woven mats and red felt spreads (*hi-mōsen*).*

WOVEN MATS *Komo, Mushiro*

Woven straw mats called *komo* (plates 152, 153) were indispensable items for the home from ancient times, but with the spread of better-quality *mushiro* mats in the Edo period (1600–1868), they ceased to be used much indoors. Nonetheless, they remained important for outdoor uses, especially in rural farming communities when drying harvested grain, pounding glutinous-rice cakes (*mochi*), or engaging in other activities that required a clean surface.

Mushiro were of two types: *i-mushiro* and *tō-mushiro*. The former were made of a rush called *igusa*, and woven as for the surfacing of tatami to a standard width of 3 feet (90 centimeters) and to various lengths. Typically of a single thickness, they were occasionally also layered in double-thickness or edged with cloth borders. Spread over tatami or wooden floors, they made for comfortable sleeping during the sticky summer months. From the Meiji era (1868–1912), colorful patterned mats (*hana-mushiro,* literally "flower-patterned mats"; plates 58, 59) woven of dyed *igusa* were especially prized for their decorative value in the home. The latter *tō-mushiro,* woven of split lengths of rattan (*tō*) imported from Southeast Asia, have been appreciated since the Edo period for their refreshingly slick surfaces, hence they came to provide a touch of coolness in the heat of summer, and were likewise often used on the floors of dressing areas near the bath.

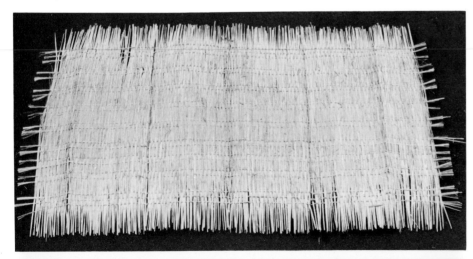

152. *Komo* mat
Approx. L. 60, W. 35 in. (150, 90 cm.);
rice straw.

153. *Komo* mat
Approx. L. 70, W. 35 in. (180, 90 cm.);
rice straw.

RED FELT SPREADS *Hi-mōsen*

Floor coverings made of animal-hair materials fell under the category of *sen*, which was subdivided into felt spreads (*mōsen*) and *jūtan*, woven carpets in general. Among the former, *hi-mōsen* (plates 57, 154, 155) felt spreads of a bright red known as *shō-jōhi*, "orangutan crimson," became extremely popular in the homes of samurai and persons of influence from the late fifteenth century on. Yet because Japan did not raise enough livestock to produce a steady supply of animal hair, these spreads had to be imported in great numbers from the continent. From the Edo period, their popularity increased to the point where they were used as a ground covering on outings, at the theater, on the floors of inns and teahouses, and even in ordinary homes; and what had originally been an imported luxury item for the privileged few found its way into everyday Japanese life. See also Benches, page 100.

154. Red felt spread
Approx. L. 70, W. 35 in. (180, 90 cm.).

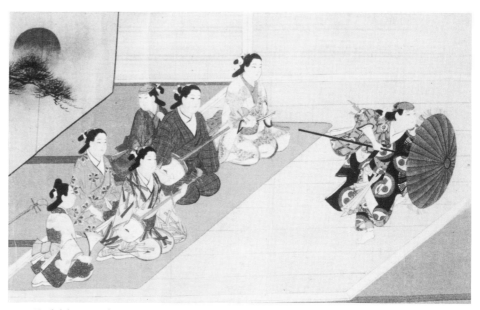

155. Red felt spread
Eighteenth century. The spread defines the musicians' seating area. By Miyagawa Chōshun.

SEATING AND BEDDING

Since neither chairs nor raised beds were used in the traditional Japanese home, the variety of zagagu, furnishings for sitting and reclining, was extremely limited. Articles for raised seating—koshikake, literally "furnishings on which to hang the hips"— can be counted on the fingers of one hand: bentwood chairs (kyokuroku), benches (endai), campstools (shōgi), and stools (ton). Those for floor-seating included cushions (enza and zabuton), bedding (futon), pillows (makura), and armrests (kyōsoku). For infants there were cribs (izumi), stools (tachi-tsubura), and cradles (yurikago).

CUSHIONS *Enza, Zabuton*

Enza, literally "round seats," are plaited of sedge (*suge*), *igusa* rush, rice straw (*wara*), water-oat (*makomo*), or other grasses in spiral (plate 156) or concentric-circular (plate 157) patterns of a diameter just large enough to sit on comfortably. While these were apparently in widespread use from ancient times, with the advent of the Edo period (1600–1868) they came to be found almost exclusively in temples and shrines. In their place, most households began to use 2- to 3-foot (60- to 90-centimeter) square padded cushions called *zabuton* (plates 81, 158), with an outer cover made of cotton, silk, linen, occasionally leather, and rarer still Japanese *washi* paper (plate 60); cotton was by far the most prevalent material. Easy to carry or stack, *zabuton* were, and are today, to be found in every household, though their ancient to medieval prototype, the *shitone*, had remained largely confined to the aristocracy.

156. *Enza* cushion
Late nineteenth century; Diam. 20 in. (50 cm.); rice straw.

157. *Enza* cushion
Late nineteenth century, Kagawa Prefecture; Diam. 22 in. (55 cm.); sedge.

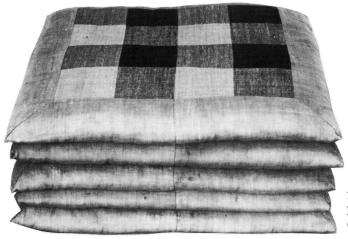

158. *Zabuton* cushions
Middle nineteenth century; W. 22, D. 22 in. (55, 55 cm.); cotton.

BENTWOOD CHAIRS *Kyokuroku*

Used primarily in temples and shrines, bentwood seats (plate 61) comprise several variations: those with crossed folding-leg frames, and those with four separate legs; those with backs joined to armrests, and those with one-piece curvilinear back-armrests only. Finishes include vermilion lacquer, black lacquer, mother-of-pearl inlay, and *maki-e*.

BENCHES *Endai*

The side platform (*endai*, or sometimes *shōgi*; plate 159) is a four-legged wooden or bamboo bench with a typical seating surface measuring 1½ by 3 to 6 feet (45 by 90 to 180 centimeters) raised approximately 18 inches (45 centimeters) off the ground. Usually set in gardens, under eaves, or on earthen-floored areas—places the Japanese would customarily walk in footwear—the *endai* was conceived as a kind of portable version of the *en* veranda of the Japanese house, which traditionally afforded a median between the raised-floor interior and the ground-level exterior where one could sit "Western-style" with legs hanging down. Often decked with a red felt spread (*hi-mōsen*; see page 98), *endai* could either be climbed onto to sit "Japanese-style" as on a raised floor, or used as a combination bench-table. Outdoors, the *endai* was just the thing for sitting and enjoying the cool of a summer's evening, for autumn moon-viewing, or for garden tea gatherings; restaurants, inns, and teahouses also found it a convenient seating and service arrangement (plate 57). Of all the types of *koshikake*, the *endai* most deeply penetrated the lifestyle of the common people.

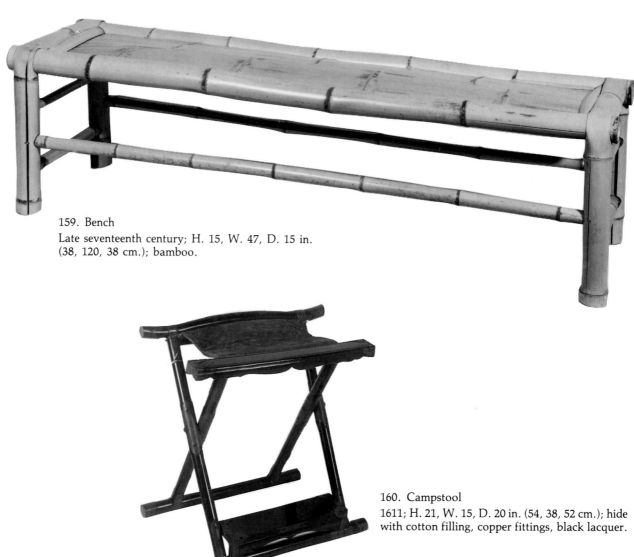

159. Bench
Late seventeenth century; H. 15, W. 47, D. 15 in.
(38, 120, 38 cm.); bamboo.

160. Campstool
1611; H. 21, W. 15, D. 20 in. (54, 38, 52 cm.); hide with cotton filling, copper fittings, black lacquer.

CAMPSTOOLS *Shōgi*

The collapsible campstool (plate 160) features legs crossed in an X to draw taut a sling-seat of plaited cords, cloth, or leather. As the name suggests, it was used on military campaigns and hunting expeditions to provide seating outdoors. Its origins date back to ancient times, but it only came into popular use from the Edo period when it provided seating for outdoor tea functions and the like.

STOOLS *Ton*

The *ton* stool roughly corresponds to the modern-day stool, and covers nearly as broad a variety of shapes and styles, including pieces made of ceramic (plate 161), rattan, and rice straw (*wara*; plate 162). In ancient times, the aristocracy sat on hassocklike *ton* fashioned by stuffing short, cylindrical silk casings, but from medieval times (1185–1573) peasants began to bundle straw into *ton* for sitting in front of the cookstoves (*kamado*; see page 142) in the earthen-floored kitchen while minding the fire. Ceramic *ton* for the garden and rattan pieces for the veranda came into use from the Meiji era (1868–1912). More recently, with the folk-art boom, *ton* made of tightly wound rounds of straw rope have gained wide acceptance for interior use.

161. Ceramic stool
Early twentieth century; H. 17, Diam. 14 in. (43, 35 cm.).
Stool with affected Chinese-style decoration.

162. Rice-straw stool
Early twentieth century; H. 14, Diam. 13 in. (35, 33 cm.);
rice straw.

ARMRESTS *Kyōsoku*

Independent armrests (plates 163, 164) on which to lean while seated on the floor were called *kyōsoku* (though earlier they were known as *hyōki*, the Japanese reading of the Chinese name). A support board (*hyōban*) measuring approximately 18 by 6 inches (45 by 15 centimeters) was elevated on legs at either end, and covered with a cotton-padded cushion. Armrests might be made of imported *karaki* woods, zelkova, or paulownia, or lacquered and decorated in mother-of-pearl inlay or *maki-e*.

BEDDING *Futon*
PILLOWS *Makura*

A set of *futon* bedding (plate 165) consists of a mattress (*shiki-buton*) and one or more top quilts (*kake-buton*; plate 63). The average mattress is a large rectangular cotton or silk case stuffed with cotton wadding approximately 40 by 70 by 4 inches (100 by 180 by 10 centimeters). Top quilts—also called *yogi*, or "night wear"—are likewise made of cotton or silk stuffed with cotton wadding, but could be either rectangular or shaped like an oversized kimono with sleeves and a collar so that they might be "worn" while sleeping.

Pillows, all known as *makura* of one sort or another, are many and various. From the middle of the Edo period on into the Meiji era, the two main types were a cylindrical stuffed pillow (*kukuri-makura*; plate 166) and "box pillow" (*hako-makura*; plates 64, 165): the former is bolsterlike, and sometimes long enough for two-person use; the latter has a smaller *kukuri-makura* elevated on a hollow wooden-box base, and was placed under the neck so as to keep carefully coiffured hair unmussed and intact. For summer naps, there were cool ceramic and rattan pillows, as well as "perfume pillows" (*kō-makura*; plate 65) to scent coiffures while sleeping.

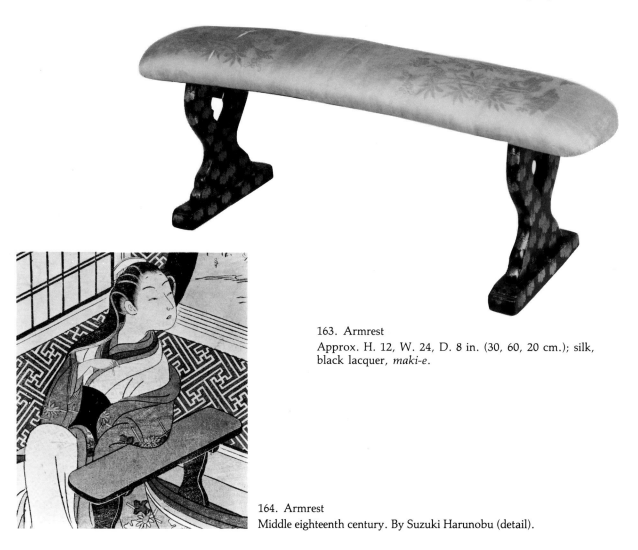

163. Armrest
Approx. H. 12, W. 24, D. 8 in. (30, 60, 20 cm.); silk, black lacquer, *maki-e*.

164. Armrest
Middle eighteenth century. By Suzuki Harunobu (detail).

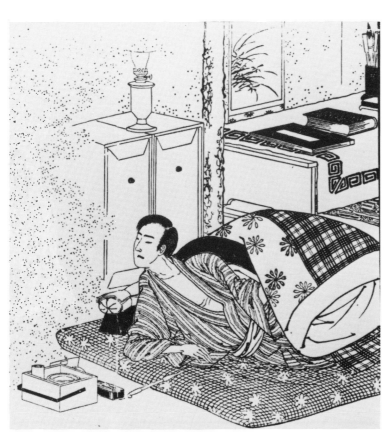

165. Bedroom furnishings
Late nineteenth century. Visible in this illustration are a mattress and top quilts, a box pillow, and a tobacco stand with a long-stemmed pipe. In the background are two book boxes with an oil lamp on top, and beyond that, a writing table. By Tsukioka Yoshitoshi (detail).

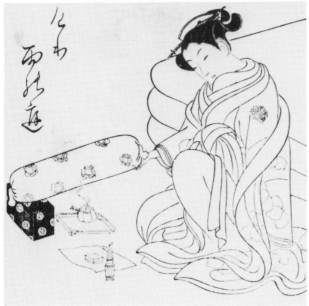

166. Cylindrical stuffed pillow
1770. By Suzuki Harunobu (detail).

167. Collapsible pillow for travel
Early twentieth century; H. 7, W. 4, D. 3 in. (18, 10, 7 cm.); whale baleen, no finish.

CRIBS *Izumi* BABY STANDERS *Tachi-tsubura*
CRADLES *Yurikago*

Traditional Japanese baby cribs go under the generic name *izumi* and include oblong baskets woven of straw (plate 168), oblong wooden tubs of barrellike construction, and rectangular boxes with headboards. The basketry and straw plaiting on woven cribs varied from region to région, but generally they were lined with seaweed or straw ash, then layered on the bottoms and sides with quilted padding on which to lay the babies for napping while the parents worked at farming or fishing.

The baby stander (*tachi-tsubura*; plate 169) had a hole in the top for supporting infants upright and a box affixed in front for holding toys or food. Infants might thus stay conveniently occupied off to the side while the family ate their meals, although this practice was largely confined to comparatively affluent farming households and townsfolk.

Hammock-style suspended cradles (*yurikago*, literally "rocking baskets"; plate 170) were used in Hokkaido to the extreme north of Japan and in Okinawa to the tropical south. Okinawan *yurikago* were designed to keep babies off the ground, cool, and away from insects: an open gridwork floor of thick rattan vines would be suspended from an oval frame of the same material by coils of rope, then lined with *adan* palm leaves or a *mushiro* mat (see page 97) woven of boxwood strips, and finally the whole arrangement would be suspended by ropes from either end.

168. Crib
Early twentieth century, Akita Prefecture; approx. H. (rear) 16, W. 24, D. 16 in. (40, 60, 40 cm.); rice straw.

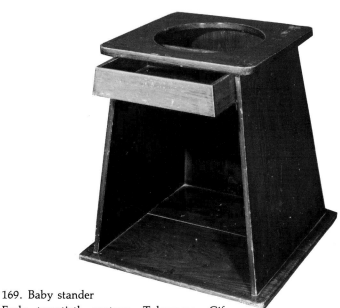

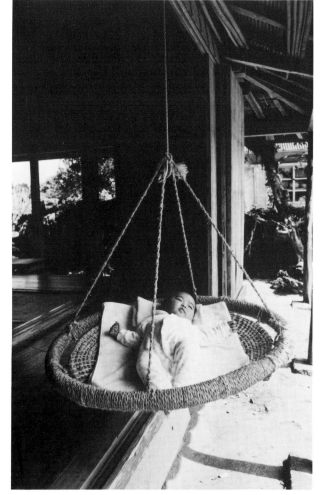

169. Baby stander
Early twentieth century, Takayama, Gifu Prefecture; H. 20, W. 16, D. 12 in. (50, 40, 30 cm.); cryptomeria, *shunkei* lacquer.

170. Suspended cradle
Early twentieth century, Okinawa; Diam. 28 in. (70 cm.).

LIGHTING DEVICES

The varieties of traditional Japanese lighting devices (shōmei-kigu) are extremely numerous and may be roughly classified into those for interior or exterior use, and again into those to be set in place and those designed for hand-carrying. Fuel was generally either oil or wax, with oil in wider use than the comparatively more expensive wax even though it fell short in luminosity.

Interior lighting was of three main types: those to be set on the floor—oil lamps (tōdai), framed-paper lanterns (andon), and candlestands (shokudai); those for hanging from the rafters or ceiling—framed-paper hanging lanterns (tsuri-andon) and roofed hanging lanterns (tsuri-tōrō); and wall lanterns (kake-tō) for hanging on the wall or posts. Portable lighting included hand-held candlesticks (teshoku) and collapsible paper lanterns (chōchin). In addition, with the increasing westernization that began in the Meiji era (1868–1912), kerosene lamps were introduced into the scheme of Japanese lighting. These were at first exclusively imported items, but eventually came to be produced domestically to more typically Japanese design.

OIL LAMPS *Tōdai*

All stationary lighting devices that feature an oil dish (*tōsan*) set with a wick (*tōshin*) fall under the generic name *tōdai* (literally "lamp stand"). Specific names were often determined by the shape of the base, as with the chrysanthemum-base oil lamp (*kikuza-tōdai*; plate 171) and the expressive "cow-manure"-base oil lamp (*gyūfun-tōdai*; plate 172). Up through the medieval times (1185–1573) such lamps were the main form of interior lighting, but with the popularization of portable framed-paper lanterns (*andon*) in the Edo period (1600–1868), the only type of *tōdai* that remained in use was the short oil lamp (*tankei*; plate 70). This is essentially an oil saucer attached to a bamboo shaft or other upright element, which in turn stands on a base and is provided with a loop or hole above for positioning the wick to trail down into the oil. The base often contains a drawer for storing spare wicks or oil pitchers.

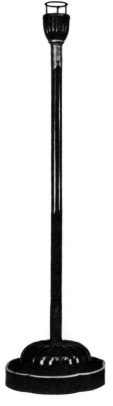

171. Chrysanthemum-base oil lamp
Middle nineteenth century; H. 44 in. (112 cm.); black lacquer.

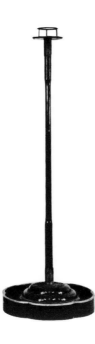

172. "Cow-manure"-base oil lamp
Middle nineteenth century; H. 38 in. (97 cm.); black lacquer.

One rather unusual type of oil lamp is the rat lamp (*nezumi-tōdai*; plate 173), which contrives to affix a rat-shaped ceramic oil jar atop the upright shaft. The jar is connected to a tube in the shaft in such a way that whenever the oil in the dish runs low, the tube causes oil to drip from the rat's mouth (see below). As similarly devised lamps do exist in other lands—for example, the so-called bird-fountain lamp of India— it can be surmised that the rat lamp was patterned after ones imported at the peak of foreign trade during the Momoyama period (1573–1600).

FRAMED-PAPER LANTERNS *Andon*

When paper is applied to a frame enclosing an oil dish to make a light chamber (*hibukuro*), the result is the *andon* (plates 71–73). Various types exist, most notably the squared *kaku-andon* (plate 71), the cylindrical *maru-andon* (plates 174, 175), and the more elaborate *ariake-andon* (plate 73). This last type essentially consists of a base and framed-paper shade, both box shaped, the base doubling as the second shade: whenever a lower level of lighting was desired, the slightly larger base, which would have full- or crescent-moon openings or both cut through one or more sides, could simply be slipped over the paper shade.

Somewhat rarer is the "pillow lamp" (*makura-andon*), which consists of a traditional Japanese pillow mounted on the lid of a box that holds a small lamp set-up. Thus, an overnight guest at an inn might get up in the middle of the night and have a lamp close at hand.

OTHER OIL LAMPS *Gatō, Hyōsoku*

The less-expensive, low-fire ceramic *gatō* (literally "tile lamp"; plate 176), like the double-shaded *ariake-andon*, provided two levels of light, both figuratively and literally. Placing the oil dish on an upper platform atop a bell-shaped cover gave a brighter light, while setting it in an interior chamber done in openwork designs effectively dimmed it.

The utilitarian oil lamp (plates 177, 178), called by such names as *hyōsoku* or *tankoro*, is distinguished by a design that places the wick upright in the center of the oil dish, and by a hollow base that holds the fuel. Generally not very bright but useful for their long-burning flame, *hyōsoku* were most often used in toilet and bathing areas.

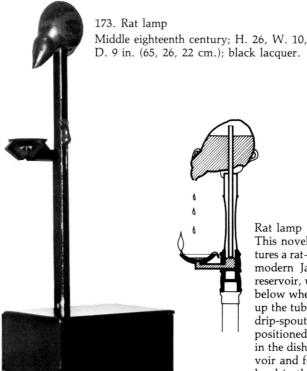

173. Rat lamp
Middle eighteenth century; H. 26, W. 10, D. 9 in. (65, 26, 22 cm.); black lacquer.

Rat lamp
This novel, early self-regulating oil lamp features a rat—symbol of the midnight hour in premodern Japanese lore—that conceals an oil reservoir, which drips fuel oil into the wick dish below whenever a drop in the oil level lets air up the tube to break the surface tension at the drip-spout. As the lower end of the air tube is positioned exactly at the optimum level for oil in the dish, air continues to enter the oil reservoir and force oil to drip until it reaches that level in the wick dish.

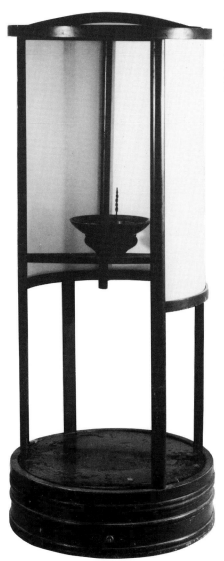

174. Cylindrical framed-paper lantern
H. 35, Diam. 14 in. (90, 36 cm.); cryptomeria, paper, black lacquer.

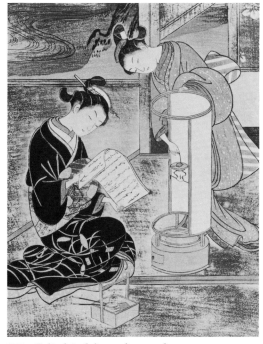

175. Cylindrical framed-paper lantern
Middle eighteenth century. By Suzuki Harunobu (detail).

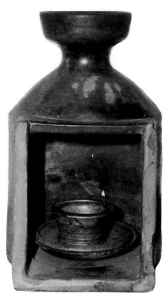

176. *Gatō* oil lamp
Eighteenth century; H. 14, Diam. 10 in. (35, 25 cm.).

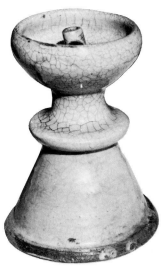

177. *Hyōsoku* oil lamp
Late nineteenth century, Niigata Prefecture; H. 4¾, Diam. 2¾ in. (12, 7 cm.).

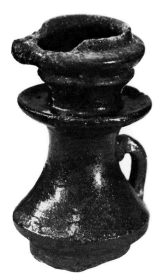

178. *Hyōsoku* oil lamp
Late nineteenth century; H. 3½, Diam. 2⅓ in. (9, 6 cm.).

CANDLESTANDS *Shokudai*

Despite the seemingly endless variety of candlestands all called *shokudai* (plates 66–69, 179–84), the fundamental design is nothing more than a short, upright shaft on a base, with a spike on top for positioning a candle. Most are made of wood, though other materials include metal, ceramic, and stone. Candlestands could be extremely plain, even primitive looking—for example, a section of tree root left completely unfinished—or they might be very ornate, such as the lathe-turned candlestand (*hiki-mono-shokudai*; plate 180); or the "cow-manure"-base candlestand (*gyū-fun-shokudai*), often decorated with *maki-e*, mother-of-pearl inlay, and ornamental metal fittings; or the chrysanthemum-base candlestand (*kikuza-shokudai*; plate 181) with its base of carved, rounded petals. Finally, there is the adjustable candlestand (*jizai-shokudai*; plate 183) that allows the height to be varied, and the shaded lamp stand (*bonbori*) that features a round (plate 76) or an upward-opening, octagonal (plate 182) paper lampshade.

Until Western paraffin candles entered Japan in the Meiji era, Japanese candles were made of a mixture of sumac wax and vegetable oil coating a narrow paper-cone wick. This paper wick would not burn completely, but left an ash build-up that required trimming to keep the flame from dimming (plate 184). Hence all pre-Meiji candlestands were invariably provided with ash containers and wick-scissors, the last somewhat closer to simple pincers than to the Western candlesnuff.

179. Candlestand with wick-scissors and built-in ash receptacle
Traditional Japanese candles made of paper wicks and vegetable wax would not burn completely and so required frequent trimming. The candlestand here represents an ingenious solution to storing the two accessory items.

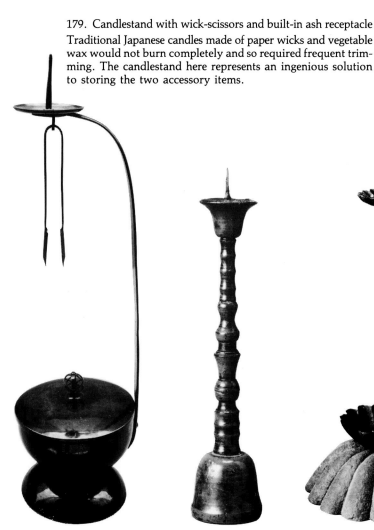

180. Lathe-turned candlestand
Early seventeenth century; H. 11 in. (29 cm.); *negoro* lacquer.

181. Chrysanthemum-base candlestand
Late seventeenth century; H. 16 in. (41 cm.); iron.

182. *Bonbori* candlestand
Early twentieth century; H. 22, Diam. 9 in. (55, 22 cm.); *hinoki* cypress, no finish.

HANGING LANTERNS *Tsuri-andon, Tsuri-tōrō*

Hung from ceiling or beam, the framed-paper hanging lantern (*tsuri-andon*; plates 75, 185) takes the general form of a broad square, round, or octagonal papered lampshade with an oil dish suspended underneath. The roofed hanging lantern (*tsuri-tōrō*; plates 74, 145, 186), on the other hand, has an enclosed light-chamber housing of paper pasted over bamboo basketry, or of small translucent *shōji* paper panels set into a roofed "house" of wood, or again of cast bronze or iron with open grillwork designs. Typically more ornamental than functional, roofed hanging lanterns, up through medieval times, had been used almost exclusively in temples and shrines, but with the popularization of tea-ceremony culture came to find a place in the common home under the eaves by the garden or entryway, or illuminating the outside hand-washing basin (*chōzu-bachi*).

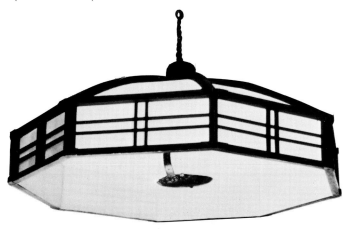

185. Framed-paper hanging lantern
Late eighteenth century; H. 12, Diam. 28 in. (30, 70 cm.); wood, paper.

186. Roofed hanging lantern
Early twentieth century; H. 14, Diam. 8 in. (35, 20 cm.); iron.

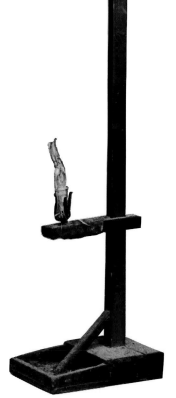

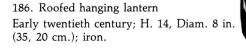

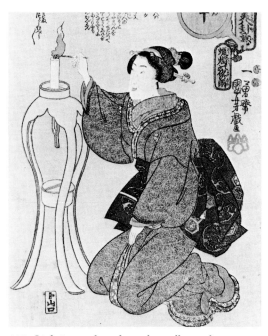

183. Adjustable candlestand
Nineteenth century, Akita Prefecture; H. 31, W. 10, D. 12 in. (80, 25, 30 cm.); cryptomeria, lacquer.

184. Lighting a three-legged candlestand
Middle nineteenth century. By Utakawa Kuniyoshi (detail).

WALL LANTERNS *Kake-tō*

Wall- or post-hung lighting goes by the generic name *kake-tō* and includes the wall framed-paper lantern (*kake-andon*; plate 187) and wall candleholder (*kake-joku*; plate 188). The former has a papered frame inside of which would sit an oil dish or utilitarian oil lamp (*hyōsoku*), and which might be shaped in a vertical rectangle with a squared or rounded front. Mostly associated with restaurants, inns, brothels, and other places of business, *kake-andon* also functioned as a sign when the name of the establishment was inscribed in ink on the outward paper face.

Wall candleholders are rather simple L-shaped pieces consisting of a narrow board or iron rod with an extended horizontal piece at the bottom for positioning a candle, and a hook on top for hanging. Affluent farming and merchant households would hang them up by the score.

HAND-HELD CANDLESTICKS *Teshoku*

Easy-to-carry candlesticks or small handled candlestands, grouped together as "handled lights" (*teshoku*), are made of either wood or metal in a variety of styles (plates 189–91). Those with paper lampshades similar to *bonbori* lamps are called, predictably enough, *bonbori teshoku*, and generally are made of red-lacquered wood. *Teshoku* served mainly to light the way down dark corridors to and from sleeping quarters.

COLLAPSIBLE PAPER LANTERNS *Chōchin*

Hand-held paper lanterns called *chōchin* were introduced from China in the Muromachi period (1392–1482), and subsequently were produced in a great many styles. First, there was the traveler's spherical or oblong dangling paper lantern (*bura-jōchin*) complete with handle. When fitted with a bonnet against the rain, it became a horseback paper lantern (*bajō-jōchin*) (plate 193). A smaller traveler's lantern that could be folded accordion-style to fit in the bosom of a kimono is the *Odawara-jōchin* (plate 194). Its cylinder-shaped body is encased top and bottom in metal to prevent crushing when collapsed, and oiled to waterproof the paper, both measures to improve durability on the road.

Portable lanterns that could also be fixed stationary include the cased paper lantern (*hako-jōchin*; plate 195) and bow-stretched paper lantern (*yumihari-jōchin*; plate 196). The cased lantern has an accordioned cylindrical shade with large bentwood end-

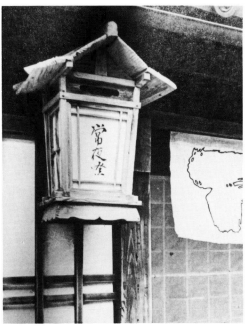

187. Wall framed-paper lantern
Early twentieth century.

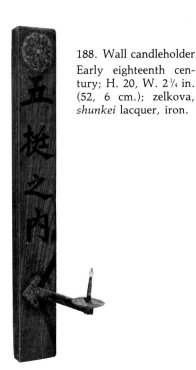

188. Wall candleholder Early eighteenth century; H. 20, W. 2¼ in. (52, 6 cm.); zelkova, *shunkei* lacquer, iron.

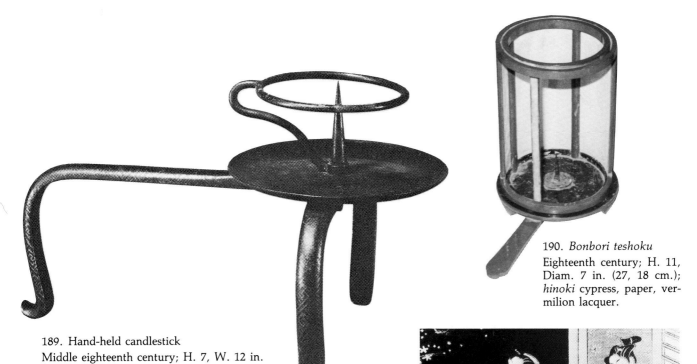

189. Hand-held candlestick
Middle eighteenth century; H. 7, W. 12 in.
(18, 30 cm.); copper.

190. *Bonbori teshoku*
Eighteenth century; H. 11,
Diam. 7 in. (27, 18 cm.);
hinoki cypress, paper, vermilion lacquer.

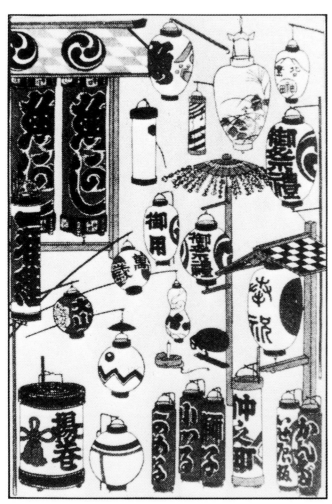

192. Paper lanterns in all their diversity

191. *Bonbori teshoku*
Middle eighteenth century. By Suzuki Harunobu
(detail).

193. Horseback paper lantern
Eighteenth century; H. 22, Diam. 12 in. (55, 30
cm.); *hinoki* cypress, bamboo, paper.

cases top and bottom, a handle on top for carrying, and a built-in support rod to keep it from collapsing when set on the ground. This design was further improved to allow manipulation with one hand, the result being the bow-stretched lantern, which is drawn taut by a frame of bowed lengths of bamboo or whale baleen, and provided with legs.

Hanging paper lanterns include such items as a smaller version of the *bura-jōchin* (*hōzuki-jōchin*) and the Gifu-style *chōchin* (plate 197), which features lyrical bird-and-flower designs painted on silk or Mino *washi* paper, and was used at Urabon, the midsummer Buddhist Festival for Deceased Souls.

The storehouse paper lantern (*kura-jōchin*; plates 198, 199) is made with wire mesh that reinforces the shape and contains the paper if it should accidentally catch fire (a fairly common occurrence), which would wreak havoc otherwise.

The "gyroscopic" lantern (*gandō*; plate 200) is of particularly ingenious design. Used for much the same purpose as today's flashlight, it consists of a barrel-shaped tube that holds a free-rotating candleholder that keeps the candle upright.

194. Odawara paper lantern
Middle eighteenth century.
By Suzuki Harunobu (detail).

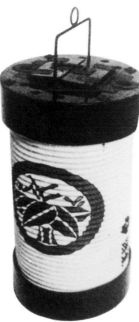

195. Cased paper lantern
Eighteenth century; approx. H. 20, Diam. 12 in. (50, 30 cm.); *hinoki* cypress, bamboo, paper.

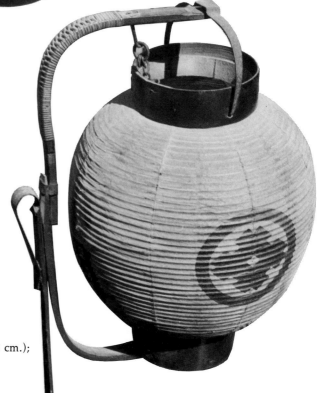

196. Bow-stretched paper lantern
Eighteenth century; H. 20, Diam. 12 in. (50, 30 cm.); *hinoki* cypress, bamboo, paper.

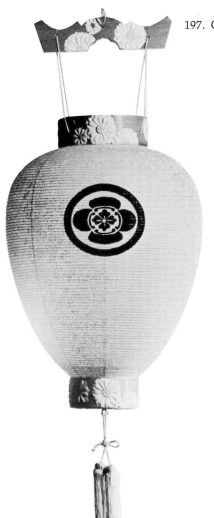

197. Gifu-style paper lantern

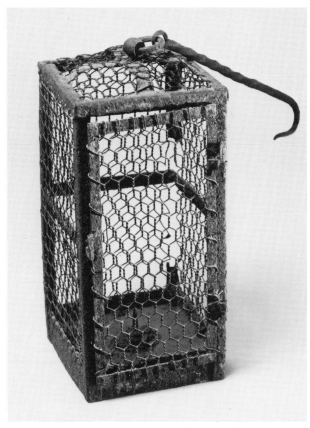

198. Storehouse paper lantern (without paper)
Eighteenth century; H. 16, W. 8, D. 8 in. (40, 20, 20 cm.).

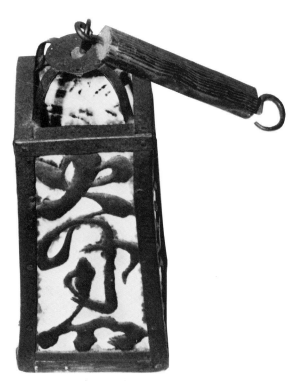

199. Storehouse paper lantern
The clever handle design of this lantern allows it to be either hand-carried or hung in place. The iron frame that houses the fire chamber and its paper shade, thus guarding against warehouse fires, is thoughtfully embellished with characters reading "beware of fire."

200. "Gyroscopic" lantern
Eighteenth century; H. 13, Diam. 11 in. (34, 28 cm.); *hinoki* cypress.

KEROSENE LAMPS *Sekiyu-ranpu*

Kerosene lamps include hanging, carrying, and stationary types, the most characteristically Japanese designs developing among stationary lamps (plates 77–79, 201, 202). Perhaps this reflected the same conditions in the floor-seated Japanese lifestyle that also saw stationary framed-paper lanterns (*andon*) enjoy the widest use of any lighting device in that category. These Japanese-style kerosene lamps might have bases fashioned of bamboo, and sometimes box-shaped lampshades reminiscent of those on *andon* lanterns.

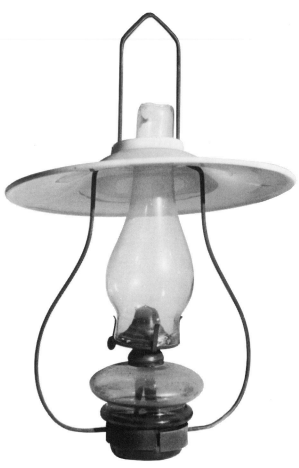

201. Hanging kerosene lamp
Early twentieth century; H. 17, Diam. 12 in. (44, 30 cm.); glass, iron, copper. This model enjoyed the most widespread use throughout the Meiji era.

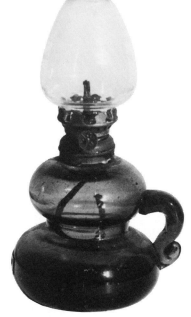

202. Kerosene lamp
Type: carrying lamp
Early twentieth century; H. 8, Diam. 4 in. (20, 10 cm.); glass.

HEATING DEVICES

Traditional Japanese devices for heating the home included sunken hearths (irori), hibachi, and heater-tables (kotatsu). The last two each have smaller versions in hand warmers (te-aburi) and portable heaters (anka). Company and family alike would gather in a close circle around these in the winter, hence they also served as symbols of hospitality, and were often very painstakingly crafted in reflection of the "face" they presented to guests. The wealth of designs in this category is quite striking.

SUNKEN HEARTHS *Irori*

Sunken hearths have a long history of use for cooking as well as heating, especially in rural homes. Smaller versions were also used in tearooms for heating water kettles.

Most hearths were in or near the center of the room, but one variant, the "walk-up" hearth (*fumikomi-ro*; plates 81, 203), was placed at the room edge adjoining the lower earthen-floored area of the house, thus eliminating the need to remove footwear.

Pots and kettles were suspended over the *irori* by means of hooks hung from the ceiling or roof beams. The most rustic of these pothooks were simply forked branches, followed closely by a rather straightforward design that allowed height adjustments by looping the suspension rope around one of a series of notches along a vertical shaft that was hooked at the lower end to accept pot or kettle handles (see below). Probably the most encountered form of pothook, however, was the so-called free hook (*jizai-kagi*; plate 80), which could be freely adjusted to whatever height by means of drag-tension on the suspension rope threaded through an additional horizontal member. Many of these horizontal pieces are carved in the shape of fish (plate 80), folding fans, or other characteristic folkloric designs. Furthermore, there were two methods of suspension: the hook could be hung directly from the ceiling or a beam, or a large U-shaped wooden hook might first be attached to the ceiling or beam, and the suspension rope tied to that (plate 204; see next page).

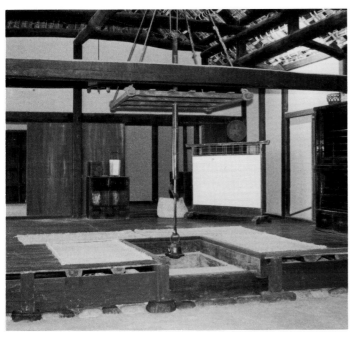

203. "Walk-up" hearth
Late eighteenth century, Miyagi Prefecture.

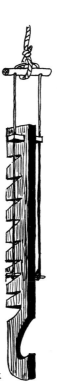

Saw-toothed adjustable-height pothook

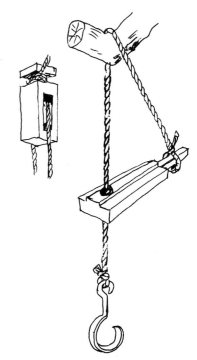

Freely adjustable pothook with fan-shaped horizontal member

HIBACHI *Hibachi*

Braziers with copper linings to hold ashes and burning charcoal were called *hibachi*—literally "fire pots"—and made of many different materials including wood, metal, ceramic, clay, and rattan. Hibachi were mainly used to generate warmth, and boiling water or cooking were secondary uses. The hibachi grill in the West has borrowed only the name, and as a Western variation should be differentiated from the traditional Japanese hibachi. The best-quality wooden braziers are known as palace hibachi (*goten-hibachi*; plate 84). These take the form of large, open, square trays raised on tiny "cat's paws," and are finished with lacquer and *maki-e*, decorated in the corners with forged and tooled ornamental fittings, and covered with a domed wire mesh grating. As the name suggests, they were actually used in palaces, though they also were to be found in the homes of samurai and affluent merchants.

In more popular use were the tree-trunk hibachi (*dōmaru-hibachi*), the box hibachi (*hako-hibachi*), and the long hibachi (*naga-hibachi*). In its simplest form, the tree-trunk brazier (plates 87, 205) consists of a piece of paulownia, zelkova, chestnut, or other wood hollowed out and fitted with a drop-in metal ash-receptacle (*otoshi*); paulownia-trunk pieces were preferred for their insulating ability and their smooth finish that was pleasant to the touch. Elaborate pieces boast decoration in *maki-e*.

Box hibachi are of two types: those a with copper lining attached directly to the inner board faces of the firebox (plate 206), and those with a removable raised lip over a round hole in the center of the box into which a copper *otoshi* is drop-fitted. The actual materials and designs of box hibachi vary considerably; styles range from the fanning *susohiro* "spread skirt" and broad-waisted *dōbari* pieces to those raised on carved *geshōdai* risers.

Long hibachi (plates 85, 89, 207, 208) are rectangular wooden affairs that average 13 by 24 by 14 inches (33 by 60 by 36 centimeters) and usually bear handle insets on either end. In addition, some pieces have drawers to one side and could also be used as a desk; some, like the *Yoshiwara hibachi*, have built-in copper containers (*dōko*) for boiling water; some, like the *daiwa-hibachi* (plate 89), have an extended overhanging lip that functions as a table. All these designs have a row of drawers across the bottom. Three-pronged iron trivets (*gotoku*; plate 207) set into the ash would support kettles and small pans, while over the entire pit area paper-covered boxlike hoods called *jotan*, or "charcoal helpers," would serve to conserve fuel and utilize waste heat.

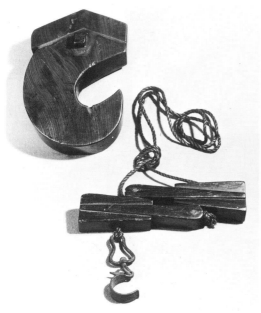

204. Free hook with ceiling hook
Late nineteenth century; approx. H. 5, W. 13 in. (12, 33 cm.); zelkova, *fuki-urushi* lacquer.

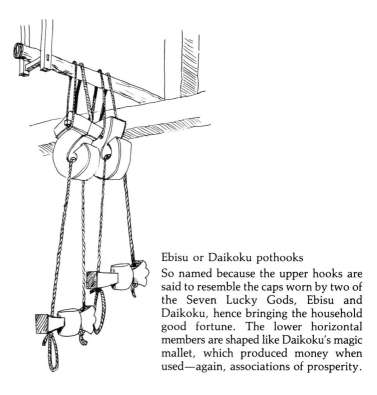

Ebisu or Daikoku pothooks
So named because the upper hooks are said to resemble the caps worn by two of the Seven Lucky Gods, Ebisu and Daikoku, hence bringing the household good fortune. The lower horizontal members are shaped like Daikoku's magic mallet, which produced money when used—again, associations of prosperity.

205. Paulownia-trunk hibachi
Late nineteenth century; H. 11, Diam. 18 in. (28, 45 cm.);
paulownia.

206. Box hibachi
Late nineteenth century; H. 9, W. 14, D. 14 in. (24, 34,
34 cm.); zelkova, rosewood, *fuki-urushi* lacquer.

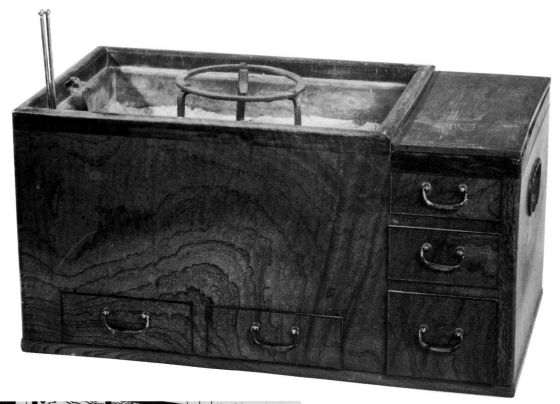

207. Long hibachi
A standard design, with typical three-
pronged trivet and chopstick-pokers.

208. Long hibachi
Late nineteenth century. By Tsukioka
Yoshitoshi (detail).

Metal braziers (plates 86, 209) are usually made of copper, brass, or iron in a deep-bowled shape with free-swinging loop handles and three short legs, although some sit on wooden bases. Among these, the so-called lion's bite hibachi (*shikami-hibachi*) were favored for their decorative feet shaped like lions.

Ceramic braziers first appeared toward the latter part of the Edo period (1600–1868), and gained widespread popularity from the Meiji era (1868–1912). Of these, most were of blue-and-white patterned porcelain (plate 210). Again, styles varied considerably, perhaps the most unusual design being the shop hibachi (*mise-hibachi*), a cylinder tall enough to deliver heat to chair- or standing-height.

Cheaper low-fire earthenware hibachi were also to be had, but as these tended to be quite fragile, they came to be set under protective wooden frames and quilted covers used for portable heater-tables (*oki-gotatsu*).

Rattan hibachi (plate 211) likewise came into fashion from the end of the Edo period, and were woven of imported Southeast Asian rattan into basket-shaped articles into which were drop-fitted metal *otoshi*.

Scaled-down hibachi known as *te-aburi* (plates 82, 83), ceramic or metal hand-warmers for use by one or two persons at most, were also to be had.

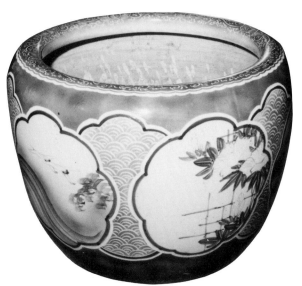

210. Ceramic hibachi
Early twentieth century; H. 16, Diam. 21 in.
(40, 54 cm.).

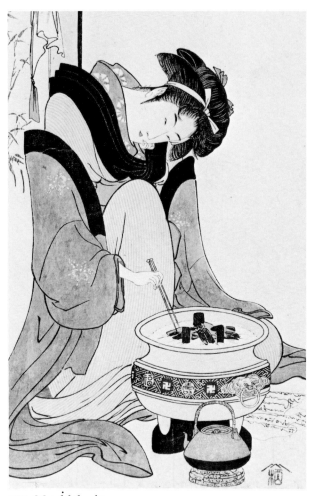

209. Metal hibachi
The courtesan Okita of the Naniwaya Tea House toys with the coals with chopstick-pokers while lost in thought. By Kitagawa Utamaro (detail).

211. Rattan hibachi
Late nineteenth century; H. 16, Diam. 16 in.
(40, 40 cm.).

HEATER-TABLES *Kotatsu*
PORTABLE HEATERS *Anka*

Quilt-covered heater-table units called *kotatsu* (plates 212, 213) entered the scheme of Japanese household furnishings in the Edo period and are still in use today. Essentially low table-sized frames of wood grating set over a heating element (modern units have electric elements attached to the underside of the frame) and topped first with one or more quilts—which confine the heat to the area enclosed by the table—and then by a single tabletop leaf, heater-tables functioned as tables in the colder months around which all would gather, legs under the quilts.

Designs are of two general types: portable heater-tables (*oki-gotatsu*), which were set down anywhere on the floor and heated with small hibachi, and sunken heater-tables (*hori-gotatsu*; plate 212), requiring large rectangular foot-warming pits specially cut through floor or tatami, with charcoal-fire receptacles (*otoshi*) drop-fit in holes in the pit floor. Sunken heater-tables are larger than the portable versions and appear to have developed first as a variation upon the open hearth (*irori*). The use of quilts made for much greater fuel efficiency, and only a minimum of charcoal was needed to heat the leg space beneath the table frame.

Likewise, the portable heater (*anka*; plates 214–16), should properly be considered an offshoot of the heater-table since it was used under quilt covers. Its most advantageous feature was its portability—it was much smaller than the *oki-gotatsu*, easy to carry, and intended for individual use. Made of the same low-fire ceramic as earthenware hibachi, these portable 1-foot (30-centimeter) high articles exist in numerous designs: some are little more than lid devices—again perforated—to be placed over hibachi; others are in the form of domed boxes with perforations or vents on three sides and a fully or partially open fourth side into which a small hibachi could be slipped. Occasionally, stone or paulownia *anka* are also to be found.

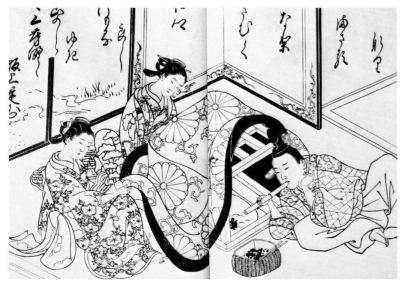

212. Heater-table with sunken pit
A gentleman blows the coals to flame in the fire pit of the heater-table, and readies to add more charcoal from the basket in the foreground. Illustration from a 1743 book.

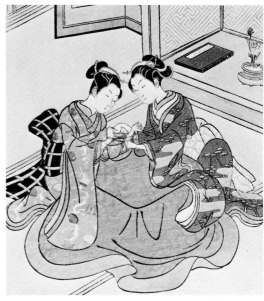

213. Heater-table
Middle eighteenth century. By Suzuki Harunobu (detail).

214. Portable heater
Early twentieth century; H. 10, W. 12, D. 12 in.
(25, 30, 30 cm.); unglazed.

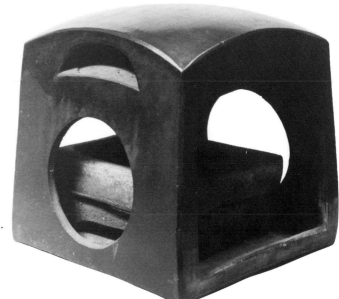

215. Portable heater
Early twentieth century; H. 12, W. 10, D. 10 in.
(30, 25, 25 cm.).

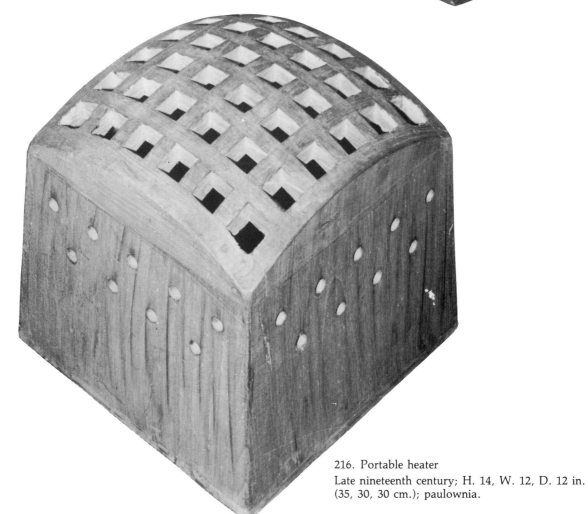

216. Portable heater
Late nineteenth century; H. 14, W. 12, D. 12 in.
(35, 30, 30 cm.); paulownia.

WRITING AND STUDY FURNISHINGS

*Furnishings related to writing and scholarship may be classified into storage articles and writing surfaces. Among the former were book boxes (*honbako*), document boxes (*bunkō*), and letter boxes (*fubako*); the latter included various desks or writing tables known as tsukue, as well as formal writing tables (*bundai*) and reading stands (*kendai*). Accessories for hobbies and studies in various traditional disciplines included such items as decorative stands (*kadai* and *shoku*).*

BOOK BOXES *Honbako*

The generic name for all box-type units for storing bound or scrolled written materials, book boxes (*honbako*) include simple lidded storage boxes (*fumi-bitsu*; plate 217), cabinet-like *honbako* proper, and drawered book chests (*shomotsu-dansu*), the oldest variety of the three being the *fumi-bitsu*.

In ancient times the Chinese-style coffer with legs (*kara-bitsu*) and the Japanese-style coffer without legs (*wa-bitsu*) were the most convenient means of storing quantities of sutras, scrolls, and bound materials that could not be shelved like books (see Coffers, page 84). From the Edo period (1600–1868) on into the Meiji era (1868–1912), cabinet-like *honbako* gained prevalence (plates 218, 225). *Honbako* proper are typically upright box units with drop-fit covers (*kendon-buta*) concealing two or three interior shelves, and occasionally with drawers across the bottom. Some *honbako* even have two or more separate lidded chambers side by side. The increased use of upright *honbako* paralleled the rise of shelvable bound-format materials from medieval times (1185–1573) on and the popularization of the writings themselves, answering a demand for simple and practical storage units. Accordingly, most are extremely plain and made of unfinished cypress, cryptomeria, paulownia, or fir.

Drawered book chests (plate 219) enjoyed a brief popularity among upper-class feudal lord households during the Momoyama (1573–1600) and early Edo periods as a requisite part of bridal trousseaux. These small, drawered cases that could hold an entire set of books are enclosed by a case or doors and provided with a handle on top for carrying. Furthermore, because these were also intended to contribute to

218. *Honbako* proper
Late nineteenth century; H. 35, W. 13, D. 18 in. (90, 33, 45 cm.).

217. Lidded storage boxes (detail)

the interior decor, most pieces were lavishly crafted and finished with elegant *maki-e* designs.

DOCUMENT BOXES *Bunkō*
LETTER BOXES *Fubako*

Originally, document boxes (*bunkō*; plates 93, 220) were intended for holding loose papers and pieces of writing, but eventually they were drafted into all manner of uses. These slightly rectangular lidded boxes of wood, paper, leather, or other materials varied widely in manufacture and aesthetic detailing with the tastes of those who treasured them.

Letter boxes (*fubako*, also called missive boxes [*jōbako*]; plate 92) had a more specified function: the formal presentation of written communications. Through medieval times, they had been used exclusively by the aristocracy, but from the Edo period came to be used even by wealthier members of the common classes. These narrow, rectangular boxes have deep-nesting covers tied in place with braided cords looped through two rings attached midway down opposite sides. The most formal *fubako* are lacquered with *maki-e*, although boxes of bamboo and *Yaku-sugi* cryptomeria are also to be found. Sizes range from around 18 by 4⅓ by 3½ inches (45 by 11 by 9 centimeters) on the large end of the scale to about half that size for small pieces.

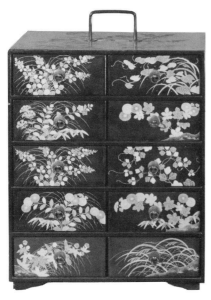

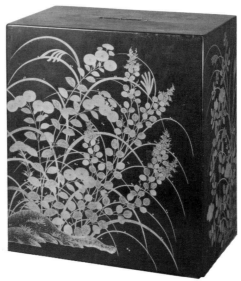

219. Drawered book chest
Sixteenth century; H. 15, W. 13, D. 9 in. (37, 33, 24 cm.);
Kōdaiji maki-e, black lacquer.

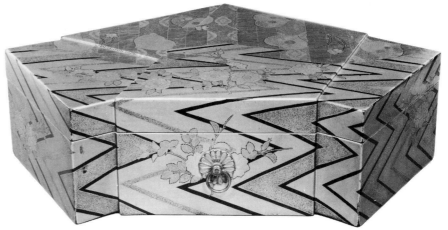

220. Document box
Sixteenth century; H. 5, W. 18, D. 10 in. (12, 46, 26 cm.);
silver fittings, black lacquer, sprinkled metallic background, *maki-e*.

WRITING BOXES *Suzuribako*

Boxes for holding such traditional writing implements as inkstones (*suzuri*), water-droppers (*suiteki*), brushes (*fude*), inksticks (*sumi*), and perhaps even penknives, were known as *suzuribako* (literally "inkstone boxes") and are found in several varieties including the flat writing box (*hira-suzuribako*) and stacked writing box (*kasane-suzuribako*). A related item, the portable writing box (*kake-suzuribako*), incorporates a *suzuribako* within a chestlike structure that could also hold writing paper, making it eminently practical. Later, the *kake-suzuribako* was fitted with a safe and became an important business fixture (see page 76).

The type most commonly referred to as simply *suzuribako* is the flat writing box (plate 221), which was for use on top of writing desks (*fuzukue*). Stacked writing boxes (plate 223), as the name suggests, are made up of five to seven levels of individual writing boxes to be passed out to participants in poetry gatherings and the like.

Many other *suzuribako* were custom-made; there are even some extravagant *tansu* chest–like pieces done in all-over *tsuishu* carved vermilion lacquer.

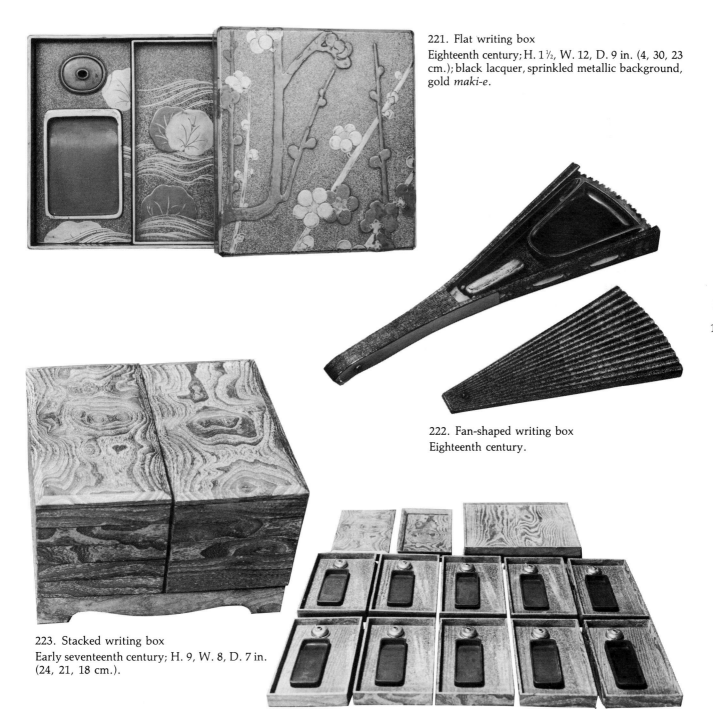

221. Flat writing box
Eighteenth century; H. 1½, W. 12, D. 9 in. (4, 30, 23 cm.); black lacquer, sprinkled metallic background, gold *maki-e*.

222. Fan-shaped writing box
Eighteenth century.

223. Stacked writing box
Early seventeenth century; H. 9, W. 8, D. 7 in. (24, 21, 18 cm.).

WRITING TABLES, DESKS *Tsukue*

Desks and working surfaces of all kinds—sutra-reading desks (*kyō-zukue*), writing tables (*fuzukue*), and accounting desks (*chōba-zukue*)—fall into this category.

Sutra-reading desks (plate 224) were used not only in Buddhist temples, but also in the home, set out bedecked with flowers, candlestands, and censers before the household Buddhist altar (*butsudan*) during ritual observances. True to Buddhism's continental origins, the most common designs have something of a Chinese flavor to them, with winged tops (*fude-gaeshi*) on splayed legs (*soriashi*) or "cat's paws" (*nekoashi*), and aprons (*maku-ita*) with openwork or other embellishments.

Writing tables (plates 90, 91, 225) were likewise originally found in temples in ancient times when temples were the principal centers of learning. At that time, *fuzukue* were almost identical in design with the above sutra desks, except that they lacked aprons. Almost all pieces from the Edo period on, moreover, had a rectangular wood frame or a pair of wood strips attached to the legs that acted as footpads (*tatami-zuri*) to prevent wear and tear on the tatami mats. From the cheapest to the most luxurious of materials and finishes, the variety in desks of this kind was virtually endless. With the advent of the Meiji era, drawers were also added.

Accounting desks (plates 226, 227) were to be found in most business establishments. Some doubled as ordinary *fuzukue* desks, while others were specially made with a battery of drawers.

FORMAL WRITING TABLES *Bundai*

At special gatherings for composing *renga* linked-verse, haiku, and other forms of poetry, special writing tables called *bundai* (plates 228, 229) were brought out to hold writing boxes (*suzuribako*), and *kaishi* or *tanzaku* poem papers. Tables were of various styles and materials, the standard size approximately 3½ by 24 by 12 inches (9 by 60 by 30 centimeters), with upturned tops and legs undercut in decorative designs. Since tables were more emblematic of aesthetic taste than practical in function, they are generally quite lavishly crafted.

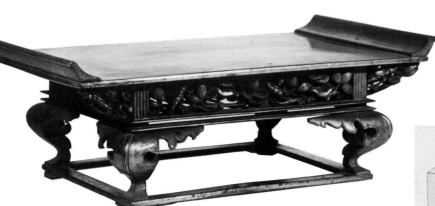

224. Sutra-reading desk
Early seventeenth century; H. 8, W. 28, D. 14 in. (22, 70, 36 cm.); *fuki-urushi* lacquer.

225. Study furnishings
At a temple school, a youth sits at a writing table, grinding ink in an inkstone, while in the foreground a boy practices with an abacus. In the background, a book box stands with its drop-fit front cover in place.

226. Simple shop arrangement
A shopkeeper seated at an accounting desk with an open ledger. From a 1781 illustration.

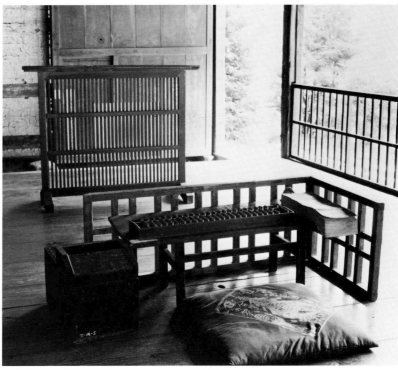

227. Business furnishings set-up in the shop office
Typical early eighteenth-century layout. In the foreground a low slat screen (*chōba-goshi* or *kekkai*) partitions off an accounting desk, on top of which are an account ledger and abacus. A money box has been placed to the side within easy reach. In the background stands a single-panel screen.

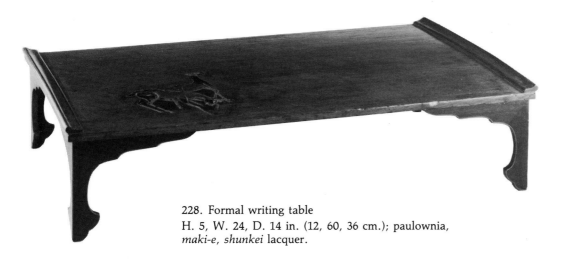

228. Formal writing table
H. 5, W. 24, D. 14 in. (12, 60, 36 cm.); paulownia, *maki-e*, *shunkei* lacquer.

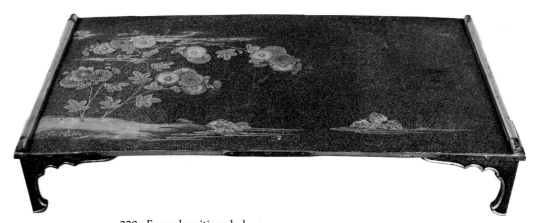

229. Formal writing desk
Sixteenth century; H. 3¾, W. 22, D. 12 in. (9.5, 55, 31 cm.); *maki-e*, copper fittings, finely cut gold and silver leaf.

READING STANDS *Kendai*

Essentially low lecterns for reading and recitation at floor-seated height, reading stands consist of an angled tray supported by one or more shafts affixed to a base (plate 94). Writings or musical scores could be placed on the tray for easy reading. When imported from China in the fifteenth century, *kendai* carried a name that when literally translated meant "idle person's shelf."

DECORATIVE STANDS *Kadai, Shoku*

These were decorative stands used in tea ceremony and flower arranging for placing special displays in the honored *toko* alcove, *kadai* (plate 230) standing relatively shorter than *shoku* (plate 231). Their aesthetic function dictated fine crafting, many pieces boasting imported *karaki* woods, *tsuishu* vermilion carved lacquer, or mother-of-pearl inlay.

230. *Kadai* stand
Late nineteenth century; H. 9, W. 20, D. 14 in. (23, 50, 35 cm.); rosewood, *fuki-urushi* lacquer.

231. *Shoku* stand
Eighteenth century, Okinawa; H. 14 in. (35 cm.); incised gold decoration.

TOILETTE AND BATHING ACCESSORIES

Furnishings for the toilette, hair dressing, and personal hygiene were to be found in the homes of the aristocracy and common classes alike, and formed an indispensable part of the bridal trousseau. Up through medieval times (1185–1573), the standard toiletry set was fairly basic: a metal mirror set on a mirror holder (kagami-tate), and a handy box (tebako; see plate 96) filled with combs, cosmetic aids, and toiletries. From early in the premodern era (1573–1868), however, there were separate furnishings for the toilette—coiffure stands (kushidai) for hair accessories, and dressing stands (kyōdai) for makeup and other supplies. An assortment of basins (tarai) and their complementary pitchers (hanzō) fulfilled related needs.

MIRRORS *Kagami*

Up until the middle of the Edo period (1600–1868), mirrors (plates 232, 234) in Japan were made of bronze, in either of two styles: flat rounds with attached handle shafts, or smaller rounds with eyes called *chū* on the back for threading loops of braided cord through. Both are usually embellished with delicate cast bird-and-flower or other designs on the back. The largest handled mirrors (*e-kagami*) measure upward of 1 foot (30 centimeters) in diameter; others are small enough to slip into the bosom of a kimono. Often they were paired sets, large and small. Special fitted-lid boxes were made to the exact outline of *e-kagami*, the finest of these bearing designs in *maki-e*, while more ordinary items were done in plain black lacquer. Cases for the smaller round mirrors (*maru-kagami*) are circular with domed smooth-seal (*inrō-buta*) or lip-to-lip (*aikuchi*) lids. Toward the latter part of the Edo period, glass mirrors of the same round-with-handle shape appeared, and only later in the Meiji era (1868–1912) did the traditional circular shape give way to squared pieces. This eventually led to larger and larger mirrors, culminating in full-length framed mirrors set on a wooden footed stand (*sugatami*; plate 99), a style that recalls single-panel screens (see page 93).

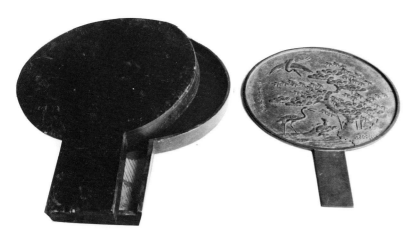

232. Handled mirror
Nineteenth century; Diam. of mirror 9 in. (24 cm.).

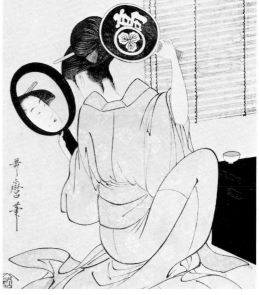

233. Handled mirror
Late eighteenth century. By Kitagawa Utamaro (detail).

MIRROR HOLDERS *Kagami-tate*
COIFFURE STANDS *Kushidai*

Mirror holders (*kagami-tate*; plates 95, 234) were for positioning large *e-kagami* at viewing height. Of various sizes, the most common folding-type stood approximately 24 inches (60 centimeters) high. Where, as with mirrors, high-class pieces often featured *maki-e* designs on lacquer, the more ordinary finish was plain black lacquer, the whole often enlivened with a braided scarlet cord.

Coiffure stands (*kushidai*, literally "comb stands"; plate 100) served to hold the various combs, perfumed oils, ribbons, and hair ornaments for styling hair. All such articles were kept in the drawers of the base unit, and set out on the raised-lip or winged top during use. Since they formed a set with the mirror holder, coiffure stands, too, came in varying degrees of decoration, from high-class *maki-e* on lacquer to plain black lacquer and wood-grain finishes.

Wall-hung glass mirrors came into use in the Meiji era, eliminating the need for holders, but coiffure stands enjoyed continued popularity through the 1930s.

DRESSING STANDS *Kyōdai*

There exist two distinct types of dressing stands: those used by the aristocracy (plate 234) and those belonging to the common classes (plates 95, 235). The former has a nearly square base, with two or three drawers, surmounted by a mirror frame in a shape reminiscent of Shinto shrine *torii* gates—a twin-posted framework with a triangular crossbar flared in upswept Chinese-style gable (*karahafu*) endings. Including a round mirror set in place on a frame and drawers filled with cosmetic articles,

234. Dressing stand with matching set of cosmetic accessories
Eighteenth century; H. 25, W. 11, D. 11 in. (64, 27, 27 cm.). This dressing stand and matching "twelve boxes" represent the Edo-period standard for the toilette. All pieces are lacquered in black with vine patterns in *maki-e*. The individual pieces include, in the back right, a dressing stand; a gargling bowl; an eared basin surmounted by a basin gridiron, on which, in turn, sit a tooth-dye cup (*kane-hai*) and a container for boiling tooth-dye (*kane wakashi*). Below the basin are a box for tooth-dying supplies, a gallnut-powder box, and a long box for the basin gridiron; from the front right, a handled mirror in its case, a smaller round mirror, a squat cylindrical mirror case, and an oval box for hair-setting liquid (*binmizu*); below the dressing stand in the mid-ground, a domed rouge container (*beni-choko*). Other accessories are unknown.

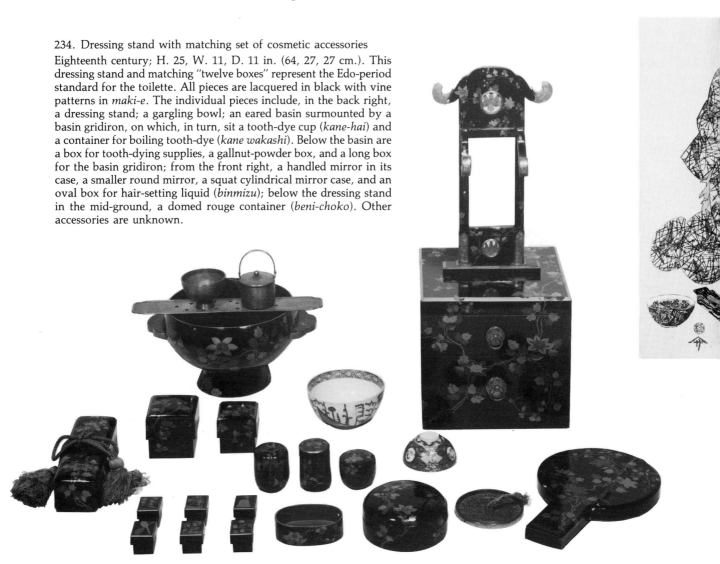

these upper-class furnishings were almost always richly decorated with *maki-e* and ornamental metal fittings. Furthermore, they came with a sizable accompaniment of boxes and cases: the so-called twelve containers (*jūni-tebako*), which included four white-face-powder boxes (*oshiroi-bako*), four comb cases (*kushibako*), two round-mirror cases (*maru-kagami-bako*), and two hair-oil vessels (*abura-ire*); a comb-cleaner case (*kushiharai-bako*); an eyebrow-makeup case (*mayu-tsuzukuri-bako*) holding a small mirror, eyebrow color, and brushes; a tooth-dying case (*haguro-bako*) containing a gallnut-powder box (*fushi-bako*), a tooth-dying device (*haguro-tsugi*), a gargling bowl (*ugai-chawan*), and other sundry items related to the tooth-dying process (*kane-tsuke*); a basin-gridiron case (*watashigane-bako*); a nail-clipping-knife case (*tsumekiri-bako*); a hair-tie box (*musubi-bako*); a cosmetic supply box (*sumiaka*); a comb stand (*kushidai*); and a traveler's comb case (*tabi-kushige*). They were also stocked with a vast array of other minor implements and accessories. Due to an exaggerated formalization in the social codes surrounding these many "requisites," there was considerable duplication of items.

Dressing stands used by the common classes were generally made of zelkova, chestnut, or mulberry, and consisted of a large drawered base with a removable tray-top, which turned over to reveal socket holes for setting up a folding mirror holder (*kagami-tate*) from one of the drawers. They generally came with a paired set of large and small handled mirrors (*e-kagami*; see plate 95). One disadvantage of the design, however, was that when set up the mirror faced to one side, rather than forward. With the influx of glass mirrors in the Meiji era, the very design of vanities in general came under Western influence (plates 98, 101).

235. At the dressing stand
Late nineteenth century. By Gototei Kunisada (detail).

236. Complete set of cosmetic accessories
Late seventeenth century. For use in the households of feudal lords and aristocrats, the ornately lacquered handy box held various implements for applying face powder, lip rouge, and tooth-dye.

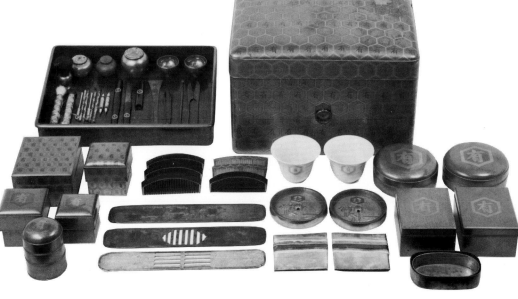

BASINS *Tarai*

Basins include those for women's toilette and personal hygiene, those for tooth-dying (*kane-tsuke*), and those for bathing and sundry tasks.

Among the first group are horned basins (*tsuno-darai*), eared basins (*mimi-darai*), bucket-shaped basins (*oke-darai*), and metal basins (*kana-darai*). Of these, the horned basins (plate 237) that made their appearance in the Heian period (794–1185) are particularly interesting. Two hornlike handles protrude from each side of a round, wooden footed bowl, not only making for easy carrying, but actually serving to keep kimono sleeves from falling into the water. Especially fine examples are finished in black lacquer and *maki-e*. These were often paired with *hanzō* water pitchers (see below) finished in the same manner.

Horned basins had a long history of use, but were gradually replaced in the Edo period by the smaller eared basin (plates 234, 238), finer pieces bearing *maki-e* decorations.

Used in conjunction with *tarai* of the first two categories were slightly oblong, spheroid spouted pitchers (*hanzō*; plate 239) for pouring hot and cold water into *tarai*, whose lacquer finishes they often matched.

The bucket-shaped basin (plate 240) is a miniature version of a clothes-washing tub, complete with staves held together with braided bamboo rings (*taga*), and as a rule, standing on legs. Besides plain wood pieces, there are also lacquered, even *maki-e*, wares.

237. Horned basin
Late sixteenth century; H. 7, Diam. 15 in. (19, 37 cm.); black lacquer, gold *maki-e*.

238. Eared basin
Early seventeenth century; H. 6, Diam. 8 in. (17, 21 cm.); black lacquer, gold *maki-e*.

239. Spouted pitcher
Late sixteenth century; H. 8½, Diam. 8 in. (22, 20 cm.); black lacquer, gold *maki-e*.

The last in this category, metal basins (*kana-darai*) are simply round copper tubs with handles on either side. Whereas in the Edo period people had used bucket basins to wash their faces, press-formed metal (and also enamelware) basins approximately 1 foot (30 centimeters) in diameter and 8 inches (20 centimeters) deep came into use from the Meiji era.

Another category of basins developed around the traditional aesthetic dictating that unmarried women blacken their teeth, a custom that prevailed through the Meiji era. Women would apply an iron oxide preparation (*kane*) directly to their teeth, rinse their mouths, then spit the excess into dye spittoons (*kanehaki-darai*). These are smallish, bowl-shaped basins finished in black lacquer. Eared basins also met this need.

The third category comprises various other basins made for douse-showering or a quick bath (essential for cooling off during sticky Japanese summers), for washing hair, for bathing newborn babies, and so on (plates 241, 242). Most noteworthy among these is the legged basin for washing hair.

Basins were also made for washing clothes (plate 243), the most common type being of wood and measuring 31 to 35 inches (80 to 90 centimeters) across, but only 8 to 12 inches (20 to 30 centimeters) deep. A ribbed wooden washboard similar to those in the West would be leaned up against the rim of the washbasin for scrubbing.

240. Bucket-shaped basin

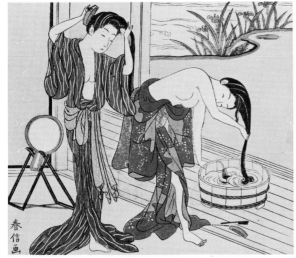

241. Washing hair in a basin under the eaves
Middle eighteenth century. By Suzuki Harunobu (detail).

242. Bathing in a large basin
Late eighteenth century. Originally, the practice of pouring water over oneself carried religious implications, but by the Edo period it had become simply a way of cooling off during the hot summer months. By Katsukawa Shunshō (detail).

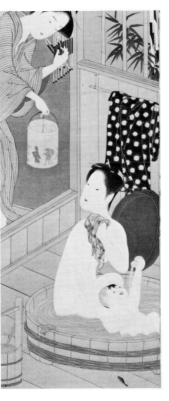

243. Washing the laundry
Early nineteenth century. By Kitagawa Utamaro.

BATHS *Furo*

The generic Japanese term for the bath is *furo* (plates 244–46), but more exactly there are at least two main types of tubs: the squared bath (*yokusō*) and the round or elliptical one (*furo-oke*), both preferably made of cypress. A hole some 1 foot (30 centimeters) square was cut in the bottom of these tubs and fitted with a metal firebox, from which led an exhaust pipe.

Other schemes included the so-called boiler-pot bath (*kama-buro*; plate 245) that had a broad iron slab set over the opening of a domed cookstove (*kamado*; see page 142), and topped it with an open-bottomed wooden barrel. The barrel was sealed to the slab with plaster, and a wooden bottom was "floated" inside to prevent direct contact with the hot iron. This type of bath was also jokingly called the *Goemon-buro*, after Ishikawa Goemon, an Edo-period thief who was sentenced to be boiled to death.

Another type was a cross between a steam bath and a hot water bath (plate 246). The water was filled to only half the depth of the tub, and the bather sat on a submerged platform, half in and half out of the water, under a cover that trapped the steam. This arrangement was commonly used in farm households to conserve water and fuel.

To provide drainage in bathing areas, sections of slat flooring (*sunoko*; see plate 244)—made of 4-inch (10-centimeter) widths of cypress or other wood or of split or slender lengths of bamboo nailed down onto joists at spaced intervals—were placed around the tub.

BATH STOOLS *Koshikake*

Low stools used in bathing areas (plate 247) consist of a small 1-foot (30-centimeter) long slab of cypress or other wood on two short feet held together by a tenon-jointed crosspiece. The Japanese customarily soap and rinse before getting into the tub so as to keep the hot water clean for the next bather, and most often assume a squatting posture while they do this; the *koshikake* affords the bather greater comfort by keeping the posterior out of any water pooled on the floor of the bathing area.

245. Household bath
Early nineteenth century. Heated from a masonry fire-chamber below. Illustration from a popular novel from the same era (detail).

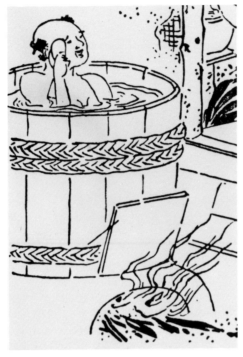

246. Barrel steam bath
A popular one-person steam bath at one time in common use in Shiga and Niigata prefectures, the barrel would be partially filled with hot water, and a stand or slat-floor platform set inside. The bather would climb in, and the lid and door were then shut. From a sketch by an English visitor to Japan at the end of the Edo period.

244. Bathing setup
A typical public bath of the late-nineteenth to early-twentieth centuries: 1. Bathtub, 2. Slat flooring, 3. Stirring rod (*yukaki-bō*) for mixing bathwater, 4. Handled washbucket (*te-oke*) for drawing water, 5. Ladle (*hishaku*) with bentwood cup for drinking. The partition on the right-hand side separates the men's and women's baths, although the actual tubs for soaking and for rinsing (the smaller tub on the right) are connected under the wall. Bathers would wash outside the tub, squatting on the slat flooring, and pour buckets of water from the smaller tub over themselves to rinse away soap; only after this would they climb into the main tub to soak. In this way, the water in the main tub remained clean longer.

247. Bath stool
Twentieth century; H. 8, W. 12, D. 8 in. (20, 30, 20 cm.); cypress, no finish.

MEALTIME FURNISHINGS

Mealtime furnishings may be roughly divided into tray-tables and other food service surfaces on the one hand, and actual food containers on the other.

Dining surfaces included tray-tables (zen), boxed tray-tables (hakozen), dining tables (chabudai and zataku), and box-legged trays (kakeban). Up until modern times, meals were most often eaten from individual zen or boxed tray-tables. It was only after the midway point of the Meiji period (1868–1912) in the cities, and well into the Taishō (1912–26) or Shōwa (1926 to present) eras in the countryside, that families took to eating from one common dining table.

Among other relatively less important dining surfaces were simple trays (bon), elevated trays (takatsuki and tsuigasane), and place-setting trays (oshiki).

Food containers included the portable food chests (hokai), ornamental sweets boxes (jikirō), stacked food boxes (jūbako), and picnic cases (sagejū) for serving rice, rice cakes (mochi), and other solid foods; for liquids there were saké servers and pitchers (yutō).

TRAY-TABLES *Zen*

Tray-tables, most often distinguished by the shape of the legs, come in many varieties. Among them are butterfly-leg tray-tables (*chōashi-zen*), Sōwa's tray-tables (*Sōwa-zen*), plain-wood tray-tables (*kigu-zen*), cat's paw tray-tables (*nekoashi-zen*), and walnut-leg tray-tables (*kurumi-ashi-zen*). In general, the first two were reserved for special occasions and the last three for daily use. Of these the butterfly-leg tray-table (plate 105), at 7 inches (18 centimeters) above floor level, stands the highest. Used by the bride and groom at weddings or brought out at the new year and other auspicious occasions, its legs resemble butterflies and the four corners of the top are "clipped off" (*sumikiri*).

The *Sōwa-zen* (plate 248), said to have been designed by the tea-ceremony master Kanamori Sōwa (1584–1656), was used by host and guest alike. Pieces have rounded corners, sit some 6 inches (15 centimeters) high, and are finished in all-over black or vermilion lacquer.

248. Sōwa tray-table
Late nineteenth century; H. 5, W. 13, D. 13 in. (13, 32, 32 cm.); black and vermilion lacquer.

249. Plain-wood tray-table
Late nineteenth century; H. 9, W. 14, D. 14 in. (23, 35, 35 cm.); *hinoki* cypress, *shunkei* lacquer.

The plain-wood tray-table (plate 249) was used mainly in tea ceremony, but also gained popularity among servants and in commoner households. Made of either *hinoki* or *sawara* cypress, and occasionally done in translucent, amber *shunkei* lacquer, a clipped-corner top sits nearly 7 inches (18 centimeters) high on two flat panels with squared cut-out windows.

The cat's paw tray-table (plates 104, 250) and walnut-leg tray-table (plate 251) were again used by family and servants alike, the former piece squatting a little over 4 inches (10 centimeters) high on short, scrolled legs and often finished in black lacquer. The latter actually has whole walnut shells for legs.

250. Cat's paw tray-table
Early twentieth century; H. 7, W. 24, D. 17 in. (17, 60, 42 cm.); zelkova, *fuki-urushi* lacquer, mother-of-pearl inlay.

251. Walnut-leg tray-table
Early nineteenth century; H. 1½, W. 11, D. 11 in. (3.8, 29, 29 cm.); *negoro* lacquer.

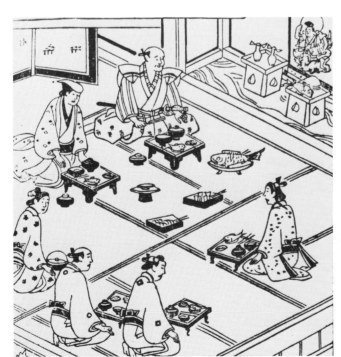

252. Tray-tables and social rank
As can be seen in this illustration of a celebration, the master and mistress of the household (most likely of the samurai class) eat off of butterfly-leg tray-tables, while the servants use lower cat's paw tray-tables. In the middle of the room, a stacked food box has been unstacked to serve various food items. Note also the *sanbō* elevated trays set before the household alcove in the background. From a 1688 popular novel by Ihara Saikaku.

BOXED TRAY-TABLES *Hakozen*

A convenient form of individual tray-table, the boxed tray-table served both for utensil storage and as a dining surface (plates 253, 254). Generally used by persons of lesser status—servants, women, and children—the most common form is that of a hollow or drawered square box with a removable shallow tray-lid. Most are made of cryptomeria, cypress, or chestnut, and finished in an austere red *bengara* stain or *shunkei* lacquer in recognition of their purely practical function.

DINING TABLES *Chabudai, Zataku*

Communal dining tables, known collectively as *handai*, which could seat two to five, have precedents in the Heian period (794–1185), namely the *daiban* banquet table, which served large numbers of the aristocracy at ceremonial dining occasions. This custom largely died out in the middle ages (1185–1573) and was supplanted by individualized dining from tray-tables. Only with the introduction of Western dining practices in the Meiji era did communal dining again take hold—albeit minus chairs. It returned in the form of *chabudai* (literally "tea-service stands"; plate 255), which like its predecessors remained low for floor-seating. *Chabudai*—which could have round, oval, or square tops—served as everyday dining surfaces, and were distinguished by collapsible legs for quick storage.

With the combined popularization of *chabudai* and influence of Western furniture, there developed from around the Taishō era the zataku *table*, a special type of dining surface for use when entertaining guests (plate 256). Generally some 3 feet (90

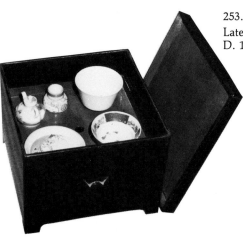

253. Boxed tray-table
Late nineteenth century, Akita Prefecture; H. 9, W. 12, D. 14 in. (24, 30, 35 cm.); cryptomeria, black lacquer.

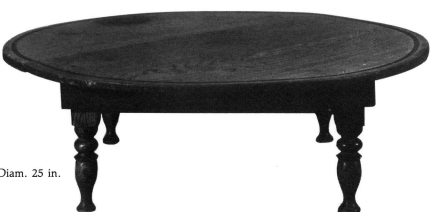

254. Boxed tray-table
Early twentieth century, Nagoya, Aichi Prefecture; H. 15, W. 20, D. 14 in. (38, 50, 35 cm.); *hinoki* cypress, *shunkei* lacquer.

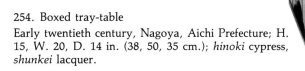

255. *Chabudai* dining table
Early twentieth century; H. 7, Diam. 25 in. (18, 63 cm.).

centimeters) long and 1 foot (30 centimeters) high, with four nonfolding legs, these tables might be rectangular, oval, or circular. Many were made of imported woods (*karaki*), and had aprons decorated in Chinese-style thunderbolt patterns.

BOX-LEGGED TRAYS *Kakeban*

More elegant than the simple elevated trays were the box-legged trays (plate 104) that did service in aristocratic and samurai households. Though in medieval times the trays received an uncomplicated lacquer finish, by the premodern era (1573–1868) *kakeban* had found a position of honor among mealtime furnishings, serving as individual place settings for formal occasions. Their finish was elevated with their status, and accordingly they were decorated in black lacquer and high-relief *maki-e*.

TRAYS *Bon*

Trays, known under the generic name *bon* (plates 257, 258), have been used in Japan since ancient times for carrying food and drink. The designs and materials are numerous, and include lathe-turned (*hiki-mono*), bentwood (*mage-mono*), gouge-hewn (*kuri-mono*), board-constructed (*ita-mono*), dry-lacquered (*kanshitsu*), and basket-woven (*ami-kumi-mono*) articles. Though the most representative *bon* are circular, shapes are diverse and even include the handled basket-tray (*tesage-bon*), in design closer to the Western concept of a basket than that of a tray. Many particularly beautiful regional designs in *bon* also developed from the Edo period (1600–1868) on, and trays were quite often painted with charming folkloric patterns.

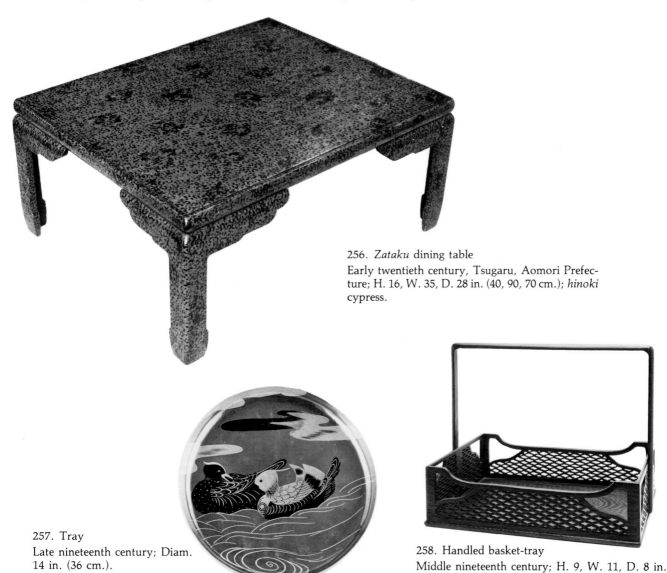

256. *Zataku* dining table
Early twentieth century, Tsugaru, Aomori Prefecture; H. 16, W. 35, D. 28 in. (40, 90, 70 cm.); *hinoki* cypress.

257. Tray
Late nineteenth century; Diam. 14 in. (36 cm.).

258. Handled basket-tray
Middle nineteenth century; H. 9, W. 11, D. 8 in. (22, 27, 20 cm.); *fuki-urushi* lacquer.

PLACE-SETTING TRAYS *Oshiki*

Flat, square trays of cypress or cryptomeria called place-setting trays were the main meal surface for the common classes up until premodern times. Moreover, finishes only came to be applied from the Edo period, most often in *shunkei*, black, or *negoro* lacquer. The simplest form is the plain, square, flat place-setting tray (*hira-oshiki*; plate 259); those with faceted corners (*sumi-oshiki*) fall into two types: clipped-corner place-setting trays (*sumikiri-oshiki*; plate 260) or lobed-corner place-setting trays (*irisumi-oshiki*; plate 261).

ELEVATED TRAYS *Takatsuki, Tsuigasane*

Up through medieval times the footed tray (*takatsuki*) and the broad-pedestaled tray (*tsuigasane*) had been used for waiting on nobility, but came the Edo period they began to be used at the new year, flower-viewing time, and other festive occasions for serving rice cakes and sweets, and for making ceremonial offerings of food to the deities. Once pried from their original duties, elevated trays evolved until they were used almost exclusively as offertory stands.

The footed tray (plate 103) takes the form of a round or square tray raised on a lathe-turned foot and base. The broad-pedestaled tray (plate 102) is essentially an *oshiki* tray on a hollow base cut through with holes; those made of unfinished cypress or cryptomeria with such openings on three sides were sometimes known simply as *sanbō*, literally "three-directions," although two- and four-holed *sanbō* were also to be found.

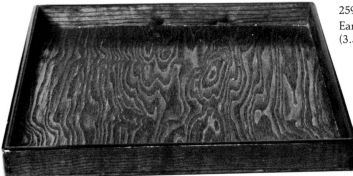

259. Flat place-setting tray
Early twentieth century; H. 1⅓, W. 14, D. 14 in. (3.5, 36, 36 cm.); mulberry, *fuki-urushi* lacquer.

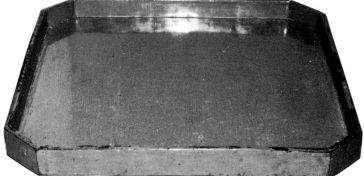

260. Clipped-corner place-setting tray
Early twentieth century; H. 1⅓, W. 14, D. 14 in. (3.5, 36, 36 cm.); *hinoki* cypress, vermilion lacquer.

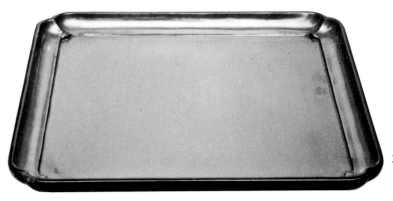

261. Lobed-corner place-setting tray

PORTABLE FOOD CHESTS *Hokai*

Originally portable food hampers, from the Edo period on *hokai* food chests (plate 262) came to be used for presenting cakes and steamed buns at wedding celebrations. Many different shapes were to be found; the classic *hokai* that numbered among the requisite furniture articles for daimyo lords was cylindrical in shape with splayed legs, banded from top to bottom, and had a lid tied down with braided and tasseled cord. Many are finished in black lacquer with *maki-e* decorations. The average size is around 2 feet (60 centimeters) in height and 1 foot (30 centimeters) in diameter.

ORNAMENTAL SWEETS BOXES *Jikirō*

These had initially been portable lunch boxes used when picnicking outdoors during flower-viewing season, but later came to serve as containers for sweets (plate 107). Highly appreciated for their aesthetic charm, many particularly decorative *jikirō* were specially fashioned for use in fancy drawing-room tea ceremonies.

STACKED FOOD BOXES *Jūbako*

Jūbako (plate 263), a series of three, five, seven, or more small lacquered boxes stacked one upon another, were used for taking foods and sweets on outings much the same as *jikirō*, but were, and still are, perhaps most associated with the ceremonial presentation of special dishes such as *sekihan* (an azuki bean and glutinous-rice dish) on auspicious occasions.

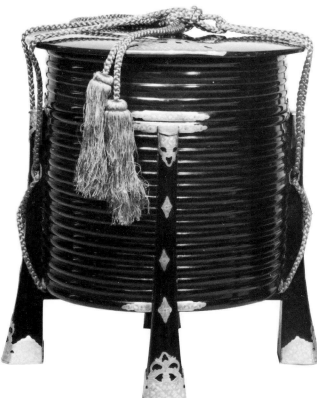

262. Portable food chest
Middle nineteenth century; H. 20, Diam. 14 in. (50, 35 cm.); *hinoki* cypress, black lacquer.

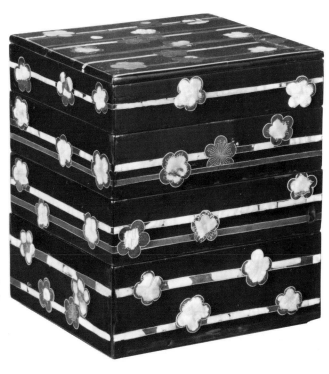

263. Stacked food boxes
Late eighteenth century; H. 10, W. 9, D. 8 in. (26, 23, 21 cm.); black on vermilion lacquer, silver *maki-e*, mother-of-pearl inlay.

PICNIC CASES *Sagejū*

A particularly ingenious assemblage of saké servers, *jūbako*, saké cups, and plates in one portable lunch case for flower-viewing or theater-going, picnic cases (plates 108, 264) contain an amazing number of dining utensils. The outer case usually has a large handle spanning the top and is often elaborately decorated due to its use in public places. Numerous variations are to be found.

SAKÉ SERVERS *Heishi, Sashi-daru, Tsuno-daru*

Special saké servers for wedding celebrations and other festive occasions, the saké jar (*heishi*; plate 265) was used until the mid–Edo period, and the rectangular saké keg (*sashi-daru*; plate 109) and horned keg (*tsuno-daru*; plate 110) thereafter. The *sashi-daru* are narrow and rectangular, while *tsuno-daru* are tall, cylindrical kegs with two extended hornlike staves and a crosspiece forming a carrying handle. A variant on this is the *usagi-daru*, or "rabbit keg," with two tall "ears" extending from a squat, round body.

264. Picnic case

Late nineteenth century. Picnic case broken down into component elements: 1. Serving dishes (*mori-zara*) for passing around food items selected from the stacked boxes, 2. Stacked boxes, 3. Individual place-settings (*sara*), 4. Saké containers, 5. Extra box for additional tidbits, passed around as is.

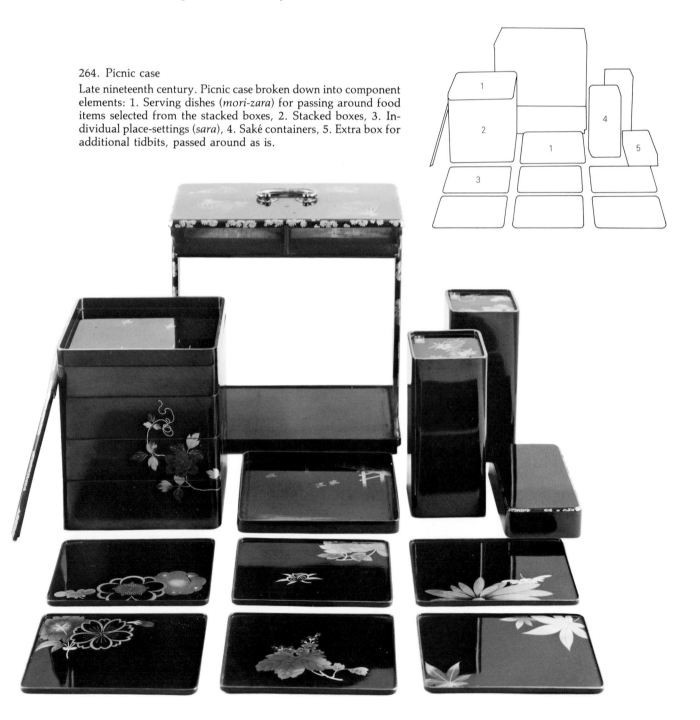

PITCHERS *Yutō*

Spouted vessels used at banquets for serving broth—and also occasionally for saké or hot or cold water—*yutō* (literally "hot-liquid pitchers"; plate 266) can be roughly divided into two types: one is basically cylindrical in design with a domed lid and a fixed vertical grip attached opposite the spout; the other more like a kettle with the body suspended by a larger, fixed or pivoting carrying handle.

TOBACCO STANDS *Tabako-bon*

The custom of pipe-smoking was imported into Japan from quite early on, and at first was accommodated by placing a miniature brazier (*hi-ire*) and a bamboo tube with water for extinguishing coals (*haifuki*) on an ordinary square tray. Soon, however, special tobacco stands (*tabako-bon*; plates 267, 268) were made with raised box sides and carved-out grips (*tekake*) or drop-handles (*sage-zuru*). Many designs showed a striking blend of functionalism and aesthetic refinement.

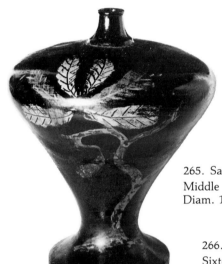

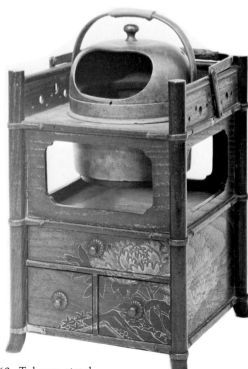

265. Saké jar
Middle seventeenth century; H. 14,
Diam. 11 in. (36, 27 cm.).

266. Pitcher
Sixteenth century; H. 10, Diam. 9⅔ in. (25,
24.5 cm.); mother-of-pearl inlay, black and ver-
milion lacquer.

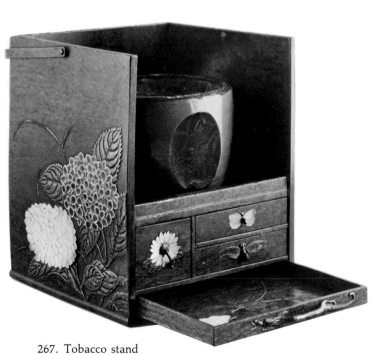

267. Tobacco stand
Late seventeenth century; H. 9, W. 7½, D. 7 in.
(22, 19, 18 cm.); *fuki-urushi* lacquer.

268. Tobacco stand
Late seventeenth century.

KITCHEN FURNISHINGS

In traditional Japanese homes, the kitchen furnishings were few and basic. Kitchen cabinets (daidokoro-todana) *held cooking and eating utensils, crockery, and trays. The mainstay of all kitchens was, of course, the cookstove* (kamado) *for boiling and simmering; this was complemented by the portable boxed hearth* (okiro) *for grilling. Various casks and buckets* (taru *and* oke) *and other vessels, most notably storage jars* (kame), *filled secondary kitchen needs.*

KITCHEN CABINETS *Daidokoro-todana*

Kitchen cabinets (plates 111, 112) for dishes and provisions were known by such names as "tray cabinet" (*zen-dana*) and "water-area cabinet" (*mizuya*). Ordinarily they took the form of two levels of enclosed shelf units with sliding doors. From the Meiji period (1868–1912), a row of small drawers for chopsticks and the like came to be inserted in a band across the middle, while the doors bore ventilation portals in cut-out patterns screened with wire mesh, slit bamboo, or reeds.

COOKSTOVES *Kamado*

Two main types of cookstoves went by the name *kamado*. Those used mostly in farm households were made of one or more built-up round or squared domes of baked earth on the earthen floor of the cooking area (plates 270, 271). The domed hollows served as fire chambers, each with one or more round openings on top into which collared pots might be set so that the heat of the chamber was directed at the pot bottoms. In some cities, this type of stove was also to be found in the homes of older, more traditional merchant families who regarded solid earthen cookstoves as symbols of prosperity; these *kamado* might have stone floor sills laid around the base, or be surfaced with plaster, and even handsomely finished in black lacquer.

Urban cookstoves were likely to be smaller than their rural counterparts, elongated, and with stone or wooden bases (plate 271). In Kyoto and Osaka, these were often located in an earthen-floored kitchen area right at the backdoor in plain view from outside, hence they were made large and impressive-looking.

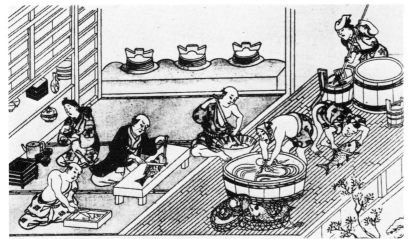

269. Kitchen of a large Edo-period household
The cookstove is set with three pots (*kama*). Slatted flooring serves as the "sink area" where foods could be washed. By Hishikawa Moronobu.

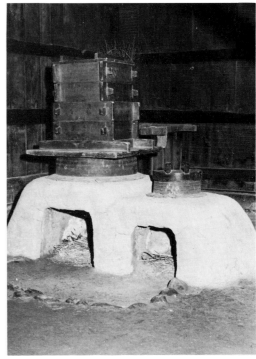

270. Cookstove
Approx. H. 28, W. 98 in. (70, 250 cm.).

PORTABLE BOXED HEARTHS *Okiro*

Portable boxed hearths (plate 272) developed as smaller versions of sunken hearths (*irori*; see page 115), but were used mainly for direct grilling of fish and small pieces of food rather than simmering or boiling, which was done in pots on the *kamado*. Small bisqueware grills called *shichirin*, usually round in shape, were the most common type, although some *okiro* used by the aristocracy were made of metal.

CASKS *Taru*
BUCKETS *Oke*

Staved and bamboo-banded casks or kegs (*taru*) and buckets (*oke*) essentially differ in whether or not they have fixed lids. As with casks in the West, *taru* were used for storing liquids (plates 112, 273), and more particularly for aging and storing saké and soy sauce, so they were tapped with pour-spouts either in the lid or near the bottom. Smaller keg-size versions were used for transporting saké on outings (plate 274). Ceremonial saké kegs used at weddings were often given beautiful lacquer finishes (see Saké Servers, page 141). Buckets were predictably wider in function, being used for everything from hauling and storing water to pickling vegetables; buckets were not only convenient for keeping grains, but special *oke* called *ohitsu* (plate 275) could actually be used to serve cooked rice and other foods.

STORAGE JARS *Kame*

Ceramic jars called *kame* were common storage items in most kitchens. Water jars (*mizu-game*; plate 276) typically measured 24 to 28 inches (60 to 70 centimeters) across at the mouth and 24 to 32 inches (60 to 80 centimeters) in depth.

Smaller jars (plate 277) were used for storing *miso* bean paste, seasonings, and pickled vegetables. From the eighteenth century, kiln towns began producing these glazed ceramic and porcelain jars in great quantities.

272. Portable boxed hearth
H. 14, Diam. 12 in. (35, 30 cm.).

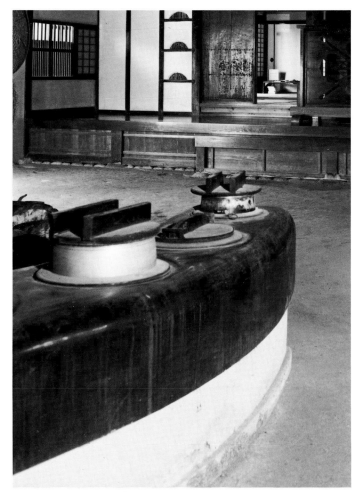

271. Cookstove
Middle nineteenth century; approx. H. 20, W. 47 in. (50, 120 cm.). Ordinarily, cookstoves had three openings on top into which were set pots for rice, vegetables, and tea; however, bigger stoves might have as many as seven openings.

273. Cask for storing liquid
Early twentieth century; H. 35, W. 28 in. (90, 70 cm.).

274. Keg for transporting saké
Early twentieth century; H. 6, Diam. 12 in. (15, 30 cm.);
cryptomeria, bamboo.

275. *Ohitsu*
Early twentieth century; H. 12, Diam.
11 in. (30, 27 cm.); *hinoki* cypress.

276. Water jar
Early twentieth century; H. 30, Diam. 26 in.
(75, 65 cm.).

277. Storage jar for *miso* bean paste
Early twentieth century; Diam. 6 in. (15 cm.).

MISCELLANEOUS

Needless to say, there are many types of traditional Japanese furnishings that do not fit neatly into any of the categories thus far. Here, then, are some of the more important miscellaneous items.

CLOTHES RACKS *Ikō*

Essentially a crossbar on which to hang kimono and other articles of clothing, *ikō* clothes racks are of two types: those that stand on the floor, in general simply called *ikō*; and suspended clothes racks (*tsuri-ikō*), simple two-pole devices, running horizontally, over which clothes were draped. Among free-standing designs are single-panel screen–like (see page 93) pieces with clothes bars across the top, reminiscent of Shinto shrine *torii* gates (plate 278), and two-panel folding screen–type pieces (*ikō-byōbu*; plate 49), the latter becoming the more prevalent from the middle of the Edo period (1600–1868).

In monied households the *torii*-style pieces were quite large (plate 279)—standing on the average 5½ feet (166 centimeters) high, with crossbars spanning some 7 feet (210 centimeters)—and finished in either black lacquer or lavish *maki-e*. Common pieces, however, were about half that size in height and breadth, and of a simple finish, such as *fuki-urushi*. Two-panel folding *ikō* were generally set in the corner of a room, so many were provided with crossboard seats. Suspended racks were hung by ropes or narrow notched boards attached to each end. These were made in endless variety, from the most elaborate *maki-e* and *karaki*-wood pieces down to the humblest of plain lengths of bamboo.

SEWING BOXES *Hari-bako*

Sewing boxes called *hari-bako*—literally "needle boxes" (plates 280, 281)—include wooden drawered pieces, small versions of cosmetic handy boxes (*tebako*; plate 96) or *kōri* hampers (see page 85), and even simple paper boxes. Quality pieces of black lacquer formed part of the bridal trousseau. Most *hari-bako* were simple affairs, made of zelkova, chestnut, cryptomeria, or mulberry and finished with clear lacquer.

278. Clothes rack
Early twentieth century; H. 38, W. 44, D. 9 in. (98, 111, 24 cm.); paulownia, *fuki-urushi* lacquer.

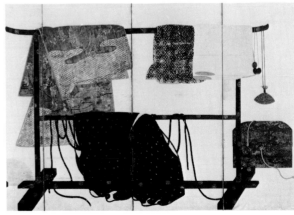

279. Clothes rack
Early seventeenth century. From "Tagasode Folding Screens" (detail).

FOOTSTOOLS *Fumidai*

Footstools, also known as "foot stands" (*kyatatsu*) and "risers" (*fumitsugi*), were made in a number of characteristic regional designs. The most representative of these are the "scaffold-style" (*yagura-gata*; plate 282), the "horse-saddling–style" (*uma-no-kura-kake-gata*), and the ordinary box-style with a hole cut in the front to let the stool double as a waste receptacle.

DISPLAY STANDS *Okidoko*

For rooms not architecturally provided with built-in *toko* alcoves, the *okidoko* portable display stand (plate 283) was the answer. These include the hanging shelf with sliding-panel compartment (*tsuri-fukuro-dana*), the floor-sitting shelf unit with sliding-panel compartment (*oki-fukuro-dana*), and units combining aspects of both.

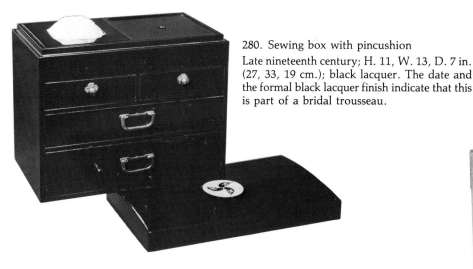

280. Sewing box with pincushion
Late nineteenth century; H. 11, W. 13, D. 7 in. (27, 33, 19 cm.); black lacquer. The date and the formal black lacquer finish indicate that this is part of a bridal trousseau.

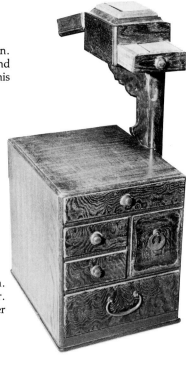

281. Sewing box
Early twentieth century; H. 18, W. 9, D. 11 in. (45, 23, 27 cm.); mulberry, *fuki-urushi* lacquer. The small compartment above the raised drawer held a pincushion.

282. "Scaffold-style" footstool
Early twentieth century; H. 26, W. 18, D. 16 in. (67, 45, 40 cm.); zelkova, *fuki-urushi* lacquer.

283. Display stand
Early twentieth century; H. 15, W. 37, D. 14 in. (38, 95, 35 cm.); Japanese oak.

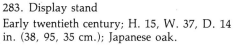

2

THE
HISTORY

CHRONOLOGY

PREHISTORIC

Jōmon ca. 10,000 B.C.–ca. B.C. 300

Yayoi ca. 300 B.C.–ca. A.D. 300

Kofun ca. 300–710

ANCIENT

Nara 710–94

Heian 794–1185

MIDDLE AGES (MEDIEVAL)

Kamakura 1185–1333

Northern and Southern Courts 1333–92

Muromachi 1392–1482

Warring States 1482–1573

PREMODERN

Momoyama 1573–1600

Edo 1600–1868

EARLY MODERN

Meiji 1868–1912

Taishō 1912–26

Shōwa 1926–89

A FLOOR-SEATED CULTURE

Over the centuries, Japanese culture has continued to charm and intrigue people from other cultures. What seemed perfectly natural to the Japanese has somehow always remained elusive to visitors from the West and even from other countries in the Orient. More than a millennium ago, emissaries from China could not help but remark on the "curious" Japanese lifestyle: their taste for raw foods and for sitting on the floor. In those first contacts, the Chinese no doubt saw this quite literally as "low life," and ascribed the "groveling" postures to a lack of culture. Soon enough, however, the Japanese had unmistakably acquired all the trappings of civilization—and yet they still preferred to sit on the floor.

If people know anything at all about Japan, they know that the Japanese sit on the floor; it remains one of the principal distinguishing features of Japanese culture. Naturally, this custom has to a very large extent shaped the world of Japanese household furnishings, and thus presents itself as a good place to start looking at their historical development.

The influx of chairs into Japan can be traced back as far as the late Kofun, or Tumulus, period (ca. 300–552) to the early part of the Nara period (710–94), when they were introduced from the continent and enjoyed considerable use among members of the ruling class who were intent on affecting a Chinese lifestyle. With the coming of the isolationist Heian period (794–1185), however, chairs fell into disuse. The Kamakura period (1185–1333) saw the second introduction of chairs along with Sung-dynasty Ch'an (Zen) Buddhism. Once more, they were mainly used by upper-class samurai who frequented the Zen temples and took to sitting in chairs in imitation of the head priests. This time, too, the fashion was not taken up by the common people and interest soon faded. The third time around, chairs were brought to Japan in the Momoyama period (1573–1600) by missionaries and traders from Spain and Portugal. Suddenly chairs were again the rage among upper-class samurai, wealthy merchants, and entertainers, then just as quickly the fad waned. Unlikely as it must seem, up until the Meiji era (1868–1912), when the practice was reintroduced from the West, sitting in chairs never figured significantly in Japanese life. For what possible reason was the chair so stubbornly resisted?

Approaching this question antithetically, anthropology reveals three main reasons behind the historic change in most parts of the world from sitting on the floor to using chairs. First of all, it served to guard against the dampness and chill of the ground. Second, as an indicator of social standing, it came to enhance the relative status of those who sat above the level of others. This elevation of the plane of vision was of extreme importance, both for physical comfort and as a sign of status. In images from ancient Egypt and Greece, figures from the ruling classes are shown sitting on chairs and lying on beds, while the slaves kneel on the ground. Similar expressions are to be found throughout the world, wherever society gave rise to class hierarchies. Then, there is a third type of reason depending more on historical, political, or geographic circumstances; these are many and varied, but may include, for example, subjugation or domination by foreign powers. In China, the change in sitting customs came during the Northern and Southern Sung dynasties period, when the chair-seated Hsien-pei nomads of the T'o-pa clan from the north conquered the Han Chinese to set up their own Northern Wei dynasty. In the case of Europe, slightly different circumstances prevailed: the many countries and peoples in close proximity on the continent mutually influenced and even took on each other's traditions. The culture of chair-seating was born in Egypt, passed through Mesopotamia to influence Greece, came to Rome when Greece entered the sphere of Roman domination, then became part of Byzantine civilization, and ultimately spread over all of Europe.

How, then, do these three conditions apply to Japan? In the first place, the problem of ground moisture was effectively solved by raising the floor level itself. Stilt-elevated architecture was introduced from the Asian continent around the third to second centuries B.C. along with iron tools and rice farming. Raised buildings offered a superior moisture barrier, so they soon came to be used for grain storehouses and for living quarters among the ruling clans. Thus, from the very first, architecture itself effectively served in place of chairs to distinguish social status.

The third condition is somewhat more complicated, and yields only to speculation. Possibly the major factor here was Japan's relative isolation as an island country in the Far East. Having escaped military invasion and foreign domination until modern times, Japan lay beyond most navigated trade routes, and even purposely cut itself off from communication with the outside world several times over the course of history. When chairs and other foreign articles did find their way to Japan, it was always as curious objects out of cultural context. With no real connection to the persons who made or used these things, chairs remained at best precious toys of the few—decorative items that never found their way into the daily life of the people.

All things considered, the Japanese have historically exhibited a strong conservatism toward their own traditions. Certain aspects of Japanese culture have continued with only minor changes all the way from the Kofun period to the present day. Indeed, the sheer continuity of Japan's floor-based culture makes the task of tracing the growth of Japanese traditions in furniture both rewarding and coherent.

PREHISTORY AND THE ANCIENT PERIOD
(ca. 300–794)

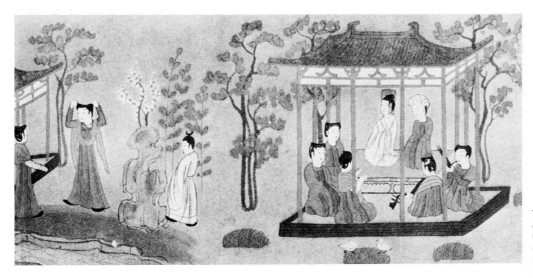

This depiction of Prince Siddhartha and his wife, on a Chinese-style "couch" that could also be used for reclining, evokes the Chinese influence on life in ancient Japan.

The history of Japanese furniture properly begins in the Kofun period (ca. 300–710), when members of the imperial Yamato clan began living in raised-floor dwellings. Prior to this, even the ruling classes had lived in pit dwellings where the only "furnishings" to speak of were straw mats (*mushiro*) used as floor coverings and door flaps, primitive pitch-pine lamps, oil lamps, baskets, and lacquerware with a basket core. There were few comforts other than mounded "beds" of earth and open hearths—prototype cookstoves (*kamado*) first appearing toward the end of the Kofun period. Nonetheless, most of the Japanese populace continued to live in pit dwellings well into the middle ages (1185–1573). The first real tradition of furniture thus starts with the move to raised-floor dwellings, and the birth of a separate upper-class culture.

Little remains at the earliest raised-floor dwelling sites other than post holes; the furnishings have long since disappeared. Clues as to what the interior of these dwellings were like, however, may be found in the strictly preserved ancient architectural style of the Daijōgū palace halls where imperial investiture ceremonies (*daijōsai*) were traditionally held reign after reign.

Built "log-cabin style" of timbers not stripped of their bark, with posts planted in holes in the ground and gables thatched in fresh-cut grass, Daijōgū were small—12 by 30 feet (3.6 by 9.0 meters)—with the entrance at one end, an ante-area for ladies-in-waiting, and the main area farthest back. The floors were covered with *mushiro* mats; the walls were made of matted grass and covered inside and out with more *mushiro* mats. The ante-area was partitioned off all around with grass-woven *sudare* blinds, and further separated from the main chamber by cloth doorway curtains (*tobari*). In the center of the main area a few layers of tatami mats were stacked up and spread with a *fusuma* coverlet to prepare a sleeping area. Above this sleeping area was suspended a "dust-catcher" canopy (*shōjin*) consisting of a wood-lath grid covered with a *mushiro*. To the side of the sleeping area were laid two half-sized tatami mats where the emperor and a divine presence (*kami*) were supposed to sit.

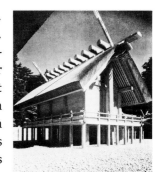

Raised-floor structure (main hall of Grand Shrine of Ise)

Pitch-pine lamp

Lacquerware with basket core

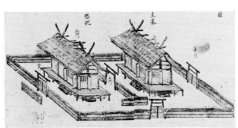

Prototype cookstove

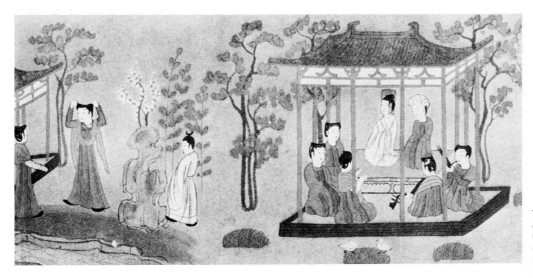

Daijōgū palace halls

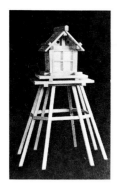

Model of a wooden roofed lantern

Tripodal oil lamp

Haniwa figurine on cushion

Haniwa figurine on sling stool

Lighting was provided by two devices: a wooden roofed lantern (*tōrō*) with its miniature roofed light chamber standing on eight legs—this being a Shinto convention—and a tripodal oil lamp (*tōdai*) consisting of an earthenware oil dish set between three poles lashed together at the "waist." Off to one side stood a table, again with eight legs, on which was placed a basket holding the emperor's clothes, shoes, and toiletries, as well as a small box for personal effects. There was no table for dining; instead a small grass mat called a *sugomo* was laid on the floor as a place setting. Excavations of Kofun-period tumuli have brought to light various funerary articles, among them sarcophagi and earthenware statuary called *haniwa*, many of which hint at the furniture of the time.

Haniwa in the shape of human figures, animals, and houses were buried along with rulers to accompany them into the afterlife. Certain of these figurines are shown sitting on seats; some isolated representations of seats also exist. Judging from these, the furniture items then in use included stools with braided or leather sling seats, with or without back- or armrests; four-legged upright chairs with back- and armrests; and large daises without rests. The stools, known as "legged saddles" (*agura*), resemble seats common among Eurasian nomadic peoples, and were probably used by shamans or by leaders on hunts and campaigns. The others were used inside ruling-class homes for sitting with both legs raised. Many *haniwa* houses show daises in their interior dioramas; to scale, the dais seats are raised 12 to 16 inches (30 to 40 centimeters) off the floor, with tops scored to represent woven mat coverings.

Eventually, raised-floor architecture achieved a more refined, stately expression. Palaces and shrines housing the exalted rulers and shamans were probably very similar to the two greatest Shinto structures in Japan, the Grand Shrines of Ise and Izumo, which rigorously preserve their ancient architectural conventions even today. Directly planted posts (*hottate*), including external ridge-posts, support thatched roofs, with crossing upswept gable-ends (*chigi*) and cylindrical ridge decorations (*katsuogi*). Floors are, of course, raised, and the walls are of unfinished wood. Hinged-door entrances, hung with curtains, lead to single-room interiors.

The sixth to eighth centuries ushered in dramatic change throughout the Far East. Chinese civilization truly blossomed as dynastic rule shifted from the Sui to the T'ang at the beginning of the seventh century. In the arts and in trade, not to mention statecraft, T'ang China led the way, and Japan was not the only country eager to follow its example. The Japanese imperial family sought to legitimize its authority in the mold of China's central government and to actively acquire the trappings of Chinese culture. Buddhism was imported into Japan at this time, and official emissaries were sent to China regularly in a systematic effort to learn all there was to learn.

Not surprisingly, when Japan established its first major capital, Heijō-kyō (present-day Nara) in 710, the T'ang capital of Ch'ang-an was the model. Laid out in an orderly street grid approximately three miles square (4.2 by 4.7 kilometers), a grand southern avenue led straight to the palace, dividing the capital into nearly symmetrical halves—the "left" and "right" cities, dotted here and there with Buddhist temples. The palace grounds were nearly three-quarters of mile square (1 by 1.2 kilometers), the twelve gates in its walls giving entry to gardens and palatial halls of a scale never before

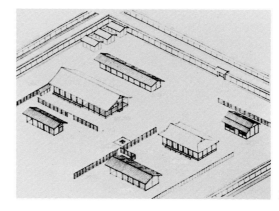

Palatial residence in Heijō-kyō

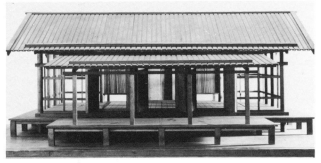
Model of Nara-period aristocratic residence

seen in Japan: the Daigokuden hall where the emperor presided over ceremonies of state, the Chōdōin hall where the court convened, the Burakuin hall where sumptuous banquets were held. All buildings had tile roofs and vermilion columns in the continental fashion. Inside the halls, a cloistered colonnade, again in Chinese architectural style, enclosed the emperor's living quarters and Shishinden audience hall, although, curiously enough, these were in the older style of the Grand Shrine at Ise, built of unfinished wood. This typified the dichotomy between public functions and private life among the aristocracy at the time.

Furnishings in Heijō palace were likewise diversified. The thrones (*gyokuza*) of the emperor and empress, with their black-lacquered square platforms with vermilion-lacquered railings and steps, occupied a central position in the Daigokuden. Over these hung octagonal canopies surmounted by metal phoenixes and draped with silk, while on the daises were placed either tatami mats and quilting, or sword stands and chairs. The emperor's chair was of ebony; the empress's chair had mother-of-pearl inlay.

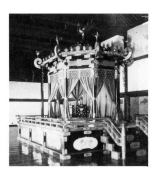
Reconstruction of Heian-era throne thought to be identical with the Nara-period style

Chairs were symbolic of authority, and reserved exclusively for the emperor, empress, crown prince, and certain ministers. Chairs were square with four legs, *torii*- (Shinto shrine gate-) shaped backs, and railings—all very much like the chairs encountered previously in Kofun-period *haniwa*. Seats were covered with tatami mats and *shitone* cushions; they were large enough to sit on with both legs raised. The throne chair for an infant emperor would have a brocade-covered footrest attached in front. Chairs used by the emperor in the inner palace were of rosewood.

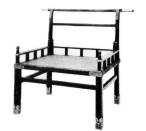
Chair with *torii* gate-shaped backrest

Daises called *shōji* were also used for seating on ceremonial occasions. These are of various sizes, shapes, and materials, the largest measuring 90 by 25 inches (250 by 65 centimeters); the smallest some 2 feet (60 centimeters) square. Height, however, was set at a uniform 15 inches (39 centimeters) for all. Depending on the person and the occasion, *shōji* would be topped with thin tatami mats, *enza* cushions, or brocade cushions; in the case of the emperor, an armrest was added.

Two other kinds of raised seating saw use in the palace, primarily by court ladies, but also by the emperor and ministers at banquets: a rectangular four-legged wooden bench finished in black or vermilion lacquer (*gosshi*) and a cylindrical stool made of rolled-up rough-grade straw matting (*sōton*).

Armrest

The most commonly used cushions among the aristocracy were the *shitone* and *enza*. *Shitone* are made of several layers of *komo* matting covered and then trimmed with cloth borders of different colors and patterns according to the rank of the user. *Enza* are of two types: the one, a plaited length of *gama* bulrush or *suge* sedge grass wound into a flat coil; the other, essentially a round *shitone*.

Meals were taken at low tables called *daiban*. At their largest, these ran to 35 inches by 8 feet (90 by 240 centimeters); at the smallest down to half that, which was the size for individual use. Their height was uniform at 18 inches (47 centimeters), so units could be combined at banquets. Finishes were of black or vermilion lacquer, sometimes with *maki-e* designs.

Sōton stools and low banquet table (*daiban*)

Many such articles used by the aristocracy of the Nara period (710–94) are preserved to this day in the Shōsōin imperial repository on the grounds of Tōdaiji temple in Nara. Established in 751 by decree of the emperor Shōmu, the repository houses a sizable collection of personal effects, craft items, and furnishings of the

"Ladies Under Trees" (detail)

emperor and empress. There is no better firsthand source of information on the daily life, environment, and furnishings in the Heijō palace.

To begin with, the *Record of Offerings to Tōdaiji Temple* (*Tōdaiji Kenmotsuchō*), which dates from the mid-eighth century, lists over one hundred folding screens (*byōbu*) among the imperial household articles donated to the Shōsōin. The number suggests that screens were an extremely popular item with the Nara-period court, yet today relatively few examples remain in the repository. These are four- and six-panel screens, assembled by means of cords through holes in the panel frames in the Chinese method. Nonetheless, the materials used and other clues show that the screens are definitely Japanese. The most famous of these, known as "Ladies Under Trees" (*Torige Ritsu-jo*), depicts a T'ang beauty on each of its six panels and was originally decorated with colorful bird feathers; another has Chinese calligraphy, again done in bird feathers; the other two have nature scenes executed in wax- and press-resist dyeing techniques. Furthermore, according to the eighth-century classic *Chronicles of Japan* (*Nihon Shoki*), the first folding screens to reach Japan came during the reign of the emperor Tenmu (672–86) as gifts from the Korean kingdom of Silla.

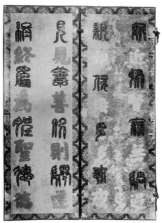

Feather-appliqué calligraphy screen (detail)

Wax-resist-dyed screen panel

Press-resist-dyed screen panel

No other partition devices from the Nara period are to be found in the Shōsōin. However, the contemporaneous *Record of Holdings of Saidaiji Temple* (*Saidaiji Shizaichō*) lists two partition screens: a nearly 4-foot (115-centimeter) high panel of "Buddha Descending from Paradise" (*Fudaraku Jōdo Henshōji*), and a 9-foot (270-centimeter) high "Paradise of Bhais'ajyaguru" (*Yakushi Jōdo Henshōji*), both no longer extant.

Many felt floor coverings are preserved in the Shōsōin, though according to the *Record of Offerings to Tōdaiji Temple*, these are only part of the original sixty. Existing pieces include patterned *kasen* and solid-color *shikisen* mats. The *kasen* mats feature various ornate schemes of decoration: T'ang flower patterns on shaded indigo, green, or dark brown backgrounds; bird-and-flower rondels in the center of a white field bordered by mountains, clouds, and birds; a border of figures around a center of flowers; or again, all-over T'ang arabesque designs. The *shikisen* mats are of solid crimson, purple, dark brown, white, and other colors. All are foreign-made and imported from the continent, some from areas along the Silk Road as far away as Sassanian-dynasty Persia.

T'ang flower-pattern mat

The emperor Shōmu's own bed is also kept in the Shōsōin. Measuring 93 by 47 by 13 inches (237 by 120 by 33 centimeters), its four-legged, open-slatted frame is of Japanese cypress, painted in Chinese powdered-seashell white (*gofun*). The Tōdaiji record states that two such beds were arranged side by side with tatami mats set on them, covered with quilting, and topped with a green coverlet when used by the emperor. Partial remains of a quilt and coverlet, as well as a white silk pillow thought to have been used on the bed, are also preserved. Furthermore, scholars believe that around the bed was set a canopy frame called a *tochō*, which consisted of four

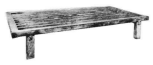

Emperor Shōmu's bed

L-shaped baseboards, each with three upright posts supporting a rectangular lath-grid ceiling covered with white silk or paper, and draped on all four sides with silk curtains. Neither the *tochō* nor its curtains, however, are to be found in the Shōsōin.

Other items for seating and reclining that have survived to the present day include a chair and an armrest. The chair is of zelkova wood and has four legs and a rattan-caned square seat, a *torii* gate–shaped backrest, and a railing around the sides. The armrest is of rosewood, with a straight armrest board supported by legs on either end.

The main storage unit used in palace interiors during this period was the *zushi* cabinet, of which three are preserved in the Shōsōin. One of these, a double-door zelkova-burl cabinet of outstanding beauty, was used by several emperors in turn. It stands on a Chinese-style openwork base, and inside are two shelves that are reputed to have held various writings, a flat scepter (*shaku*), rhinoceros-horn cups, and a game board for a dice game (*sugoroku*). The other two cabinets are made of black persimmon wood; one is noteworthy for its doors front and back. Two more cabinets of the same period are preserved in Hōryūji and Tōdaiji temples. The former, probably of Chinese make, is fashioned of strips of thin bamboo, and at one time held sutra scrolls; the latter, of nearly identical design with the double-door piece in the Shōsōin—probably the most prevalent style of that day. Records show that many temples had similar *zushi* cabinetry, as well as ones of elliptical or table-height design.

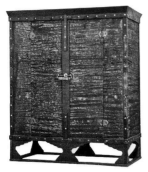

Zelkova-burl *zushi* cabinet

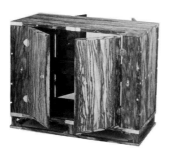

Front- and rear-opening two-tiered *zushi* cabinet

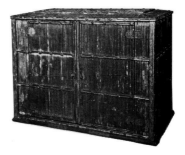

Bamboo-strip *zushi* cabinet

Whereas *zushi-dana* display shelves of this period were essentially decorative furnishings imported from China, *tana* shelves were eminently practical storage units of domestic origin. The Shōsōin has two *tana* units, both of which are plain yet sturdily built, as if they had been used in a storehouse.

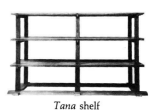

Tana shelf

Probably the most important storage items of the period, however, were the *hitsu* coffers. Though *hitsu* had been around since the fourth or fifth century, Nara-period pieces are the earliest extant examples. These are of two types: *kara-bitsu* and *wa-bitsu*, the so-called Chinese and Japanese styles. Chinese-style coffers stand on legs; Japanese-style pieces are without legs, but have rods for carrying at the front and back, and sometimes have wooden strips on the sides as well. *Kara-bitsu* are thought to have reached Japan from the Korean Peninsula in the third or fourth century, and were used to hold writings, sutras, valuables, clothing, weapons, food, and other small effects. Their double role in transporting and storing articles must have greatly enhanced their value at that time, when rulers had no fixed seat of government. Many examples of both types have survived to this day; some were purely functional, some decorated.

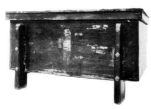

Chinese-style coffer

Japanese-style coffer

Lacquered leather box

Woven *tsuzura*-vine box

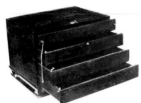

Box with drawers

Various smaller boxes are also kept in the Shōsōin, including square, rectangular, round, and polygonal pieces made of wood, leather, lacquered leather, vine, willow, and *igusa* rush. Wooden boxes are of plain wood, decorated with mother-of-pearl inlay, and painted in colors or gold and silver; leather items are painted in oil- (*mitsuda-e*) or water-base colors; those of lacquered leather are either plain or decorated with designs in gold and silver. Interestingly enough, among the wooden boxes is a more sophisticated one with drawers—a curiosity considering that after this single example, box-type furniture with drawers did not really take hold in Japan until the premodern period (1573–1868).

In heating devices, the Shōsōin houses three hibachi, one each of marble, copper, and nickel. All are of the same round design resting on three sculpted lions.

Three types of tables are also found in the Shōsōin: dining tables, offertory stands, and slat-legged pieces. Dining tables are low and rectangular and of a style thought to have been used in Japan since the fifth century. Offertory stands for placing before Buddhist altars laden with religious offerings include elliptical and flower-shaped pieces, which would have been draped with brocade cushions. The slat-legged stands are generally tall, with up to several dozen upright stiles lined up supporting either side of the top board. Flowers, incense, and sutra scrolls were placed on these during Buddhist ceremonies; alternately, they were used for scriptural writing.

Copper hibachi

Flower-shaped offertory stand

Multi-legged table with wood strips affixed to legs to protect tatami matting

No less than fifty-five mirrors are preserved in the repository. The majority were imported from China, but unlike the severe designs of earlier Wei- and Han-dynasty mirrors, these are quite ostentatiously decorated, most likely an indication of their transition in status from magical objects and symbols of authority to items for personal cosmetic use.

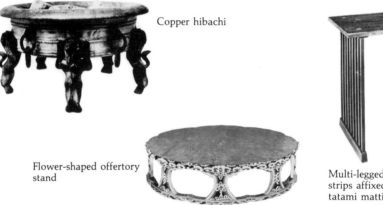

Bronze mirror with dragon motif

Bronze mirror with flower motif in mother-of-pearl inlay

Handscroll stand

Other miscellaneous furniture items include a handscroll stand and a censer. The former is basically an upright T-shaped rack of zelkova and rosewood decorated in gold and silver pigments, with special metal fittings at either end of the crossbar to hold a handscroll in place. The censers are highly decorative, made of wrought silver and bronze, spherical in shape, with openwork designs, and contain an iron incense burner mounted on a gyroscopic setup.

Surveying these many articles passed down in the Shōsōin reveals certain distinguishing characteristics of the life of the Nara-period aristocracy. Most notably, the high level of technical crafting and design can be traced almost exclusively to

T'ang China and Central Asia. For example, such decorative motifs as the "Ladies Under Trees" seen in the *byōbu* folding screens, or the arabesque, mystic mountain landscape and phoenix designs on boxes and *hitsu* coffers occur much earlier in Sassanian Persia, and obviously were transmitted via Silk Road trade routes to Ch'ang-an and eventually to Japan. All these items exhibit a strong sense of color and pattern; all are well composed and constructed. The picture they paint in technical advancements alone is one of a society suddenly boosted centuries ahead of the previous age: woodworking, lacquering, metalwork, and dyeing all are handled and combined with the cosmopolitan taste of the High T'ang. Research on the materials used shows that most furnishings were of Chinese origin. Even so, foreign designs notwithstanding, a good number of pieces appear to be Japanese, which means that foreign craftsmen must have made their way to Nara at that time.

Nonetheless, for all the new continental affectations in the public sphere—city planning, palace architecture, and imperial household furnishings—the actual lifestyle of even the ruling class had changed very little from that of the previous age. In fact, by the next historical period, the Heian (794–1185), the aristocratic lifestyle would essentially revert to older, more traditionally Japanese forms. More than anything, this indicates that the Japanese never truly embraced Chinese values in regard to lifestyle and the home environment, but merely took on certain secondary attributes of continental living for prestige. As much as Chinese furnishings may have overwhelmed the Japanese aristocracy of the time and continued to exert a major external influence for centuries to come, traditional Japanese furniture maintained a distinct identity.

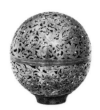

Wrought-silver censer
(closed and open)

THE GOLDEN AGE OF THE ARISTOCRACY
(794–1185)

Though seriously ill and resting his head on a pillow, Prince Kashiwagi receives his friend. Typical of Heian-period decor, the room is broken by numerous partition devices: a free-standing curtain (bottom left), a "fill-in-wall" (left), *misu* blinds (top), and a folding screen (right). From *Tale of Genji Scroll*.

In 794, the capital of Japan was shifted to Heian-kyō (present-day Kyoto), a city nominally compared to China's eastern capital, Luo-yang, the rival city of Ch'ang-an. Not coincidentally, the move away from Heijō-kyō signaled a cooling of interest in the now-waning T'ang culture. By 894, Japan had stopped sending envoys to T'ang China altogether, and began shaping its own unique aristocratic culture.

The new capital had its palace and imperial quarters as before, but now culture came to reside more in the private villas of influential members of the aristocracy. These "lesser palaces" were built in a new architectural style called *shinden*, which linked basically traditional Japanese buildings through a series of covered walkways in the Chinese manner. The grounds of these villas often occupied whole blocks between the grid streets of the city, with main quarters (or *shinden*, from which the style takes its name) in the middle facing south and side buildings (*tsui*) to the east and west; a "fountain pavilion" (*izumi-dono*) and a "fishing pavilion" (*tsuri-dono*) often faced onto an artificial lake amidst a tastefully landscaped garden. The buildings themselves were of unpainted wood, with round columns and thatched or boarded hip-gable roofs; deep overhanging eaves (*hisashi*) covered slat-floored (*sunoko*) veranda passages around the main chamber (*moya*). The interior of the main chamber was unpartitioned and bare. Eventually, even the Imperial Palace was rebuilt in the *shinden* style, and an official known as the "warehouse master" (*kurōdo*) was specially charged with moving and arranging furnishings for every occasion.

Clearly the most important accouterments for rendering the empty space of *shinden*-style interiors habitable were partition devices such as *misu* blinds, various *tobari*

Shinden-style villa (from 1842 book)

curtains, *shōji* panels (still opaque, not yet the translucent paper screens), single-panel screens (*tsuitate*), and folding screens (*byōbu*). Defining a "room" started from the very separation of inside from out; there were no doors, only openings between columns where large drop-leaf panels called *shitomido* might be swung into place, leaving the interior in complete darkness. In order to have light and privacy, *misu* blinds would be hung at eye level between the columns. These are made of thin strips of bamboo woven with red silk thread, and bordered on all four sides in brocade, with or without middle strips of brocade. Metal hooks (*ko*), provided for holding the rolled-up blinds, dangled on braided silk cords when not in use. Often, many *misu* were hung in a row, surmounted by a 1-foot (30-centimeter) wide length of the same brocade as a horizontal flap (*mokō*) to hide the hanging nails. For funerals and other inauspicious occasions, the borders would be black and the hooks white.

Partitioned palace interior
1. *Misu* blinds, 2. Folding screens, 3. "Draw curtains," 4. Free-standing curtains (*kichō*), 5. *Chōdai* sleeping arrangement, 6. *Shōji* sliding panels

The term *tobari*, at first used mainly to refer to doorway curtains, gradually became the generic name for all cloth room-curtains: *kabeshiro*, *hikimono*, *kichō*, *chōdai*, and *zenjō*. All except the last were distinguished largely by usage. In design, most were made of 14-inch (35-centimeter) widths of fabric—raw silk with bird-and-flower or wild-grass motifs in white pigment for summer, silk gauze with violet-brown resist- or tie-dyed patterns for other seasons—seamed together to the necessary length and lined with white silk gauze. Some were padded with wadded cotton for winter insulation. All were supplied with 3½-inch (9-centimeter) wide tie-ribbons (*nosuji*) of the same length as the curtains, attached at 14-inch (35-centimeter) intervals; these had butterflies or other designs on a red or purple ground. *Tobari* that were used like *misu* blinds as translucent interior-exterior partitions between the columns were called "fill-in walls" (*kabeshiro*); those for use in unspecified locations were called "draw curtains" (*hikimono*). When draped from special free-standing black-lacquered stands with boxlike bases, two upright posts, and a long crossbar on top, they were called *kichō*. *Chōdai* were a consolidation of the sleeping area and *tobari* canopy arrangement that had been in use since the fourth or fifth century: a four-poster tatami-mat "bed" draped on four sides with *tobari*, now of finer flower-patterned silk gauze. Alternately, some sleeping enclosures featured *shōji* panels, possibly after Chinese prototypes: a central opening on the front was curtained with *tobari*, and had sliding

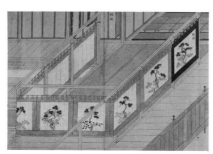

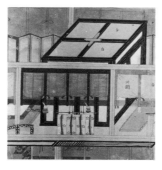

Intercolumnar curtains (*zenjō*)

Sleeping area with *shōji* panels

panels on both sides and a fixed panel at the back, making a miniature room of sorts. Inside, a mirror and "rhinoceros horn" of cypress wood were hung on a post as protective hex devices. *Zenjō* were made of six or seven strips of fabric with a border on all four sides and a rope casing across the top edge that allowed them to be tied between columns. These were painted with scenes of falconry or Chinese landscapes.

Shōji screens were made by surfacing wood-lath grids front and back with paper, silk, or other fabrics, decorated on one side with calligraphy or fabric, and set in a black-lacquered frame. These were fitted between columns as room dividers. The "Panel of the Sages" (*Kenjō-no-shōji*) of the Shishinden formal ceremonial hall and the "Wave-Crested Sea" (*Araumi-no-shōji*) of the Seiryōden imperial throne hall of the palace were particularly famous. *Torii-shōji*, a special arrangement of sliding *shōji* panels in a fixed intercolumnar frame, allowed passage, presaging later built-in architectural *shōji* paper "sliding doors." Far more common at this time were portable *shōji* panels on free-standing bases, much like single-panel screens.

Folding screens of the Heian period (794–1185) were largely the same as those of the Nara period (710–94) found in the Shōsōin repository, except that the decorations ceased to take inspiration from continental examples and started to depict domestic landscapes and customs.

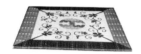

Shitone cushion

Floors in the palace and villas were of wood, so various furnishings had to be placed about for sitting and reclining. *Mushiro* and *komo* mats were used extensively as floor coverings in *shinden*-style buildings; items for sitting included tatami mats, *shitone* and *enza* cushions, and armrests. Of these, the first two changed only slightly from the previous Nara period: *mushiro* were of more finely woven *igusa* rush, and had a backing layer and borders, the highest-quality ones being special dyed flower-patterned mats. *Komo* were of coarsely woven rice straw (*wara*), water-oats (*makomo*), or sedge (*suge*). It was in the Heian period that their dimensions were first standardized. They were spread out to cover the entire floor space evenly, and on top of these were placed tatami only where someone sat or slept—the age of wall-to-wall tatami was still far in the future.

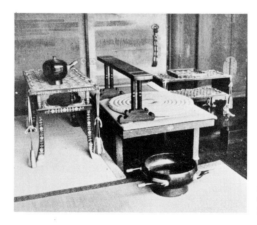

Enza cushion and armrest on dais (*shōji*), and for daily ablutions a horned basin and pitcher

Tatami at this point in time were made of several layers of *komo* sewn together with linen thread, surfaced with a *mushiro*, and bordered and backed with cloth. Cushions and armrests remained unchanged from the Nara period.

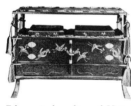

Edo-period replica of Heian-era two-level partially enclosed cabinet

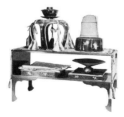

Edo-period replica of Heian-era two-level framed shelf

The main types of storage furniture in the Heian period were *zushi-dana* shelves, plain utilitarian shelves (*tana*), and coffers (*hitsu*). The first of these took a low *zushi* cabinet and added a shelf on top to form the two-level partially enclosed cabinet (*nikai-zushi*), an item found in most aristocratic household interiors from this time on, often decorated with *maki-e* or mother-of-pearl inlay. A step down in status but nonetheless prevalent were the two- and three-level framed shelf units (*nikai-dana* and *sankai-dana*) without enclosed space; these were kept on the verandas protected by the overhanging eaves, rather than in the main area with the *nikai-zushi*. All, however, were used in pairs. *Zushi-dana* held such everyday items as incense-jar boxes (*kō-tsubo-bako*), comb boxes (*kushi-bako*), tissue-paper boxes (*zōshi-bako*), and medicine boxes (*kusuri-bako*); *tana* held charcoal carriers (*hitori*), mouthwash cups (*yusuru-*

tsuki), spittoons (*dako*), and sundry "unclean" items. Other related furnishings included the musical instrument cabinet (*kangen-zushi*) and the toiletry cabinet (*okimono-zushi*).

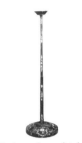

"Chinese-style Coffer with Phoenix Rondels"

Japanese- and Chinese-style coffers (*wa-bitsu* and *kara-bitsu*) were used more than ever before, now generally in pairs, with decorations in *maki-e* or mother-of-pearl inlay. The most representative example is the "Chinese-style Coffer with Phoenix Rondels" (*Hōōmon-kara-bitsu*) in the collection of Hōryūji temple.

Somewhere between storage and partition units were clothing racks (*ika*; later *ikō*) of either the more free-standing type, which resembled the single-panel screens, or the more practical suspended style.

Even with the drop-leaf panels open, interiors tended to be quite dark due to the deep eaves, so lighting was important. Oil lamps (*tōdai*) were often spoken of in terms of height: those from 1½ to 3 feet (45 to 90 centimeters) tall were called "short oil lamps"; beyond that they were considered tall. Most were lacquered black, with occasional *maki-e* or mother-of-pearl decorations. Sheets of oil-paper (*uchishiki*) would be laid under the lanterns to protect the floor from dripping oil.

Mother-of-pearl-inlaid tall oil lamp

Roofed hanging lanterns (*tsuri-tōrō*) were hung from the eave-rafters to illuminate the veranda passageways. Those used in the Imperial Palace were of forged iron, but wooden ones were more common; the typical design featured a square chamber under a gabled roof.

Heating was provided by *hioke* and *subitsu*. The former were bentwood hoops or hollowed out tree-sections fitted with ceramic ash containers. Fancy bentwood *hioke* might, however, have painted designs in Chinese white and pigments, and ash containers of silver or copper. *Subitsu*, literally "charcoal coffers," were wooden, box-shaped containers—the best articles being lacquered and decorated in *maki-e*—lined with copper sheets.

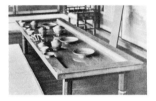

Bentwood *hioke* heater

Food service furnishings included footed trays (*takatsuki* and *tsuigasane*), dining trays (*oshiki*), individual meal-setting trays (*tsukue*; only later would they evolve into the study furnishing discussed on page 124), and banquet tables (*daiban*). In the Nara period, the *takatsuki* tray had originally been a footed compote on which food was set directly, but now its role changed to that of a carrying tray for dishes. Square or round, it stood on a single-stemmed base. The standard item was lacquered vermilion on its upper surface and black on all other parts, although there were also plain-wood and *maki-e*–decorated pieces. *Oshiki* were plain-wood square trays, often also made of rare woods. *Tsuigasane* trays were essentially *oshiki* on hollow, box-shaped stands, used at ceremonies and banquets. *Tsukue* were individual meal-setting trays, raised on four corner feet to a proper height for eating while seated on the floor. At banquets and special occasions, *tsukue* would be set out in rows, one to each guest. In the palace and aristocratic villas the most common types were

Meal-setting trays grouped and in a row

of red-stained cypress, of chestnut with silk on the upper surface, and of magnolia with yellow silk. Legs were typically carved in scalloped openwork (*geshō*) endings. Banquet tables had also been used as dining-service trays since the previous historical period, and would continue to enjoy such use into the next. *Kakeban* likewise served as individual "dining tables," finer examples being made of aloeswood, rosewood, or other rare wood.

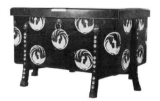

Banquet table

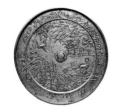

Japanese-style bronze mirror

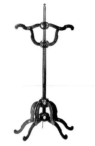

Uprooted tree–shaped
mirror stand

Handy box with "wheels mid-
stream" design in *maki-e*

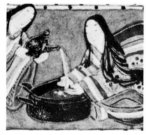

Matching pitcher and horned
basin in use

Cosmetic accessories were numerous in the Heian period. Bronze mirrors came into everyday use for the first time, and with this change Japanese-style mirrors (*wakagami*) began to feature non-Chinese designs—pines, cherry blossoms, cranes, deer, and other subjects that appealed more to native sensibilities. Pieces produced in this period became models for Japanese mirrors up through the Edo period (1600–1868). Yet despite the new look of these mirrors, the *nekoji-gata kyōdai* mirror stand, shaped like an uprooted tree, seemed to hark back to the days of magical symbolism.

Combs and other articles for the toilette were kept in special boxes. Lidded comb boxes (*kushi-bako*) measured 12 inches (30 centimeters) square and 3 inches (8 centimeters) deep, and were divided into three sections on the inside to hold scissors, tweezers, rake-combs, ear cleaners, face powder, and the like. Chinese-style comb cases (*kara-kushige*) were somewhat smaller, but had an extra box on top for lip-rouge and oil-base makeup. Hairdressing boxes (*kakage-no-hako*) also held combs,

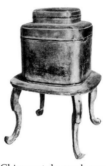

Chinese-style comb case

Contents of comb case

scissors, and the like and were kept close at hand. Handy boxes (*tebako*) were similar to comb boxes, but had a broader range of use, holding the complete inventory of women's needs in toiletries, writing utensils, and even pillows.

Basins of earthenware, ceramic, and plain wood were already widely used, but the so-called horned basins (*tsuno-darai*) first made their appearance at this time.

For reading and writing there were such furnishings as writing tables (*fuzukue*), bookshelves (*sho-dana*), book coffers (*fumi-bitsu*), and writing boxes (*suzuribako*). No Heian-period writing tables have survived, but they supposedly existed in many varieties for ceremonial purposes, for bureaucratic paperwork, for sutra-copying, and so on, in black lacquer and plain wood. For easy access to scrolls and other written materials, there were room-use bookshelves. Part decorative by design, they were often lacquered and decorated in *maki-e*. More functional storage was provided by book coffers of plain cryptomeria or cypress, which were apparently kept in storehouses. Writing boxes held inkstones, inksticks, water droppers, and brushes. These were either arranged box-in-box fashion with the inkstone and water dropper in the innermost section, or layered box-on-box.

A full setting of furnishings in a *shinden* interior might have looked as follows: The veranda passageways were hung with *misu* blinds just inside the *shitomido* openings; at each intercolumniation was placed a *kichō* curtain-on-a-stand, with standing oil lamps and suspended *tōrō* lanterns in front of every column. Along the north side of the main area of the building, *shōji* panels were fitted in between the columns as fixed partitions. In the middle of the main area was set up a *chōdai* sleeping area, with three tatami mats on the floor to its eastern side and *shitone* cushions placed on them for sitting. Beside that setup would be a 3-foot (90-centimeter) *kichō*, and on the north side of the tatami a pair of two-level partially enclosed cabinets holding personal effects; a folding screen would form a backdrop behind that. This all made a sort of "living room." Two more tatami were arranged on the southern veranda, with *shitone* cushions and armrests, another *kichō*, a pair of two-level framed shelves with a mirror case (*kagami-bako*), and a folding screen standing nearby, completing the ladies' toilette area.

In general, Japanese furniture evolved into more open and decorative designs from the basically Chinese forms of the previous period. Even the decorations themselves began to reflect a sensitivity to the native Japanese environment, as more and more seasonal plants and animals were taken up as motifs. Patterns became asymmetrical, more naturalistic. Furthermore, increasing attention was paid to the harmony and refinement of sets: boxes made to fit exactly into cabinets, matching ornamentation on groups of furnishings.

Perhaps it was simply that it took several centuries to fully digest all that had impinged on Japan in the short span of the Nara period; or again, perhaps it was that the arts of the Heian period, including the art of lifestyle, were largely given over to the women of the aristocracy, who were otherwise kept out of political affairs. Whatever the case, the Heian period was marked by a sense of elegance and feminine "salon culture"—witness the way of life depicted in the world's first novel, Lady Murasaki's *Tale of Genji*—the likes of which rivaled even the High T'ang, and which would continue to set the standard of excellence for ages to come.

MEDIEVAL TIMES (1185–1573)

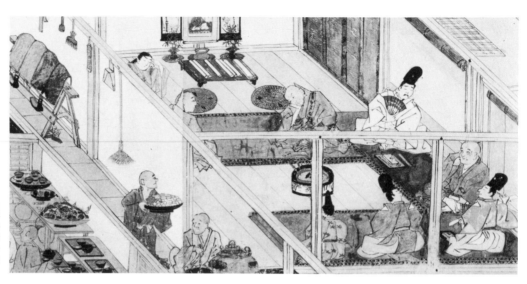

Floor-seating in the middle ages. Sitting around a bentwood hibachi, aristocrats and priests compose *waka* poetry. In the background, an early arrangement that foreshadowed the *toko* alcove.

Fully tatami-matted room with opaque sliding panels

The historical periods that followed—the Kamakura (1185–1333), Northern and Southern Courts (1333–92), Muromachi (1392–1482), and Warring States (1482–1573)—saw repeated political upheavals throughout Japan as one samurai clan after another rose to power. Culturally, it was an age of transition, the tastes of the aristocracy of the Heian period (794–1185) lingering on until around the Northern and Southern Courts period, when the samurai finally established a lifestyle of their own by embracing the newly imported Zen religion and later the tea cult. This transition roughly corresponded to changes in architecture and thus also in furnishings.

A pattern becomes apparent: whatever belonged to the privileged classes of one period in Japanese history becomes sought after and finally attained by the ascendant class in the next. When the Minamoto-clan samurai first seized control in the Kamakura period, they wanted nothing more than to live in *shinden*-style villas like the aristocrats of the Heian period, but eventually that style lost its aura of prestige. Where the *shinden* style had left interiors unarticulated and unspecified, newer villas of the feudal lords began to have separate rooms and even separate wings for daily life and for receiving guests: the main building (*shuden*) and the meeting place (*kaisho*), the latter frequently serving as a multipurpose room.

Corollary to this trend was the gradual incorporation of formerly movable, independent furniture into the architecture itself as fixtures. Tatami mats, which had been an occasional furnishing for sitting, had by the Muromachi period become a flooring material completely covering the wooden underfloor. Translucent paper screens (*akari-shōji*) came to be built in as sliding doors. Walls and opaque sliding

Translucent paper screens

panels (*fusuma*) now partitioned off rooms, so that actual bedrooms removed any need for canopied sleeping areas. Writing tables (*fuzukue*) were set into bay windows as decorative interior accents, after similar features in Zen temples where monks could study without additional light. It was these "study alcoves" (*shoin*) that gave their name to the new architectural style.

The first real embodiment of the *shoin* style was the Higashiyama-dono villa of the eighth Muromachi shogun, Ashikaga Yoshimasa (r. 1449–74). A reconstructed plan of the reception area of that villa includes not only a *shoin*, but built-in staggered shelves (*chigai-dana*) and an alcove, both for displaying art objects from the military ruler's vast collection. The oldest existing building with both *shoin* and built-in display shelves is the Dōjinsai study alcove in the Tōgudō hall of Jishōji, the "Tem-

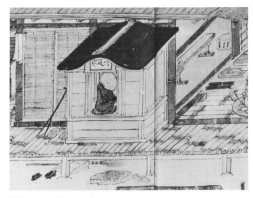

Writing table in place by bay window

Built-in staggered shelves and "study alcove" of Dōjinsai

ple of the Silver Pavilion," also built by Yoshimasa. As the popularity of the *shinden* style declined and the *shoin* appeared and underwent further refinements, a need for a room in which to entertain guests exerted itself. This, in turn, led to a demand for embellishment, and the *shoin* study alcove spawned the *toko* alcove (*tokonoma*), a display area with a thick, broad slab of wood (*oshi-ita*) that provided a raised display surface just above floor level. The articles to be set in the alcove soon became formalized: on the *oshi-ita* board sat an incense burner, a candlestand, and a vase of flowers; above hung a painted scroll.

The historical development of furnishings adapted to these new settings can be traced back to the Kamakura period. At that time, new techniques, especially in lacquering, began to extend the possibilities of existing Heian-style furnishings. *Maki-e* techniques were expanded: Added to the "burnished relief" finish (*togidashi-maki-e*) of the Heian period were "low-relief" (*hira-maki-e*) and "high-relief" finishes (*taka-maki-e*). Then there was the special "pear-skin" finish (*nashiji*) rendered by dusting freshly lacquered surfaces with gold dust. Mother-of-pearl inlay (*raden*) techniques likewise evolved, and were used together with *maki-e* and a slivered-gold-leaf incised finish (*kirigane*). Perhaps the finest examples of these mixed techniques are the so-called Autumn Field with Deer Lacquer Box (*Akino-shika-maki-e Tebako*) and the medallioned handy box known as *Ikakeji-fusen'ryo-raden-maki-e Tebako*. Meanwhile, in the temples were developing various types of vermilion lacquer, most notably the vermilion-on-black *negoro* lacquer, which were used on such exemplary pieces as the Tōdaiji's stacked trays (*rengyō-shūban*), Kōzanji's Chinese-style coffer (*kara-bitsu*), and the later Muromachi-period flower-shaped tray (*rinkabon*).

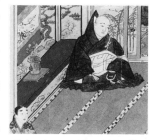

Toko alcove with *oshi-ita* display board (1483 illustration; detail)

Medallioned handy box

Tōdaiji's stacked trays

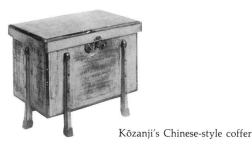

Kōzanji's Chinese-style coffer

Flower-shaped tray

Trade with China was resumed in the Kamakura period, and the influx of Sung-dynasty crafts stimulated the growth of numerous carved lacquer techniques, including incised inlay techniques and *Kamakura-bori* lacquer. By the Muromachi period, Japanese lacquer crafting—now showing the strong influence of Ming China and Yi Korea in mother-of-pearl inlay techniques—was capable of producing designs of utmost refinement and subtlety, often depicting subjects from Japanese poetry.

Another major factor directly related to the development of Japanese furnishings in the middle ages was the rise of a distinct merchant class in Muromachi society that catered to the needs of the samurai. Significantly enough, the greatest symbol of that class was a new partition device, the doorway curtains (*noren*) hung at shop entrances emblazoned with their names or trademarks. Two possible antecedents are imaginable—the *mushiro* flaps over the entrance to pit dwellings, and the *kabeshiro* and *hikimono* intercolumnar curtains of *shinden*-style villas—the one suggesting the continuity of a peasant culture wholly separate from that of the upper classes; the other, a gradual "filtering down" effect. Clearly, the fact that *noren* were used as interior partition devices hung in the passages between rooms, often with purely decorative nature motifs, argues more for the latter.

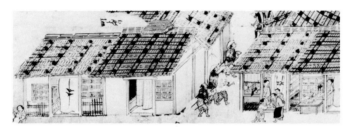

Doorway curtains and *mushino* mat (second from left) hung in entryways

Zushi-dana compound shelf-cabinet

Storage cabinetry in the middle ages saw the evolution of the Heian *zushi-dana* shelves into the Kamakura *zushi-dana* enclosed cabinet and staggered shelf unit. This further transformed into the Muromachi "black shelf" (*kuro-dana*), a three-level framed shelf staggered on the middle level, used for holding personal effects. These two shelf units (and later, in the Edo period [1600–1868], a third, the *sho-dana*) became standard pieces of furniture for inclusion in bridal trousseaux. Yet another cabinet, the *okidana*, had decorated sliding *fusuma* panels instead of hinged doors. Materials such as rosewood or Chinese quince argue for continental origins, yet the overall styling was Japanese; there probably were sliding-door *zushi* in the Heian period, whereas all known Chinese cabinets had hinged double doors.

In cosmetic accessories, there developed in the Muromachi period dressing stands (*kyōdai*), combined mirror and *tebako* storage case units with either one or two mirror support posts on top—the former being the older style. A prime example is the "Chrysanthemum Lacquer Dressing Stand" (*Kikumon-maki-e Kyōdai*), which has Buddhistic "flaming jewel" finials on the post end and a hook for holding the mirror in place; the base is low and has two drawers. As time went on, however, the two-post style took precedence, with the bases getting bigger and the mirrors smaller.

"Chrysanthemum Lacquer Dressing Stand"

A sturdier, box-shaped armrest featuring feather-stuffed pads on top and usually storage space in the base emerged, and as these were used mainly for recuperation and childbirth, they were eventually included in bridal trousseaux.

Folding screens (*byōbu*) also underwent a transition: the introduction of the paper hinge, which replaced the cord-tying of panels, allowed the panels to fold freely both in and out without individual frames, so that they could form one large, continuous

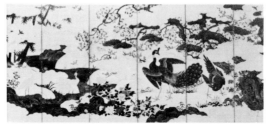

Box-shaped armrest

Folding screen with unframed panels

picture area. Thus screens gained greater importance in the scheme of interior decor, painted in a wide variety of styles.

A new heating device, the heater-table (*kotatsu*), made its appearance during the Muromachi period. At this early date, it was simply a wooden framework placed over an *irori* hearth and covered with a thin quilt; it soon became quite popular due to the availability of wadded cotton bedding materials.

Articles for food service, such as tray-tables (*zen*) and place-setting trays (*oshiki*), also spread to the masses, and there developed many regional styles. *Negoro* lacquer finishing entered the popular domain, and was used on great numbers of *oshiki*.

Again, these popularizations reflect the growing cultural strength of the common classes. Religious activities became more pronounced, and both Shinto and Buddhism flourished, with new sects of the latter appearing. Articles related to worship—though not considered household furniture in the strict sense of the word—were now brought into the home. Sutra-reading tables (*kyōzukue*) were finished in formal black lacquer and had aprons (*maku-ita*) carved in various openwork patterns. Some had drawers or rolled edge tops (*fude-gaeshi*). In temples proper, they were sometimes used as writing tables (*fuzukue*), and in fact many designs were taken from earlier *fuzukue*.

In front of Buddhist altars were placed smaller tables called *maezukue* for the requisite "three altar pieces" (*mitsu-gusoku*): an incense burner (*kōro*), a flower vase (*kabin*), and a candlestand (*shokudai*). Prior to the Muromachi period these tables stood almost waist high; later they became lower. Four legs were customary, but eight- and sixteen-legged pieces also existed, as well as four-legged ones with elegant bentwood "heron legs" (*sagi-ashi*). Since these were generally considered decorative, they often had *maki-e*, mother-of-pearl inlay, or carved aprons. Good examples are the Kamakura-period "Peony Arabesque Openwork Altar Stand" (*Botan-karakusa-sukashibori-maezukue*) of Engakuji temple, and the Muromachi-period *maezukue* of Kenchōji and Nyakuōji temples. With the emergence of Zen Buddhism, bentwood chairs (*kyokuroku*), among others, found limited acceptance in religious rituals, due in great part to the Chinese influence on religious furnishings.

Among the upper classes, literary culture blossomed in the *shoin* salons of the Muromachi period, and most of the associated furniture was highly decorative. Particularly important among these were formal writing tables (*bundai*) and writing boxes (*suzuribako*). Originally, text stands had been used by members of the court for composing poetry on special occasions; the stands were reduced in size during the Kamakura period as substitute writing tables, and finally lost their practical-use character on into the Muromachi. Many were lavishly decorated in low- or high-relief *maki-e*, occasionally with matching writing boxes.

The Heian-period box-in-box *suzuribako* had come to the fore, and among the superior Kamakura-period examples is the "Chrysanthemum Hedge Mother-of-Pearl Lacquer Writing Box" (*Magaki-kiku-raden-maki-e Suzuribako*), and from the Muromachi, the "Mt. Kasuga Raised-Lacquer Writing Box" (*Kasugayama-maki-e Suzuribako*). Otherwise, writing boxes were compartmented on the inside with simple dividers. Around this time, *suzuribako* of this latter type were also combined with safes to produce the first portable writing box–safe (*kake-suzuri*).

Writing tables came to be sumptuously decorated, the finest existing piece perhaps being the "Chrysanthemum Hedge Lacquer Writing Desk" (*Magaki-kiku-maki-e Fuzukue*), the upper surface of which is completely covered with chrysanthemum designs.

Reading stands (*kendai*) probably developed at this time from a Chinese prototype called the *lanchia*, while *sho-dana* bookshelves achieved independence from Heian-style *zushi-dana* shelves. Lastly, for written materials there appeared two special types of storage units—*fuguruma*, literally "writing carts"—one a smaller, string-pull wheeled *sho-dana* that was decorative enough to sit in the *shoin*, the other a larger one, thought to have been a coffer on rollers, meant to be kept in the storehouse.

"Peony Arabesque Openwork Altar Stand"

Temple chair with bentwood backrest

Formal writing desk (top view)

"Chrysanthemum Hedge Mother-of-Pearl Lacquer Writing Box"

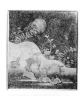

"Mt. Kasuga Lacquer Writing Box"

"Chrysanthemum Hedge Maki-e Writing Table"

THE AGE OF FEUDAL SPLENDOR (1573–1600)

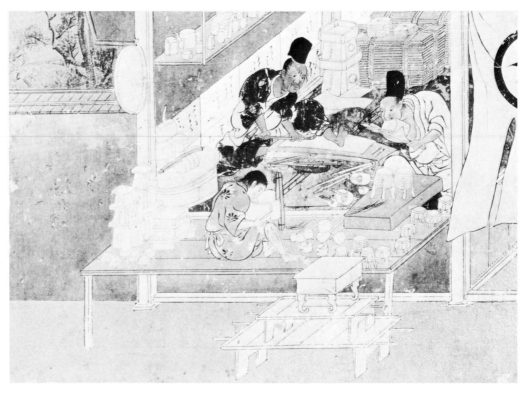

In producing *hinoki*-cypress bentwood furniture, craftsmen flatten, form, and stitch the wood. Pieces shown include, from the front left, elevated trays, miniature Chinese-style coffers, ladles, miniature portable food chests, and, in the foreground, early offertory stands.

Himeji Castle

Nearly a century of fighting between feudal lords closed out the medieval period (1185–1573), the succession of shogunates serving to define the times and set cultural standards. The Momoyama period (1573–1600) saw Oda Nobunaga (1534–82), then Toyotomi Hideyoshi (1536–98) seize power, before Tokugawa Ieyasu (1542–1616) finally established a central government under his clan in the city of Edo (present-day Tokyo). The first part of the Edo period (1600–1868), just after Ieyasu proclaimed himself shogun, however, was still dominated by Momoyama culture.

Fantastic wealth had accrued from increased domestic productivity and trade with the continent, and for the first time there was even contact with Europe. The warlords of the period built massive castles and flaunted their wealth in extravagantly ornate *shoin*-style palaces on the grounds. Rooms were fully articulated for specific functions, and decorated floor-to-ceiling. The Ni-no-maru Palace of Ieyasu's Nijō Castle is particularly famous for its finely carved transoms, polychrome-painted ceiling panels studded with brass fittings, and bold murals on the sliding screens by artists of the Kanō school.

Less show of opulence was made in buildings of a new, understated architectural style called *sukiya*, which embodied the subtleties of the Zen-influenced *suki* tea cult. Spiritual values and otherworldliness were reflected in humble, often rustic-looking

Ni-no-maru Palace of Nijō Castle

tearooms with straw-flecked mud walls, unplaned columns, and not a trace of color. *Sukiya* tearooms, such as the Tai-an built on the grounds of Myōki-an temple for Hideyoshi, were very small, yet complexly ordered spaces; each element was chosen to contribute to an uncanny harmony of opposites, a condensation of the Japanese aesthetics of asymmetry and unity-in-diversity. Later, the same aesthetics were applied on a larger scale toward the creation of the clean-line *sukiya* style of the Katsura Detached Palace, which in turn had considerable influence on modular Japanese domestic architecture and interior design in general, as well as on furnishings.

The Momoyama period ranged to the extremes of taste, ornate and simple, both enjoyed by the rulers and wealthy connoisseurs. It thus stood as the best measure of the totality of Japanese aesthetics, although many possibilities that emerged in this short time period would not be fully realized until much later.

Folding screens (*byōbu*) became important furnishings in Momoyama castles. Intended both as decorations and symbols of status, "gold-and-blue screens" (*konpeki-byōbu*) with polychrome lions or falcons or wind and thunder gods on gold-leaf backgrounds made awe-inspiring contributions to *shoin* audience halls. Others specifically commemorated rulers' exploits, such as the capturing of territory or the building of a castle. Among these were Nobunaga's "Azuchi Castle Screen" (*Azuchi-jō-zu Byōbu*), Hideyoshi's "Juraku Palace Screen" (*Jurakudai-zu Byōbu*), and the two-screen sets "Scenes In and Around Kyoto Screens" (*Rakuchū-rakugai-zu Byōbu*) and "Map of Japan Screens" (*Nippon-zu Byōbu*). Still other screens depicted festivals, popular events, or Western themes. Many were sent abroad, such as the screen presented by Nobunaga in 1581 to the Catholic emissary Valignani Alessandro, preserved in the Vatican. Furthermore, on festive occasions wealthy families would often set screens by the entrances to their homes for all to see in a friendly "screen competition," a custom followed to this day in parts of western Japan.

Tai-an tearoom of Myōki-an temple

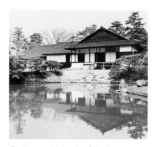

Katsura Detached Palace

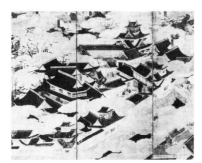

"Juraku Palace Screen" (detail)

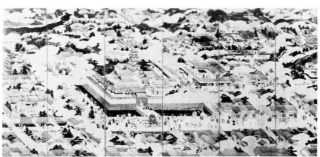

"Scenes in and around Kyoto Screen"

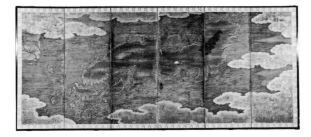

"Map of Japan Screen"

"European Knight Screen" (detail)

As early as the Northern and Southern Courts period (1333–92) crimson felt mats called *hi-mōsen* had been imported from China, but from the middle of the sixteenth century rugs and carpets began to arrive from Portugal and Spain, where the wool and weaving industries were quite strong. Portuguese missionaries then active in Japan reported that feudal lords received their gifts of carpets with great pleasure, for it seems that the wealthy indulged an exoticism through acquisition and display. They would even take carpets to the theater to use in box seating areas, or hang them from windows out over the street when watching festival processions, perhaps in imitation of the European practice of draping tapestries from balconies. From the seventeenth century on, mats and carpets were imported from Holland and England in order to meet the demand.

Shamisen player seated on a bentwood folding chair

"Queen Mother Lacquer Chair"

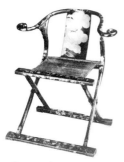

"Chrysanthemum Lacquer Chair"

Another import that was the object of great curiosity was the bentwood chair (*kyokuroku*), first brought to Japanese Zen temples by Chinese priests, then reintroduced by Western traders supplied from Macao. Bentwood chairs were even used on the Kabuki stage to lend an air of the exotic. The finest extant pieces are the "Queen Mother Lacquer Chair" (*Seiōmo-maki-e Kōi*) and the "Chrysanthemum Lacquer Chair" (*Kiku-maki-e Kōi*), the pair thought to have been used by Hideyoshi and his wife.

Some feudal lords also seem to have slept on beds presented to them by missionaries. Hideyoshi himself is reported to have had an ornately carved bed.

In domestic furniture styling, the very formal *shoin*-style palace interiors gave rise to the idea of whole sets of decorative furnishings with matching motifs. One set standardized at this time was that for samurai-class bridal trousseaux, which included the so-called three shelves—*zushi-dana*, *kuro-dana*, and *sho-dana*—cosmetic accessories, writing boxes, game boards for go (*igo*) and Japanese chess (*shōgi*), and folding screens, almost anything that could be decorated. Some sets comprised over a hundred items, all worked in the same elaborate high-relief *maki-e* or incised gold-inlay or coral-inlay motifs. Eventually, wealthier members of the merchant class followed suit and had special sets of bridal furniture made, fewer in the number of items and less ornate, but nonetheless based on those of the samurai.

Cabinet and shelf styles in general were developing at a rapid pace, and gradually began to include numerous combinations of staggered shelves, drawers, and sliding panels, with various finishing treatments from *tsuishu* carved lacquer to plain wood, the latter clearly influenced by the *suki* taste in tea.

Furnishings directly related to *suki* tea connoisseurship, however, were few. Small tearooms could hold only a bare minimum of people and objects, simplicity and austerity being the whole point of the discipline. Portable boxed hearths (*okiro*) for heating the kettle would be brought in only when no sunken hearth (*irori*) could be cut in the floor. Tastes ran to unfinished mulberry, paulownia, or bamboo for small, almost rustic, portable tea-ceremony shelves (*chanoyu-dana*) for holding tea utensils. Two-panel hearth screens (*furosaki-byōbu*) scarcely 20 to 28 inches (50 to 70 centimeters) high and unadorned lighting, such as hand-held candlesticks (*teshoku*) and short oil lamps (*tankei*), were little more than symbolic gestures at furnishing. If not for the exactingly balanced and streamlined design of these items, they might have come from some farmhouse; as it was, though, the degree of calculated simplification only attests to the urbaneness of the privileged classes at this time. Later schools of tea would strive for greater decorativism, but the severity of *suki*-inspired articles would continue to influence furniture and interior design up to the modern age.

Lastly, three other major directions in technique and design appeared around this time. *Kōdaiji maki-e*, named after Kōdaiji temple where Hideyoshi's widow took up residence, represented the state of the art in Momoyama lacquering, and was done

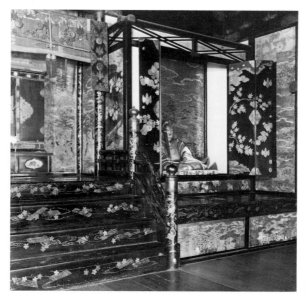

Inner sanctuary of Kōdaiji temple

by accenting freehand low-relief *maki-e* with selected areas of gold-dusted "pear-skin" lacquer (*nashiji*). Typical designs included gold clouds drifting above autumn grasses, or more dramatically, two completely unrelated designs diagonally juxtaposed "half-and-half" fashion on two different backgrounds (*katami-gawari*).

"Half-and-half" pattern

Especially fine *maki-e* work was done by masters of the Kōami tradition in lacquering. Kōami-style pieces were noted for their meticulous detailing and unusual materials; original techniques included pewter-dusting (*suzufun-maki*), coral mosaic (*sango-hari*), and silver-bradding (*ginbyō-uchi*). On into the Edo period, the Kōami lineage would be official lacquer craftsmen to the Tokugawa clan.

The Kōetsu style in *maki-e* developed as an application of *Kōdaiji maki-e* techniques to the designs of the multi-talented artist-connoisseur Hon'ami Kōetsu (1558–1637). Works in this style generally take subjects from classical Japanese poetry or epics, and treat them in a strikingly bold and graphic manner. Particularly famous examples are the "New Year's Lacquer Shelf" (*Nenohi-maki-e Dana*) and the "Yatsuhashi Lacquer Writing Box" (*Yatsuhashi-maki-e Suzuribako*).

Kōami *maki-e*

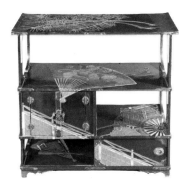

"New Year's Lacquer Shelf"

"Yatsuhashi Lacquer Writing Box"

The Momoyama period closed, interesting enough, with the first exportation of Japanese furnishings to Europe, a practice that continued until the proscription of Christianity by the shogunate in 1614. Two types of furnishings were produced for export: small everyday items, typically small chests (*ko-dansu*), and articles related to worship, such as the Bible stand with IHS motif.

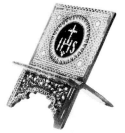

Lacquer IHS Bible stand with mother-of-pearl inlay

THE AGE OF THE TOWNSFOLK (1600–1868)

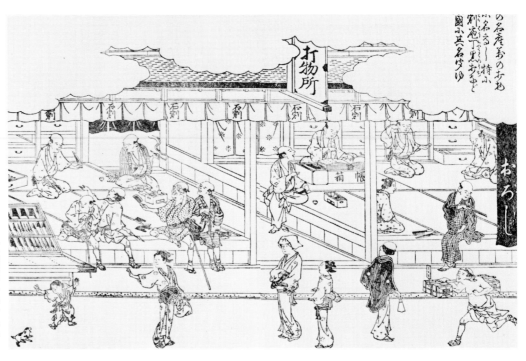

With the emergence of an affluent middle class, the demand for furniture for private and commercial use increased dramatically. Here, in an Osaka cutlery shop, *tansu* chests stocked with wares line the rear wall; at the right a clerk at an accounting desk inspects a ledger.

Japan's first truly urban culture developed during the 268 years of the Edo period (1600–1868), almost in spite of the policies of the Tokugawa shogunate. In an effort to end all fighting and centralize the economy, a strict system of social stratification was implemented, which gave land income to members of the samurai class, but effectively reduced them to bureaucrats.

The rulers feared change. Foreign trade was curtailed except for the shogunate's monopoly on goods from China and Holland, though this was not enough to bring much income. What it did, however, was put the ruling samurai class at the mercy of the merchant class, who gained increasing control of the domestic trade of goods, while the agricultural productivity that was supposed to provide for the rulers could hardly exceed the level of self-sufficiency. By the end of the eighteenth century the Tokugawa shogunate was near bankruptcy, and the merchant townsfolk were enjoying a life of comfort such as they had never known. The samurai kept conservatively within the bounds of old forms; it was rather among the townsfolk that a new lifestyle emerged, and with it, new ideas in decor and furnishing.

The typical townhouse had two stories and a tiled roof. The merchant family lived at the back of the house and upstairs, while they kept shop in the area closest to the street. The street entrance was hung with the shop doorway curtain (*noren*), which was taken in at night. Function was the key word in townhouse architecture, not aesthetics as in the *shoin*-style palaces of the ruling class. The shogunate placed a ban on such "luxuries" as *toko* alcoves with decorative shelves, *shoin* window-desks, and lacquer finishes. Nonetheless, wealthier merchants skirted the ban by improving their homes in less ostentatious ways, often by incorporating such elements of the *sukiya* style as unfinished but beautifully grained woods or natural-bark posts.

Function was likewise the initial reason behind the boom in chests (*tansu*) and other drawered furnishings among the common classes from the end of the seventeenth century. Previously, storage for clothing had never been a problem simply because no one had had more than one kimono—coffers (*hitsu*) and trunks (*nagamochi*) had been necessities only of the well-clothed upper classes—but now in the cities of Edo (present-day Tokyo) and Osaka there were even major stores selling fabric by the

bolt to members of the merchant class. In addition, as the common classes began to spend and the flow of goods increased, these same commercial outlets had need of storage cabinetry and other furnishings.

Lumbering and woodworking tools had also undergone a revolution since the days of wedge-splitting, adzing, and rush-sanding. The two-man crosscut saw (*oga*) reached Japan from the continent during the Warring States period (1482–1573), and finally came into the hands of the commoners during the Edo period, whereupon it was modified into a more efficient one-man model. This tool, together with improvements in domestic commerce, greatly increased the availability of cheap furniture-grade wood. The manufacture of *tansu* became a big business, bringing storage furnishings to the common people at lower costs.

Two-man crosscut saw

Chests soon came to be made for many different purposes, not just storing clothing, yet in terms of design there was little variety to Edo-period *tansu*. Metal fittings were plain; surfaces were left unfinished or given a minimal coating of black lacquer, since rigid social codes forbade anything so decorative as *maki-e* to commoners. Toward the end of the Edo period, the dual-purpose stairway chest appeared.

Eventually, however, wealthier merchants outstripped samurai households in the amounts they were spending on furniture, and they, too, began having sets of bridal furnishings made. A bridal etiquette book of the period lists no less than one hundred ten "requisite" pieces for such a set, and one surviving set that belonged to a rich Osaka merchant had over two hundred pieces decorated in high-relief *maki-e*. Needless to say, the shogunate and local authorities passed ordinances against this sort of extravagance, but they were utterly ignored.

One-man crosscut saw

The custom of making bridal furnishings even passed down to ordinary commoners, especially in western Japan, spreading nationwide in the early modern age (1868–1945) and continuing in some places even to this day. These furnishings ceased to be the showpieces of upper-class weddings, but now met the everyday needs of a lifetime, from marriage on. Typical items included chests, trunks, hampers, mirrors and mirror stands, clothes racks, cosmetic cases, and sewing boxes—indeed, many of the pieces discussed in the first part of this book.

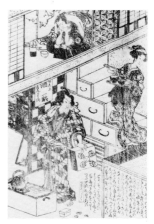

Ascending a stairway chest

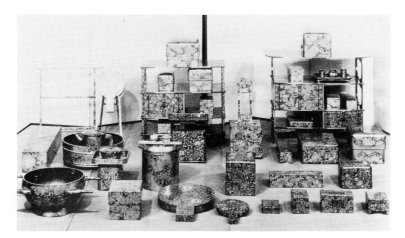

Full array of bridal furnishings

Overall, furniture design, especially toward the end of the Edo period, was characterized by two trends. On the one hand, furnishings became more standardized and were less freely executed. This was particularly true with upper-class furnishings, which had a longer history of precedents. Even *suki*-influenced furnishings became increasingly contrived, as great skill was used to work "accidental" natural materials into preconceived molds. On the other hand, cabinetry of the period was sturdy and practical. The *tansu* that antique collectors today prize for their design were generally made in the early modern age. Even so, the arts of lacquering disseminated from Kyoto during this period, and in some regions lacquer-favored styles flourished: *shunkei* lacquer in Gifu and Akita prefectures (see plate 18) and *tsuishu* in Murakami, Niigata Prefecture, to name but two.

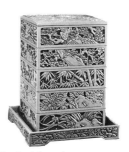

Stacked box done in *tsuishu* carved lacquer, Murakami

THE EARLY MODERN AGE (1868–1945)

The dichotomy of East and West. By the early twentieth century, many had eagerly embraced some form of Western culture, and Western-style drawing rooms became the fashion of the day.

Early Meiji-era chair with *maki-e* embellishment

When the Tokugawa shogunate finally fell in 1868, the first order of national importance became modernization, that is to say, westernization. Rapid changes in lifestyle had visible effects on architecture and furnishings in the Meiji (1868–1912), Taishō (1912–26), and prewar Shōwa (1926 to present) eras, the initial transition period being roughly divisible into three stages: the beginning of the Meiji era until around the Russo-Japanese War (1904–05), the end of the Meiji era until the Tokyo Earthquake of 1923, and the early Shōwa years.

From the very outset, the Meiji government began a program of "facelifting" in the city of Edo in an effort to transform it into the new "Eastern Capital," Tokyo. Major public buildings were erected under the guidance of Western architects and technicians; the Akasaka Detached Palace built for the imperial family was modeled

Akasaka Detached Palace (exterior view)

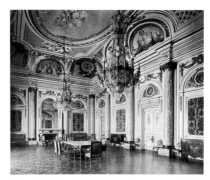

Akasaka Detached Palace (interior view)

Meiji-era working conditions, telephone company

after Versailles. Many private industrialists followed suit, and had their businesses located in Western-style premises. It even became fashionable to receive guests in a Western addition built onto one's house—initially in an awkward affectation of Western decor patched onto traditional woodframe architecture, but later of authentic brick construction. Nonetheless, few would have thought of actually living anywhere but in the Japanese wing of their homes.

After World War I, amidst an atmosphere of prosperity, reinforced concrete office buildings made their appearance, and even the middle class took to "cultured homes" (*bunka jūtaku*) complete with entryways, drawing rooms, and studies in the

Art Nouveau or Secession styles. Most Japanese in the cities were straddling lifestyles at this point, sitting in chairs at the workplace and when decorum required, but feeling more comfortable on tatami mats.

Then, in the early Shōwa era, came the Modernist architecture of the Bauhaus and of Le Corbusier, while a growing sense of nationalism fired by militarist elements prompted a reevaluation of Japanese traditions. Still, the social life of Japan was conducted at chair-and-table height; the Japanese would never go back to completely tatami-style living.

"Cultured home" with a Western-style reception area (right) and Japanese-style living quarters (left)

Before mourning the passing of old Japan, however, it should be noted that the early modern age at last saw a wide variety of traditional Japanese furniture reach the common people, and as a result there was a blossoming of regional styles. Furthermore, many new furnishings for lighting, heating, and food service came into use.

The furnishings most representative of regional styles were *tansu* chests. In Tokyo and the surrounding Kanto region there were unfinished paulownia chests with plain but solid metal fittings. In the Kansai region centered around Kyoto and Osaka, chests made of paulownia or cryptomeria were given a black lacquer finish and delicately shaped fittings. On the southwestern islands of Kyushu and Shikoku, *tansu* were made broad and tall, with numerous drawers large and small, and hinged or drop-fitted door compartments. Many had complicated trick features such as hidden drawers or false bottoms. Some pieces were extravagantly finished with bird-and-flower motifs in mother-of-pearl inlay in black lacquer. The city of Sendai to the far north in the Tohoku region was famous for wide zelkova chests decorated with perhaps the finest metalwork in all of Japan (see plate 6): large plate-fittings were cut, chased, and embossed in intricate lion, dragon, and arabesque designs. The Hokuriku region on the opposite side of northern Honshu was also known for zelkova *tansu*. More specifically, those from the port of Sakata (see plate 2) were often finished in *fuki-urushi* lacquer and had large areas cased in thick iron fittings; those from the nearby castle town of Tsuruoka included black-lacquered paulownia and cryptomeria pieces replete with lacquer-toned hardware in pine-bamboo-plum, crane-and-turtle, or other auspicious motifs (see plate 3). Further down the Japan Sea coast, landowners in the port town of Niigata had stronger chests specially made of zelkova throughout (see plate 24), with careful but quiet *fuki-urushi* lacquer finishes. Across the strait from Niigata lay Sado Island and the *tansu*-producing towns of Ogi and Yawata. Both made chest-on-chest pieces having two full-width drawers top and bottom. But whereas Ogi *tansu* were of *fuki-urushi*-finished zelkova with oversized decorative hardware (see plate 5), Yawata *tansu* faced plain or black-lacquered paulownia with rectangular and straight-edged openwork iron plates large enough to nearly cover entire drawer fronts.

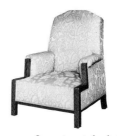

Single-panel screen showing Art Nouveau influences

Japanese Secession-style chair

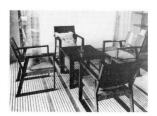

Japanese Bauhaus-influenced chair-and-table set

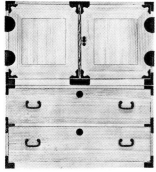

Chest, Tokyo

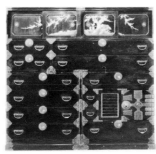

Chest, Kyushu

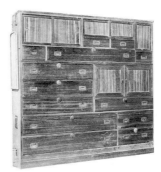

Chest, Shikoku

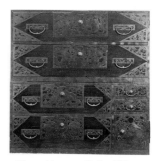

Chest, Yawata, Sado, Niigata Prefecture

Large zelkova chests were again the order of the day in the Toyama, Fukui, and Kanazawa (see plate 27) districts, also on the Japan Sea side of Honshu, while inland around Matsumoto in the mountainous reaches of Nagano, merchants preferred small, sturdy ledger chests (*chōba-dansu*) with angular metal fittings (see plate 18). In Takayama, the "little Kyoto" in the mountains of Gifu further west, simple yet exceptionally refined zelkova and cypress chests were finished in a warm amber *shunkei* lacquer (see plate 26), frequently without metal fittings. The list of popular regional styles could go on and on.

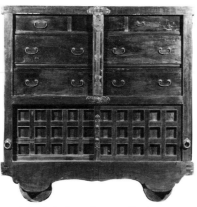

Wheeled chest, Toyama Prefecture

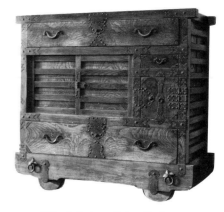

Wheeled chest, Fukui Prefecture

At the same time, government functionaries and wealthy entrepreneurs during the prosperous late Meiji to early Taishō years sought a distinct look in Japanese-style furnishings more related to the clean-line *sukiya* architectural tradition. Not limited to specific types of furniture—there were decorative shelves, small chests of drawers, writing tables and boxes, flower stands, tobacco trays, and braziers, among others—all were executed with a singular precision that still stands as an all-time high point in Japanese woodworking. Drawers were planed to such exact dimensions that they could be interchanged or inverted and still fit within a hairbreadth of space; boxes were made absolutely watertight without any glue; "seamless" surfaces hid complex joinery of an unbelievably high order. Unlike upper-class furnishings of earlier periods, the appeal of these pieces had nothing to do with elegant lacquer or *maki-e* finishes; rather, judicious selection of fine-grained and well-cured mulberry, zelkova, plum, paulownia, ironwood, or boxwood, and balancing of the total design made for a grace that showed best with only the most delicate transparent finish or none at all.

Westernization had immediate effects on lighting. Kerosene lamps entered Japan early on in the Meiji era and were soon produced domestically (see plates 77–79), so that by the turn of the century their use had spread nationwide, replacing more traditional candlestands and oil lamps. Natural gas lamps were also among early imports, but were used almost exclusively to light streets and other public works until the advent of brighter refractory mantles. Yet by the end of the era, gas companies had been established, while single-mantle lamps had gained wide acceptance in Japanese households and multiple-mantle lamps in most major buildings. Eventually, however, as everywhere else in the world, when electric lighting caught on during the early Shōwa era, gas was relegated to heating and cooking.

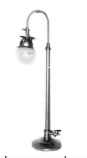

Japanese gas lamp

Meiji-period street by gaslight

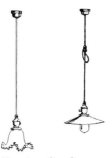

Electric ceiling fixtures

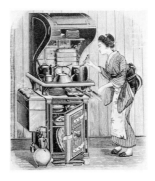

Western-style gas range

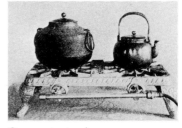

Gas counter-top burners

By 1909 a Japanese musical instrument maker had imported fine-grade slicing machinery from Germany, and was producing veneered wood. Soon after World War I, Japan was exporting cheap veneer sheets. This trend toward lower costs also led to the use of lesser woods such as Nara oak and beech, and to mass production techniques. At first these innovations were applied only to the manufacture of Western-style furnishings, but quickly enough they came to be used in making newer hybrid types of furniture. The most typical of these "Japanese-Western" (*wayō-setchū*) items was the low dining table (*chabudai*), which allowed communal dining from tabletop serving dishes in the Western style while sitting on the floor in the Japanese manner.

First mass-produced Japanese furniture

*　　*　　*

Only after World War II did an international lifestyle and Western household furnishings really catch on in Japan. Dramatic improvements in the means of transportation and communication had shortened distances to the West, greatly facilitating the traffic of persons, material goods, and ideas. Added to this was the general collapse of tradition and the desire coming on the heels of national defeat to make a clean break with the past. Moreover, the transition from an agrarian to an industrial nation brought rapid economic growth and increased capacity to buy the trappings of foreign culture.

Perhaps the most fundamental shift in the postwar Japanese lifestyle came about through the rise of the nuclear family and smaller dwellings. Rapid urbanization brought about fundamental changes in the structure of society and in people's thinking, eroding faith in the old forms and traditions. The new cultural goal that emerged at this time was the American lifestyle—albeit the living room–kitchen–children's room ideal could only be had in a miniature apartment-size version. Yet it seemed clear the dream life of "convenience" and "comfort" could be attained with Western furnishings such as chairs, tables, and beds. At the same time, industrialized mass production increased supplies and lowered costs, making the dream an obtainable reality. Thus, according to a 1983 nationwide survey conducted by the Japanese government's Economic Planning Agency, 65.1% of all households (farming households included) had dining-room sets (dining table and chairs), 47.5% had Western-style beds, and 40.5% had sitting-room sets (sofa, armchairs, and coffee table).

Nonetheless, even though to Western eyes the "pure" Japanese lifestyle has all but disappeared, the majority of Japanese hold a special place in their hearts for tatami-floored rooms and traditional furnishings. Even today, apartments and houses will generally have one Japanese-style room. In fact, many busy urbanites find the simplicity of a room with tatami and *tansu* a refreshing and soothing change of pace from their all-too-Western surroundings, and dream of someday being able to retire to a Japanese-style villa. And it should be noted that they are probably not alone, for furnishings and other accouterments of Japanese living are now cherished abroad as among the finest in the world, providing a welcome touch to homes everywhere.

READERS' ADVANTAGE™ ENROLLMENT FORM

I am filling this form out for:

☐ Myself ☐ A Gift: Name of the Giver

First Name Initial(s) Last Name

STEP 1: MEMBER INFORMATION

☐ Mr. ☐ Mrs. ☐ Ms. ☐ Miss ☐ Other

First Name Initial(s) Last Name

Address Apt.

City State ZIP

Home Telephone Number E-Mail Address

Telephone numbers will be used for customer
service and security purposes only.

Periodically, we will notify you of special offers, events, and other member benefits. Since the most timely and relevant messages
about Readers' Advantage will frequently be sent by e-mail, we recommend that you provide us with your e-mail address.

STEP 2: READ BELOW TO ENJOY CONTINUOUS MEMBERSHIP BENEFITS *(Not applicable for gift option)*

☐ I would like to enroll in the **Automatic Renewal Plan** to ensure uninterrupted enjoyment of my Readers' Advantage privileges,
and to have the exclusive option of receiving a **FREE additional membership card** for another member of my household. By selecting
the renewal plan, I authorize Barnes & Noble, Inc. to renew my annual membership each year until I notify them otherwise. I understand
that my annual membership fee* (plus applicable taxes) will be billed to my credit card automatically.

Charge My : ☐ MasterCard ☐ Visa ☐ American Express ☐ Discover ☐ Diners Card ☐ JCB

Card Number: Expiration:
 Month Year

By enrolling in auto-renewal, I would like to receive a free additional card for:

First Name Initial(s) Last Name

E-Mail Address (Optional)

STEP 3: PLEASE READ AND SIGN BELOW

By signing below I accept all the **Terms and Conditions** of the Readers' Advantage Program. If I have chosen the Automatic Renewal
Plan, my signature below also authorizes the use of my credit card for program renewal.

Signature: _____ Date: _____

STEP 4: PLEASE TELL US ABOUT YOURSELF *(Optional)*

On average, how many books do you buy **per year** from: ☐ Amazon ☐ Borders ☐ Barnes & Noble ☐ Other

Why do you buy books? (check all that apply): ☐ Tools for work ☐ For school (educator) ☐ Give as gifts
 ☐ For children ☐ For school/continuing education

We respect your privacy. It is our policy not to sell or provide individual customer information to anyone outside Barnes & Noble, Inc. or its subsidiaries.
*For more information, you can obtain a copy of the Terms & Conditions and Privacy Policy at the information desk at any Barnes & Noble bookstore, or visit www.bn.com

BARNES&NOBLE
www.bn.com

BN-ENR

Internal Use Only

Affix Card Sticker Here

PRINTED IN CANADA

3

THE
TECHNIQUES

WOOD

THE WOODWORKER'S THREE CRITERIA

Japanese craftsmen came to know and respect many woods for their inherent characteristics, applying each to its best advantage. By far the three most sought-after qualities were resistance to stress and distortion, ease of crafting, and beauty. Let us consider each of these requirements in turn.

First, certain woods "breathe" more than others, expanding and contracting with moisture and dryness so that they warp or split—flaws the Japanese refer to as *kurui*. Evergreen woods tend to be less prone to moisture-related imperfections than broadleaf varieties. Naturally, the more resilient the wood, the less likely it is to crack; the more densely lignified, the less it will "give."

Woods comparatively free of *kurui* include paulownia, Japanese cypress, cryptomeria, Sawara cypress, fir, Japanese pagoda-tree, mulberry, Amur cork-tree, Shioji ash, and yew. Among the varieties with greater *kurui* tendencies are zelkova, Japanese judas-tree, Japanese chestnut, horse chestnut, and pine—particularly those resinous sapwood pines known as *koematsu*, or "fat pine." Yet even varieties that might otherwise have been avoided for fear of flaws were used if they had desirable qualities. In such cases, special steps were taken to reduce risks.

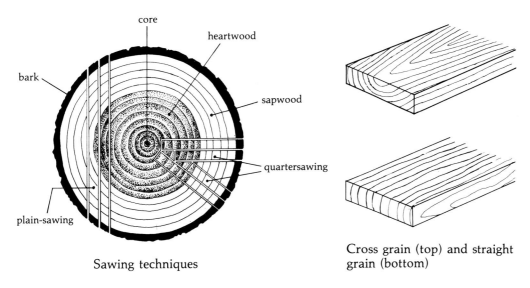

Sawing techniques

Cross grain (top) and straight grain (bottom)

Furniture makers were careful to select materials free from knots, cracks caused by improper drying, rotting, pitch pockets, uneven grain, or abnormal hard spots. Care was also taken not to use the very heartwood of the tree, which easily splits open, and instead use only non-core materials. Of course, Japanese craftsmen paid additional attention to the particular cut of the wood: plain- (or tangent-) sawing the length of a log across the annual rings produces cross-grained planks with an open texture of widely spaced, meandering markings; quartering the log lengthwise into four wedges and then cutting into planks (quartersawing) yields straight-grained timbers densely stratified in fine, straight lines for greater strength. And since the grain runs straight through quartersawed wood, the expansion-contraction rate for opposite faces, back and front, left and right, is equal, lessening the chance of warping.

At the drying stage, care is taken to ensure slow, even evaporation of moisture. The smaller the exposed surface area, the slower the process, hence logs are allowed to dry without stripping the bark, the cut ends painted or covered with paper or nailed over with boards. Logs are stored away from sunlight and precipitation, and out of direct contact with the ground, so that the ambient moisture level remains fairly con-

stant. As much as possible, "breathing space" is left between the logs, and they are shifted about from time to time to improve air circulation. Exceptions to the rule are made in the case of paulownia and other woods with a high concentration of alkaline impurities. These woods are left out in the rain or soaked in large troughs of water to leach out the undesirable substances. All these techniques contrast markedly with those of the modern lumber industry, where artificial drying methods employing gas kilns, warm air currents, chemical drying agents, or even ultraviolet irradiation speed up the process.

Careful woodworking practices can also greatly extend the range of usable woods. Thin boards can be backed with other materials or laminated in cross-grain layers. Board faces can be alternated front and back as necessary to conceal blemishes. Special schemes of joinery and reinforcement are also important: allowing ample space for expansion and contraction, affixing hidden crosspieces behind cosmetic surfaces, extending board edges to cover flaws, and so on.

The second characteristic, ease of crafting, again has to do with the relative hardness and grain of woods. Among the woods considered best overall for woodworking are Japanese cypress, paulownia, mulberry, Japanese judas-tree, fir, and straight-grained timbers of cryptomeria and pine; somewhat less than optimum are zelkova, Shioji ash, hemlock-spruce, Japanese chestnut, imported woods (*karaki*), and plain-sawed cryptomeria. For more sculptural carving, cherry, zelkova, Japanese pagoda-tree, boxwood, and yew are best. On the other hand, certain *karaki* woods and Japanese chestnut are notoriously poor at taking nails.

Third, the beauty of the wood is related to the natural luster and grain patterns on its surfaces. On the one hand, a rule of thumb runs that the harder the wood, the finer its luster, with Japanese chestnut, black persimmon, boxwood, and *karaki* at the top of the list. Beautiful wood-grain effects, on the other hand, fall into several distinct categories: "jewel patterns" (*tama-moku*), "crepe-silk patterns" (*chirimen-moku*), "silver patterns" (*gin-moku*), and "ripple patterns" (*hajō-moku*). Jewel patterns occur in woods with irregular annual rings, especially when sawed to reveal marbled whorls. Also known as "fish-scale patterns" (*jorin-moku*), "peony patterns" (*botan-moku*), "grape patterns" (*budō-moku*), "condensation patterns" (*chijire-moku*), or "bird's-eye patterns" (*chōgan-moku*), they are commonly found in the trunks of Japanese chestnut, camphor, zelkova, Shioji ash, Japanese maple, and horse chestnut trees. Crepe-silk patterns appear in straight-grained timbers as small, repeating vertebra-like knots of a silken luster running down the length of the grain, and are most often seen in horse chestnut. Silver patterns resemble broad-swatched "vertebrae," are more irregularly spaced than those of the above crepe-silk pattern, and are common to Nara oak and evergreen-oak. Finally, ripple patterns are caused by wavy configurations of wood fibers that manifest as horizontal bands playing across the straight grain, particularly in Japanese maple.

Overall, the woods most used for furniture with plain wood or lightly finished surfaces were mulberry, persimmon, yew, cryptomeria, paulownia, Japanese pagoda-tree, zelkova, Japanese chestnut, Shioji ash, and horse chestnut; those most used under heavier coats of lacquer were Japanese cypress, magnolia, and Japanese judas-tree; while those typically used for secondary or unexposed members were cheaper grades of paulownia and cryptomeria.

ANNOTATED LIST OF WOODS

Many different varieties of wood were used in traditional Japanese furniture. In grouping these, it makes more sense not to classify them as softwoods and hardwoods, but rather to view them in the Japanese way, as evergreen and broadleaf woods, which is truer to their actual appearance and respective uses.

EVERGREEN WOODS

■ *HINOKI* CYPRESS (*hinoki*; *Chamaecyparis obtusa*). The prime variety of Japanese cypress, it has been known and appreciated since ancient times. Its habitat extends

from the mountainous reaches of Fukushima Prefecture in the north to Shikoku as its southernmost limit. The best timbers are known by their region of origin: *Kiso-mono* from the Kiso Valley and *Hida-mono* from the Hida back country (both in Gifu Prefecture), *Bishū-mono* from Aichi Prefecture, *Kishū-mono* from Wakayama Prefecture, and *Yoshino-mono* from Nara Prefecture.

Resilient, resistant to cracking and warping, and comparatively lightweight for its density, Japanese cypress is of the optimum hardness for woodworking. It stands up to moisture and wears well. Long preferred in Japan for its characteristic whiteness and fragrance and as a symbol of purity, it was revered as a sacred tree and used in shrine and temple architecture, as well as for upper-class dwellings. Shinto ritual implements are likewise made of *hinoki* cypress, as are almost all celebratory utensils traditionally used in the home on auspicious occasions. The bark of the tree also yields shingles for roofing shrines, temples, and upper-class dwellings. *Sawara* (*Chamaecyparis pisifera*) is another kind of native cypress, sometimes called pea-fruited cypress.

■JAPANESE CRYPTOMERIA or CEDAR (*sugi*; *Cryptomeria japonica*). Prevalent throughout Japan, it is found almost nowhere else in the world. The best-grade timbers come from Akita Prefecture in northern Honshu. Evenly grained, lightweight, and soft-textured, cryptomeria wood has a low oil content and a piquant aroma. It is easily split into wedges and sawed and shaved. Its ready availability nationwide makes it a primary structural timber for building. In furniture, it is used for everything from the smallest containers to large coffers (*hitsu*), trunks (*nagamochi*), writing tables and desks (*tsukue*), and shelving (*todana*). Moreover, the fragrance of cryptomeria kegs imparts a distinctive sharpness to saké in much the same way that oak barrels lend body to whiskey. The *sugi* that flourish on Yaku Island off Kyushu (*Yaku sugi*) are prized for their exceptionally vivid grain pattern, which is highly regarded for its decorative value in architecture and furniture.

■JAPANESE YEW (*ichii*; *Taxus cuspidata*). Yew grows throughout Japan, the best timbers coming from Hokkaido and the Hida-Takayama district of Gifu Prefecture. Fine-textured, dense, and resilient, its smooth grain makes it a handsome choice not only for furniture, but for craft items, Buddhist sculpture, and other art objects.

BROADLEAF WOODS

■ZELKOVA (*keyaki*; *Zelkova serrata*). With yellowish beige outer layers and an amber red toward the heartwood, zelkova is appreciated for its bold grain and high luster. A medium-hard wood, its strength lies in its great resilience and the fact that it allows very little or no expansion, contraction, or warping. The very best timbers are furthermore quite resistant to rotting. Grown on three of the four main islands of Japan—Honshu, Shikoku, and Kyushu—this member of the elm family was even used as building timbers. In furniture, it is most commonly used for such items as chests (*tansu*), trunks (*nagamochi*), and writing tables and desks (*tsukue*). It is one of the most expensive Japanese furniture woods.

■PAULOWNIA (*kiri*; *Paulownia tomentosa*). This tall deciduous tree came to Japan from the continent quite early, and now ranges from the northernmost island of Hokkaido to the Kagoshima area of southwestern Kyushu. Unusually lightweight and soft-textured for a broadleaf, it is both easy to work with and impervious to atmospheric moisture. Its expansion-contraction rate is exceptionally low, and warping and splitting are almost unheard of once boards have been shaped, planed, and assembled. The finest wood is an elegant pale cream hue. Paulownia grows so quickly that in times past farming households could plant a seedling in the yard when a daughter was born, and have a full-grown tree from which to make the requisite bridal furniture by the time she was of marrying age.

Paulownia was, of course, utilized primarily for *tansu* chests. Yet surprisingly enough, because it ranks as one of the least heat-conducting woods, it also proved to be perfect for hibachi. Furthermore, its lightness and crack-resistance made it ideal for *geta* footwear and theatrical masks.

■MULBERRY (*kuwa*; *Morus alba*). A fine-textured wood of considerable durability, luster, and beautiful grain patterns, it is easily worked, but resists warping and other flaws. Famous as the source of leaves for raising silkworms, the tree also produces prime furniture material—albeit sericultural pruning keeps trees too small in the trunk to serve both purposes. Furniture-grade wood must instead be obtained from completely wild trees, the finest of which are said to come from Okura and Miyake islands off Izu Peninsula. Some of these trees are between five hundred and a thousand years old. Unsurpassed for their rich and intricate grain, they possess a natural golden glow that is highly prized. Mulberry wood was widely used for such furniture items as dressing stands (*kyōdai*), full-length framed mirrors (*sugatami*), sewing boxes (*hari-bako*), clothes racks (*ikō*), writing tables and desks (*tsukue*), and tea chests (*cha-dansu*). In fact, mulberry tea chests were formerly so popular that along with paulownia *tansu* and zelkova long hibachi (*naga-hibachi*), they figured as one of the three representative pieces of late-nineteenth- and early-twentieth-century Japanese furniture. Mulberry wood characteristically deepens in color and glow over the years, hence its frequent use for bridal trousseau furnishings, the folk-wisdom running that it will "age beautifully with the woman."

■JAPANESE CHESTNUT (*kuri*; *Castanea crenata*). This tall deciduous member of the beech family grows in all parts of Honshu, Shikoku, and Kyushu. Its porous wood not only develops cracks and warps easily, but is too rough-grained to craft easily. Nonetheless, Japanese chestnut is tough and hard and resists water damage. It was often used for farming-household chests and coffers (*hitsu*).

■HORSE CHESTNUT (*tochi*; *Aesculus turbinata*). Tinged with either a yellowish or muddy-greenish cast in its outer layers and of a washed-out green at the heart, the wood is fine-grained, resilient, and very lustrous. With a low expansion-contraction rate, it is often used as a flooring as well as a decorative material.

IMPORTED TROPICAL WOODS *Karaki*
Aloeswood, Chinese quince, ebony, Indian ironwood, rosewood, sandlewood.

Tropical woods imported mainly from Southeast Asia, Thailand, India, and the Philippines—although some came from as far as the African and South American continents—were grouped under the generic name *karaki*, literally "Chinese trees," since woods were originally brought to Japan by way of China. Extremely hard and dense, the various *karaki* woods exhibit truly rich colors and sheen, while remaining impervious to moisture and rotting. *Karaki* furniture can be enjoyed for generation after generation, and its looks will continue to improve with a minimum of care. Hence these woods came be treasured in Japan. Rosewood furniture was found in Japan as early as the Nara period (710–94) and is preserved in the Shōsōin imperial repository. Only much later, though, in the Edo period (1600–1868) were the common classes finally able to obtain *karaki* furniture of their own, after a sizable network arose to provide increased supplies at lower prices. Typically used for shelves (*tana*), writing tables and desks (*tsukue*), decorative stands (*kadai* and *shoku*), and writing boxes (*suzuribako*).

JOINERY

Over the centuries, Japanese techniques of wood joinery were refined to a high art. Cabinetmakers and woodworkers took great pride in their skills and accomplishments, their discipline and inventiveness. They were well aware of their place in a tradition that required considerable training and knowledge.

So important was the woodworker's art that furniture came to be popularly known as *sashimono*, literally "fitted things," in recognition of these complex and often ingenious assemblages of interlocking stiles, crosspieces, and panels. Typically, the term *sashimono* referred to unfinished furniture, or at most, to pieces finished in transparent lacquer so that the joinery still showed. But, of course, the very same careful crafting went into furniture items finished in opaque lacquer. Nonetheless, this says a great deal about the Japanese tendency to group furniture items in terms of production details rather than end use, which in turn bears a strong relation to the historical development of Japanese woodworking techniques.

The earliest example of *sashimono* technique shows up in certain shaft fittings for arrowheads of the Jōmon period (ca. 10,000 B.C.–ca. 300 B.C.)—the primitive beginnings of "tenon-fitting" (*hozo-sashi*).

In the Yayoi period (ca. 300 B.C.–ca. A.D. 300), tenon-fitting techniques had become established. Studies of recently unearthed remains of Yayoi-period footed trays (*takatsuki*) and seats have revealed usage of such techniques as the plain tenon joint (*hira-hozo-tsugi*; see joinery sketches on pages 187–92, no. 31), slant "through" tenon joint (*keisha-tōshi-hozo-tsugi*, no. 33), and keyed "through" tenon joint (*kusabi-tōshi-hozo-tsugi*, no. 35).

Later, on sarcophagi of the Kofun period (ca. 300–710), the vocabulary of joinery techniques had expanded to include stopped lapped butt joints (*tsutsumi-uchitsuke-tsugi*, no. 8) and plain slot joints (*hira-oiire-tsugi*, no. 13).

By the sixth century plain edge joints (*hira-hagi-tsugi*, no. 1) and half-lapped slot joints (*katadōzuki-oiire-tsugi*, no. 14) had appeared. Nonetheless, there were as yet no mitered or complex joints.

It was not until the Nara period (710–94) that joinery really came into its own. In fact, joinery of that time progressed to a level almost on a par with that of the modern age. Surveys of woodcrafts in the Shōsōin imperial repository in Nara reveal that woodworkers had complete command of such complex techniques as dovetailed box joints (*ari-kumi-tsugi*, no. 41) and mitered concealed box joints (*tome-kakushi-kumi-tsugi*, no. 39). Certainly many of the treasures in the repository bespeak a refinement of technique easily equal to producing almost any furniture item.

This expertise did not, however, filter down to common-class furnishings until some nine centuries later in the Edo period (1600–1868). Two major reasons may be cited for this: slow development of carpentry tools and extremely limited economic growth. These two adverse conditions effectively meant that dressed lumber was in short supply and only affordable to the upper classes. Finally, in the Muromachi period (1392–1482), there appeared the two-man crosscut saw, followed in the late fifteenth to early seventeenth centuries by numerous improvements in carpentry tools, which in turn brought furniture with sophisticated joinery within reach of the average household.

The word *sashimono* dates from this period, an expression of people's strong curiosity toward the woodworker's craft. In other words, although joinery techniques had been around for a long time, precision-crafted furnishings were not part of the daily life of most Japanese households until the Edo period, so that *sashimono* joinery became synonymous with furniture in the public eye.

On economic fronts as well, specialization in *sashimono* as a distinct division of labor from architectural carpentry or other crafts did not really exist prior to the

eighteenth century, hence there had been no competitive incentive to perfect techniques.

Another factor that assisted the further growth of professional cabinetry and woodworking was the spread of tea ceremony with its emphasis on a naturalistic aesthetic. This encouraged refinements in plain-wood furniture, necessarily making fine joinery a point of appreciation.

At the same time, strict social codes in the Edo period prohibited furniture finished in lacquer and *maki-e* to all but the samurai and aristocratic classes. This was intended as one of many ways to keep the merchant and farming classes in their place and to make sure they did not squander funds that would have gone into taxes to support the samurai. Still, as samurai went bankrupt in the peacetime Edo economy while merchants grew wealthy, these townsfolk sought luxuries. Some broke the rules outright, and had lavish *maki-e* furnishings made; others opted for "hidden" luxuries. Unlacquered yet finely crafted furnishings were one example of this. To meet this increased demand, there arose a great number of woodworkers and cabinetmakers, all versed in the intricacies of joinery.

Japanese wood joinery can be broadly classified into either structural joints that bind (*kumi-te*), which include all the examples in the sketches, or joints that extend the length (*tsugi-te*). Japanese traditional furniture is assembled almost exclusively by means of the former type, the latter being used largely in architecture to extend the axial span of beams, joists, and others structural members.

Terminology is far from standardized, varying not only regionally, but even from one woodworker to the next. Every attempt has been made in this book to provide descriptive, cross-referenced terms.

Edge joints (*hagi-tsugi*, nos. 1–6) bond two boards edge to edge, typically with a coat of glue, and were most often used to produce multiple board-width shelving or side-panels for shelf units. These include the plain edge joint (*hira-hagi-tusgi*, no. 1), lapped edge joint (*aikake-hagi-tsugi*, no. 2), tongue-and-groove edge joint (*honzane-hagi-tsugi*, no. 4), and splined edge joint (*yatoizane-tsugi*, no. 5).

Butt joints (*uchitsuke-tsugi*, nos. 7, 8) secure the end of one board perpendicularly against the broadside or edge of another, with or without pegs or nails, and were used for affixing the sides on box-type furnishings and attaching shelves to shelf units. Representative of these are the plain butt joint (*hira-uchitsuke-tsugi*, no. 7) and lapped butt joint (*tsutsumi-uchitsuke-tsugi*, no. 7).

End joints (*hashibame-tsugi*, nos. 9–12) cap the ends of boards with a crosspiece to prevent panels from splitting or warping. Such edging was frequently used on cabinets (*todana*), doors, box-lids, writing tables, and desk tops. Common examples are the mitered end joint (*tome-hashibame-tsugi*, no. 9) and tongue-and-groove end joint (*honzane-hashibame-tsugi*, no. 10).

Slot joints (*oiire-tsugi*, nos. 13–18) join boards perpendicularly, the end of one housed in a groove gouged across the face of the other. They are sometimes classified together with butt joints, and like them were used on box-type furnishings and shelves. Typical of these are the plain slot joint (*hira-oiire-tsugi*, no. 13), half-lapped slot joint (*katadōzuki-oiire-tsugi*, no. 14), and dovetailed slot joint (*ari-oiire-tsugi*, no. 18).

Lap joints (*aikake-tsugi*, nos. 19–24) figure here as a means of interlocking the longitudinal faces of boards at right angles, and were often used for coffers (*hitsu*) and the like. The plain lap joint (*hira-aikake-tsugi*, no. 19) and mitered lap joint (*tome-aikake-tsugi*, no. 21) are two among many.

Miter joints (*tome-tsugi*, nos. 25–30) trim the corners off both boards where they intersect so that neither edge shows. Accordingly, they were used to conceal construction at baseboard corners and for joining the sides of box-type pieces, leaving no exposed ends. In the standard miter joint, panels meet at a 45° angle, but there are variant schemes that allow flexibility: one edge might be angled greater than 45° to meet a correspondingly lesser-angled piece, or both angles would be greater than 45°, as in the case of hexagonal or octagonal pieces. To each of these angular schemes can be adapted such basic designs as the plain miter joint (*hira-tome-tsugi*, no. 25) or slip-feathered miter joint (*hikikomi-tome-tsugi*, no. 30).

Tenon joints (*hozo-tsugi*, nos. 31–35) fit the trimmed end of one board tongue-in-groove fashion into the longitudinal face of another. They are often used in assembling the legs of writing tables and desks and other open-frame items. The tendon can either pass through the other element or stop without completely penetrating, known respectively as "through" (*tōshigata*) and "halted" (*tsutsumigata*) schemes. Either way, there are many different designs possible—plain tenon joint (*hira-hozo-tsugi*, no. 31), half-lapped tenon joint (*katadōzuki-hozo-tsugi*, no. 32), and split-wedged tenon joint (*warikusabi-hozo-tsugi*, no. 36), to name a few.

Box joints (*kumi-tsugi*, nos. 37–42) fit panels together perpendicularly or obliquely by means of various enmeshing notches, and again were used mainly for assembling box-type furnishings. Two fundamental designs are the plain box joint (*hira-kumi-tsugi*, no. 37) and dovetailed box joint (*ari-kumi-tsugi*, no. 41).

Joints for extending length, in those rare cases when used in furniture making, almost always served to increase the length or height of frame elements. More often than not, either the box-tenoned splice (*hako-hozo-tsugi-te*) or lapped splice (*aikake-tsugi-te*) were borrowed from the architectural vocabulary of longitudinal joints.

TYPES OF JOINTS

EDGE JOINTS *Hagi-tsugi*

Also called "parallel joints" or "board joints." Boards are joined side-to-side along their longitudinal edges to make one continuous, broad surface, as in board flooring.

1. PLAIN EDGE JOINT
(*hira-hagi-tsugi* or *imo-hagi-tsugi*)

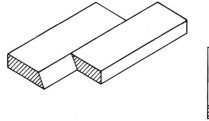

"DOWELED" (*aikugigata*)

4. TONGUE-AND-GROOVE EDGE JOINT
(*honzane-hagi-tsugi*)

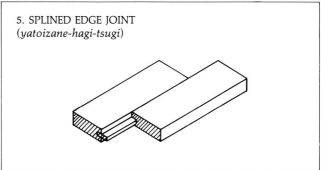

2. LAPPED EDGE JOINT (rabbeted edge joint or shiplap joint)
(*aikake-hagi-tsugi* or *aijakuri-hagi-tsugi*)

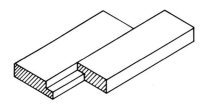

5. SPLINED EDGE JOINT
(*yatoizane-hagi-tsugi*)

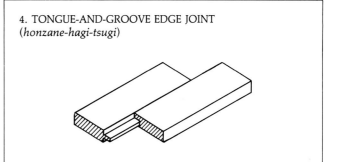

3. BEVELED EDGE JOINT OR SCARF JOINT
(*naname-hagi-tsugi* or *keisha-hagi-tsugi*)

6. DOVETAILED EDGE JOINT
(*ari-hagi-tsugi*)

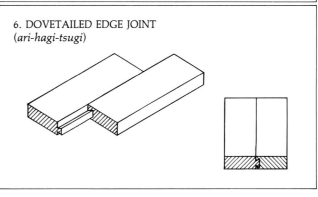

BUTT JOINTS *Uchitsuke-tsugi*

The simplest joints, also the weakest. The end of one board is butted onto another, and fastened with glue, nails, or pegs.

7. PLAIN BUTT JOINT
(*hira-uchitsuke-tsugi*)

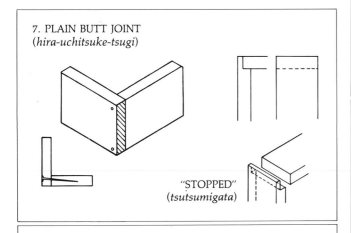

"STOPPED"
(*tsutsumigata*)

8. STOPPED LAPPED BUTT JOINT
(*tsutsumi-aikake-uchitsuke-tsugi*)

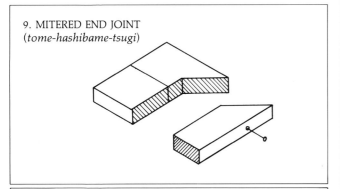

END JOINTS *Hashibame-tsugi*

Also called "clamp joints" or "breadboard ends." A board is fastened crosswise onto the end of one or more other boards to conceal the end grain, and to prevent the longitudinal movement of edge joints.

9. MITERED END JOINT
(*tome-hashibame-tsugi*)

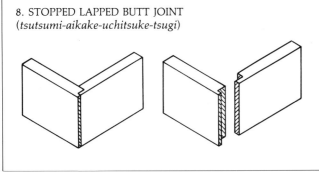

10. TONGUE-AND-GROOVE END JOINT OR STRAIGHT END JOINT
(*honzane-hashibame-tsugi* or *bō-hashibame-tsugi*)

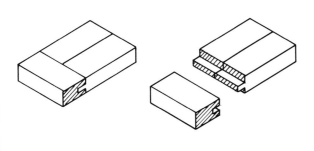

11. SPLINED END JOINT
(*yatoizane-hashibame-tsugi*)

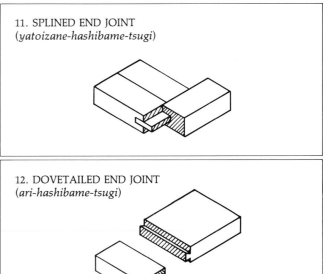

12. DOVETAILED END JOINT
(*ari-hashibame-tsugi*)

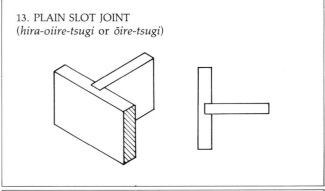

SLOT JOINTS *Oiire-tsugi*

Also called "dado joints" or "housed butt joints." A groove is cut across the midsection of one board into which the end of another board is fitted. Often used in shelf units to attach shelves to the case panels.

13. PLAIN SLOT JOINT
(*hira-oiire-tsugi* or *ōire-tsugi*)

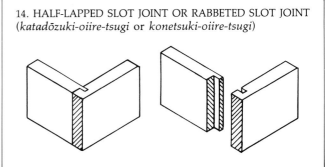

14. HALF-LAPPED SLOT JOINT OR RABBETED SLOT JOINT
(*katadōzuki-oiire-tsugi* or *konetsuki-oiire-tsugi*)

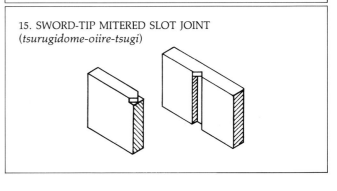

15. SWORD-TIP MITERED SLOT JOINT
(*tsurugidome-oiire-tsugi*)

16. TENONED SLOT JOINT
(*hozo-oiire-tsugi*)

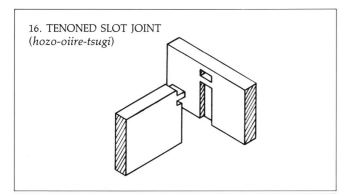

17. SPLINED SLOT JOINT
(*yatoizane-oiire-tsugi*)

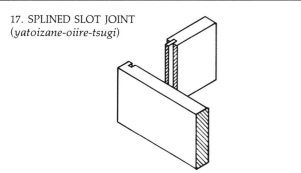

18. DOVETAILED SLOT JOINT
(*ari-oiire-tsugi* or *suitsuke-ari-tsugi*)

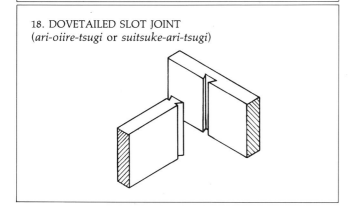

LAP JOINTS *Aikake-tsugi*

Corresponding notches are cut in the upper face of one board and the underside of another, allowing an overlapping drop-fit.

19. PLAIN LAP JOINT
(*hira-aikake-tsugi* or *aijakuri-tsugi*)

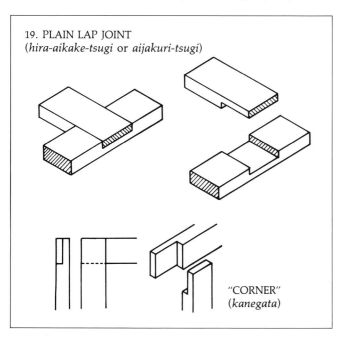

"CORNER" (*kanegata*)

20. CROSS LAP JOINT
(*jūji-aikake-tsugi*)

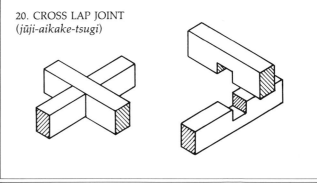

21. MITERED LAP JOINT
(*tome-aikake-tsugi*)

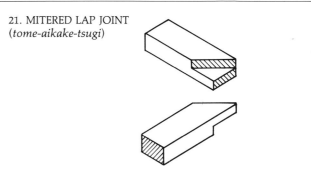

22. SHOULDERED LAP JOINT
(*atari-aikake-tsugi* or *katatsuki-aikake-tsugi*)

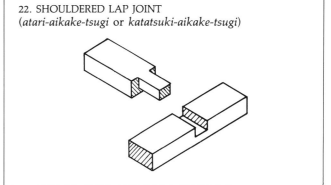

23. PEGGED LAP JOINT
(*komisen-aikake-tsugi*)

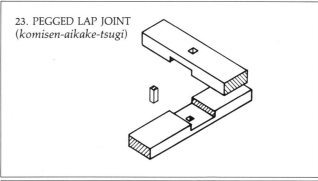

24. DOVETAILED LAP JOINT
(*ari-aikake-tsugi*)

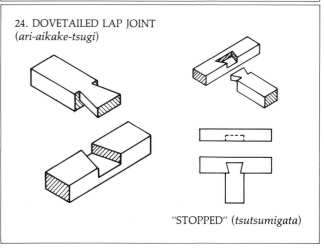

"STOPPED" (*tsutsumigata*)

MITER JOINTS *Tome-tsugi*

Essentially a type of butt joint in which boards are cut at corresponding angles, or "mitered," then fitted together. Stronger than simple butt joints, they are typically used in framing elements of stands, open shelf units, and table and seating legs.

25. PLAIN MITER JOINT
(*hira-tome-tsugi*)

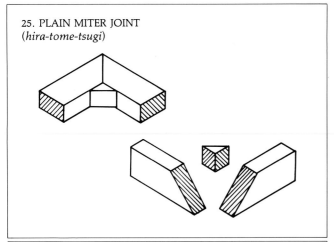

26. THREE-WAY MITER JOINT
(*sanbō-tome-tsugi*)

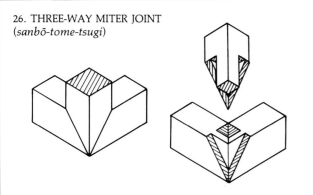

27. TENONED MITER JOINT
(*hozo-tome-tsugi*)

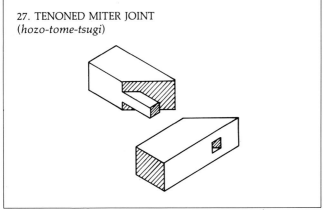

28. BOX-TENONED MITER JOINT
(*hakohozo-tome-tsugi*)

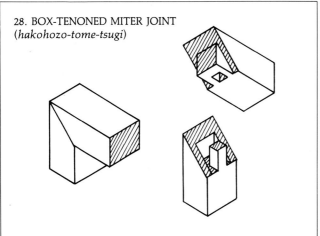

29. SPLINED MITER JOINT
(*yatoizane-tome-tsugi*)

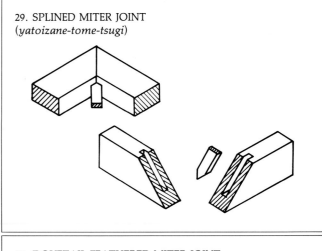

30. DOVETAIL-FEATHERED MITER JOINT
(*ari-hikikomi-tome-tsugi* or *chigiri-tome-tsugi*)

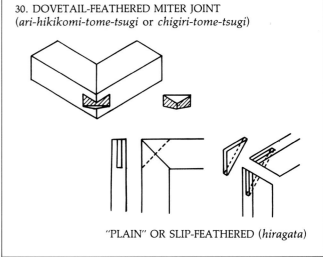

"PLAIN" OR SLIP-FEATHERED (*hiragata*)

TENON JOINTS *Hozo-tsugi*

Also called "mortise-and-tenon joints." A tonguelike tenon is made out of the end of one board, and fitted into a corresponding hole or groove in the lateral face of another board. Widely used in all framing elements, these are among the most secure joints in Japanese cabinetry.

31. PLAIN TENON JOINT
(*hira-hozo-tsugi*)

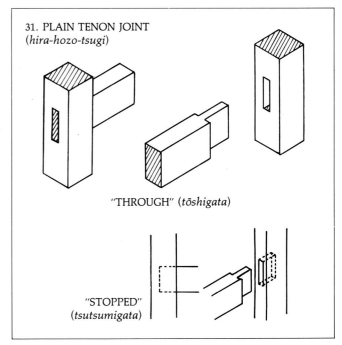

"THROUGH" (*tōshigata*)

"STOPPED"
(*tsutsumigata*)

32. HALF-LAPPED TENON JOINT
(*katadōzuki-hozo-tsugi*)

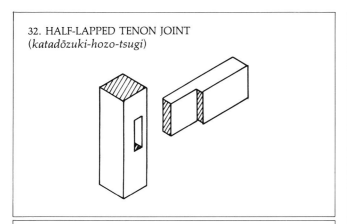

33. BEVELED TENON JOINT OR SLANT TENON JOINT
(*naname-hozo-tsugi* or *keisha-hozo-tsugi*)

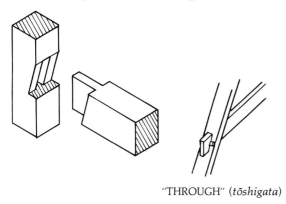

"THROUGH" (*tōshigata*)

34. SWORD-TIP MITERED TENON JOINT
(*tsurugidome-hozo-tsugi*)

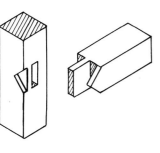

35. PEGGED TENON JOINT OR KEYED TENON JOINT
(*komisen-hozo-tsugi* or *kusabi-hozo-tsugi*)

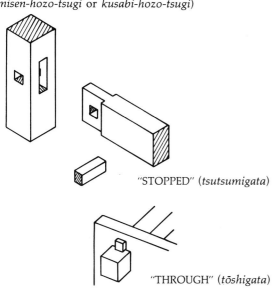

"STOPPED" (*tsutsumigata*)

"THROUGH" (*tōshigata*)

36. SPLIT-WEDGED TENON JOINT
(*warikusabi-hozo-tsugi*)

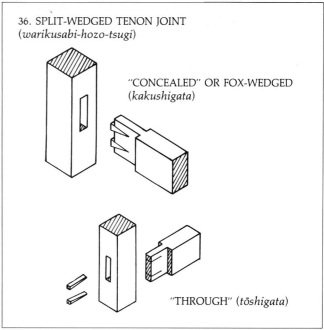

"CONCEALED" OR FOX-WEDGED
(*kakushigata*)

"THROUGH" (*tōshigata*)

BOX JOINTS *Kumi-tsugi*

Also called "open-mortise corner joints" or "slip joints." A mortise is notched in the end of one board, a tenon or narrow midriff into the end of another, then they are fitted together tongue-and-groove. Used for framing elements; multiple mortise-and-tenon compound box joints are used to make drawers.

37. PLAIN BOX JOINT OR BRIDLE JOINT
(*hira-kumi-tsugi* or *sanmai-tsugi*)

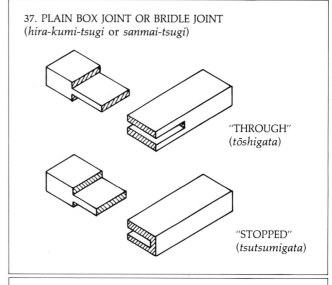

"THROUGH"
(*tōshigata*)

"STOPPED"
(*tsutsumigata*)

38. LAPPED BOX JOINT OR LAPPED BRIDLE JOINT
(*aikake-kumi-tsugi* or *aikake-sanmai-tsugi*)

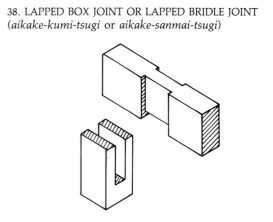

39. MITERED BOX JOINT OR MITERED BRIDLE JOINT
(*tome-kumi-tsugi* or *tome-sanmai-tsugi*)

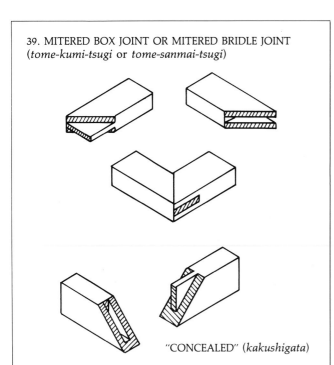

"CONCEALED" (*kakushigata*)

40. MITERED DOVETAIL BOX JOINT
(*tome-ari-kumi-tsugi* or *tome-ari-sanmai-tsugi*)

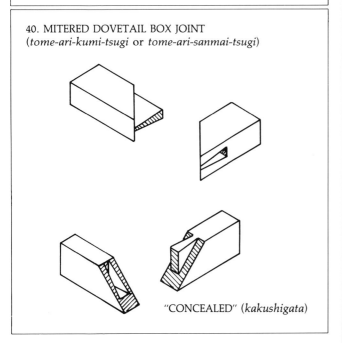

"CONCEALED" (*kakushigata*)

41. DOVETAILED BOX JOINT OR DOVETAILED BRIDLE JOINT
(*ari-kumi-tsugi* or *ari-sanmai-tsugi*)

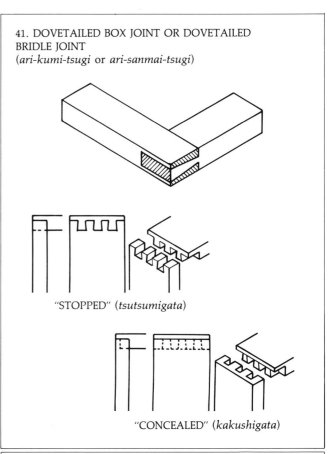

"STOPPED" (*tsutsumigata*)

"CONCEALED" (*kakushigata*)

42. INVERSE DOVETAILED BOX JOINT
(*uchi-ari-kumi-tsugi*)

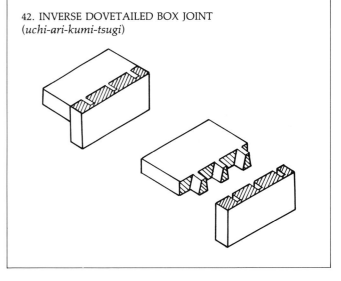

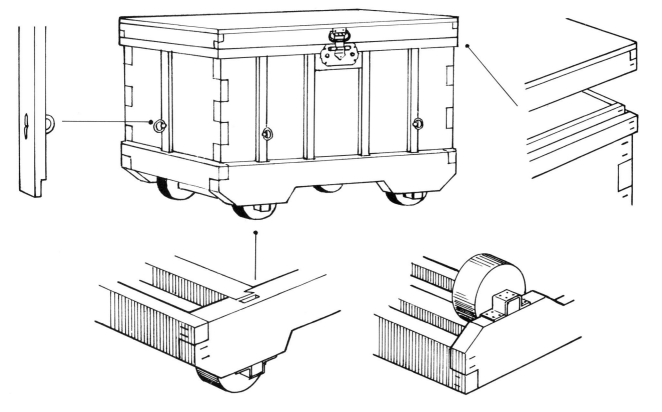

Typical joinery work for wheeled trunk

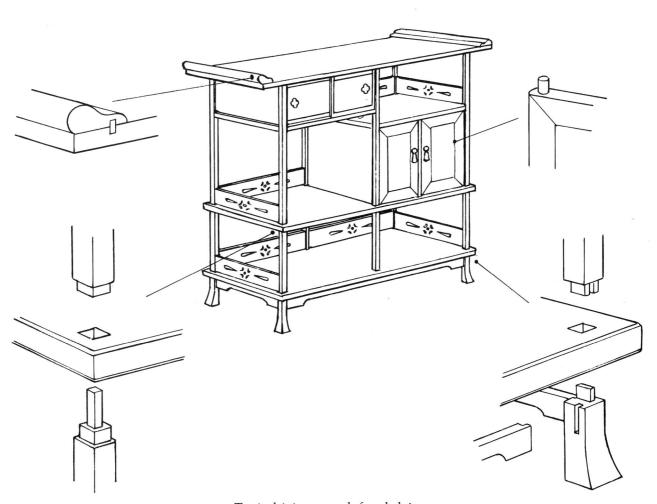

Typical joinery work for shelving

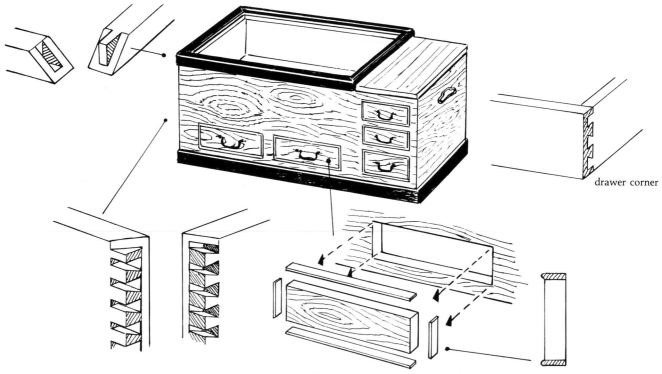

drawer corner

Thin wood strips frame the drawers and at the same time fill in the gaps left after sawing.

Typical long hibachi joinery and drawer work

Typical joinery work for writing table

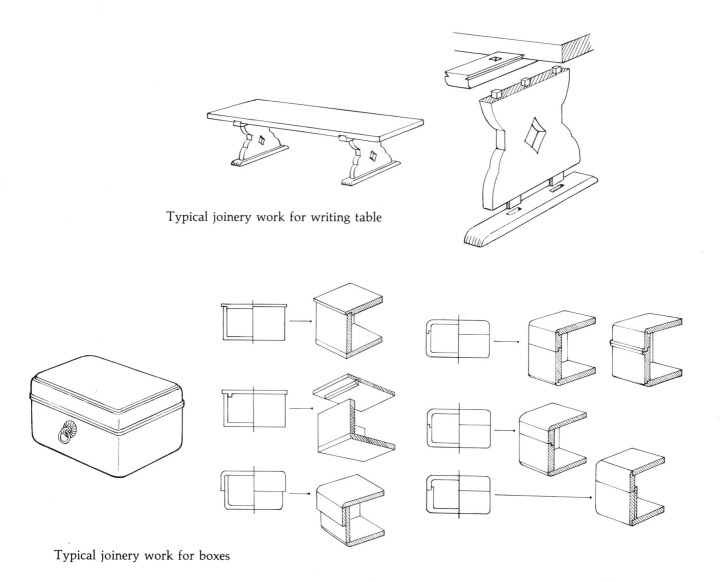

Typical joinery work for boxes

FINISHES

Traditional Japanese wooden furnishings were given different finishes according to their intended use and the nature of their wood surfaces. Over time many furniture items became associated with particular finishing practices, but in general the original purpose of applying finishes was to protect and seal the wood, while also heightening the decorative appeal. Furthermore, smoother finished surfaces often improved the usefulness of furnishings, especially heavy-duty storage units, and occasionally lacquer itself acted as an adhesive for joinery.

Lacquering techniques have an extremely long history in China, Korea, Thailand, and throughout Southeast Asia, and are known to have reached Japan by the Jōmon period (ca. 10,000 B.C.–ca. 300 B.C.).

The refined sap of the sumac-family lacquer plant (*urushi*; *Rhus verniciflua*)—not to be confused with synthetic Western opaque "lacquer" varnishes—requires special skill in handling, not only because it is highly reactive and can cause severe rashes, but also due to its unusual drying requirements. *Urushi*, as the liquid is likewise known, does not harden through evaporation as do most other finishes. Rather, the process depends on the interaction of oxygen and the oily substance urushiol, which most effectively bonds its constituent latex to wood surfaces under conditions of high temperature and humidity. Lacquerwork is often done in an *urushi-buro*, a special room where a damp, dust-free atmosphere can be maintained. The optimum temperature range for slow, even drying is between 107° F (40° C) and 146° F (60° C). Above that point, lacquer suddenly refuses to harden until a 220° F (100° C) threshold is passed; then hardening time rapidly decreases with rising temperatures regardless of the moisture factor. Once dry, however, the surface becomes impervious to acids and alkali, salts, and alcohol; it repels water, guards against rotting, and, surprisingly, makes for good heat and electrical insulation. More than even its sealing qualities, though, lacquer is known for its beautifully rich and sleek appearance.

There are many kinds of lacquer finishes, transparent and opaque, plain and decorated. The difficulty and expense of these lacquering techniques also vary greatly.

KIJIRO LACQUER

Undoubtedly the most extensively used transparent finish, it is applied on almost any wood with beautiful grain patterns, but produces especially outstanding results on zelkova, Japanese maple, and horse chestnut. The base can either be left its natural hue or tinted yellow or red, although in lighter shades than *shunkei* lacquer. Wood surfaces are typically polished with a fine whetstone to smooth all plane marks and accentuate the wood grain before lacquering and buffing. *Kijiro* was the representative finish for chests (*tansu*) from the Sendai area. (For the step-by-step process, see pages 198–200.)

FUKI-URUSHI LACQUER

This "wiped-on" lacquer technique, sometimes called *suri-urushi-nuri*, or "rubbed-in" lacquer, involves repeatedly applying clear lacquer with a cloth or brush, then removing the excess until the wood is sufficiently saturated and a thin layer is built up over the surface. It provides a low luster and smooths over minor pits in the wood, yet since the lacquer is made to penetrate deep into the grain, it cannot chip off like other finishes. Best suited to such strongly grained and colored woods as zelkova, chestnut, and Shioji ash, it is frequently encountered on chests from the Tohoku and Hokuriku areas, although it was also used on such diverse items as writing tables (*fuzukue*) and cabinets (*todana*).

SHUNKEI LACQUER

In this technique, a single, even coat of transparent lacquer is applied over wood that has previously been tinted yellow using gardenia seeds or gamboge, or red using iron oxide or cochineal. The result is a glossy amber or brick-red finish, handsomely shading each surface from a light center out to darker-pooled edges. Often used for tray-tables (*zen*), trays (*bon*), chests, and trunks (*nagamochi*), particularly of horse chestnut, Japanese cypress, cryptomeria, Japanese pagoda-tree, paulownia, and zelkova.

HANA LACQUER

In this technique, pigments are mixed directly into the lacquer to render it opaque, and perilla oil is added to produce an extremely high gloss. The lacquer is brushed on and requires no final sanding or buffing; typical colors are black or dark red. Most often used on tabletops, shelves (*tana*), tray-tables, writing tables, and chests.

ROIRO LACQUER

This older, more classic type of opaque lacquer requires a much more involved process to achieve a high gloss without the addition of oil, but the result is a finer and harder finish. A coat of pure black lacquer is applied to the prepared smooth wood surface, polished with wood charcoal when dry, repeatedly rubbed *fuki-urushi* fashion with raw lacquer, then repolished with soft *washi* (Japanese paper) or a cotton cloth soaked in rapeseed oil and powdered deerhorn. Used for high-quality shelving, writing tables, chests, and other furnishings where the expense of this laborious technique is no object.

NEGORO LACQUER

In this variation of *hana* lacquer, a coat of vermilion lacquer is applied over black lacquer, and is then allowed to wear away naturally, exposing patches of the black undercoat. *Negoro* lacquer was originally used for ceremonial implements and furnishings in Buddhist temples—the name *negoro* supposedly derives from a temple called Negoroji—but eventually the tasteful subtlety of its worn look commended the technique to such everyday household effects as trays, tray-tables, writing tables and desks, coffers, and candlestands.

YASHA DRY FINISH

On chests of paulownia, which the Japanese prefer not to lacquer, exposed wood surfaces are often treated with a liquid obtained by boiling the seeds of the birch-family shrub *yashabushi*. This dyes the wood a delicate shade close to its natural hue, while bringing out the grain and protecting against rotting.

MAKI-E

The generic term for all embellishment or designs in powdered gold or silver applied to lacquer, *maki-e* includes decorations in high relief (*taka-maki-e*), burnished relief (*togidashi-maki-e*), low relief (*hira-maki-e*), and those worked into the lacquer ground as overall patterns (*ji-maki-e*). *Maki-e* decoration found use on a wide range of furnishings from shelving, chests, and trunks to coffers, writing tables, and trays.

MOTHER-OF-PEARL INLAY *Raden*

Raden abalone-shell inlay involves basically the same processes as Western mother-of-pearl techniques, and is equally expensive, hence it is seen only on high-quality furniture items. Unlike *maki-e*, which was developed in Japan, *raden* found its way to the island country from T'ang-dynasty China in ancient times. Often used in tandem with *maki-e*, it is especially effective on black lacquer.

TSUISHU CARVED LACQUER

This Sung-dynasty Chinese technique of gouging designs out of thickly layered lac-

quer reached Japan in the Kamakura period (1185–1333). The term *tsuishu*, or "carved vermilion" lacquer, refers generically to carved black or yellow lacquer finishes as well—more precisely *tsuikoku* and *tsuiō* (Ch. *t'ihong*, *t'ipei*, and *t'ihuang*, respectively). *Tsuishu* may be worked into deep-cut bird-and-flower designs, figure-in-landscape scenes, or curvilinear arabesques called *guri* or *guri-guri*. This technique is often seen on such mealtime furnishings as trays or sweets boxes (*jikirō*), or on such study furnishings as writing boxes (*suzuribako*), *sho-dana* shelving, and letter boxes (*fumibako*).

KAMAKURA-BORI LACQUER

Originally conceived as a Japanese imitation of *tsuishu* finishing, this technique substitutes a few layers of lacquer on carved wood for the time-consuming process of building up thick layers of pure lacquer. In general, black lacquer serves as an undercoat for top coats of vermilion lacquer. As the name suggests, the technique has roots in Kamakura, a center of Buddhism from the late twelfth century on, from when *Kamakura-bori* was used on special wooden backpacks (*oi*) in which itinerant priests kept clothing and ritual implements. *Kamakura-bori* lacquer is generally preferred for small furniture items such as tray-tables, trays, tobacco trays, and writing boxes, although larger pieces such as dressing stands (*kyōdai*), shelves, and writing tables are sometimes also finished in this manner.

Mother-of-pearl inlay

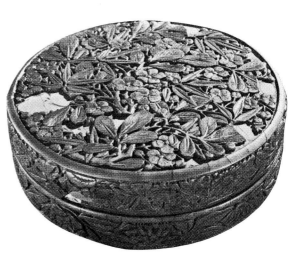

Tsuishu carved lacquer

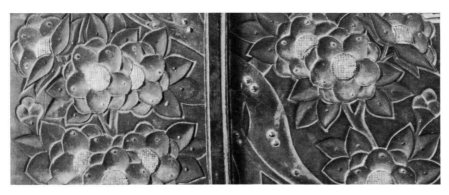

Kamakura-bori lacquer

TYPICAL *KIJIRO* LACQUERING TECHNIQUE

FILTERING THE LACQUER

Freshly tapped raw lacquer is filtered through linen cloth to remove bits of bark and other impurities. Two wooden spatulas are used to transfer small quantities of the lacquer to the cloth, which is then wrung out.

REFINING THE LACQUER

The lacquer is poured into a pot and stirred continuously over very low heat to evaporate excess moisture. The originally light-colored liquid turns into a dark, thick syrup and is put into a bowl for keeping.

1. FILLING THE WOOD

The wood surface is first moistened with a brush to allow dents and plane marks to swell and become flush. Next, finely powdered baked earth is applied to the surface, which is leveled with a whetstone.

2. SEALING THE WOOD

A mixture of lacquer and powdered whetstone is applied with a wooden spatula and worked in, then the excess is wiped away.

3. RUBBING

The wood is left to dry for one day, then rubbed with a medium whetstone. The surface becomes extremely light-colored and absolutely smooth.

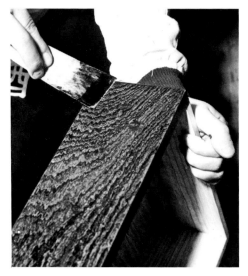

4. APPLYING RAW LACQUER

Filtered but unrefined lacquer is worked into the wood surface. Raw lacquer is preferred for its superior ability to penetrate and harden the wood grain.

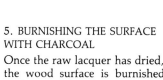

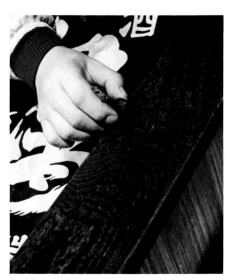

5. BURNISHING THE SURFACE WITH CHARCOAL

Once the raw lacquer has dried, the wood surface is burnished with charcoal and water where needed to even out the depth and color of the base finish.

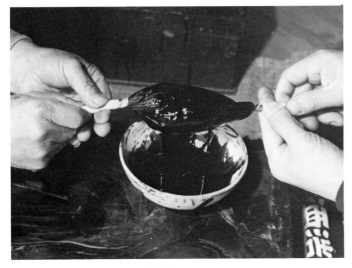

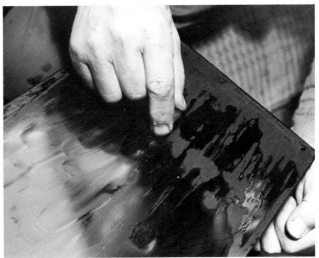

6. APPLYING REFINED LACQUER
A small amount of lacquer that has been heat-treated is passed through filter paper into a standard measuring dish and worked into the grain with a wooden spatula.

7. BURNISHING WITH CHARCOAL
Once dry, the wood surface is again burnished with charcoal. Lacquer characteristically hardens better in humid conditions, so the rainy season is often the best time for lacquering; a coat will often harden within two hours.

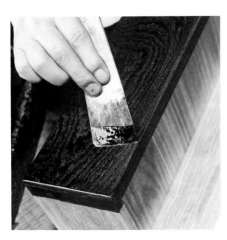

8. APPLYING A SECOND COAT
Steps 6 and 7 are repeated.

9. BRUSH COATING
For the first time, lacquer is applied with a brush, not a wooden spatula. A simple *kijiro* lacquer procedure stops upon completion of this step.

10. BURNISHING THE BRUSH FINISH
The brush coat is burnished with charcoal, which does not scratch the surface like sandpaper.

11. APPLYING THE MIDDLE COAT
Step 9 is repeated.

12. BURNISHING THE MIDDLE COAT
Steps 10 and 11 are repeated.

13. APPLYING THE FINAL COAT
The final brush coat is applied.

14. WATER RUBBING
A paste of powdered whetstone and water is rubbed over the surface with a fine wool cloth until the finish looks like ground glass. This step is typically omitted on small furniture items.

15. OIL RUBBING
Camellia-seed oil is rubbed over the surface, again with a wool cloth, applying powdered whetstone time and again to absorb any excess.

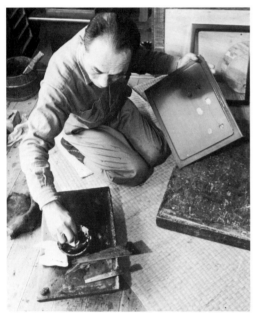

16. RAW LACQUER RUBBING
Raw filtered lacquer is tamped onto the surface with a wadded applicator, spread out, and wiped off with a dry cloth. The article is left to dry in a special drying chamber.

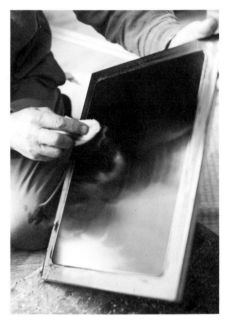

17. POLISHING
The surface is painstakingly polished with a few drops of oil on a wool cloth. A small drawer can take one full hour.

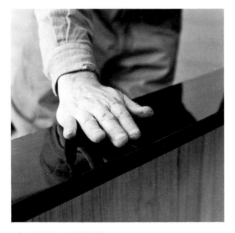

18. HAND WIPING
The surface is wiped with the palm of the hand using powdered deerhorn to remove any oil.

19. FINAL POLISHING
A final "once over" with a sparing amount of oil on a wool cloth, followed by powdered deerhorn. When the polishing is finished the surface is completely free of oil.

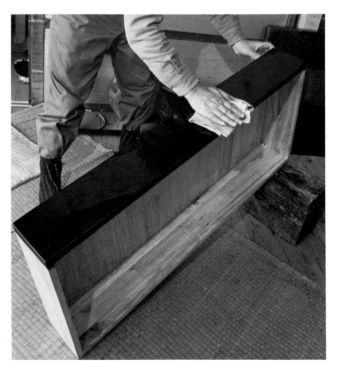

METALWORK

Metal fittings on traditional Japanese furnishings may be generally broken down into the categories of locks (*jōmae*), hinges (*chōtsugai*), various pulls, pole-carrying handles (*sao-tōshi*), latches (*tome-kanagu*), decorative hardware (*kazari-kanagu*), and sash hardware (*obi-kanagu*). (See pages 202–7 for illustrations.)

Locks affixed to doors, sliding panels, and drawers include both fixed mechanisms (*kotei-jō*) and removable mechanisms (*yūdō-jō*): sliding-door locks (*sashikomi-jō*), single-action locks (*omote-jō*), and interior locks (*uchi-jō*) are among the former; and padlocks (*ebi-jō*) representative of the latter.

Hinges on doors and lids might be mounted on either the exterior or interior. In addition to the common plate-shape, there were such styles as the band hinge (*obi-chōtsugai*) and T-shaped hinge (*chō no ji*).

The category of drawer pulls also includes rings (*kan*), knobs (*tsumami*), and sliding-panel finger holds (*tekake*). There are several main styles, the oldest being the squared pull (*kaku-te*) and "fiddlehead fern" pull (*warabi-te*), the latter of which survived long after the former had fallen into disuse. From the Meiji era (1868–1912) on into the first part of Shōwa (1926 to present), the "leech" pull (*hiru-te*), "melon" pull (*mokko*), "military fan" pull (*gunbai*), and "comb" pull (*kushigata*) were added to the list, with special embedded pulls (*umekomi-hikite*) enjoying considerable popularity during the Taishō era (1912–26); there were also numerous other variants in the early Shōwa. Through all historical periods knobs and free-swinging rings mounted, most commonly, on round or flower-shaped escutcheons were used on drop-fit doors and small drawers.

A distinction was made between drawer pulls and grip handles affixed to or recessed into the sides and tops of furnishings. Though they may appear similar (or might in fact be of the same shape), they differ in function; grip handles were used to hand-lift and transport entire furniture units, not simply to open doors or drawers.

Pole-carrying handles were affixed to either side of large furniture items such as chests (*tansu*) and trunks (*nagamochi*) so that the weight could be distributed between two persons, each shouldering an end of a carrying pole passed through the loops formed when these handles were raised. In the case of stacked chests, these handles sometimes also functioned to align pieces. The oldest styles were fashioned by bending metal bars or rods into U-shapes, and attaching them so that they could be either swung or slid down and out of the way when not in use. From the beginning of the Shōwa period on, however, a variant of the sliding design that allowed the handle to drop into a flush metal casing gained popularity.

Latches were affixed to doors, sliding panels, and lids, and styles include drop-pinion (*otoshi*), twist (*neji-kake*), turn-slide (*sashi-tsubo*), and cross-bolt (*uchikake*).

Decorative hardware served both to adorn and to reinforce exposed end-grain and joints of chests, shelving (*tana*), household Buddhist altars (*butsu-dan*), and desks and writing tables (*tsukue*). These include door and drawer corner plates (*sumi-kanagu*) as well as corner and slide braces (*herikanagu*) such as the three-way "dragonfly" (*tonbo*), T-brace (*chō no ji*), split T-brace (*ore-chō*), and bar brace (*nirami*). Other ornamental fittings include family crests (*jōmon*) and trademarks (*yagō*).

Sash hardware provided bracing on one or more faces of heavy furnishings such as chests and cash boxes (*zeni-bako*). Some fittings took the form of grids laid flat on one side; others, of bands completely around the perimeter.

Metals for fittings include iron, copper, brass, nickel-silver, silver, and certain other alloys. Of these, iron was the most widely used, followed by copper—though hardly a close second since it was nearly two-and-one-half times more expensive. Nonetheless, from the Taishō era it came into greater use on small and high-quality chests. Silver

was used even more sparingly as a complement to copper, but only for damascene work and minor trim in places that did not require a harder metal. Sometimes alloys with a silvery cast were substituted.

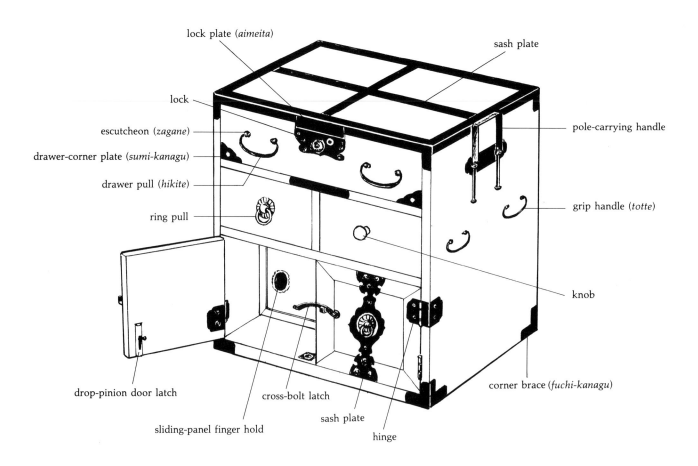

lock plate (*aimeita*)

sash plate

lock

escutcheon (*zagane*)

drawer-corner plate (*sumi-kanagu*)

drawer pull (*hikite*)

ring pull

pole-carrying handle

grip handle (*totte*)

knob

drop-pinion door latch

cross-bolt latch

sliding-panel finger hold

sash plate

hinge

corner brace (*fuchi-kanagu*)

Metal fittings for chest

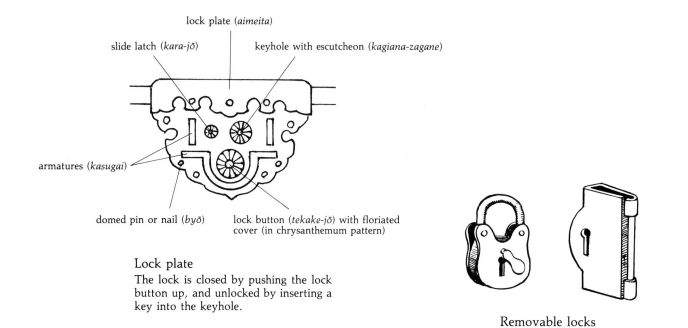

lock plate (*aimeita*)

slide latch (*kara-jō*)

keyhole with escutcheon (*kagiana-zagane*)

armatures (*kasugai*)

domed pin or nail (*byō*)

lock button (*tekake-jō*) with floriated cover (in chrysanthemum pattern)

Lock plate
The lock is closed by pushing the lock button up, and unlocked by inserting a key into the keyhole.

Removable locks

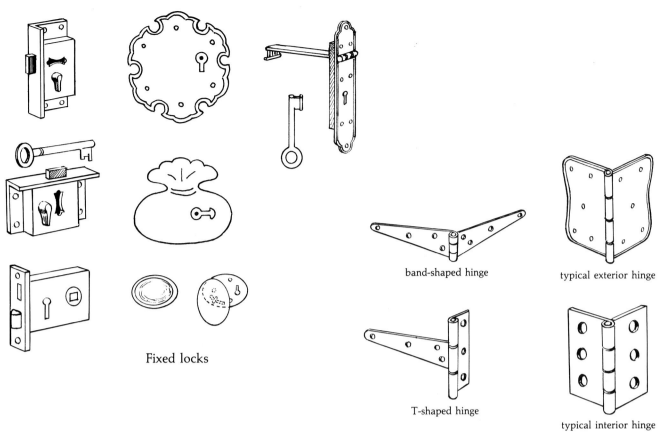

Fixed locks

band-shaped hinge

typical exterior hinge

T-shaped hinge

typical interior hinge

Hinges

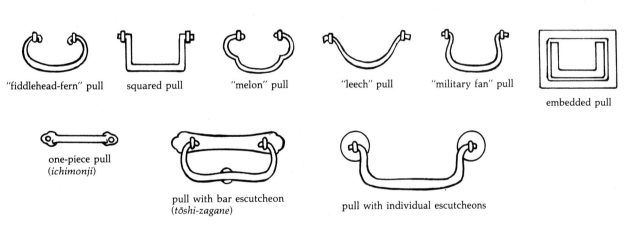

"fiddlehead-fern" pull

squared pull

"melon" pull

"leech" pull

"military fan" pull

embedded pull

one-piece pull
(*ichimonji*)

pull with bar escutcheon
(*tōshi-zagane*)

pull with individual escutcheons

Pulls

Ring pulls and knobs

Sliding-panel finger holds

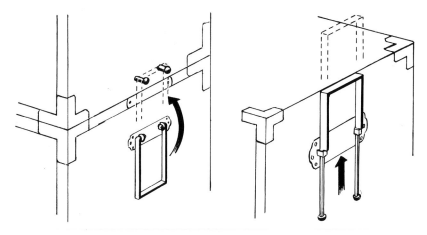

Pole-carrying handles

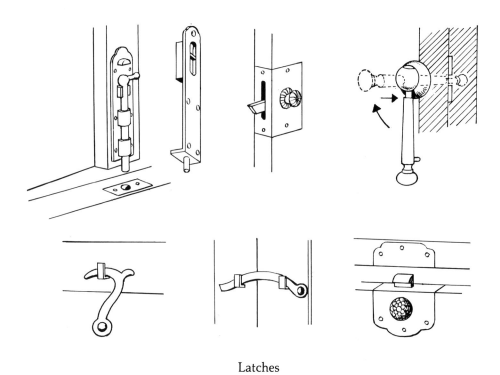

Latches

three way "dragonfly" brace

bar brace

bent-top T-brace

T-brace

split T-brace

Types of corner and side braces

Chest with bands of sash hardware

METAL FITTING MOTIFS

PLANT MOTIFS

CHERRY BLOSSOM (*sakura*)

PEONY (*botan*)

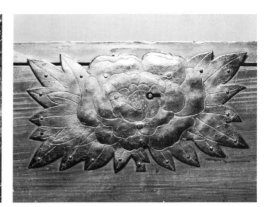

PEONY

CHRYSANTHEMUM (*kiku*)

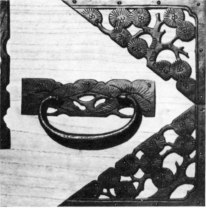

PLUM BLOSSOMS (*ume*)

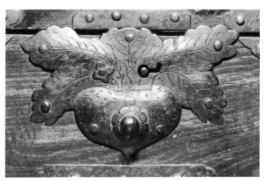

TURNIP (*kabura*)

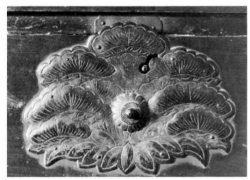

PINE (*matsu*)

PINE

MANDARIN-ORANGE BLOSSOM (*tachibana*)

FIGURE MOTIFS

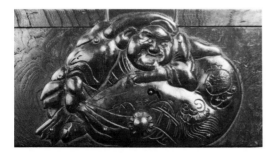

DAIKOKU, GOD OF WEALTH

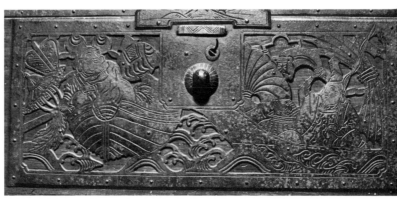

EBISU AND DAIKOKU

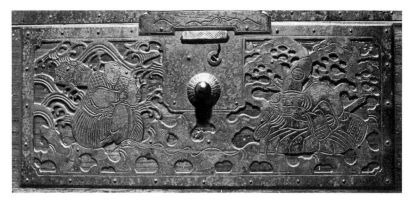

URASHIMA TARŌ, THE FISHER-BOY

CHINESE CHILD

ANIMAL MOTIFS

CARP (*koi*)

TURTLE (*kame*)

TURTLE

PEACOCK
(*kujaku*)

CRANE (*tsuru*)

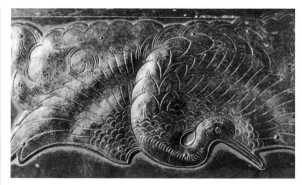

CRANE

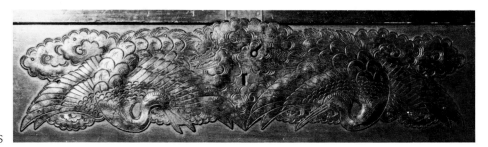

CRANES

MYTHICAL-ANIMAL MOTIFS

CHINESE LION (*kara-jishi*)

CHINESE LION

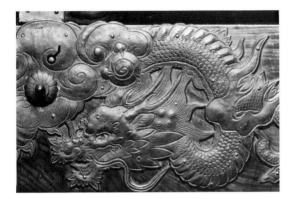

DRAGON (*ryū*)

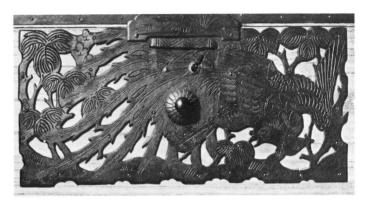

PHOENIX (*hōō*)

COMBINATION MOTIFS

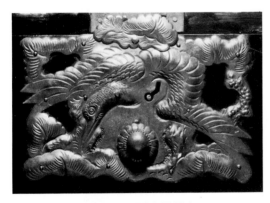

CRANE WITH PINE-BAMBOO-PLUM .
(*tsuru ni shōchikubai*)

FALCON WITH PINE-BAMBOO-PLUM
(*taka ni shōchikubai*)

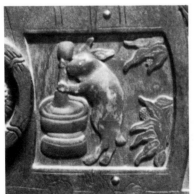

RABBIT POUNDING RICE CAKES
(*usagi no mochitsuki*)

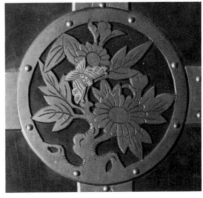

PEONIES AND BUTTERFLY
(*botan ni chō*)

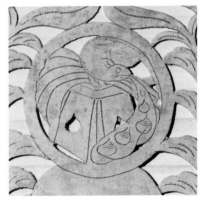

RAT ON A RAISED TRAY
(*nezumi ni sanbō*)

TYPICAL METALWORKING TECHNIQUES

1. DRAWING THE PATTERN
A line drawing of a dragon, lion, or other design is made in ink on paper. If the design is to be repeated, it may be traced from a master drawing placed under the paper.

2. MARKING THE SHEET METAL
Using a handmade scriberlike tool, the outline is scratched into the metal.

3. CUTTING THE SHEET METAL
The necessary amount of metal is cut out of the sheet with shears, or in the case of thick sheets, with a hammer and chisel.

4. PASTING THE PATTERN
The paper pattern is cut to size and carefully pasted face up onto the surface of the cut sheet metal.

5. SELECTING TOOLS
Various chisels and punches for outlines, openwork, and embossing are chosen and placed within easy reach.

6. OUTLINING THE PATTERN
Using a sharp, fine-tipped chisel, the outline is tapped out following the pattern paper.

7. INCISING
Texture and patterns are given to the metal surface by incising with a chisel.

8. REPOUSSÉ
The metal plate is placed face down on a soft lead base. Areas of relief are hammered out from the back into the lead base using a round-tipped chisel.

9. RETOUCHING
The metal plate is turned face up once again, and the outline is carefully gone over with a sharp line-work chisel.

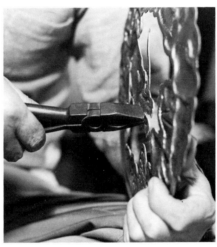

10. REMOVING OPENWORK AREAS
Unnecessary areas are removed with pliers. Additional detail work with a fine-tipped chisel may be needed to ease removal and to clean up corners afterward.

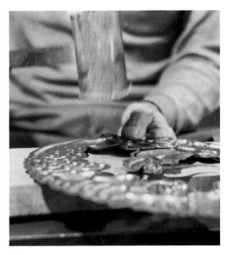

11. FLATTENING
Distortions or twists in the metal resulting from the previous step are flattened out with a mallet.

12. FILING
Sharp and rough edges are filed down with various hand files.

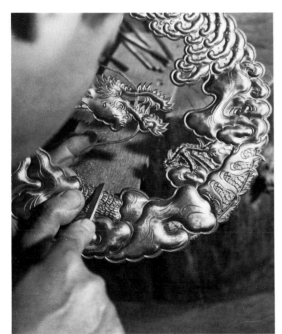

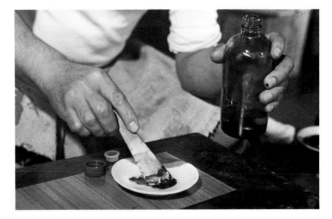

13. FILTERING LACQUER
Lacquer is filtered through a layer of paper, and then thinned, if necessary, with castor oil (as shown). Overly thick lacquer will hide the finer chiseling work.

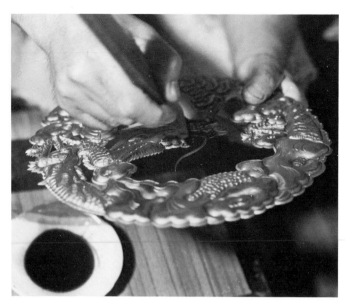

14. APPLYING LACQUER

Lacquer is brushed on the upper surface of the hardware. At this stage it appears dark brown.

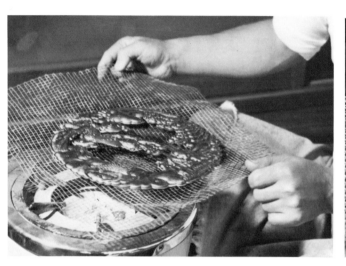

15. INITIAL HEATING

The hardware plate is heated from underneath over a charcoal brazier for two or three minutes until the lacquer smolders and turns black.

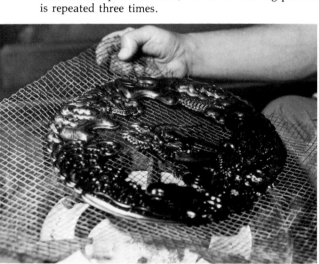

16. REPEATED HEATING

Once the lacquer has dried, the above heating process is repeated three times.

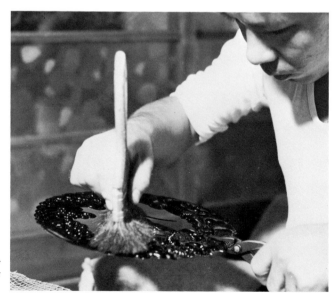

17. WAXING

The hardware plate is warmed slightly, and the entire surface is quickly wiped with wax, then polished to a shiny black with a fine metal brush.

APPENDICES

ABSTRACT MOTIFS IN JAPANESE FURNITURE

well frame (*igeta*)

incense seal (*kō no zu*)

lobed corner (*irisumi*)

tie strings (*tasuki*)

diamond (*hishi*)

well-frame diamond
(*hishi-igeta*)

pine-bark lozenges
(*matsukawa-bishi*)

compound flower lozenges
(*saiwai-bishi*)

cypress fence weave
(*higaki*)

key fret (*saya-gata*)

basket weave (*kagome*)

flax leaf (*asa no ha*)

turtle shell (*kikkō*)

sword-tip triskelion
(*ken-saki*)

double weave (*san-kuzushi*)

checkerboard (*ishi-datami*)

fish scales (*uroko*)

thunderbolt (*rai*)

fishnet (*hoshi-ami*)

regularly interlocking
circles (*shippō-tsunagi*)

interlocking loops
(*kumiwa-chigai*)

sea crest (*seigaiha*)

grassy shoal (*suhama*)

opposed vertical serpentine
lines (*tatewaku*)

gouge swirls (*guri*)

melon (*mokkō*)

Persian rondel (*ban-e*)

tree bark (*kuchiki-gata*)

three-tiered pine
(*sangai-matsu*)

arabesque (*karakusa*)

ILLUSTRATED HISTORY OF JAPANESE FURNITURE

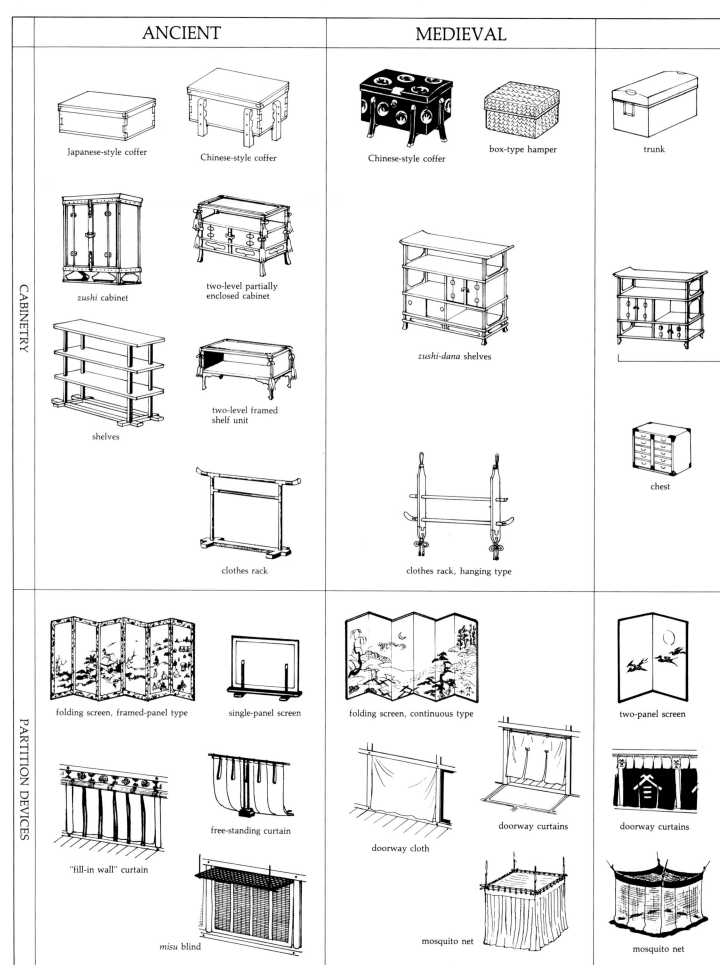

	ANCIENT	MEDIEVAL	

CABINETRY

Japanese-style coffer

Chinese-style coffer

Chinese-style coffer

box-type hamper

trunk

zushi cabinet

two-level partially enclosed cabinet

zushi-dana shelves

shelves

two-level framed shelf unit

chest

clothes rack

clothes rack, hanging type

PARTITION DEVICES

folding screen, framed-panel type

single-panel screen

folding screen, continuous type

two-panel screen

"fill-in wall" curtain

free-standing curtain

doorway cloth

doorway curtains

doorway curtains

misu blind

mosquito net

mosquito net

Note: Pieces are shown only in the time frame in which they first appeared, though many of them enjoyed continued usage down through successive eras.

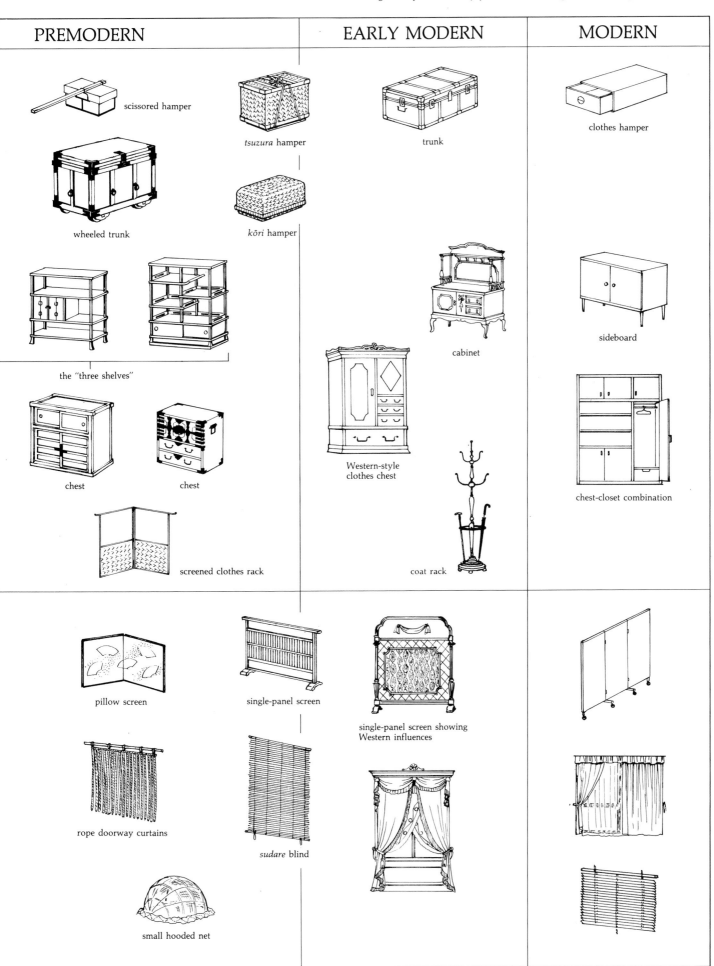

PREMODERN	EARLY MODERN	MODERN

scissored hamper

tsuzura hamper

trunk

clothes hamper

wheeled trunk

kōri hamper

the "three shelves"

cabinet

sideboard

chest

chest

Western-style clothes chest

chest-closet combination

screened clothes rack

coat rack

pillow screen

single-panel screen

single-panel screen showing Western influences

rope doorway curtains

sudare blind

small hooded net

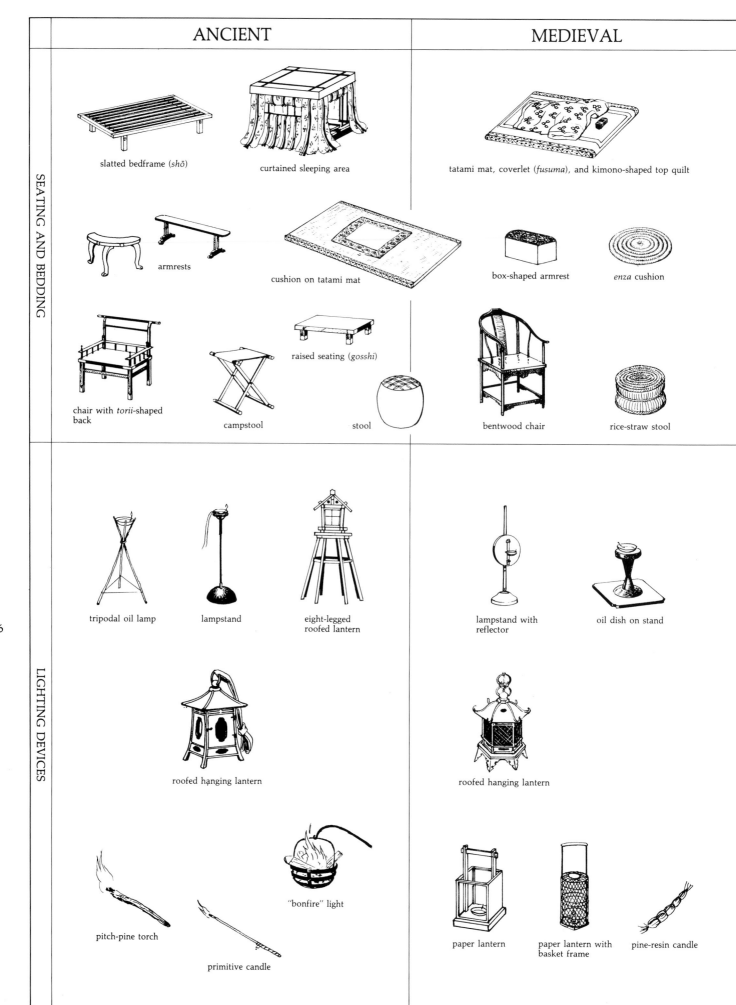

	ANCIENT	MEDIEVAL

SEATING AND BEDDING

slatted bedframe (*shō*)

curtained sleeping area

tatami mat, coverlet (*fusuma*), and kimono-shaped top quilt

armrests

cushion on tatami mat

box-shaped armrest

enza cushion

chair with *torii*-shaped back

raised seating (*gosshi*)

campstool

stool

bentwood chair

rice-straw stool

LIGHTING DEVICES

tripodal oil lamp

lampstand

eight-legged roofed lantern

lampstand with reflector

oil dish on stand

roofed hanging lantern

roofed hanging lantern

pitch-pine torch

primitive candle

"bonfire" light

paper lantern

paper lantern with basket frame

pine-resin candle

PREMODERN	EARLY MODERN	MODERN

futon mattress and kimono-shaped top quilt

futon mattress and top quilt

armrest

zabuton cushion

cushion

cushion with backrest,
or "legless chair"

bentwood chair with
crossed legs

bamboo bench

chair

bentwood chair

lampstand short oil lamp squared framed-paper lantern cylindrical framed-paper lantern

gatō lamp

kerosene lamp Western-style lamp electric light

framed-paper hanging lantern

wall lantern Gifu-style paper lantern

hanging kerosene lamp

hand-held candlestick storehouse paper lantern "gyroscopic" lantern

chandelier

fluorescent light

horseback paper lantern

Odawara-style paper lantern

bow-stretched paper lantern dangling paper lantern cased paper lantern

metal hand lamp

portable kerosene lamp

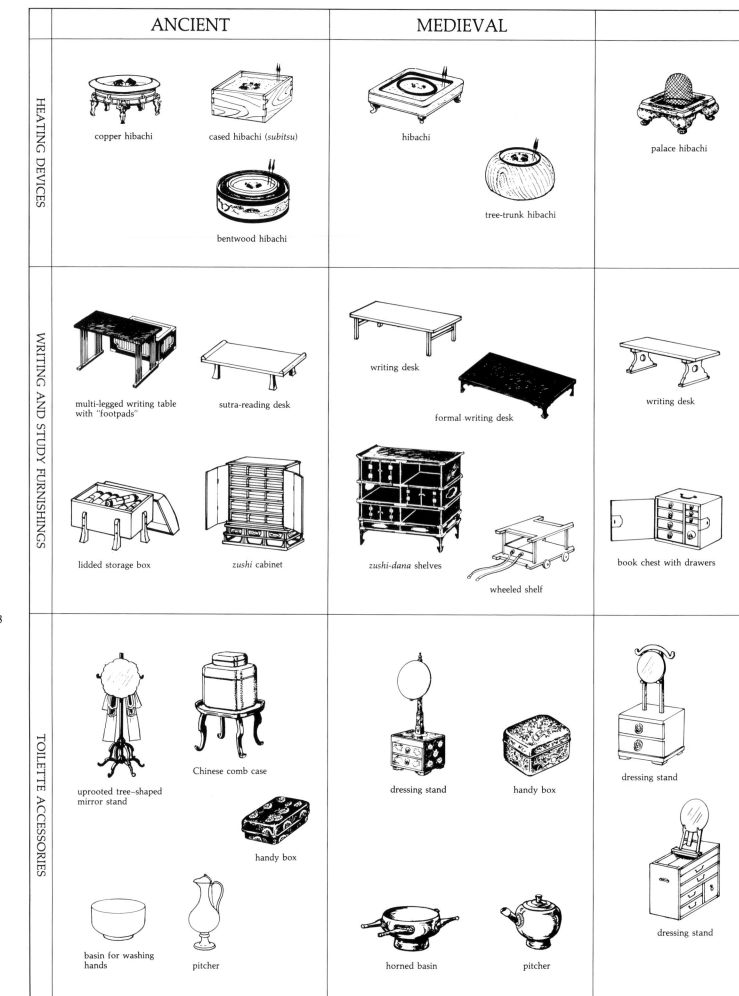

	ANCIENT	MEDIEVAL	
HEATING DEVICES	copper hibachi · cased hibachi (subitsu) · bentwood hibachi	hibachi · tree-trunk hibachi	palace hibachi
WRITING AND STUDY FURNISHINGS	multi-legged writing table with "footpads" · sutra-reading desk · lidded storage box · zushi cabinet	writing desk · formal writing desk · zushi-dana shelves · wheeled shelf	writing desk · book chest with drawers
TOILETTE ACCESSORIES	uprooted tree–shaped mirror stand · Chinese comb case · handy box · basin for washing hands · pitcher	dressing stand · handy box · horned basin · pitcher	dressing stand · dressing stand

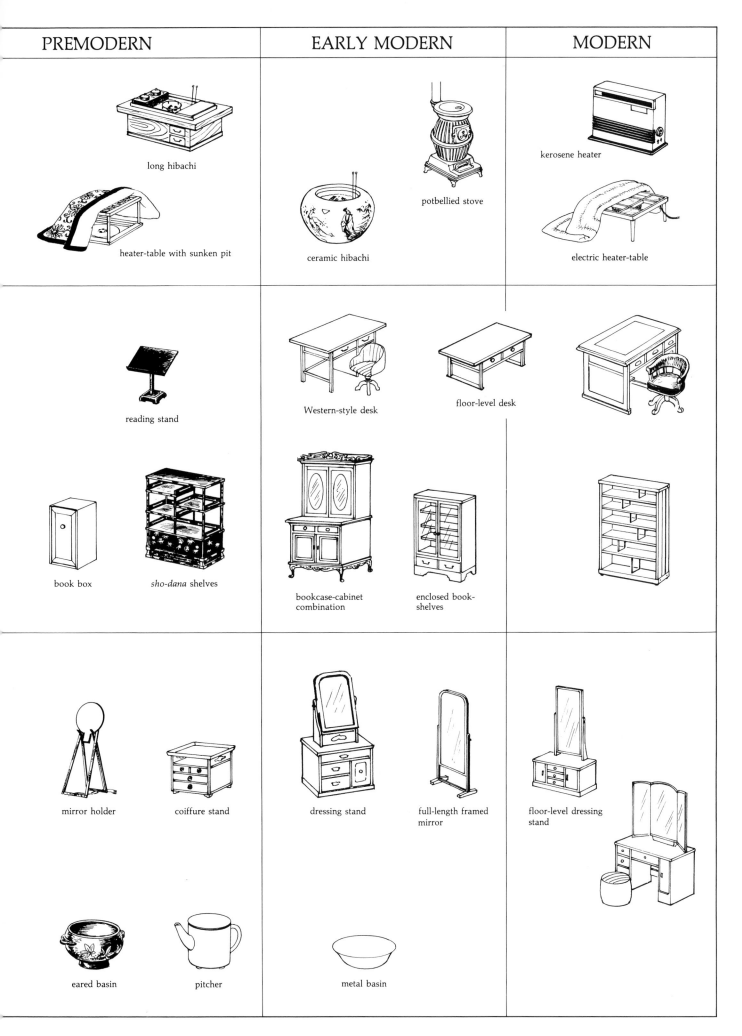

PREMODERN	EARLY MODERN	MODERN

long hibachi

heater-table with sunken pit

ceramic hibachi

potbellied stove

kerosene heater

electric heater-table

reading stand

Western-style desk

floor-level desk

book box

sho-dana shelves

bookcase-cabinet combination

enclosed book-shelves

mirror holder

coiffure stand

dressing stand

full-length framed mirror

floor-level dressing stand

eared basin

pitcher

metal basin

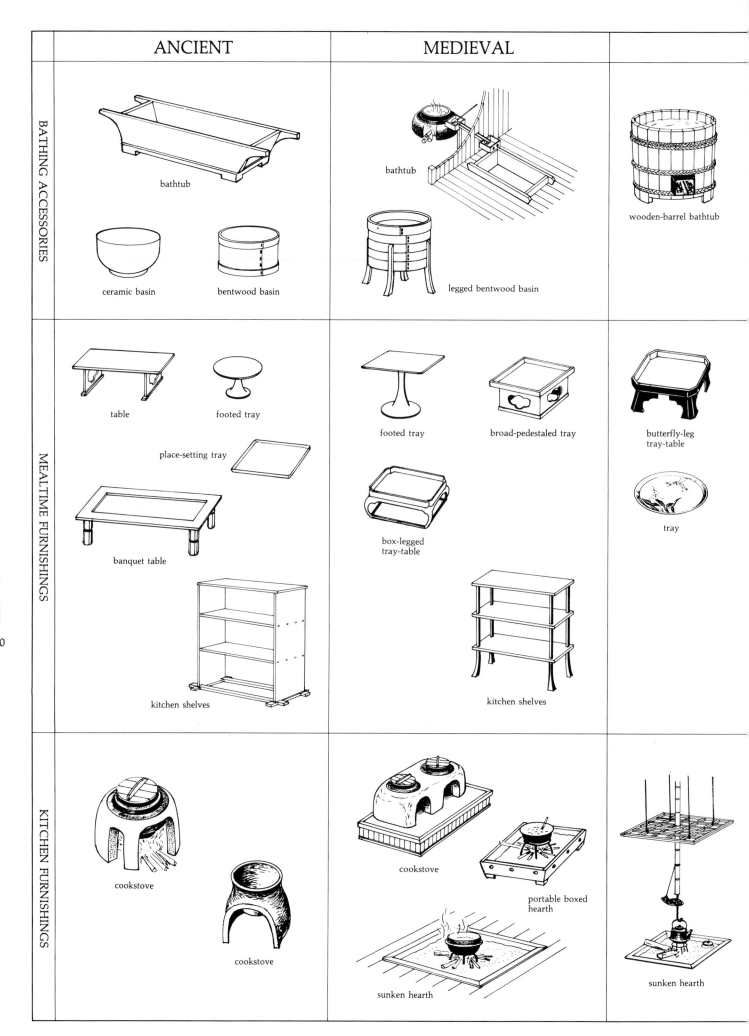

	ANCIENT	MEDIEVAL	
BATHING ACCESSORIES	bathtub ceramic basin bentwood basin	bathtub legged bentwood basin	wooden-barrel bathtub
MEALTIME FURNISHINGS	table footed tray place-setting tray banquet table kitchen shelves	footed tray broad-pedestaled tray box-legged tray-table kitchen shelves	butterfly-leg tray-table tray
KITCHEN FURNISHINGS	cookstove cookstove	cookstove portable boxed hearth sunken hearth	sunken hearth

PREMODERN	EARLY MODERN	MODERN

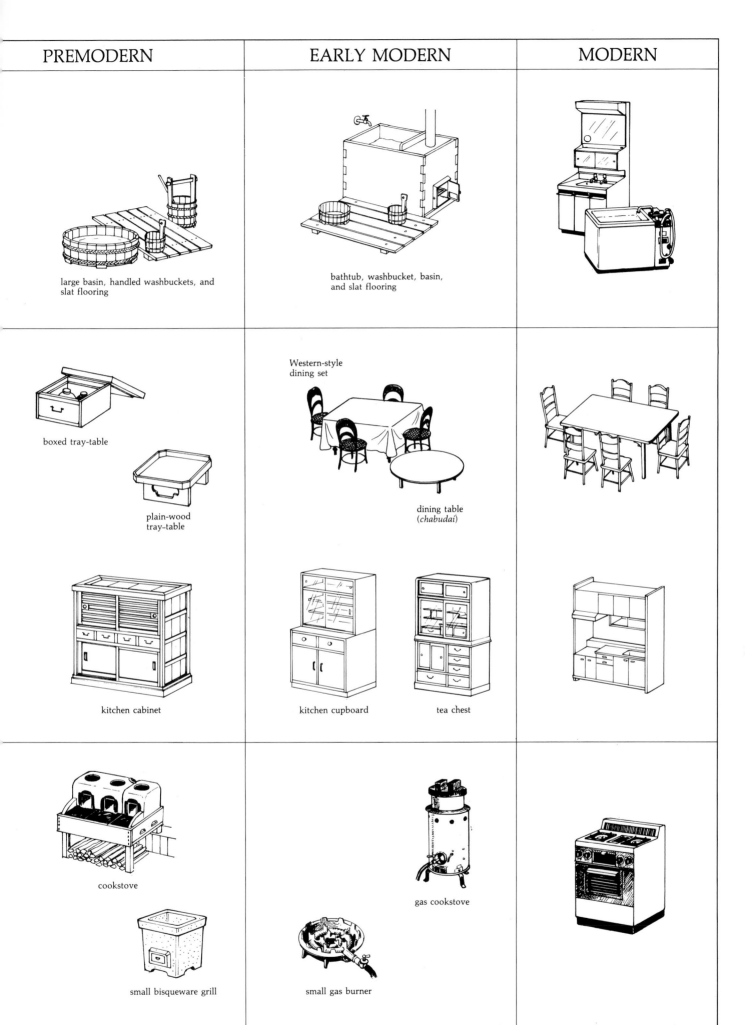

large basin, handled washbuckets, and slat flooring

bathtub, washbucket, basin, and slat flooring

boxed tray-table

plain-wood tray-table

Western-style dining set

dining table (*chabudai*)

kitchen cabinet

kitchen cupboard

tea chest

cookstove

gas cookstove

small bisqueware grill

small gas burner

INDEX

Italicized numerals indicate page numbers of color plates.

222

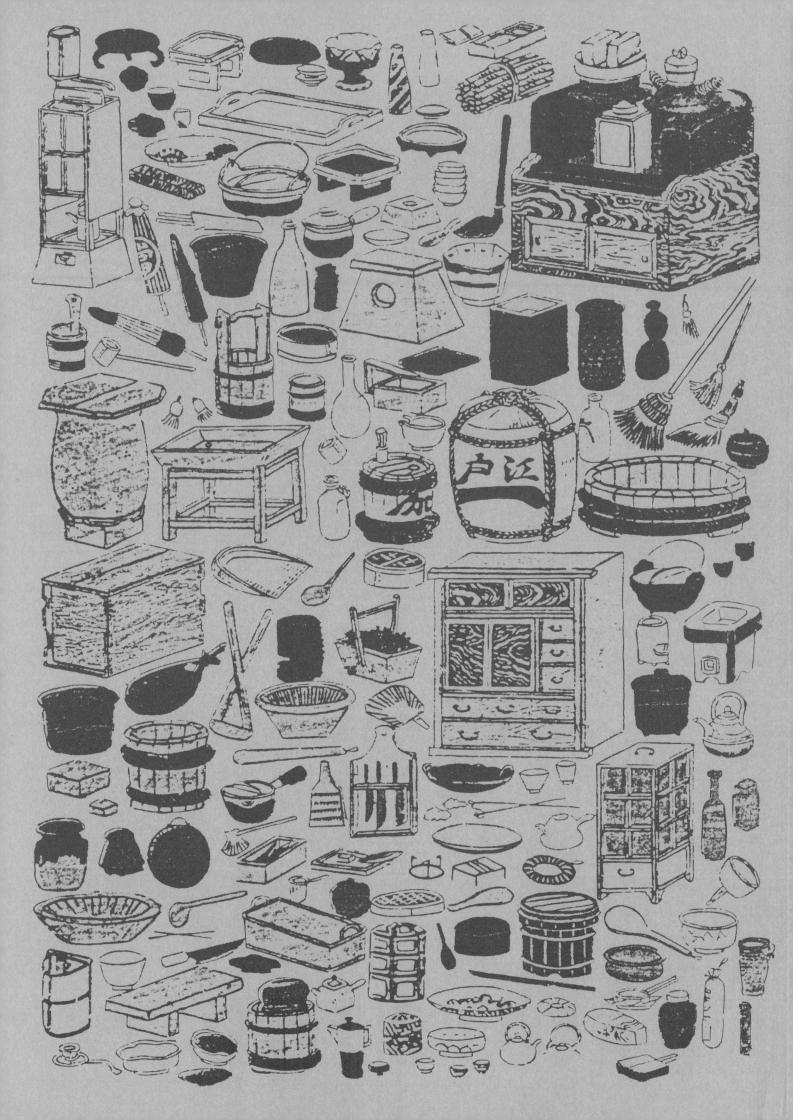